Courting Failure

Women and the Law in
Twentieth-Century Literature

Heidi Slettedahl Macpherson

The University of Akron Press
Akron, Ohio

All inquiries and permissions requests should be addressed to the
publisher, The University of Akron Press, Akron, OH 44325–1703

LIBRARY OF CONGRESS CATALOGING-IN-PUBLICATION DATA
Macpherson, Heidi Slettedahl.
Courting failure : women and the law in twentieth-century
literature / Heidi Slettedahl Macpherson.
p. cm. — (Series on law, politics, and society)
Includes bibliographical references and index.
ISBN 978-1-931968-47-8 (alk. paper)
—
ISBN 978-1-931968-48-5 (pbk. : alk. paper)
1. American literature—20th century—History and criticism.
2. Law in literature. 3. Women in literature. 4. Courts in literature.
5. Canadian literature—20th century—History and criticism.
6. English literature—20th century—History and criticism.
7. Women—Legal status, laws, etc. 8. Legal films (Drama)—
History and criticism. 9. Legal television programs (Drama)—
History and criticism. 10. Feminist literary criticism. I. Title.
PS228.L39M33 2007
820.9'3554—dc22
2006039518

The paper used in this publication meets the minimum
requirements of American National Standard for Information
Sciences—Permanence of Paper for Printed Library Materials,
ANSI Z39.48—1984. ∞

Cover art: *Blind Justice III* by Vergie Banks.
All Copyrights Reserved by Artist Vergie Banks
www.littleredtricycle.com

To Allan, always

Contents

Acknowledgments

A number of scholars have lent me time, advice, and sources over the years, including Janet Beer, Susan Castillo, Martin Kayman, Ian Scott, Jacquie Berben-Masi, Annette Bennington-McElhiney, Dianne Dutton, Monika Fludernik, and Greta Olson. I would like to thank Vivien Hughes and Michael Hellyer (retired) at the Canadian High Commission. Some of the research for this book has been made possible through the generous assistance of the Canadian government's Faculty Research Program. I have benefited from presenting aspects of this book as conference papers or invited presentations in Oxford, Strasbourg, Nice, Aberystwyth, Cambridge, Reading, and Birmingham. Earlier versions of chapters of this monograph have appeared in the journals *Cycnos*, *Journal of Indo-American Studies*, *Compar(a)ison*, and *Journal of American Studies*, and in Monika Fludernik and Greta Olson's *In the Grip of the Law*. Thanks are also extended to the anonymous readers who offered suggestions for improvements and amendments of the original manuscript.

I thank my students at the University of Central Lancashire for their engaging, sometimes odd, and always thought-provoking responses to the texts that I teach and that find their way into this book. I am particularly indebted to my class Contemporary Women Writers (2002), who took opposing views of *Affinity* and other texts on women and the law.

I thank my colleagues at the University of Central Lancashire. Without the university sabbatical I was awarded in January 2005, this book would not have been completed. Specific mention goes to Will Kaufman and Alan Rice, for reading drafts of chapters or grant applications; and to Janice Wardle and Daniel Lamont for support, intellectual debate, and much-needed cups of coffee.

Final thanks go to my family: Judy Clayton, Amy Northrop, Bob Slettedahl, Jill Winter, and most importantly, Allan Macpherson, for love and support.

Literature, Law, and Desire

To the extent that law itself is a narrative, it cannot only be the accumulated record of issues resolved through application of law to facts by a neutral decision maker. By recognizing the tinted narrative lens, we can understand how law reinforces the views of the powerful through the continual retelling of stories from the dominant perspective.[1]

This book emerges out of the recognition that women's literature and literature about women seem insistently to revisit questions of the law, the parameters of the court, and the regulation of desire. It is not based on whether the representations of the law in literature are accurate or truthful (though there are instances in which I will be comparing the real life basis of the texts with their fictional, dramatic, or filmic counterparts), but it is rather an exploration of what is still a relatively underexplored aspect of the law and literature field(s): women and the law in contemporary literature and culture.

My interest in the field is as a literature specialist and a feminist, and I am particularly concerned with how women as subjects of courtroom dialogue and debate become translated into objects on display and with the ways in which their voices become contained or controlled by narratives to which they have only limited access. Carolyn Heilbrun and Judith Resnik, pioneers in the area of feminist law and literature, argue that the feminist branch of the field is particularly interested in women's *stories*: how they are told, what they might reveal or conversely conceal, and how shared or familiar tales intersect (in this, they have much in common with Critical Legal Scholars). Disappointed that much of this sharing of stories involves a

recitation of women's injuries and silences, they argue that feminist studies should instead explore women's "right to anger, their use of power . . . [and] their noncomplicity in the role of sex object."[2] This is a utopic desire. Indeed, one need only read the latest newspapers to discover that although one may prefer to read of women's power and success in the courtroom, one is confronted—as we shall see—with images of the mad, the bad, and the powerless instead.

That *the law* comes first in the law and literature movement is clear from a quick examination of much of the movement's critical work, and it is within this context that my introduction proceeds. It has become almost compulsory for law and literature books to start by exploring the rich, and sometimes beleaguered, history of the law and literature movement (such as it is), and so this book is no exception. The idea of a movement calling itself "law and literature" can be traced back to the early part of the twentieth century in an oft-quoted article by Benjamin Cardozo entitled "Law and Literature" (1925). The next significant text in the field was James Boyd White's *The Legal Imagination* (1973), which is most often seen as having kick-started the movement in its current formulation(s). Since then, the field has been divided into a variety of subsets, the most common of which are the "law as literature" and "law in literature" constructions. Richard Weisberg credits this division to Ephraim London, a New York lawyer.[3] Law *as* literature is primarily concerned with the literary quality of the law, thus reading legal texts as literary texts, whereas law *in* literature focuses on how the law is depicted in literature itself, and this latter subfield is the main focus of this text.

More recently, Tony Sharpe has suggested two further categories: "literature as law" ("a competitive emulation of law by literature") and "literature in law" (the "comparison within a literary text, between legal methodology and its own ways of working").[4] Sharpe's reformulation of the law and literature project is not meant to privilege literature, but to "consider some of the ways in which law has been misunderstood or misrepresented in literature."[5] In this formulation, Sharpe follows in the footsteps of a high-profile critic of the law and literature movement: Richard Posner. Posner argues that "[t]here are better places to learn about law than novels—except perhaps to learn how

laymen react to law and lawyers."[6] Posner's stance is particularly con-
frontational, but other critics welcome the way that law and literature
find spaces in common. As Dieter Paul Polloczek argues, this might
be particularly useful for liberal humanists or feminist critics who
"continue to describe beneficial interactions, both historical and spec-
ulative, between judicial authority and literature, seeing both as per-
formances of a communal rhetoric open to many voices, and in this
sense capable of moral progress."[7] While this stance is perhaps ideal-
istic—Richard Weisberg would characterize it as "sentimentalist"[8]—
it does serve to highlight one way in which law and literature might
be fruitfully joined with feminism, a possibility I explore in the pages
and chapters to come.

A connection between literature and the law is certainly not new,
as critics such as Robert Ferguson and Theodore Ziolkowski point
out. Indeed, Ferguson outlines the historical trajectory of the law and
letters interface. Arguing that lawyers "dominated" early American lit-
erary circles, Ferguson sets out the ways in which this was the case:

Half of the important critics of the day trained for law, and attorneys con-
trolled many of the important journals. *Belles lettres* societies furnished the
major basis of cultural concern for post-Revolutionary America; they
depended heavily on the legal profession for their memberships. Lawyers
also wrote many of the country's first important novels, plays, and poems. No
other vocational group, not even the ministry, matched their contribution.[9]

Yet Theodore Ziolkowski argues that the interdisciplinary practice of
law and literature is "too fascinating and important to be conceded to
the lawyers. Issues of law are so central to human society that they
dominate many of the landmark works of Western literature and
thereby have a claim on the attention of all educated people."[10] As a
result, he coins his own interdisciplinary space as "literature and law"
in a reversal of the usual order.[11] Indeed, of all designations, this
might fit my own stance most clearly. It is certainly the case that liter-
ary critics have made important headway into the movement over the
last few years, not least because their skills of narrative analysis are
particularly well suited to the field. The journal *New Formations* ded-
icated an entire special volume, *Legal Fictions*, to the project in 1997.
It is in focusing on narrative itself—the organization of story—that

practitioners of law and literature have most in common. However, as Polloczek argues, the field continues to lack "interdisciplinary consensus" on "whether it is the approximation or the distance between law and literature that ought to be emphasized."[12] In a separate but related argument, Willem J. Witteveen suggests that the present quest to expand the law and literature canon could lead to a fragmentation of a developing discipline (though, paradoxically, he also argues that the field should embrace additional kinds of texts, moving away from the standard focus on the novel).[13]

Jane Baron contends that the "multiplicity of approaches and concerns that leads some to see literature as a source of nearly endless possibilities may lead sceptics to dismiss law and literature as an empty vessel, a phrase devoid of content."[14] Baron argues that law and literature proponents (in her terminology, "law-and-lits") fall into three basic camps: humanist law-and-lits, who think literature is good for lawyers; hermeneutic law-and-lits, who want to focus on literary theory and "interpretive methodologies borrowed from literary studies"; and narrative law-and-lits, who are interested in storytelling.[15] There is certainly a well-developed strand of law and literature research which maintains that literature offers the lawyer an opportunity to become somehow better at his or her job, or that the teaching of literature is more than just an easy option for law students tired of the "harder" material.[16] In relation to the second group, individuals like Sanford Levinson are frequently cited,[17] and as an example of the last group, David R. Papke presents a range of legal storytelling in his edited collection *Narrative and Legal Discourse*. Well-known legal storytellers include Richard Delgado and Jerome Culp, among others.[18] Baron finds fault with each of these approaches and also contends that "legal scholars seemed to have turned to literary studies just when there was the least consensus within the latter field about how to read."[19] She further argues that the "certainty with which legal scholars assert what are actually quite contestable readings is, thus, understandable, but still incongruous."[20]

One of the perennial problems of interdisciplinary study is that it is perplexing to see the use that nonspecialists make of your own specialism and to see or try to understand their understanding of the critical

debates in the subject that you more fully "own." Indeed, to my eyes, a lot of the law and literature movement seriously misreads the nature of literary studies. A surprising emphasis is placed on either authorial intentionality or canonicity, with no or little awareness of how these ideas have been successfully challenged in literary studies. That judges must decide between competing interpretations and within a framework of historical narratives perhaps ensures this focus. At the same time, though, it remains somewhat surprising to see how literature is being referenced in texts edited in the late 1990s and beyond. Many law and literature texts resolutely refer to "the reader" as a generic "he," an anachronism that has been successfully rooted out of most literary studies.

In addition, much of the law and literature field concentrates its debates on the so-called great works of literature: thus, contemporary texts, as well as texts by women, working-class writers, or ethnic minority writers, are only haphazardly addressed in textbooks aimed at a general law and literature audience. In the appendix to their 1991 article "Norms and Narratives: Can Judges Avoid Serious Moral Error?" Richard Delgado and Jean Stefancic note the numeric discrepancy between white men and white women considered part of the law and literature canon and argue that only two ethnic minority men figure, and no women.[21] Although clearly such stark divisions have altered, the case for inclusion has by no means been won. Michele G. Falkow, for example, in an article about great works, acknowledged that she selected her texts by canvassing the syllabuses of "top" colleges, thus inadvertently invoking elitist measures twice; admittedly, she acknowledges Toni Morrison's *Beloved* as a canonical text, but her methods—apparently straightforward to her—reveal the same biases against women writers and writers of ethnic minorities in their comfortable retention of the status quo.[22] In another example, a new coursebook, *Law and Popular Culture*, published in 2004, offered only a handful of pages on gender and feminism and even fewer pages on ethnicity, while purporting to offer a comprehensive account of how the law works in popular film. As a result, the law continues to be seen as a white male enterprise, with a few "others" mentioned as appropriate.[23] Feminist law and literature textbooks have rectified

some of these omissions, though they also often confine themselves to better-known works of literature. Darwinian notions of "survival of the fittest" appear to take the place of any serious analysis of why some works of literature are or remain marketable, while others, popular at the time of their appearance, disappear.

Ronald Dworkin, for example, puts forward an "aesthetic hypothesis" that suggests that critics are principally interested in offering an interpretation which shows the text in the best light.[24] Dworkin also values the literary canon, as well as "coherence or integrity in art." He argues that "[a]n interpretation cannot make a work of art more distinguished if it makes a large part of the text irrelevant, or much of the incident accidental,"[25] and yet, few literary critics would argue that their primary role is that of enhancing a work of art (though, admittedly, many feminist critics such as myself wish to rescue texts that have been critically overlooked, often because of their contestatory politics). Even fewer would suggest that a literary text has to be taken in its entirety in order to be valuable; in relation to Angela Carter's fantastical narrative *Nights at the Circus*, for example (analyzed in chapter 1), I refer to only one small section: the prison scene that itself does seem almost incidental to the wider narrative, but that offers a telling exploration of the panopticon, an important image or structure in women's literature.

In the introduction to *The Mirror of Justice: Literary Reflections of Legal Crises*, Ziolkowski states that he does not wish to "engage in the polemics that enliven many of the contributions to Law and Literature,"[26] and despite my concerns noted above, this is a feeling I share. Indeed, a surprising number of law and literature articles appear to cite disputes and critical contests with other critics—which may be a measure of their lawyerly nature. Examples of such critical disagreements abound, but the most commonly cited ones include Richard Posner on Richard Weisberg; Stanley Fish, Robin West, and Weisberg on Posner; and Weisberg on "feminists" and "postmodernists." Nevertheless, it is important to recognize that law and literature experts do not speak with one voice, and that my own voice is at odds with some of the leaders in the field, namely Weisberg and Posner (who, as I note above, are themselves at odds with each other). In order to set

out my critical stall (as it were), it will then be necessary for me to explore how these critics address the law and literature interface and to look at some of the issues that this interdiscipline faces and reacts to and against (including feminism and the politics of storytelling), before concluding with a case study of Morley Callaghan's short story, "A Wedding-Dress," which has also been ably explored by the law and literature critic Gary Boire.

In the Name of the Father: Weisberg and Posner on the Canon

Resistance to or ignorance of feminist concerns is evident in much law and literature scholarship, particularly from scholars who see either canonicity or intentionality as the mainstays of the field. Out of the twenty-five texts that Barry R. Schaller discussed at length and accorded abbreviated titles in A *Vision of American Law,* only one, Joyce Carol Oates's *them,* was by a woman. Schaller argues that he "began to search for meanings that would bring coherence and clarity to a story of law and culture."[27] Clearly, "clarity" and coherence are possible only if one does not acknowledge the female. Schaller is certainly not the only law and literature critic to ignore or sideline the female; it is an unfortunate element of the field, particularly in relation to two scholars, Weisberg and Posner, who stand out both for their impact on law and literature and for their resistance to claims from outsider voices.

Richard Weisberg is one of the leading proponents of law and literature (in old critical terms, a founding father), and I admire Weisberg's commitment to the field, if not his convictions. He is, for example, an editor of one of only two law and literature journals, launched as *Cardozo Studies in Law and Literature* but now simply entitled *Law and Literature.* He is also the author of many articles in the field, frequently a guest speaker at law and literature conferences (indeed, he presented a keynote address at the Law and Literature conference in Nice in 2001 that inaugurated my own participation in the field), and has written two major texts: *The Failure of the Word: The Lawyer as Protagonist in Modern Fiction* (Yale University Press, 1984) and

Poethics and Other Strategies of Law and Literature (Columbia, 1992). It is the latter text which interests me here.

Weisberg is a fan of the "Great Books" tradition and justifies his exclusive focus on the canon as a pedagogical one: it is justified in the sense that working on major texts is the first step toward incorporating difference and opening up the canon for new voices. However, as Gaurav Desai, Felipe Smith, and Supriya Nair argue, "judging by his later work, it does not seem that Weisberg thinks that the time is right even now to fully integrate any of these 'lesser-known voices.'"[28] Moreover, in relation to all outsider voices but especially in relation to the voices of ethnic minority writers, they argue that "most of the work in this area currently speaks more to the struggle to be heard rather than to resounding success."[29]

In this exploration of poetic ethics, Weisberg sticks primarily to "establishment male authors" but argues that this "hardly denotes acceptance of the traditional canon when the male narrative enterprise itself is being criticized for its violence and its twisting of the truth."[30] This seems a curious argument, and Weisberg's reluctance to engage with outsider narratives is disappointing. He argues that "even when treating male-authored texts, some of which have no female characters, the Law and Literature syllabus still raises many issues of concern to feminists."[31] This is no doubt true, but it does not excuse the lack of representation he promotes. As Desai, Smith, and Nair argue, "the ideal scenario is one in which is there is a balance between a number of critical approaches and a diverse range of texts. Readings of the traditional canon that approach it from feminist or race-conscious perspectives are, of course, a very important aspect of literary scholarship. But they cannot be held to be sufficient."[32]

Throughout, Weisberg references "law" rather than "the law," as if law is a person whose name can be called. The name is, however, always the name of the father. In the preface to *Poethics*, Weisberg vilifies his fellow law and literature critics Posner and James Boyd White, but also lists, on his dedication page, ten "lifelong friends," all male. Against this list, in the edition shelved at the University of Toronto's Robarts Library, a (presumably) female reader has scrawled, "Watch out for girl germs."[33] Indeed, this delightfully subversive com-

ment resonates almost as much as Weisberg's own words, and offers a sort of (dis)authorizing gloss that disables the premises on which it is formed.

When answering the criticism that law and literature has failed to embrace or even engage with contemporary literary theory, Weisberg disingenuously argues that leveling this criticism is much like criticizing Freud for not taking on Marx. Further, he argues, "it cannot fairly be resented of one progressive line of thinking that it pays scant attention to other contemporaneous innovators."[34] Such an argument is a critical sleight of hand, for the movement itself, in its very name, embraces literature. To then deny the last twenty years of literary theory in this "new" discipline is not only deceitful but regressive.

In an article published in 1999, Weisberg reiterates many of his previous points, but goes even further in his antipathy toward feminists and postmodernists. He suggests that "for twenty or twenty-five years, lawyers interested in stories have sustained the unfashionable position—anathema even or especially to literary theorists—that the single text or collection of texts both exists and can be referenced to the real world."[35] This stubborn refusal to see that challenging the canon does not amount to challenging the existence of texts *per se* is disingenuous again. Moreover, as has been noted above, many branches of feminist criticism hold fast to a notion of correspondence between the literary and real worlds (if not, it has to be stressed, to a naïve notion of transparency).

Weisberg's offhand remarks about feminists need no further exploration here: but his is one voice that is implicitly contested in the writing of this book, which focuses on the textual representation of women's voices. I offer analysis of texts by both men and women (refusing the gender separatism practiced elsewhere in the recognition that separate is never equal). It is true that the great preponderance of my analysis focuses on women's literature, but this is because more women than men have been proactively feminist. Some of the texts I analyze are well known (indeed, almost "canonical"), and others are more recent and less often critiqued. I believe (to misquote Weisberg's stance) that even when treating female-authored texts, some of which focus only fleetingly on male characters, the law and

literature movement still raises many issues of concern to all law and literature experts, feminists and nonfeminists alike. In this respect, I follow Weisberg's call to "make the reader uneasy about the legal assumptions that preceded the understanding of the story,"[36] though surely to different ends. As Jacqueline St. Joan remarks, "in interpreting testimony, weighing evidence, and assessing credibility, judges are most likely to rely on the dominant perspective not only because it is the most familiar, but also because legal precedent usually is grounded in that point of view."[37] My text is one that offers a chance to look from a different point of view: one that highlights and foregrounds women's myriad and differently experienced encounters with the law.

In the preface to his revised edition of *Law and Literature* (1998), Richard Posner comments that American law has "troubled encounters" with women and those whom he terms "blacks."[38] If American law cannot successfully or appropriately deal with half the population (taking, in this instance, the "plight" of women alone), then surely this says something about the way in which the law works (or doesn't work). The fact that this statement can be made at all reveals the battle which faces the feminist and/or race-conscious critic of legal and literary studies. Posner is, by all accounts, the most frequently cited law and literature critic, an ironic fact given his stiff (and I use the term advisedly) criticism of the project. He characterizes the movement as "full of false starts, tendentious interpretations, shallow polemics, glib generalizations, and superficial insights."[39] In this, of course, it has much in common with any discipline, and this is thus no real criticism at all. Posner suggests that it is acceptable to take different critical stances toward each half of this "and" subject: "Law is a system of social control as well as a body of texts, and its operation is illuminated by the social sciences and judged by ethical criteria. Literature is an art, and the best methods for interpreting and evaluating it are aesthetic. There is no inconsistency between being a formalist in literature and an antiformalist, a pragmatist, in law—which happens to be my position."[40] There may well be no inconsistency here, but again, we find that the emphasis on aesthetics leaves little room for other forms of critical intervention into the arts. Moreover, Posner, like Weisberg, is critical of a variety of well-established schools of

critical thought. He indiscriminately lumps together critics whom he sees as having a "radical bent" under the term "postmodernists"; this grouping includes critics employing "neo-Marxism, radical feminism, critical theory and poststructuralism,"[41] a combination that would surprise, if not in some instances dismay, many of the diverse scholars who take up these various positions.

Posner, to give him credit, does acknowledge that in relation to the canon, the Darwinian notion of survival of the fittest may have more to do with chance and circumstance than with "good literature," but this is a minor concession.[42] He is, moreover, suspicious of popular culture.

It is, however, in his suspicion of feminism that we most clearly part ways. Consider the following quotation: "Feminist literary critics are trying to boost the reputation of a number of women writers, some hitherto unknown, but it is too early to say whether their efforts will succeed."[43] When he argues that feminists are "trying to boost" women's literary reputations, he clearly means they are not quite achieving it. When he cites "a number of women writers" but offers no names, he is clearly dismissive of the project, and when he assigns to an imaginary future the end results of such efforts, he denies the very real progress made by feminists in re-visioning the canon and/or dismantling the concept altogether.

This is not to say that Posner is all wrong; occasionally he offers useful gems, and his writing has a clarity that many critics would do well to emulate. But his story of the law is not my story; it is not, on the whole, the story of contemporary texts or writing about and by women, and it is necessary to break free from the rather limited canon of texts that characterize early (and some later) versions of the law and literature movement. Critical studies such as those undertaken by Elizabeth Villiers Gemmette prove that the preponderance of texts analyzed in law and literature courses are written by white men of European descent;[44] even here, though, such evidence is read in opposing ways, reminding us of Stanley Fish's argument that it is "entirely possible that the parties to our imagined dispute might find themselves pointing to the same 'stretch of language' (no longer the same, since each would be characterizing it differently) and claiming

it as a 'fact' in support of opposing interpretations."[45] In this instance, we have Weisberg pointing to Gemmette's second study as evidence of the health of law and literature as a movement, whereas Judith Resnik sees in this study the critical preponderance of canonicity.[46]

Law and literature critics must continue to challenge their own critical enterprise and continue to find new ways to engage with texts from outside the canon: texts by African Americans, by women of all ethnicities, and by writers from the late twentieth century and beyond. The powerful work of feminist critics such as Judith Resnik, the late Carolyn Heilbrun, Robin West, Martha Albertson Fineman, Maria Aristodemou, and Patricia Williams, to name but a few, is helping to shape feminist law and literature, and it is to the questions and debates of this field that I now turn.

Gender: What Difference Does it Make?

Feminist law and literature is a field that, in some ways, replicates issues that have been prominent in feminist literary studies for some time: voice versus silence, the performance and punishment of femininity, the right to anger, and the consequences of stepping outside of prescribed gender roles. Feminist law and literature critics take a variety of stances in relation to this hyphenated discipline, from liberal-humanist calls for equality under the law, to recognitions that equality may not, in fact, be the solution at all. Michael Thomson argues that "there has been minimal feminist engagement with this field of scholarship. Indeed, the interaction between feminism and law and literature has been, at best, hesitant, tentative."[47] Such a criticism is both unfounded and quite clearly gendered. Here, feminists themselves are rendered unsure, quiet, small: characteristics frequently associated with women for the purposes, overt or concealed, of disabling their authority. Yet as authors *and* authorities, women have been very vocal about the challenges facing law and literature, as well as their disappointment that changes are not occurring fast enough. Marie Ashe, Jane Baron, Elizabeth Villiers Gemmette, and Carol Sanger are but a few of the prolific women writing on a range of law and literature topics; as Sanger remarks, in relation to the short story "A Jury of Her Peers" but with equal applicability to the entire law

and literature enterprise, "what we are able to see is often not a matter of what is before us, but of the particular qualities of the lens we choose for the examination."[48]

In her essay "Economic Man and Literary Woman: One Contrast," Robin West boldly announces: "I use the word 'woman' to include men as well as women, 'she' to include the male pronoun, and 'womankind' to include mankind."[49] Thus for West, the literary woman is a figure who encompasses both men and women in a reversal of the usual gendering of the anonymous. Such a bold critical stance moves beyond the token gesture of referring to the reader as "she" throughout an article, and by this I don't mean to undervalue the importance of this tactic for raising awareness. What I am suggesting is that West's terminology requires readers to engage in a radical rethink; by using the literary woman trope insistently, West constantly draws attention to gender, even as she is, apparently, erasing it. This erasure of gender is thus fundamentally different from the erasure of gender that the figure of blind justice suggests; in the courtroom, to ignore gender (as to ignore ethnicity, sexual preference, class, and other identity markers) is *sometimes* to cause harm. As Catherine MacKinnon powerfully argues,

Inequality is treating someone differently if one is the same, the same if one is different. Unquestioned is how difference is socially created or defined, who sets the point of reference for sameness, or the comparative empirical approach itself. Why should anyone have to be like white men to get what they have, given that white men do not have to be like anyone except each other to have it? Since men have defined women as different to the extent they are female, can women be entitled to equal treatment only to the extent they are not women?[50]

This book comes of a struggle to adapt to and understand a post-egalitarian feminist stance. My liberal Anglo-American feminism—a feminism that seeks equal treatment under law and in society, and reevaluates female contributions to the arts and science—has been challenged on a number of fronts during the course of my research: from revisionist feminists who dismiss the feminism of the 1970s and 1980s that shaped my intellectual heritage as somehow "essentialist"; from feminists who have almost insistently picked at the evidence of their own blindness, particularly around ethnicity and race consciousness (but, as with scabs, such picking might simply create scars rather

than heal differences); and from postegalitarian feminists who suggest that women are indeed different—not only from each other but, more importantly, from men—and thus need a different legal system, too.

Noting that the law is "a system of rules and norms, many of which are designed to have universal application," Martha Fineman argues that what is in fact needed is a nonuniversal application.[51] Specifically, she argues that "[n]eutral treatment in a gendered world or within a gendered institution does not operate in a neutral manner. There are more and more empirical studies that indicate that women's relative positions have worsened in our new ungendered doctrinal world."[52] Such a "postegalitarian" stance, where equity and not equality under the law is what is at stake, is a complex and admittedly problematic stance. If women constitute a special case, in what ways do they do so, and in what ways don't they? And does such a position argue—untenably—that all women are the same, and that they experience the same harms in the same way? Such questions are at the heart of a feminist analysis of law and literature.

Ellen Adelberg and Claudia Currie argue that formal "gender neutrality" should be replaced by "gender sensitivity."[53] Such a sensitivity should—and in many cases does—go hand in hand with a recognition of other identity markers as equally important, markers of ethnicity, class, and sexual orientation. As Frances Olsen carefully points out, "The issue between sameness and difference depends entirely upon context. Women can be oppressed by same treatment and they can be oppressed by different treatment. In some contexts differences should be deemphasised; in other contexts it would make no sense to do so."[54] One critic who has been particularly strong in this field is the criminologist Carol Smart. Instead of focusing on the idea that law is sexist, or male, Smart prefers the notion that law is gendered, which means that "we can begin to see the way in which law insists on a specific version of gender differentiation, without having to posit our own form of differentiation as some kind of starting or finishing point." She has famously concluded that "Woman is a gendered subject position which legal discourse brings into being." Smart further argues that "[i]t is this Woman of legal discourse that feminism must continue to deconstruct but without creating a nor-

mative Woman who reimposes a homogeneity which is all too often cast in our own privileged, white likeness."[55]

According to Smart, law produces polarized and specific gender differences.[56] What is clear is that women *are* treated differently from men under the law, despite assurances otherwise, and often (though not always) to their detriment. Certainly critics have posited a "chivalry" argument that suggests that female criminals benefit from the judicial system's inability to see a feminine woman as truly capable of or culpable for violence, with the result that their sentences are sometimes lighter than those handed down for men. As Helen Birch argues, "the judicial system, reflecting the attitudes of society as a whole, often punishes women who step beyond the bounds of acceptable female behaviour, while demonstrating a chivalric, paternal attitude to those whose acts of violence can apparently be explained by reference to their hormones (biology) or emotions (irrationality)."[57]

Studies have shown that particularly in relation to child deaths, "[m]others were less likely than fathers to be convicted of murder or to be sentenced to imprisonment, and were more likely to be given probation and psychiatrist dispositions."[58] Anne Worrall argues that women who do receive lighter sentences enter into a sort of quasi contract, whereby they let their lives be defined and represented "primarily in terms of [their] domestic, sexual, and pathological dimensions."[59] Such a strategy sometimes works, with fines and probation orders given where custodial sentences might be imposed; other times, when women are defined as unnatural or ill-suited for domestic duties, they actually find that this "contract" works against them.

Women who are violent are particularly at risk of this misreading. Allison Morris and Ania Wilczynski suggest that "[v]iolent women are usually presented by [criminologists] as 'evil'—they have chosen to act in a way which contradicts traditional views of women; as 'masculine'—they are not 'really' women; as 'sad'—they could not cope with social pressures; or as 'mad'—they did not really know what they were doing."[60] These characteristics recur with regularity in texts about women, and even feminists are not entirely immune from shorthand explanations for women's (still aberrant) violence: "Feminists too seem puzzled about how they should respond to women's

violence. . . . [T]hey seem unsure whether it betrays or supports feminist causes."[61]

This may be because the violent female criminal remains surprisingly rare. In a September 2002 trawl of the *LexisNexis* online network, the simple inputting of "women and crime" netted more results than the system could handle (any search that generates more than a thousand results is automatically redirected for further refinement). Even when I limited the search in a variety of ways, the result was the same. This was, apparently, a hot topic. When I changed the keywords to "female criminals," though, I found only seven recent news reports, of which only three dealt with "real-life" crime (the rest were film, stage, or book reviews). Of the three, one was focused on the "special needs" of female offenders, another on a specific, high-profile case in which a woman was an alleged accomplice to a child murderer, and the final was a sort of twenty-first-century emotional phrenology course in which "criminal types"—both men and women—were identified. In this admittedly unscientific polling, the female criminal does not really exist. She is a phantasm, created by authors and scriptwriters, and the (too large to quantify) connection between women and crime is one of victimhood. Even when statistics about the rise in female violence shock us (in the United Kingdom, this has been insistently linked in newspaper accounts to the loosening of moral prohibitions against excessive alcohol intake), the reality is that with such low numbers of violent incidents reported, any rise can look astronomical. The fact that the number of female prisoners in the United Kingdom rose by 173 percent since 1992 is shocking; that in July 2004 there were only 4,487 women in prison puts that figure into perspective, particularly as another statistic shows that women account for only 6.1 percent of the U.K. prison population. Of this 6.1 percent, only 17 percent were imprisoned for violent crimes.[62] Although the raw numbers of U.S. women imprisoned are significantly higher than U.K. numbers, female offenders represent only about 1 percent of the population of U.S. women as a whole.[63]

Yet women continue to be fodder for what Sarah Wight and Alice Myers call "excessive storytelling about women's violence"; they

argue that press reports of high-profile cases (examples include Myra Hindley and Rose West in the United Kingdom; Aileen Wuornos and Karla Faye Baker in the United States; and Karla Homolka in Canada), as well as films and novels about female criminals, "can be seen as a symptom of social anxiety about women's roles and the perceived abandonment of traditional femininity."[64] The role that perceptions of femininity plays in the courtroom is a crucial aspect of this text. In their article "Convergences: Law, Literature, and Feminism," Heilbrun and Resnik explored the case of *Dixon vs. the United States*, in which a pregnant young woman killed her husband and claimed self-defense (a defense which, to a lay person, seems utterly justified. He was drunk, high on PCP, and wielding an iron bar, threatening both Evelyn Dixon and her mother, when Ms. Dixon stabbed him in the chest. It may be worth noting that Ms. Dixon was all of four foot nine). Heilbrun and Resnik note that "[d]uring the trial, the prosecutor reminded the jury several times that Ms. Dixon had not appeared teary, helpless or fearful when she spoke to the police after her husband's death."[65] They therefore ask, "How much was the jury that decided the case affected by the police and prosecutor's report that Ms. Dixon failed, when speaking about her husband's death, to appear conventionally female, that she did not cry, did not seem as helpless or distraught as might have been expected?"[66] Apparently, Dixon's real crime is her distance from societally acceptable femininity—a factor that is reiterated in almost all of the chapters that follow, whether in relation to real-life cases such as Aileen Wuornos's trial, or fictional cases where women do not act (and therefore are not?) like stereotypical women.

The performance and punishment of femininity is thus one strand that this feminist law and literature text explores. Another equally important strand is the way in which women's harms are misrecognized and misidentified by the law and those charged with upholding it. Robin West explores in full the way in which this might occur and suggests that, because of their differing experiences, women and men lead essentially different kinds of lives. She argues that men face sporadic violence while women face pervasive violence, or fear of violence, and that this has an effect on patterns of behavior: "one

responds to pervasive fear and pervasive threat not by changing one's behavior, but by redefining oneself."[67] West further argues that both liberal and radical feminists, by focusing on the first half of the term that describes them, unwittingly deny or downplay the plight of women. West argues that liberal feminists, whose goal is equality, do not recognize that women often act in order not to increase their own happiness, but to increase the happiness of others. Thus, she contrasts the liberal self (male) with the "giving self" (female): "women define themselves as giving selves so as to obviate the threat, the danger, the pain, and the fear of being self-regarding selves from whom their sexuality is taken."[68]

West argues that even feminist victories result sometimes in oxymorons, and she uses as examples the terms "date rape" and "sexual harassment." West deconstructs the link between pleasure ("date," "sexual") and pain ("rape," "harassment") to offer proof of a gendered (legal) view of the world.[69] Finally, in an oft-quoted passage, West starkly sets out the way that the law is stacked against a real understanding of women's experiences:

Thus, women's distinctive, gender-specific injuries are now or have in the recent past been variously dismissed as trivial (sexual harassment on the street); consensual (sexual harassment on the job); humorous (nonviolent marital rape); participatory, subconsciously wanted or self-induced (father/daughter incest); natural or biological, and therefore inevitable (childbirth); sporadic, and conceptually continuous with gender-neutral pain (rape, viewed as a crime of violence); deserved or private (domestic violence); nonexistent (pornography); incomprehensible (unpleasant and unwanted consensual sex) or legally predetermined (marital rape, in states with the marital exemption).[70]

As if in agreement, Resnik notes that "[a]s women make visible a distinctive array of experiences and then gain power to alter laws and reframe contexts, counterclaims of neutrality and timeless truths attempt to quiet these voices and diminish their power."[71] It is at this point that a postegalitarian stance is most needed. It is also at this point, to follow from Resnik's earlier work with Heilbrun, that the call to listen to women's stories must continue to be heard.

Perhaps one of the best-known legal storytellers is Patricia J. Williams, whose ground-breaking book, *The Alchemy of Race and*

Rights (1991), struggled to articulate the way in which gender and ethnicity are inevitably intertwined and contested parts of identity. Williams's book offers a personal account of encounters with the law, both inside and outside the classroom. Williams argues that law schools invoke issues of race, gender, and class in apparent response to feminist and other concerns, but that they do so in ways that maintain the hegemony of privilege. Moreover, she argues that gratuitous insertions of these factors into law exams, insertions that offer up stereotypical portraits of black perpetrators and white victims, amount to "a deep misunderstanding of the struggle, a misunderstanding that threatens to turn the quest for empowering experiential narrative into permission for the most blatant expressions of cynical stereotypification."[72] At the same time, Williams contends that scholars must take the risk of rejecting impersonal writing styles if they want transformation: "I also believe that the personal is not the same as "private": the personal is often highly particular. I think the personal has fallen into disrepute as sloppy because we have lost the courage and vocabulary to describe it in the face of the enormous social pressure to 'keep it to ourselves'—but this is where our most idealistic and our deadliest politics are lodged, and are revealed."[73] This form of scholarship is not without its detractors: Anne Coughlin, for example, questions the viability of "outsider scholarship," which attempts to insert personal narratives in order to disrupt the law's seeming objectivity. While recognizing some benefits of (or arguments for) outsider scholarship—the name given to scholarship from those who claim that their voice is rarely heard under the law—Coughlin is hard on the scholars who promote either outsider scholarship or autobiographical narrative as a radical way forward.[74] Coughlin's argument is that "reliance on the narrative form is problematic for those pursuing a radical social agenda, for some theorists have argued that narrative is made possible by and inevitably reinforces the reigning system of law."[75]

Clearly, not all feminists think alike, and some even deny the applicability of the term (West, for example, claims a humanist stance in *Narrative, Authority, and Law*). Others decry the "failures" of feminist movements: one such critic is Thérèse Murphy, whose blunt article is scathing about critics who cannot deal with the "sexed body";

her approach seemingly blames the victim in many respects, however, and remains problematic as a result.[76] Thus, in taking a postegalitarian feminist stance in this text, I am not assuming that women speak with the same voice, merely that their many voices need to be heard—and even contested. I will draw on many feminist voices (and some which claim no allegiance to feminism) in my book because I still believe in Annette Kolodny's "playful pluralism" as the best way forward for feminist thinking.[77] In her award-winning essay from 1979, "Dancing through the Minefield," Kolodny argues that such a stance means that feminists can "enter a dialectical process of examining, testing, even trying out the contexts—be they prior critical assumptions or explicitly stated ideological stances (or some combination of the two)—that lead to disparate readings."[78]

Despite their opposing stances, then, what Williams and Coughlin agree on is the relationship between narrative and law: law as a story. Where they differ is in how such stories can be told, and whether the old cry "the personal is political" has any merit whatsoever. I understand Coughlin's objections: personal narratives are not automatically radical or disruptive, and too often they can simply reinforce the status quo. As Resnik has argued, it is all too easy to disregard stories by means of "discounting" the importance of the story or "discrediting" its source: "An individual story can be rejected based on a belief that it is not true, or, if true, not troubling, or if troubling, not common but a singular event that is aberrant rather than abhorrent. In contrast, to discredit a story is always to attempt affirmatively to dislodge authority."[79]

Too often, as Resnik has noted throughout her scholarship, it is the woman's story that is denied and the woman herself who is discredited. Or, as Kim Lane Scheppele argues, "the 'we' constructed in legal accounts has a distinctive selectivity, one that tends to adopt the stories of those who are white and privileged and male and lawyers, while casting aside the stories and experiences of people of color, of the poor, of women, of those who cannot describe their experiences in the language of the law."[80] Scheppele is concerned with the experience of those whose stories are disbelieved, suggesting that they "live in a legally sanctioned 'reality' that does not match their percep-

tions."[81] It is in this context that one can explore the fictional or fictionalized stories of women's encounters with the law. Taking as a starting point either the disbelief accorded the woman before the court or her own self-censorship about her experiences, I argue that twentieth-century writers from the United States, Canada, and Britain imagine fates for their heroines which rely on silence and gaps, which explore the stories that cannot be told. As Maria Aristodemou argues, "To interrogate the messages created and inscribed by both legal and literary fictions we must go back not only to the narratives they tell but to the language they employ to tell their stories."[82] Ironically, many of these tales invoke silence as a defining feature and render the primary subject mute; as a result, issues of guilt and innocence become related less to actual crimes than to the perceived relinquishing of the "feminine." Moreover, guilt is sometimes assigned as a cover for another, possibly less acceptable crime. A case in point is Morley Callaghan's "A Wedding-Dress," which acts here as a short case study.[83]

"A Wedding-Dress": A Tale of Legal Desire

Gary Boire argues that Morley's short story "ironizes the sentimental tale, vignette, and sketch" while simultaneously functioning as "an exercise in sexist pathos."[84] In it, Lena Schwartz is a woman who has been engaged for fifteen years, awaiting her lover's ability to support her financially: she is constantly in the state of deferral, of void, as she awaits the beginning of her tale. When her lover finally lands a good job, she lands in prison—accused of stealing a dress from a department store. She wears the dress itself to the prison cell and in court the next day; thus, there is no doubt about her guilt. (Here, as in the fiction that I explore throughout *Courting Failure*, appearances matter.) But what is she actually guilty of? Theft, according to the store detective; temporary kleptomania, according to her lawyer. But her guilt is, in fact, related less to her "crime" than to her desire: to be beautiful, admired, and desired herself.

This sparse short story enacts a tale of compulsory heterosexuality and delineates the regulation of female desire; indeed, it appears that

this is the whole premise of the law in relation to Lena Schwartz. She is called an "old maid" four times in the five-page text, her unmarried state a matter for prurient rumination and disapproval. She is called an old maid first by men at a boardinghouse, who salaciously suggest that "it" is about to "happen to her" at long last; second, by a "saucy-looking" salesgirl who is set up in opposition to her as a young, desirable woman (at thirty-two, Lena is no longer considered remotely desirable herself); third, by a sergeant who feels that being an "old maid" is reason enough to keep her in cells overnight, since old maids tend to be "foxy"—in the wily sense, of course, not the sexual one. The "wisdom" that accrues to the (slightly) older woman cannot coexist with sexuality in the narratives that seek to set up women in binary opposition to each other. Finally, she is called an old maid by the magistrate, who notes that the dress that she has stolen "doesn't even look good on her" (57); thus, the theft itself is doubly inappropriate. However, he is lenient enough to let her go, so long as her fiancé pays for the dress and promises to marry her. Clearly, once she moves from the position of single (unrestrained?) woman, she will no longer be a threat. She will be containable and indeed renamed: no longer an old maid, no longer Miss Schwartz.

It is a slight story, almost dry in its narration, and unlikely to arouse great sympathy or intense feeling. Yet, as Boire comments, the text itself simultaneously hides and unmasks signs of Lena's sexuality "as a potentially unruly force—a force that she herself finds alienating"—indeed unspeakable.[85] After such a long wait to get married (in traditional narrative terms, to either begin her story or to end it), Lena is denied a voice in the text even as her body enacts covert sexual messages. She intends to buy a "charming" but "serviceable" dress for her long-awaited wedding, yet confronted with just such a dress, she is disappointed. The dress she envisions is one that will "keep alive the tempestuous feeling in her body," a dress which will "startle" her fiancé, but more importantly, perhaps, make her "wantonly attractive" and "slyly watched" by other men (54). Lena herself appears unaware of the contradictions of her desires. However, once she surreptitiously slips the dress into her coat, she feels "a guilty feeling of satisfied exhaustion" (54, 55), a reaction that can clearly be read as sex-

ual orgasm. Moreover, she feels almost immediate regret, crying because she doesn't know how to return the dress: that is, return to her previous, unblemished (virgin?) existence. It is no coincidence that the dress is "loose" on her, as it represents metonymically her own imagined state.

The law is not long in getting involved in regulating Lena's desire, and from the moment she is arrested, she is told not to speak. As the sergeant who picks her up says, "it won't do any good to talk about it" (56). Despite this prohibition, Lena speaks "almost garrulously," according to the text, but we as readers are denied her words. Moreover, her lawyer never engages her in conversation; instead, he consults her fiancé and argues for clemency on the basis of her long wait for marriage. Her fiancé also speaks *for* rather than *to* her, calling her "a good woman, a very good woman" (58), containing her within a proper, gendered space.

"What makes Lena Schwartz's trial so interesting," according to Boire, "is that it functions within the story, not simply as a tragi-comic resolution, but as a male-centred normalizing ritual."[86] With only men speaking, and only their thoughts recorded—apart from a brief, if telling, note that Lena felt "strong and resentful" (57)—the trial becomes a series of conversations within which the principal subject is excluded, indeed, almost invisible. The actants in the courtroom find Lena amusing or pathetic, and Lena herself becomes little more than a cipher. As Boire comments, "Whereas up to this point Lena has been portrayed as a sexualized body whose energy is potentially transgressive (indeed wanton!), here in the legal rituals of normalization her desires are placed squarely back within the confines of a mandated heterosexual marriage."[87]

This is in marked contrast to the other woman who is on trial that day, a "coloured woman" accused of running a bawdy-house, who "went to jail for two months rather than pay a fine of $200" (57). Of the fate of the male prisoners who share Lena's journey from prison to courtroom—a bigamist, a betting shop owner, and a drunk—we hear nothing. What we do have recorded is the fact that the female is put away, her "sexuality" reduced to commerce and further connected with money through an imposed fine, or sent away—into a mar-

riage that is intended to sublimate her unruly passions. What is also clear is that the brothel madam, a woman who commodifies the female body and who may thus invoke our moral disapproval, is allowed to *choose* her fate, whereas the old maid Lena's fate is chosen for her. In this way, then, it appears that stepping outside of "proper" gender roles (and, of course, the madam's ethnicity cannot be ignored) can potentially afford more space for movement. This reading reveals the text as a subversive one which undermines the law and the societal rules that it apparently upholds.

According to Boire, "the very prevalence of legal imagery suggests that when Callaghan 'reads' the world (and therefore its language) in his writing, he simultaneously 'reads' and interrogates their organization by means of power relations, by means of legal formulae."[88] In "A Wedding-Dress," this results in a text in which a real crime (theft) stands in for a seemingly more disturbing and indeed disruptive "crime" (female sexuality). The court enforces repression and boundaries (as part of her release, Lena is forbidden to shop for a year) and in doing so, reestablishes "appropriate" power relations. The text ends, "and they went out to be quietly married"—no doubt to live "happily ever after." "A Wedding-Dress" is a legal fairy tale, in which the heroine is tempted from the path, comes to potential harm, but is rescued by her handsome prince and led back to safety.

Taking on Weisberg's claim that it is possible to read for feminist messages in male-authored texts, "A Wedding-Dress" proves his point (and indeed many feminists have made this critical claim more eloquently and more persuasively than Weisberg). But Morley's text—like the plays, novels, and films that follow—focuses on the female, on her experience of or relation to the law. If she is sidelined (as clearly in the text she is, despite being its protagonist), then this sidelining has a political import.

In the chapters that follow, I explore more closely a range of issues to do with women and the law, returning to the critical debates about how the figure of the (fictional) woman is constructed, how her crimes and misdemeanors are detailed, and how she relates to the embodied lives of contemporary women. Because we trace much of our legal and literary understandings back to previous centuries, I felt

it was necessary to explore, in chapter 1, how twentieth-century authors recalled and reinvented nineteenth-century concerns over women's legal culpabilities. Focusing on representations of the panopticon, as well as Foucauldian and feminist readings of this space, chapter 1 examines Angela Carter's *Nights at the Circus* (1984), Margaret Atwood's *Alias Grace* (1996), and Sarah Waters's *Affinity* (1999) as texts that explore appearance and the construction of the (legal) gaze. Given the role that surveillance—whether real or imagined—plays in women's lives, the focus of this chapter is on the disciplinary gaze of the authorities and of institutions of correction. Carter, Atwood, and Waters, however, subvert the hierarchical notion of powerless prisoners and powerful authorities. The women inmates in these texts find ways to wrest control from those who seemingly have power over them. Each of these texts is a reconstruction of nineteenth-century imprisonment, and I explore how writers make use of "real" sites— Millbank Prison in London, Kingston Penitentiary in Ontario, Canada—to write beyond the ending of women's imprisonment and see beyond the panoptical gaze that initially appears inescapable.

Chapter 2 follows logically from chapter 1 and also focuses on twentieth-century texts that reconstruct or mimic nineteenth-century ones. In this chapter, however, I explore "neoslave narratives," texts that offer voice to the disenfranchised, the dehumanized, and the brutalized, and that recall the authentic slave narratives of earlier centuries. This chapter examines how African American women have been historically viewed as "property" and the ways in which their family lives have been constructed around the selling and buying of human beings. Thus, it necessarily engages with constructions of family, and especially the role of motherhood, in a system that denied blood relations and treated human beings as chattel. As one of the characters in Toni Morrison's *Beloved* (1987) reveals, "What she called the nastiness of life was the shock she received upon learning that nobody stopped playing checkers just because the pieces included her children."[89] *Beloved* is a reworking of the "story" of the historical Margaret Garner. Other fictional slave narratives explored in chapter 2 include J. California Cooper's *Family* (1991), Sherley Anne Williams's *Dessa Rose* (1986), and Valerie Martin's *Property* (2003).

These novels all explore legal and extralegal remedies for violence, the misnaming of humans as chattel, and covert theft versus property rights; each also ensures that the female slave is offered at least a partial voice. Williams's novel, like Morrison's, is partly based on authentic slave experiences and offers a fictionalized account of what might have happened if two historical women—a pregnant slave awaiting the death penalty and a white woman harboring runaways—had met; the novel is also a writing back against the misnaming of the slave experience. Cooper's novel explores inheritance and uses the trope of the covertly swapped child, so that the "rightful" heir to a plantation ends up a slave, and a slave's child becomes master. Finally, Martin's novel takes the white woman slaveholder's perspective, offering a partial and privileged account of the institution of slavery that challenges facile connections between white women and slaves. The inclusion of a text by a European American in this chapter is deliberate, in order to counter any essentialist or separatist notion in relation to literature's authorizing voices.

Following from discussions of race and motherhood, chapter 3 explores the construction of the "good mother" and the "bad mother" in both literature and society, and how such roles bring women into conflict with the law. "Real life" examples include the media circuses that surrounded the trials of Andrea Pia Yates, the mentally ill Texan mother who drowned her five children in the family bath in 2001, and Susan Smith, the South Carolina mother who drove her car into a lake with her children still inside in 1994. Filicide—the killing of a child by its parent—is more common than the general public likes to admit; when that parent is a mother, the crime appears to be a betrayal of all that a mother is supposed to stand for: comfort, care, love, protection. Indeed, this chapter engages with the supposed innate maternal instinct and explores how such myths falsely divide those who are "deserving" and those who are not. In *A Map of the World* (1996), by Jane Hamilton, for example, a farm woman who negligently causes a child's death is later accused of sustained abuse of another child in her care: here, an accidental death is misread as a clue to the woman's monstrous nature. In *The Good Mother* (1986), by Sue Miller, a mother's position *as* mother is undermined by the fact that

she conducts a sexual relationship with a man who is not the father of her daughter. This alone is enough to brand her a bad mother; thus, when the ultimate taboo—child sexual abuse—is alleged, it is clear to see that this mother will have to relinquish her role, despite no wrongdoing on her part. Finally, in *Midwives* (1997), by Chris Bohjalian, the death of a pregnant woman under the care of an unlicensed midwife leads to a manslaughter charge and a legal review of how childbirth is experienced and controlled. In *Midwives* as in the other texts, guilt and crime take on a variety of meanings. In all three texts, trials are central to the narratives but, more importantly, each in some way interrogates how motherhood itself is regulated.

Almost every text compares, in at least a small way, a courtroom to the theater, with participants acting their roles, well or not so well, the scripts prepared and either stuck to or ad-libbed. Chapter 4 thus moves away from novels and into the theater. This chapter explores the way in which twentieth-century drama evokes "unruly" or outlaw women and overtly stages their guilt or innocence within the space of a courtroom setting. Here, the idea of women on display becomes most apparent, and the way in which women's voices become co-opted is overtly challenged. Indeed, as Judith Resnik argues, "Women literally lacked juridical voice. Until quite recently, women were the objects of the discussion, as property, as victims, as defendants, but not the authors, the speakers, the witnesses, the lawyers, the judges, or the jurors."[90] This partial or occluded voice has preoccupied feminist critics and playwrights for most of the last century, and representative plays that engage with this idea include Sophie Treadwell's *Machinal* (1928), Susan Glaspell's *Trifles* (1916), Sharon Pollock's *Blood Relations* (1981), and Sarah Daniels's *Masterpieces* (1984). Each of these texts is based on or references real-life murder trials.

In this chapter I explore what Jennifer Wood describes as "usurpatory ventriloquism"—the authority to speak and act for others—that is inscribed in the asymmetrical power relations of the court and played out on the stage.[91] Treadwell's *Machinal* is loosely based on the historical Ruth Snyder, and the "Young Woman" on trial finds that legal language does her a disservice; she is unable to let her lawyer's words speak for themselves. Similarly, Glaspell's and Pollock's plays engage

with issues of voice and ventriloquism, the staging of femininity, and the central vexing question of why some women choose to murder. Pollock's play reinvents Lizzie Borden and playfully offers the audience an actress playing an actress playing Borden herself. Finally, Daniels's *Masterpieces* explores how crimes against women are misnamed, as West has indicated; issues to do with rape, pornography, sexual harassment, and prostitution are all explored from a gendered point of view, and the central character refuses, as Treadwell's Young Woman does, to allow the court to represent her falsely. Chapter 4 thus explores the ways in which guilt and innocence are "staged," as well as how drama itself works as a complicating arena for the exploration of women and the law.

Chapter 5 examines the complex relationship between women and the law in television series and television movies, as well as blockbuster films. As Adelberg and Currie contend, "Media images of courtrooms, prisons, and criminal acts serve as the source of public knowledge about offenders. Particularly in the case of women, these images are hugely distorted from reality."[92] This chapter includes a discussion of the 1930 Motion Picture Production Code, which governed the moral messages of films and forced filmmakers to ensure a "proper" reading of the law. Such a code obviously affected how films regarding crime were made. I explore in this final chapter both the real-life tragic lawbreaker as reinvented on screen (Aileen Wuornos in *Monster*, Barbara Graham in *I Want to Live!*) as well as the comic lawmaker (Amanda Bonner in *Adam's Rib*, Elle Woods in *Legally Blonde*). I conclude this chapter with an analysis of the television series *Ally McBeal*, a critically contested, postmodern, postfeminist series that has provoked a great deal of debate about the appearance of women before the court.

The title of my book, *Courting Failure*, is more than just a play on words; it is an assertion of the tension that necessarily exists between the supposedly gender-blind law and the gender-influenced society that creates the law. In my conclusion, optimistically entitled "Courting Success," I revisit many of the questions raised in the preceding chapters. Criminology has long treated the female offender as "other," and feminist analyses are a necessary counterpoint for this one-

sided portrait. Interdisciplinary studies such as law and literature also make a much-needed contribution to this debate. This monograph is an attempt to explore just a few of the implications of the space accorded the female offender, whether fictional or real, and to begin to discuss some aspects of confinement and release that characterize her position. Looking forward, the conclusion surveys the critical debates and asks what the future holds for women and the law. As writers engage with the space of legislated patriarchy and subvert further the grounds upon which women are judged, they open up spaces in the courtrooms that will not be filled with women's silence but with (as Heilbrun and Resnik hopefully prophesized and I noted at the beginning of this introduction) women's "right to anger, their use of power . . . [and] their noncomplicity in the role of sex object."[93] A key text here is the long-listed Booker Prize novel *Critical Injuries* (2001), by Joan Barfoot, which explores the hotly debated issues of restorative justice and grace. Such texts open out, rather than close down, the arena in which women tackle the law, and it is thus fitting that *Courting Failure* should end with a discussion of this challenging and important text.

In 1989, when Heilbrun and Resnik first published their article "Convergences," the law and literature movement was, Resnik argues, "indifferent to the rich infusion of feminist theory in literature departments and to the claims that feminist jurisprudence was making in law."[94] A year later, *Harvard Women's Law Journal* devoted a significant portion of volume 13 to law and literature. Throughout the 1990s, important edited collections on women and the law were published, including *Representing Women: Law, Literature and Feminism*, edited by Susan Sage Heinzelman and Zipporah Batshaw Wiseman, and *Beyond Portia: Women, Law, and Literature in the United States*, edited by Jacqueline St. Joan and Annette Bennington, as well as monographs such as Robin West's *Narrative, Authority, and Law*.

In the early part of the twenty-first century, many more texts are successfully engaging with the variety of experiences that women—both fictional and real—participate in or react to. It is in the spirit of contributing to this debate that *Courting Failure* proceeds. From invented nineteenth-century texts to the big screen, from plays to tel-

evision drama, the figure of the woman in conflict with the law offers us an opportunity to explore how a postegalitarian stance can reframe the questions—and the answers—that face those of us who have an interest in society and the law.

Chapter One

Prison, Passion, and the Female Gaze

Twentieth-century women writers engage in metaphorical rewritings of the panopticon, inserting explicit and implicit references to it within many of their novels on women and the law. Designed by Jeremy Bentham as an "inspection-house" and made famous by Michel Foucault's incisive reading of it, the panopticon is a place to set aside and observe the criminal, the damaged, or the subject who needs to be contained. Its central watchtower overlooking a circular arrangement of back-lit chambers, or cells, ensures that the prisoner believes herself to be threatened with observation at all times. The apparently constant gaze here becomes linked to punishment, with the observed prisoner always at risk of being caught breaking the rules. The result is an internalization of the law, of propriety, and a "new mode of obtaining power of mind over mind, in a quantity hitherto without example."[1] Foucault analyzes how the gaze becomes internalized, and feminist critics such as Sandra Lee Bartky have added a corrective to his work by exploring the implications of gender in relation to the power structures of the panopticon.

Such is the power of this image that women writers of the twentieth century utilize its imposing structure in their own explorations of women, power, and the law. Thus, we have Angela Carter exploring the labyrinths of power and the gaze in her fantastic novel, *Nights at the Circus* (1984), Margaret Atwood examining the role of the gazed upon within and outside prison walls in *Alias Grace* (1996), and, perhaps most overtly, Sarah Waters investigating the "queer" effects of

the panopticon on inmates and visitors alike in her novel *Affinity* (1999). These writers subvert the hierarchical notion of the prisoner as powerless, the authorities as powerful; the women inmates in the texts above turn from gaze to touch, find the power in being gazed upon, or harness the illusion of control for their own purposes. Moreover, in explicitly or implicitly seeking "improper" relationships, these fictional prisoners step outside their prisons and wrest control from those who seek to contain them.

While the purpose of the panopticon, as Foucault reminds us, is "to see constantly and recognize immediately,"[2] in these fictional texts of the nineteenth-century gaze, sight and recognition are far from equivalent. Indeed, it is in their very mapping of misrecognitions that they exert their force. Carter's female murderesses reject the part offered to them of penitent sinner and refuse to express repentance, even though they know such a stance will keep them in thrall to a governess's pitiless gaze. Alternatively, Atwood's fictionalized Grace Marks willingly (and willfully?) plays the part of madwoman, murderess, and wrongfully accused. Finally, Selina Dawes, the "wrongfully" imprisoned spiritualist in Waters's *Affinity*, uses shadows and illusion—the central mechanisms of the panopticon—in order to control Margaret, her link to the outside world. In each of these texts, the female gaze constructs the love object; in *Alias Grace*, it even incorporates it, as Grace Marks "becomes" Mary Whitney, her friend and spectral conspirator.

The gaze has long been a subject of feminist analysis, with Laura Mulvey's article "Visual Pleasure and Narrative Cinema" kick-starting the exploration of how the male gaze is normalized in film.[3] Scopophilia, or pleasure in looking, is clearly gendered. As Bartky acknowledges, "Under male scrutiny, women will avert their eyes or cast them downward; the female gaze is trained to abandon its claim to the sovereign status of seer."[4] Bartky further argues that "a panoptical male connoisseur resides within the consciousness of most women: they stand perpetually before his gaze and under his judgment. Woman lives her body as seen by another, by an anonymous patriarchal Other."[5] It is this patriarchal Other who is the implicit subject of each of the novels that I analyze here, as the women who

are being watched take control themselves, subverting the underlying principles of the panopticon for their own ends. In what follows, I will explore *Nights at the Circus*, *Alias Grace*, and *Affinity* as texts which utilize and subvert the power of the panopticon, inserting instead a feminine gaze that allows for illusion, performance, and subversive control.

Nights at the Circus: *A Women's Panopticon?*

Joanne Gass argues that Angela Carter's *Nights at the Circus* explores "the ways in which the dominant, frequently male-centered discourses of power marginalize those whom society defines as freaks (. . . in particular, women) so that they may be contained and controlled because they are all possible sources of the chaotic disruption of established power."[6] In all aspects, then, and in all arenas where Carter's women perform (the circus of the title, the brothel, the freak show, and, in particular, the prison), power is central to the narrative. As is typical for Carter, though, such power is asserted only to be subverted. This is particularly apparent in her structuring of the prison as a panopticon. In contrast to *Alias Grace* and *Affinity*, the prison in *Nights at the Circus* serves as little more than an aside in the fantastic tale of Fevvers, Carter's central, peripatetic winged woman. Indeed, the idea of a prison as an "aside"—a place to set aside and forget— makes the panoptical images particularly intriguing. Carter spends a mere two chapters exploring the panopticon before she allows her female prisoners the freedom to vanish from the prison and the text. What she does in this space, however, remains central to a feminist reading of punishment and release.

The Countess P., aware of her own guilt in relation to the poisoning of her husband, sets up a "private asylum for female criminals."[7] The narrator cautions, "Do not run away with the idea it was a sense of sisterhood that moved her." Indeed, in each of these texts, the concept of sisterhood is undermined, even as female relationships become central to the narratives, through design or desire. The Countess P. believes herself to be "a kind of conduit for the means of the repentance of the other murderesses" (210). Unpunished herself,

she remains thus unforgiven, and can only approximate her own penitence through building a penitentiary for others:

It was a *panopticon* she forced them to build, a hollow circle of cells shaped like a doughnut, the inward-facing wall of which was composed of grids of steel and, in the middle of the roofed, central courtyard, there was a round room surrounded by windows. In that room she'd sit all day and stare and stare and stare at her murderesses and they, in turn, sat all day and stared at her. (210)

Carter's explicit awareness of Foucault's reading of the panopticon becomes clear in the way that she appropriates his language to describe it. Carter notes, "During the hours of darkness, the cells were lit up like so many small theatres in which each actor sat by herself in the trap of her visibility" (211), words more than reminiscent of Foucault's description: "They are like so many cages, so many small theatres, in which each actor is alone. . . . Visibility is a trap."[8]

Carter's foray into the world of the panopticon starts with a factual, dry tone, indicating the power of the prison, while occasionally letting in a ray of humor. In one example, the narrator suggests that "[t]here are many reasons, most of them good ones, why a woman should want to murder her husband" (210). The dry third-person narrative is disrupted by these insertions, as well as a later, second-person insertion: "you were never alone, here, where her gaze was continually upon you, and yet you were always alone" (213). This change to second-person voice implicates the reader, forcing us to join with the inmates in our visible solitude. At the same time, it provokes the question: are the inmates still imprisoned when we aren't looking? The convention of referring to textual events in the present tense suggests that they are; the inmates are always stared at and staring back, always in the moment of being watched. That the past tense does not apply to discussions of textual events suggests no end to their imprisonment, as they are imprisoned afresh each time a new reader gazes upon the page. Thus, we become both prisoners (addressed as and included in "you") and prison wardens of a different kind in reading about these events.

Carter's postmodern and playful disruption of a stable position—you, I, they—is also in evidence in the way that she takes Foucault's

reading one step further, acknowledging the manner in which the gazer becomes imprisoned within this dynamic as well. The narrator is aware of the countess's own entrapment: "the price she paid for her hypothetical proxy repentance was her own incarceration, trapped as securely in her watchtower by the exercise of her power as its objects were in their cells" (214). Moreover, the countess remains blind to this fact (despite her constant gaze), while the prisoners themselves acquire power through this knowledge. Furthermore, they realize, if she does not, that they will never be freed from this prison, despite her claim that she will release the truly penitent. Victims of male abuse, these women seek not humility but justice, and find it through a disruption of the patterns of behavior governing wardens and inmates.

Thus Olga Alexandrovna leads an "army of lovers" when she finally dares first to touch and then to gaze upon her female warden, breaking the power of isolation and containment. Here, the prisoner breaks with what Bartky calls "the economy of touching."[9] Bartky argues that who touches whom, how often, and where, is influenced by hierarchical organizations of power. Thus, the powerless (in Bartky's example, women) suffer inappropriate touch (a grope, a slap) in ways that men do not, because men are licensed to touch women; they hold more power. In Carter's novel, this power is reversed; it is the prisoner who touches first and who breaks the boundary between prisoner and warden. Once touch is established—as loving, and as desirable—then gaze follows, at first surreptitiously, and then more boldly.

Emboldened by mutual desire, the women in the prison begin longing, loving relationships and overthrow the central power of the countess to effect their own release and freedom. Appropriately, "[t]hey left the countess secured in her observatory with nothing to observe any longer but the spectre of her own crime, which came in at once through the open gate to haunt her as she continued to turn round and round in her chair" (218). If sisterhood, in its idealized representation, suggests a loving relationship and a lack of violence and aggression, it does not preclude, it seems, the meting out of justice.

Carter's exploration of the panopticon reveals the way in which the authoritative gaze inscribed by the panopticon is subverted, once the gazed-upon understand the mutually imprisoning aspect of this

look. Moreover, her novel explores how these imprisoned and "docile" bodies (as Foucault has it) assert themselves as uncontainable, their pleasures released from normative control.

Kingston Penitentiary, Alias Grace, and the Object of a Panoptical Gaze

In Atwood's *Alias Grace*, imprisonment lasts much longer and takes more than one form. The historical Grace Marks was imprisoned for over twenty-eight years for her part in the murder of her employer, Thomas Kinnear. Kinnear's housekeeper-mistress, Nancy Montgomery, was also murdered, but neither Marks nor her co-accused, James McDermott, was ever convicted of this offense: in the historical record, it is the murder of a wealthy landowner—a man—that truly counts. Marks was primarily confined in Kingston Penitentiary, Ontario, and finally pardoned in 1872, after which she disappeared from public record.

Kingston Penitentiary, perhaps because of its unique history as the first federal prison in the Canadian criminal justice system, has seen its share of literary representations. In the same year that *Alias Grace* was published, Merilyn Simonds's *The Convict Lover: A True Story* (1996) also appeared.[10] Photographs of the prison and its prisoners provide proof of the story's truth. Simonds's nonfictional text explores the female as lovesick dupe, not criminal (a position or role also potentially undertaken by Grace Marks). In 1919, in the village of Portsmouth, a young woman, Phyllis Halliday, became the willing correspondent with and go-between for a convict, who signed himself "DaDy Long Legs" in missives asking for tobacco and promising affection. Simonds reconstructs the probable narrative behind the correspondence, of which only the prisoner's half remains. Like Atwood, Simonds constructs the story from fragments that are lodged in Queen's University Archives in Kingston, Ontario; she also acknowledges the many memoirs and other texts written about Kingston Penitentiary, including Roger Caron's well-known *Go Boy* (1978).

Simonds traces two years of correspondence, during which time Phyllis risked her reputation and possible legal action for supplying

contraband. The man, simply known as "the prisoner" to begin with, is offered a number, G852, before he is identified as Joseph Cleroux, though even this name is but one of several aliases. Simonds relied on historical documents in addition to the correspondence she uncovered in the attic of her own Kingston house, factors that are clear in the descriptions of the prison itself and the people who populate it. *The Convict Lover* explores what it means to be labeled a prisoner and how that label follows the prisoner wherever he goes. As Simonds notes, "According to the [Penitentiary] Act, wherever a convict set foot was penitentiary land, and so the boundaries of Portsmouth village flexed as the prison work gangs passed."[11] That there is no escape from this label accords with contemporary investigations of the panopticon, a prison structure meant to enact the threat of constant surveillance while inhibiting the prisoner's ability to see.[12] Kingston Penitentiary was at least partly based on the ideal panopticon first described by Jeremy Bentham in his letters of 1787.

Kingston Penitentiary is thus symbolically important as a site of incarceration for Ontario and beyond. As the location of historical confinement and literary release, Kingston Penitentiary was built to be one of the largest public buildings in Upper Canada. It was erected for five main reasons: "the death penalty was not being executed for crimes less than murder, fines were unjust, local gaols were bad because they lumped young offenders with seasoned criminals, corporal punishment was improper and degrading, and banishment was unenforceable and often no punishment at all."[13] The presence of a British garrison as well as large quantities of stone ensured that Kingston was an ideal site for this new prison. This admixture of moral and material reasons ironically highlights the mixed messages implied by the Canadian prison reform that Kingston Penitentiary represents.

In the article "The Kingston, Ontario Penitentiary and Moral Architecture," C. J. Taylor outlines the factors that contributed to the development of the Kingston Penitentiary. As Taylor notes, its walls "would allow the keeper to observe the prisoners through apertures even when they were in their cells but would prevent the prisoners from knowing whether or not they were being watched, giving the impression of continuous surveillance."[14] In Bentham's proposed

panopticon, the purpose of this disjuncture between seeing and being seen is clear. It is through being constantly visible that the inmate is controlled:

the more constantly the persons to be inspected are under the eyes of the persons who should inspect them, the more perfectly will the purpose X of the establishment have been attained. Ideal perfection, if that were the object, would require that each person should actually be in that predicament, during every instant of time. This being impossible, the next thing to be wished for is, that, at every instant, seeing reason to believe as much, and not being able to satisfy himself to the contrary, he should *conceive* himself to be so.[15]

Moreover, "[lateral] invisibility is a guarantee of order."[16] In other words, the inability to see one's fellow inmates prevented conspiracies, prison outbreaks, and organized unrest (though it did not, clearly, prevent the *fear* of these events by authorities, as evidenced by the liberation book questions put to inmates prior to their release).

Foucault argues that the panoptical mechanism is fundamentally about power:

Hence the major effect of the Panopticon: to induce in the inmate a state of conscious and permanent visibility that assures the automatic functioning of power. So to arrange things that the surveillance is permanent in its effects, even if it is discontinuous in its action: that the perfection of power should tend to render its actual exercise unnecessary; that this architectural apparatus should be a machine for creating and sustaining a power relation independent of the person who exercises it; in short, that the inmates should be caught up in a power situation of which they are themselves the bearers.[17]

This is "moral" architecture at its height, a model prison that ensures solitary confinement, social control, and moral reform. Taylor's reading of the purpose of this type of architecture is clear and related to Foucault's reading: "It was the architecture that should constrain and organize the inmate rather than the guard. In this way the penitentiary system would seem to embody an abstract moral principle which the inmate was supposed to adhere to when he was released."[18] Thus, the penitentiary's role became linked to "a projection of the world as it should be. The penitentiary represented a community, although an artificial one, where the old values of obedience by the lower orders to a higher power were implicit."[19] The relevance

of this for Atwood's text is clear: Grace Marks is a servant who, whatever her active or passive role in the murder of her employer, overstepped the mark of her social class.

If North American prison reformers—including the Boston Prison Discipline Society, which was influential in the building of Kingston Penitentiary—were responding to real concerns about prisoner behavior, they were also, according to Taylor, responding to manufactured concerns about the rise in immigration and urbanization as threats to civilized society.[20] In this context, it is no coincidence that Grace Marks was also an immigrant, almost automatically, then, deserving of punishment. Contemporary hysteria about immigration levels clearly has a historical precedent.

Moral architecture, as Foucault reports, "arrests or regulates movements; it clears up confusion; it dissipates compact groupings of individuals wandering about the country in unpredictable ways; it establishes calculated distributions."[21] *It keeps people in their place.* Such a recognition is important both for considering the Penitentiary Act that stated that the penitentiary is wherever the prisoner is, as well as for the way in which the immigrant—and social inferior—Grace Marks is treated.

Atwood's Grace Marks is sent to the insane asylum, the prison, and, on separate but connected occasions, private homes in order to "play out" her penitence. The historical Marks was a "celebrated murderess" who was often paraded in front of tourists (Susanna Moodie famously being one of them), but the story of her role in the murders of Thomas Kinnear and Nancy Montgomery remains unclear. An immigrant and a servant, she had no real access to power—except, perhaps, sexual power—and much media speculation existed about her relationships both with Kinnear and with James McDermott, the man who was hanged for Kinnear's murder. Grace Marks was young and, in some reports, attractive. Her gender and youth spared her from the noose but not from public vilification. Indeed, the fact that she was wearing the murdered woman's clothes when she was caught became a sign, at least for some, of her clear guilt. Like Lena Schwartz in Callaghan's short story, she was considered *visibly guilty* as a result of her attire.[22]

Atwood uses these details in her fictional recounting of Grace's life. In Atwood's version, Grace is allowed limited freedom on occasions and becomes a domestic helper to the prison governor's wife, acting as both servant and spectacle for the women who gather in this private yet public home to gain illicit thrills from their proximity to female violence. Confined by their respectability, the governor's wife, her companions, and her daughters live vicarious violence through a crime scrapbook that mimics contemporary interest in true crime narratives. Anita Biressi argues that an "emphasis upon secret and occluded knowledge stems from an extreme transgression of acceptable limits, a crossing of boundaries that seems to command a search 'into the mind of the murderer.'"[23] Exactly what the gathered women search for is not always clear, although their movement beyond acceptable limits is:

The Governor's wife cuts these crimes out of the newspapers and pastes them in; she will even write away for old newspapers with crimes that were done before her time. It is her collection, she is a lady and they are all collecting things these days, and so she must collect something, and she does this instead of pulling up ferns or pressing flowers, and in any case she likes to horrify her acquaintances.[24]

Grace also notes that what the women are most interested in are hints of sexuality: "They don't care if I killed anyone, I could have cut dozens of throats, it's only what they admire in a soldier, they'd scarcely blink. No: was I really a paramour, is their chief concern, and they don't even know themselves whether they want the answer to be no or yes" (27). Atwood acknowledges here the regulating power of gender roles, just as she had located gender as a chief component in Grace Marks's trial. Significantly, Grace fails to answer this question.

In Atwood's version, the prison governor's wife defines herself as a virtual prisoner of the penitentiary because her house is enclosed within prison walls (24). The historical prison warden, John Creighton, also defined his role as one of incarceration and necessary release. If Carter's warden is unwittingly enclosed within her prison, the historical warden Atwood relies on for her novel is ironically unaware of the inappropriateness of his longing for release.

The Warden's Daily Journals of 1870–74 cover the period of Grace Marks's release and reference her specifically in 1872. The entries are short, concerned primarily with the day-to-day running of the prison, and the entering and exiting of the prison by the warden himself. A representative entry, from Friday, January 5, 1872, runs thus: "Entered Prison at half past 6 this morning and performed all the duties of the day. I was absent from 3 to 5 for a little exercise, as I find it injurious to my health to keep so close to work as I have been lately. Left at 6 P.M." Two weeks later, the warden notes that he left the prison at 10 A.M. and "made a visit into the country, as I have been closely confined and unwell for several days past."[25] Creighton appears to find no irony in the fact that he is free to leave the prison at will, while his wards are not able to have the same liberty. His "confinement" is temporary and to an extent chosen, and his health is clearly of a higher standard than those who are not allowed the luxury of release.

However, Creighton appears to have been a prison reformer, a man who was insulted when, in a letter to the editor of the *Irish Canadian* on June 20, 1872, he was accused of behaving improperly and with vengeance. The warden's entry for June 28 gives a long and heartfelt account of his actions and moral conscience. He appears truly upset that his character has been maligned and suggests that an unhappy warden has made the story up: "I feel in my conscience that none of the men are punished cruelly or severely, and that it requires more moral courage sometimes to refrain from punishing a bad man than to inflict it." Such sentiments indicate a progressive prison regime, in hope if not in actuality.

Two entries from 1872 relate to Grace Marks herself. On Friday, August 2, 1872, Creighton notes, "Same as yesterday except that I visited the city from 12 to 2 to see Minister of Justice about Grace Marks whose pardon I received this morning. It was Sir John's [Macdonald's] request that I and one of my daughters should accompany this woman to a house provided for her in New York." Five days later, the entry reads:

Entered prison at 6 A.M. Was present in Dining Hall at Breakfast. Addressed a few words to Convicts informing them that I was called away for a few days

on Prison Business and that I hoped they would behave well in my absence. Examined and discharged Grace Marks, Pardoned after being imprisoned in this Penitentiary, 28 years and ten months. Started with her and my daughter for New York at 1:30 P.M. by order of the Minister of Justice, leaving Prison in charge of Deputy Warden.

The day before her release, like all convicts on their discharge from the penitentiary, Grace Marks was asked a series of "Liberation" questions, which were recorded in the Liberation Question Book.[26] Such questions concerned the conditions at the prison, the length of incarceration of the inmate, and the authorities' fears of a conspiracy; thus, they move from enquiring about the prisoner's experiences to any knowledge she might have about what others were plotting against the prison administration. Grace's answers are almost always single words—yes or no—and reveal no further information than is strictly required. In this way, the historical Grace Marks is much like Atwood's construction of her: a withholding witness who refuses at some level to tell her own story. Indeed, there are enough versions around without her own contribution to create a multiple reading of her guilt or innocence.

Atwood utilizes a gothic framework in order to obscure rather than illuminate her heroine's ultimate innocence or guilt. The gothic framework becomes even more explicit in Waters's *Affinity*, but in *Alias Grace*, it serves to introduce multiple and fantastic readings of pretrial events. Norman Holland and Leona Sherman identity the gothic framework as one which includes the image of "woman-plus-habitation and the plot of mysterious sexual and supernatural threats in an atmosphere of . . . mysteries."[27] Indeed, Atwood's utilization of ghosts, entrapping homes, and caddish men, with the female body as prison, works within most of the definitions of the gothic that critics offer. As Susanne Becker argues, the female gothic

plays an important role throughout the almost two centuries of modern female culture: there has been a vigorous exchange of allusions and re-visions, and even of provocations and answers, a dynamic—and self-conscious—writing and rewriting of feminine texts haunting one another: around the interrogative texture of romantic love and female desire, of gender construction between *le propre* and the monstrous-feminine, of the (contextualising) dynamics of domestic horror.[28]

Romantic love, female desire, and domestic horror become entwined in illicit ways in the text—as servant and master transgress class boundaries (in relation to Kinnear and Montgomery, as well as to Grace's friend Mary Whitney and her master-lover), and as Grace herself "becomes" the object of her own (unacknowledged) love interest, Mary herself. Grace is presumed innocent or guilty by various observers, but never herself explains fully her own reading of the events. Peter Hutchings argues that "[l]ike the vampires with whom they came to be associated, women are not reflected in murder's mirror."[29] Hutchings's metaphors work well in relation to Atwood's *Alias Grace*. The novel provides us with several images of Grace in a mirror, the most important of which has Grace looking in a mirror and contemplating her own multiple descriptions:

I think of all the things that have been written about me—that I am an inhuman female demon, that I am an innocent victim of a blackguard forced against my will and in danger of my own life, that I was too ignorant to know how to act and that to hang me would be judicial murder, that I am fond of animals, that I am very handsome with a brilliant complexion, that I have blue eyes, that I have green eyes, that I have auburn and also brown hair, that I am tall and also not above the average height, that I am well and decently dressed, that I robbed a dead woman to appear so, that I am brisk and smart about my work, that I am of a sullen disposition with a quarrelsome temper, that I have the appearance of a person rather above my humble station, that I am a good girl with a pliable nature and no harm is told of me, that I am cunning and devious, that I am soft in the head and little better than an idiot. And I wonder, how can I be all of these different things at once? (23)

This long list, quoted in full to represent the many versions of events and varying personal attributes that Atwood incorporates here, also provides a postmodern contemplation of the fluidity of identity as process, not product. Moreover, it may also covertly say something about how a lawyer constructs a case: using what is *useful* (not necessarily what is relevant or even in some cases truthful) and discarding anything that does not fit the "story." Grace claims, after all, that it was her lawyer's decision for her to appear stupid; it "fit" his case. Grace, reflected in many mirrors here, somehow continues to elude description; the many versions proffered of her give the reader less to go on, not more.

Hutchings argues that the working-class female criminal was considered "feeble-minded," the middle-class woman "mad";[30] despite her clearly determinable class status, however, Grace takes up both positions. She is feeble-minded at her trial, a factor that may have spared her life when her accomplice—or dupe, or abusive captor—was hanged; she is mad at points in the narrative, too, shipped to the nearby asylum for periods of time. It is the "mad" Grace Marks that Susanna Moodie writes about in *Life in the Clearings* (a source that Atwood was later to discredit as sensationalist and inaccurate).

Instead of providing us with "her" story, the fictional Grace records her refusal to be subject to the usual "female story," a story that has entrapped all the women that she came to know. In this "female story," the results of romantic love are disgrace, betrayal, and abandonment; this message is reinforced not only in her own family circumstances, but by her fellow servant and friend, Mary Whitney, whose liaison with the master's son leads to betrayal, botched abortion, and subsequent death. They are all, as Grace notes, "the same story" (165).

Story itself comes to define the novel, as Grace's position alters depending on who is gazing upon her. For example, Dr. Simon Jordan, the man who is given the task of psychoanalyzing her for the purpose of recovering her memory, notes of her fate: "But what does an example do, afterwards? thought Simon. Her story is over. The main story, that is; the thing that has defined her. How is she supposed to fill in the rest of the time?" (91). Moreover, the narrator comments after one of their sessions together, "They've been talking together all afternoon as if in a parlour; and now he is free as air and may do whatever he likes, while she must be bolted and barred. Caged in a dreary prison. Deliberately dreary, for if a prison were not dreary, where would be the punishment?" (186).

The punishment enacted upon the women in *Nights at the Circus*—to be permanently visible—is circumvented in many respects by Grace. She records that the height of windows in her prison prevents any sight—either in or out: "They do not want you looking out, they do not want you thinking the word *out*, they do not want you looking at the horizon and thinking you might one day drop below it

yourself, like the sail of a ship departing or a horse and rider vanishing down a far hillside" (237; italics in original). It is when Grace is *outside* the prison walls, working for the governor's wife and thus subject to the female gaze, that she undermines the notion of being watched:

There is a good deal that can be seen slantwise, especially by the ladies, who do not wish to be caught staring. They can also see through veils, and window curtains, and over the tops of fans; and it is a good thing they can see in this way, or they would never see much of anything. But those of us who do not have to be bothered with all the veils and fans manage to see a good deal more. (229)

Here, Grace wrests control from her superiors by gazing herself, and by controlling the way in which she is gazed upon. Grace thus incorporates a jumble of contradictory roles: she is the "perfect" lady, serving food for the prison governor's wife, sewing intricate patterns, maintaining chastity, and generally conforming to expected feminine behavior; she is also a violent prisoner who may or may not have invited sexual congress with a variety of men. The "truth" depends on whichever story is being told. As Judith Knelman notes, Atwood "constructs Grace through a chain of texts—contextualizes their meaning—so that they represent more than the historical events that they were constructed to mark."[31] These representations are decidedly plural, as Atwood keeps a variety of possible storylines afloat: Grace is possessed; Grace is mad; Grace is psychically disturbed; Grace is cunning; Grace is guilty. Each reading is given support in the novel; no reading is fully discounted as false. Each reading acts as a legal text, either conforming to or contradicting a lawyer's construction of innocence or guilt. Perhaps underneath this knowledge is the familiar claim that law equates with storytelling. Jane B. Baron suggests that

the claim "law is just a story" is perfectly ambiguous. . . . It could mean that law fails to take account of important experiences and facts and has therefore gotten things wrong. Or the claim that law is just a story could mean that in law, as elsewhere in life, there is no unmediated way to know the truth, i.e., to get things right, so that law can never do more than reflect some particular points of view and, necessarily, suppress others.[32]

Here, the idea of the law as a story works both ways; indeed, Cristie March calls *Alias Grace* "an authorial mosaic" because it contains so many voices and elements.[33] It does not, however, contain a definable truth.

Verbal communications are both excessive in the text—Grace's interlocutor silently accuses her of fabricating her many memories—and secreted.[34] Meaning is not readily supplied, but frequently needs to be inferred, as with the hints of lesbian desire that the text both uncovers and covers over. Grace loves her servant friend Mary so much that she appears to *become* her in a spooky, séance-invoked explanation of the murders, and she perhaps covets more than Nancy Montgomery's clothes, though supposed jealousy motives are (at least overtly) framed within assumed heterosexuality. The lesbian as ghostly spectacle (the unspeakable) and the female criminal as aberrant are clearly being connected here, and both "need" regulation. Indeed, as Peter Hutchings argues, "the nineteenth century subject is *haunted* by crime, by its signs and stories and the shapes of institutions designed for its regulation."[35] Thus it is very much in keeping with the notion of the aberrant female and the panopticon prison that Grace Marks may fabricate a story of ghostly possession; it is also in keeping with this story that she *appears* to offer an explanation that allows her to keep her innocence while permitting behavior and speech that are in themselves "unacceptable." If she is not responsible for the crimes committed during the time that the spirit of Mary takes possession of her body, then she cannot be held responsible for the vulgar voice that describes such actions. Given the novel's focus on psychoanalysis, it is also possible that this story is one of multiple personalities, or associative personality disorder, a diagnosis still under much debate in medical communities today. Either explanatory framework leaves Grace "innocent," a victim of spiritual or mental displacement, even if her actions may label her "guilty."

Simon Jordan's reaction to the séance that invokes a contested confession is one of confusion, not least because the event is meant to be a scientific exploration of hypnosis, not the spectacle it becomes: "He was expecting a series of monosyllables, mere yes's and no's dragged out of her, out of lethargy and stupor; a series of com-

pleted and somnolent responses to his own firm demands. . . . This voice cannot be Grace's; yet in that case, whose voice is it?" (400). In the trial, Grace's voice is co-opted by her lawyer to tell a story of imbecility; under hypnosis, her voice conforms neither to the historical monosyllabic Marks nor to the story of her innocence: this "other" voice may represent a slanted truth that no one present seems able to credit. Indeed, when asked to record his findings, Simon Jordan realizes that "[t]he safest thing would be to write nothing at all. . . . [T]he fact is that he can't state anything with certainty and still tell the truth, because the truth eludes him. Or rather it's Grace herself who eludes him. She glides ahead of him, just out of his grasp, turning her head to see if he's still following" (407).

This final rendering of Grace is not accidental in its ghostly metaphor. Hutchings argues that "[t]he criminal is, thus, not some shadowy counterpart of the law-abiding citizen but *as spectre* the very form of law and the shape it seeks to control, a spectre jointly produced through the discourses of law, literature, psychiatry, aesthetics and criminology."[36] As specter, Grace is the object of discourse as well as the object of the gaze: Dr. Jordan wants to capture the truth of her, to get her to speak; the governor's wife wants her to be a containable spectacle; and others want to know once and for all whether she is innocent or guilty, states of being that the courts suggest are mutually incompatible. However, Grace Marks has successfully eluded all such containers. She may be visible in her panopticon, and she may carry the penitentiary wherever she walks outside its walls, according to the Penitentiary Act, but in her refusal to speak except as Other than herself, *and* in her refusal to be penitent (just as the prisoners of *Nights at the Circus* refused to be so), she unravels the power of panoptical structures, both real and metaphorical.

Luce Irigaray offers a reading of woman that fits with the multiple, elusive readings of Grace Marks, and the failures to contain her:

Thus the "object" is not as massive, as resistant, as one might wish to believe. And her possession by a "subject," a subject's desire to appropriate her, is yet another of his vertiginous failures. For where he projects a something to absorb, to take, to see, to possess . . . as well as a path of ground to stand upon, a mirror to catch his reflection, he is already faced by another specularization. Whose twisted character is her inability to say what she represents.[37]

Innocence or guilt is ultimately unassignable to Grace Marks; they are lost in history and remain unclear even then, despite a guilty verdict. In the historical records, Grace provides monosyllabic answers to the Liberty Questions and departs for New York. In Atwood's version, Grace coincidentally ends up marrying a childhood friend, the boy who ironically helped convict her, and he seeks her penance in oddly sexual ways. Thus Atwood provides a nineteenth-century closure to her text—the fallen woman raised and married—but she hints at further degradation to come. Sarah Waters's *Affinity*, by contrast, chooses the "other" nineteenth-century closure for a wayward heroine: death.

Affinity: *The Panopticon as Queer Geometry*

Affinity (1999) is a lesbian gothic novel about a nineteenth-century prison "Lady Visitor" named Margaret Prior and her relationship with the seemingly wrongly accused spiritualist, Selina Dawes, whom she helps escape from prison. Taking its place within the framework of lesbian gothic, *Affinity* offers an unreliable yet somehow sympathetic narrator; a series of fantastical, spooky events; and a desire that cannot be readily acknowledged. The novel describes a model panopticon, Millbank Prison, which was originally designed by Jeremy Bentham and is now palimpsestically the site of Tate Britain. Its "queer geometry,"[38] recorded but only faultily understood by the narrator, is clear to the twenty-first century reader familiar both with Bentham's panopticon and Foucault's reading of it. Here, again, the gaze is feminized, as matron watches the women inmates, as Margaret's mother's gaze extends into the prison through Margaret's own awareness of propriety, and as Margaret first watches the prisoners and then transgresses into the space of the prisoners themselves.

In this context, "queerness" takes on a more significant meaning, and double discourses become the norm. Indeed, language is as important as vision in the novel. The repeated references to the "queerness" of Selina's crimes, and of Millbank, and of Margaret's passion for it, indicate a self-conscious reference to the lesbian desires of the text. A second deliberately repeated word is "unnatural";

though not repeated as frequently as "queer," its connotations also remind one of nineteenth-century medical associations of lesbianism with illness or monstrosity.

Paraphrasing Freud, Paulina Palmer argues that "the power that Gothic fantasy reveals to disturb and frighten the reader stems from its ability to articulate emotions and anxieties related to 'the return of the repressed.'"[39] What is repressed, for Margaret, is any sense of lesbian desire. Indeed, near the beginning of the text she appears to be positively homophobic when she congratulates herself on having circumvented communication between two prisoners: "I followed, though uneasily—for I have heard them talk of 'pals' before, and have used the word myself, but it disturbed me to find that the term had *that* particular meaning and I hadn't known it. Nor, somehow, do I care to think that I had almost played the medium, innocently, for Jarvis' dark passion" (67). This early passage highlights the ways in which Waters cleverly blends all of the aspects of her tightly woven text: Margaret is a typical naïve heroine, willingly expressing received societal values, while simultaneously concealing—even from the reader at this point—her own desires. Moreover, the use of the word "medium" is deliberate, clearly conjuring the image of a spiritualist.

When Margaret first enters the prison, her skirts get "caught upon some jutting iron or brick" (8). This telling detail, which marks clothes as significant in the narrative of women's (imprisoned) lives, is the first of many references to appearance, and it is linked to the female gaze: "it is in lifting my eyes from my sweeping hem that I first see the pentagons of Millbank . . . and the suddenness of that gaze, makes them seem terrible" (8). Despite this sight, Margaret Prior, a laudanum addict and bereaved spinster who is mourning the death of her scholar-father, becomes a Lady Visitor for Millbank Prison with the hope that her behavior will serve as a model for the prisoners. Like the Countess P., however, Margaret nurses crimes of her own: addiction, a suicide attempt, and a "dark passion" for another woman, her (now) sister-in-law, Helen. Given that the Gothic Romance formula focuses on issues of sexual or social transgression[40] and depends upon a sense of enclosure, where better to set a gothic text than in a model prison, with the protagonist a mere visitor?

A second narrative entwines with Margaret's while also preceding it chronologically by a year. Selina Dawes, a spiritualist, recounts her life prior to imprisonment. Her diary entries are cruder and less accomplished than Margaret's, but the reader is given no reason to disbelieve them. Indeed, so well does Waters limn Selina's character that, on a first reading, we are subject to the uncanniness of this spooky, sexy novel.

Palmer reminds us that "[h]aunting and spectral visitations, whether associated with an individual or a place, are among the most common signifiers of the uncanny in Gothic fiction."[41] Waters's novel relies on uncanniness to seduce the reader, making the prison's "queer geometry" central to this mood. Foucault's underlying reading of the panopticon is also clear. Selina bitterly acknowledges that "'[a]ll the world may look at me, it is part of my punishment'" (47). Thus, again we have a reminder of the major effect of the panopticon, which is "to induce in the inmate a state of conscious and permanent visibility that assures the automatic functioning of power."[42] Moreover, "the perfection of power should tend to render its actual exercise unnecessary. . . . [T]he inmates should be caught up in a power situation of which they are themselves the bearers."[43] In *Affinity*, Margaret acts as a bearer of power in two ways: as observer of the inmates, and as her own observer, aware of her position as a lady. Margaret is thus complicit in her own subjugation and is always aware of propriety (even when, under the influence of her medication, she transgresses that space).

Indeed, despite the fact that Selina is the prisoner and Margaret a mere visitor, Margaret is the one who becomes locked within the panoptical moment. She thinks of one of the wardens, *"You are as snared by Millbank as they are"* (244; italics in original), without recognizing that these words also encode her own ensnarement. While Selina, as prisoner, appears subject to the machinery of the panopticon, she, in fact, manages to circumvent it, creating illusions of ghostly contacts that heighten the sense of gothic power.

Palmer argues that "[w]hereas Gothic narrative explores the disintegration of the self into double or multiple facets, queer theory foregrounds the multiple sexualities and roles that the subject produces and enacts."[44] Selina is a mistress of disguise, assuming the stance of

the wronged innocent in order to entice Margaret into helping to free her. So desperate is Margaret for love that she refuses to acknowledge any artifice: "[Selina] has a way about her—I have noticed it, before to-day—a way of shifting mood, of changing tone, and pose. She does it very subtly—not as an actress might, with a gesture that must be seen across a dark and crowded theatre" (86). Margaret rejects the link between Selina and an actress, as well she might, for to acknowledge Selina's acting ability would be to acknowledge that she herself is taken in.

Moreover, historically, of course, there has been a perceived link between actresses and prostitution, and Margaret must also negate any sense that there is a sexual transaction taking place between them—even when she persuades Selina to strip for her in a scene that, upon rereading, becomes a clear exercise of power. The first reading of this scene is one of consensual pleasure: on her last visit to Millbank before the planned escape, Margaret visits Selina at bedtime, and it seems natural for Margaret to wish to watch Selina undress. Margaret exclaims, "'How beautiful you are!'" (310) and Selina's surprise and denial are responses any lover might make.

[Selina] let her dress fall from her, and removed the under-skirt and the prison boots and then, after another hesitation, the bonnet, until she stood, shivering slightly, in her woollen stockings and her petticoat. She held herself stiffly, and kept her face turned from me—as if it hurt to have me gaze at her, yet she would suffer the pain of it, for my sake. (309)

Selina's shivering and reticence appear to be the results of a cold prison and a modest nature. Once the reader knows the truth of Selina's relationship to Margaret—rather than being in love with her, she is, in fact, duping her—the passage takes on a different meaning. Selina is an actress, the prison is her theater, and Margaret as audience is duly taken in. She reads the scene as she wants to read it, not as it actually appears. She gazes upon a mere illusion, one designed to suggest that it is Margaret who is powerful, rather than the other way around. In this, Margaret again resembles the Countess P., whose desires for repentance become her own imprisonment.

Critics have noted the way in which lesbian desire has been decorporealized and made spectral,[45] as if the actual bodily connec-

tions that lesbianism connotes cannot be accommodated. In a lesbian gothic text, a ghost may act as a way of "negating physical intimacy between women."[46] Indeed, I would argue that Waters, aware of the many and varied ways in which lesbianism has remained hidden, deliberately replicates this concealment with Margaret's half-acknowledged desire and her references to hauntings. As the narrator suggests, "Perhaps, however, it is the same with spinsters as with ghosts; and one has to be of their ranks in order to see them at all" (58). For spinster, read, in this instance, lesbian, and one can see what tricks Waters is herself playing here.

Waters also plays with Selina's lesbian impulses, multiply covering over the real object of desire; Selina's "love" for Margaret is a displaced, manufactured love that hides her passion for a woman named Ruth Vigers. At the same time, Ruth Vigers is herself doubly hidden. She is Ruth to Selina, and first introduced to us as a maid; she is Vigers to Margaret, and also positioned as a maid, but there is no initial reason to connect the "two" women—Ruth and Vigers—in the text. It is only at the end that it becomes clear that Vigers acts as a conduit—or medium—of Selina's seemingly supernatural messages to Margaret. Finally, Ruth acts as an accomplice in Selina's séances, dressing up as the supposedly heterosexual ghostly "control," Peter Quick. Trickery and artifice signify such occurrences; thus it is doubly appropriate that Peter Quick, who jealously guards Selina's reputation and virtue, should himself be conjured as a lustful, heterosexual male who takes liberties with the young women at the séances. The word "control" is significant, for clearly Ruth does control Selina. Indeed, Ruth Vigers's essential voicelessness (throughout, the reader sees her primarily as a background figure and a servant) is undercut by allowing her the last line of the novel, claiming Selina for her own: "'Remember . . . whose girl you are'" (352).

At the end of the novel, Margaret is betrayed, Selina and Ruth disappear like the ghosts they have been connected to, and Margaret chooses death above a return to her stifling, spinster life. The panopticon is breached: the physical prisoner has slipped away, and the gaze has shifted. As Margaret herself realizes, "But, then, that passion was always theirs. Every time I stood in Selina's cell, feeling my flesh

yearn towards hers, there might as well have been Vigers at the gate, looking on, stealing Selina's gaze from me to her" (341–42). Margaret, denied Selina's loving gaze, is finally trapped within the gaze of propriety. Despite her class status—or perhaps because of it—she is the victim of a metaphorical panopticon, watched for failure: by her family, by the prison wardens, and by herself. In the end, then, it is not surprising that she chooses to hide away—chooses, in some ways, to inhabit a dungeon, which Foucault argues is the reverse of a panopticon, its functions "to enclose, to deprive of light and to hide."[47] The novel ends with Margaret ensconced in her home, hiding from the law in the form of a neighborhood policeman, and planning her own death. Waters's use of the panopticon as a real structure and a metaphorical enclosure is thus cleverly upturned, with the position of the prisoner finally assigned to the one who, had she not been a lady, would herself have been at Millbank, too. Margaret Prior's initial crime is attempted suicide; by the end of the novel, she has succeeded, and learned the lesson an inmate taught her: "'You think of your crimes—you don't think, "If I had not done that, I wouldn't be here," you think, "If I had only done that *better* . . ."'" (108; italics and ellipses in original).

Marie Fox notes that "narratives in both law and literature utilise punishment to effect a closure,"[48] yet these women's stories exist beyond the ending, or rather, provide a series of alternative endings that do not come together into a coherent whole: Carter's murderesses disappear, Grace Marks slides from history, and Selina Dawes is spirited away. The three texts that I have analyzed in this chapter, *Nights at the Circus*, *Alias Grace*, and *Affinity*, are linked through their incorporation of the panoptic gaze, as well as the recognition of its ultimate failure to contain these female criminals. If the panopticon is more overtly referenced in the first and last texts, it is also in operation in Atwood's novel, with the recognition that Kingston Penitentiary was, like the fictional Countess P.'s prison and Millbank Prison, based on Bentham's plans. Moreover, each of these texts foregrounds the gaze as a powerful medium of control, referring back to Foucault's reading of the panopticon. What each of these texts also does, however, is ensure that the prisoners exert control *through* the

gaze, by reflecting back or reflecting on those who think that they hold the power. The panoptical power of the prisons is thus reversed, with the prison-keepers subject to incarceration or control. The Countess P., Dr. Simon Jordan, and Margaret and the Millbank Prison wardens are thus connected through the ways in which their inspection of the prisoners results in a misrecognition of their own positions.

In this way, Carter, Atwood, and Waters engage with debates about power, illusion, and subversive control. Moreover, they explore the ways in which gender itself is implicated in these texts, as the female body comes under surveillance both by men and by women. More often than not, the gaze is feminized—though not necessarily with any kind of overarching "sisterhood" being trumpeted as the end result. Indeed, only in Carter's novel is the covert lesbian desire of the text eventually acknowledged freely. For the others, such "dark passion" takes its place as the historically hidden but more than potentially subversive element that disrupts Foucault's sense of the panopticon. Visibility may be a trap, with Foucault's prisoner remaining "the object of information, never the subject in communication,"[49] but Carter, Atwood, and Waters suggest that such a reading is only partial, as their prisoners communicate beyond—and outside—the walls that enclose them, registering desire, betrayal, and refusal to conform. As Bartky argues, "Foucault seems sometimes on the verge of depriving us of a vocabulary in which to conceptualize the nature and meaning of those periodic refusals of control that, just as much as the imposition of control, mark the course of human history."[50] If Foucault is silent on these matters, feminist writers are not, and in their explorations of women and the law, they indeed write beyond the ending of women's imprisonment, and see beyond the panoptical gaze that initially appears inescapable.

In the next chapter, the gaze turns from the prison narratives of white women caught up in nineteenth-century mores to the narratives of American slaves. Maintaining a focus on the literary pull of earlier centuries, chapter 2 focuses on the continuing fascination that the period of legal slavery in the United States has for female authors and the connections between these texts and contemporary realities.

Chapter Two

Pursuit of Property
Neoslave Narratives and the Law

This chapter explores the way in which African American women have been historically viewed as "property." Moreover, it explores the impact of constructions of race on women and the law, focusing specifically on neoslave narratives. The term "neoslave narrative" is credited to Bernard W. Bell, author of *The Afro-American Novel and Its Tradition*,[1] but has passed into common usage in the twenty years since his book appeared. Ashraf H. A. Rushdy later extended this definition: "contemporary novels that assume the form, adopt the conventions, and take on the first-person voice of the antebellum slave narrative."[2] Although the majority of actual slave narratives are credited to men, contemporary critics note the frequency with which women write neoslave narratives,[3] and this intersection of gender and ethnicity will be of interest here, particularly because of the ways in which the law is asked to be blind to both.

Richard Schur argues that race-neutral approaches to the law "refuse to acknowledge the contingent nature of social and cultural relations."[4] Even when such relations are taken into account, Angela P. Harris argues that too many feminist academics have been guilty of "gender essentialism" (the assumption of a unitary women's experience), and of privileging gender over race, or of trying to split apart the multiple constructions of identity. Harris accuses Catharine MacKinnon and Robin West in particular of neglecting the lived experiences of African American women, suggesting that "[t]o be fully subversive, the methodology of feminist legal theory should chal-

lenge not only law's content but its tendency to privilege the abstract and unitary voice."[5] Such a task is challenging and not always heeded. The urge to invoke a common oppression is strong, yet it is clear that feminists must attend to differences in ethnic origin and class, as well as the myriad other differences between women, when constructing their postegalitarian feminist stances.

Partly in response to this call to pay attention to identity markers, it has become a familiar critical shortcut for feminist academics to situate themselves in relation to the literature they study, acknowledging (testifying to?) their own critical blindspots. A number of critics have placed their own autobiographies into their texts, writing up their lives as evidence (or justification). Such autobiographical musings *can* be illuminating; Patricia Williams, for example, mines her experience as an African American law professor in *The Alchemy of Race and Rights* and argues that her academic position neither de-genders nor de-ethnicizes her. It is her propensity to tell stories—often quite personal ones—that leads her to be sometimes at odds with her own students, the dean, and her academic colleagues. She is frequently accused of not teaching *law*—her students finding it difficult to relate the daily examples of injustice that Williams highlights to textbook learning. In this instance, Williams's refusal to erase either her experience or her perception of that experience may be uncomfortable for some, but is instructive for all. In one particular instance, Williams relates the tale of her own racial heritage as the great-great-granddaughter of a raped eleven-year-old slave. The slave's "owner" Austin Miller practiced the law, and so her mother tells her, "in a voice of secretive reassurance, 'The Millers were lawyers, so you have it in your blood.'"[6] Williams's betrayal of her mother's implicit injunction against telling this story is key to this moment, as is Williams's own ontological dilemma in hearing this information: "claiming for myself a heritage the weft of whose genesis is my own disinheritance is a profoundly troubling paradox."[7] Breaking the injunction to silence reflects how Williams now has a powerful voice in front of the law, whereas her female ancestor was voiceless and powerless.[8]

Too often, though, such public displays of autobiography offer little more than a quick *mea culpa* before critics blithely proceed as

before. Christine Stansell argues that white feminists may be guilty of focusing only on themselves and their own blindspots, rather than actively engaging with the politics of African American life and culture, and it is telling that as late as 2005, Imani Perry felt it necessary to argue for the centrality of African American experience and the need for law and literature to engage more actively with African American literary traditions.[9] Even worse than outright neglect, some critics relegate discussions of race or ethnicity to what Harris calls "guilty footnotes."[10] The claim that (mostly white) academics make about being at odds with the subject and authorship of particular texts (or particular experiences) is meant to be conciliatory; often it is simply a way of deflecting criticism. As bell hooks states, "Many scholars, critics, and writers preface their work by stating that they are white, as though mere acknowledgement of this fact were sufficient, as though it conveyed all we need to know of standpoint, motivation, direction."[11] But acknowledgment of position is clearly not enough; in relation to law and literature, careful critical engagement with diverse texts is paramount, whatever their "ethnic origin" (or the critic's).

Maria Aristodemou, perhaps idealistically, argues that "[l]iterature and the imagination in general may be one way out of the difficulty of reaching out towards the other without invading or appropriating her."[12] In this context, Aristodemou's "other" does not presuppose a particular ethnicity, class, or sexual orientation; it merely defines someone as other-than-oneself. Aristodemou continues, "Although literature cannot pretend to remedy injustices to the other on the everyday, material level, its capacity to help us appreciate, understand, and empathize with what is not ourselves is a starting point to other forms of legislation."[13] Thus, there is a material benefit to studying literature in law.

At the same time, though, history shows that writers who *accidentally* display blindness in their texts fare poorly; one of the most famous examples of such blindness is apparent in William Styron's critically contested novel *The Confessions of Nat Turner* (1967), which won the Pulitzer Prize but enraged African American intellectuals for its crass and fanciful depictions of the famous slave rebellion leader.[14] In fact, one of the texts under analysis in this chapter, *Dessa Rose* (1986), is a conscious writing back to Styron's text, a corrective of his

skewed view of a slave's life.[15] Suzan Harrison suggests that controversy over Styron's right to pen a tale about Nat Turner "misses, to some degree, the point that all historical portrayals are texts and thereby subject to interpretation and not purely objective." She concedes, though, that Styron's text was read as a "conscious effort to deny the potential agency and significance of the civil rights movement. The problem is not one of the politics of identity but of the rhetorical construction of race."[16]

Another novel analyzed here, Valerie Martin's *Property* (2003), engages with a second "writing back": it is the narration of a white woman slaveholder who refuses to see the law's harm (except in relation to herself).[17] Her willful blindness (and the power it accords her) acts as a second kind of testimony and an opportunity to re-view not only the position of the black slave woman, but also the complicated constructions of legislated womanhood of her class-privileged, white mistress.

In this context, I am anxious to situate not myself, but this chapter, which is meant to act as a bridge from the invented "nineteenth"-century texts of chapter 1, to the continuing interrogation of motherhood in chapter 3. If Atwood, Carter, and Waters, the subjects of the first chapter, offer historical places and documented events to underpin their prison fictions, contemporary African American (and European American) women writers insert historical "rememories"—to use Toni Morrison's neologism—into an era when "property" (and thus property law) could refer as much to human beings as to land. Focusing on the slave mother, this chapter foregrounds an analysis of race and ethnicity in relation to the law, not in order to set such discussions aside (footnoted and forgotten), but to ensure that they receive proper and sustained analysis.

After all, as Deborah McDowell and Arnold Rampersad contend, "slavery is perhaps the central intellectual challenge, other than the Constitution itself, to those who would understand the meaning of America."[18] Indeed, slavery and its repercussions for American society have yet to be fully worked through (as contemporary lawsuits for reparations attest, or the contested claims for and against affirmative action policies). Stephen Best suggests that slavery cannot be relegat-

ed to the past, but needs to be seen as "a particular historical form of an ongoing crisis involving the subjection of personhood to property."[19] Therefore, it is not surprising that, as Hazel Carby argues, "slavery haunts the literary imagination."[20] Moreover, as the law and literature critic Robin West argues, in order to understand slavery fully, contemporary critics need to engage with and explore texts that take the "objects" of slave law as their focal point.[21]

Such critical awareness has been increasing over the last thirty years, with groundbreaking texts on slavery and slave narratives by Orlando Patterson, John Blassingame, Houston A. Baker Jr., and Robert Stepto leading the way.[22] Patterson coined the phrase "social death" to explain the slave's situation, Stepto chronicled patterns of slave narratives, Baker suggested the inevitable mismatch between attempts at "authenticity" and the perceived needs of a white abolitionist audience, and Blassingame, among his many projects, edited a number of Frederick Douglass's papers. Recent scholarship on the intersection of race, literature, and the law, and particularly on slavery and the law, is impressive. One of the best interdisciplinary texts on these intertwined subjects is Gregg D. Crane's *Race, Citizenship and Law in American Literature*.[23] This study of nineteenth-century "higher law" debates in relation to key literary and cultural material is provocative, original, and ambitious. Crane's argument situates debates about cultural production and higher law arguments within the framework of "conscience" and "consent." Taking as his starting point the Fugitive Slave Law, Crane examines the way in which key political figures developed their political stances in relation to it. He argues that books, poems, and plays about the position of the American slave were fundamental to the shift of public opinion—and thus ultimately of the judiciary. In his complex and conceptually challenging book, Crane displays a wide-ranging understanding of literature's impact on history, legal processes, and political positions. Other, more personal, interdisciplinary texts include Williams's *Alchemy of Race and Rights* and Karla Holloway's *Codes of Conduct*, which ends on a distinctly personal note, when the author visits her son in prison and enacts an almost already-written script, placing her hand on one side of the protective glass as he puts his on the other.[24]

Black feminists, as critics, creative writers, or indeed both, have been instrumental in forcing a reconsideration of the intersection of gender and ethnicity, and of ensuring that the historically voiceless have been offered a space to speak. This is especially true in relation to the figure of the American slave—particularly the slave woman. Black feminists have brought her firmly to the academy, empowering her, re-viewing her, and rewriting accounts of her life. In one such example, showing the connections between historical slaves and contemporary characters, Paule Marshall published *Daughters* (1992), a novel in which the main character, Ursa Beatrice Mackenzie, attempts to combine her intellectual and personal lives through the writing of history. She is told by a white male professor, however, that the topic of her dissertation—the relationship between the male and female leaders of a slave revolt based on her Caribbean island home (the fictional Triunion)—is inappropriate and unacademic. Marshall's text counters this racist assumption and inserts the history of these leaders into the text.[25] Significantly, though, Ursa's thesis remains unfinished, as if acknowledging that the topic cannot be finally contained or analyzed. Its ongoing effect is too pervasive to capture fully.

Certainly it is clear that the connections between "race," law, and American literature extend from Phillis Wheatley's eighteenth-century examination before a New England courthouse (1772) to the present day. In his book *Loose Canons*, Henry Louis Gates Jr. offers a compelling reading of Wheatley's examination, which he calls "surely one of the oddest oral examinations on record." Gates argues that Wheatley was one of many African "experiments" conducted by white Europeans to see if slavery was ordained by nature.[26] Of course, Wheatley's examination suggested that she was indeed the author of her own poems, but this was not, apparently, sufficient evidence to undermine the institution of slavery, or the "scientific" basis of race divisions. Karla Holloway links Wheatley's examination with Professor Anita Hill's testimony before the Senate in relation to Supreme Court Justice nominee Clarence Thomas:

Both women's testimonies were labeled incredible and both attempted a negotiation of racial and gender politics within which neither had a stable or legitimized presence. The legitimacy of their testimony was determined in a court of public and political opinion that had already judged the likelihood

of their credibility to be in large measure associated with their gender and their ethnicity. In a fair forum, the external evidence confronting the judiciary—their female bodies and their African color—would have been absolutely irrelevant, but because of the specifically racist and sexist history of cultural politics in the United States, both were absolutely essential factors and clearly relevant to each woman's credibility in those deliberations.[27]

"Race" is itself an unstable concept, developed through laws that created it as a biological fact to hide its genesis as a social convention. Toni Morrison, following Michael Rustin, argues that race is "a powerfully destructive emptiness"[28] in that, though it is based on fiction, it can produce real—and sometimes violent—outcomes. Holloway contends that since race is a nonbiological social fiction, "ethnicity" is a more appropriate term to use to discuss an individual's heritage. Specifically, Holloway contends that "race" is subject to legislation through public policies and political strategies, but that ethnicity is experienced.[29]

In this context, it is instructive to explore the controversy over the 2000 U.S. census. Sarah E. Chinn explores the proposal (and eventual withdrawal of the proposal) to include "multiracial" as a tickable item: "One objection came from African American civil rights groups, which feared that since so many black people were of mixed race due to the long history of slavery and intermarriage with Native Americans, a change in classification would in effect erase huge portions of the black population."[30] However, it was the complicated nature of defining and demarcating a "new" group that eventually ensured that the proposal was abandoned, not necessarily a response to this real political concern.

Holloway sees ethnicity as "self-determined," whereas race "is a politically conferred and simplistic abstraction that is easily co-opted into systems of abuse and domination. It is the characteristic feature of colonial imperialism at its most resistant practice and most fiercely articulated policy."[31] Perversely, then, in relation to slave narratives or neoslave narratives, it may actually be *appropriate* to use the term "race," given that slavery itself was founded on the concept of the hierarchy of "races" but that these did not admit any differences between black African peoples themselves. Moreover, in relation to enslaved peoples, the only inheritance one could claim would be the

condition of their mother. Patterson coins the term "natal alienation" for the condition of the slave because he believes that "what is critical in the slave's forced alienation [is] the loss of ties of birth in both ascending and descending generations."[32] In women's neoslave narratives, however, those very ties of birth(ing) mark the texts as specifically gendered as well as specifically raced, and ensure that these important identity markers cannot be spliced, even as history has attempted to do so, with troubling consequences—as for Patricia Williams, above, who puzzled over the ontological dilemma of her "inherited" acumen for the law, which came from one (white male) ancestor at the cost of another (black female) ancestor's humanity.

Neoslave narratives by women include three well-known novels that deal with issues of maternal and racial inheritance: Margaret Walker's *Jubilee* (1966), Gayl Jones's *Corregidora* (1975), and Octavia Butler's *Kindred* (1979), all of which explore the connections between slaves and maternity (or maternal position).[33] Indeed, Walker's text, famous for being among the first neoslave narratives, explores a slave woman's "choice" to remain in slavery rather than leave her children. Jones's novel *Corregidora*, which limns the fate of a descendent of female slaves, shows how slavery continues to pervade the lives of twentieth-century African American women. The novel's main character Ursa is made to feel responsible for passing the story of her family's slavery on and is urged—indeed implored—to "make generations" or have children herself: *"The important thing is making generations. They can burn papers but they can't burn conscious, Ursa. And that's what makes the evidence. And that's what makes the verdict."*[34] Ursa's inability to enjoy sexual relations and her shame at her violently induced infertility (her drunk husband throws her down the stairs when she is pregnant, thus inducing both a miscarriage and a hysterectomy) virtually rob her of any subjectivity of her own. Rushdy argues that Jones's novel reveals "how contemporary social relations continue to recreate debilitating ideas about racial identity by regulating black women's desire and commodifying black women's sexuality."[35]

Finally, Butler's science fiction novel concerns a young black woman named Dana who finds herself drawn back in time to Rufus Weylin, her white ancestor, every time his life is in danger. Tasked

with saving his life, Dana applies twentieth-century understandings to nineteenth-century events—near drowning, fire, and disease. She takes only what she has on her when she goes, though once this includes her (white) husband Kevin, and they are separated in time for more than five years as a result. Dana comes to feel almost maternal affection for Rufus, even as he grows to be a man of his time, a man who sees her as a "nigger" and who supports and upholds the slavery even of his own children and the enslavement of a woman he claims to love. Indeed, as a result of her role in his life, Dana is forced to play pimp for him in relation to her female ancestor, Alice, whom she reluctantly persuades to start a "consensual" sexual relationship with Rufus—in order to ensure her own eventual birth. Her ontological dilemma is more than reminiscent of Williams's above.[36]

An authentic example of the problematics of attempting to split identity markers comes from 1855. A pregnant slave identified as Celia murdered her rapist master (the putative father of her two children). Celia's subsequent behavior, which included burning his body and scattering his ashes in a public space, and her confession (though not presented in court since slaves could neither bear witness nor offer verbal evidence of defense), ensured that she was convicted and eventually hanged. This story, chronicled in *Celia, a Slave* (1991) by Melton McLaurin, reveals that the court's attempt to see Celia *only* as a black slave (and not also as a woman) resulted in her execution, despite rape laws that, *in theory*, could have protected all women from abuse.[37] As Nicole R. King argues, "In effect, Celia's lawyer was unable to convince the judge that Celia was a woman before she was a slave and thus protected by the [Missouri] law whose own wording stated that it was extended to 'any woman.'"[38] Celia was merely property, and this nullified any claim to protection she might have.

Such issues are not dead—as revealed by the census questionnaire discussed above, and through the ways that control over fertility and reproduction continue to be haunted by privilege and race. Elizabeth Tobin, focusing on Toni Morrison's *Beloved* as well as contemporary cases of contested motherhood, offers more connections: between surrogacy and race, in the case of Anna Johnson, who was paid to be artificially impregnated with a white couple's embryo; and between

black motherhood and assumed criminality, using the case of Jennifer Johnson, convicted of "drug trafficking" to her child through the umbilical cord.[39] In response to the history of control over black women's bodies, Patricia Williams imagines a "guerrilla insemination" program aimed at wealthy white women who wish to purchase semen from sperm banks in order to achieve pregnancy. She contemplates the covert swapping of sperm from white men with sperm from black men to achieve a generation of racially mixed children, in order to

challenge the notion of choice, to complicate it in other contexts: the likelihood that white women would choose black characteristics if offered the supermarket array of options of blond hair, blue-green eyes, and narrow upturned noses. What happens if it is no longer white male seed that has the prerogative of dropping noiselessly and invisibly into black wombs, swelling ranks and complexifying identity? Instead it will be disembodied black seed that will swell white bellies; the symbolically sacred vessel of the white womb will bring the complication home to the guarded intimacy of white families, and into the Madonna worship of the larger culture.[40]

One such widely reported case in Britain, which was conversely subject to a reporting ban for some time, was linked not to guerrilla tactics, but to human error; the court became involved in July 2002 when black twins were born to a white mother after an IVF clinic mix-up. The story eventually became the subject of a partially improvised and fictionalized television drama, *Born with Two Mothers*, which aired on April 21, 2005, on Channel Four. Tracing this story, as well as an American case and one in the Netherlands, Jennifer Musial suggests that they proved that "millenial [*sic*] ideas about race and reproduction continue to reflect prejudicial scientific and cultural rhetoric." Musial also argues that stories such as these are used by the media to reinforce suspicion of reproductive technology and use a shock tactic mode of address "by playing into the anxiety of racial contamination." Although the cases that Musial cites come from both sides of the Atlantic, and each country's complex negotiations of racial and ethnic understandings cannot be said to be the same, setting them alongside each other offers an example of how race is a "cultural fabrication" and racial purity is "a function of white oppression,"[41] even as acknowledgment of their different sorts of oppressions would need further elaboration.

Tobin suggests that her work uses literature to explore and potentially help (re)construct the law, and she sees the relationship between law and literature as one of reciprocity.[42] Moreover, she explicitly sets up an argument founded on the notion that issues to do with paternity (and maternity), as well as racial inheritance (and control) are issues that continue to concern contemporary society. Hence the linking of disparate texts: in Tobin's case, Morrison's novel of female slavery with contemporary accounts of African American mothers in conflict with the law.

Lesley Higgins and Marie-Christine Leps argue that literary texts that engage with legal issues are "especially useful for a discursive critique of the problematic of identity: whereas in legal terms, individuals and nations can be identified through a limited number of fixed markers, literary fictions can display them as discursive processes of elaboration, in which conflicting forces converge, disperse, and even at times annul each other."[43] This process of mutability is a vital part of the texts that follow. Judith Misrahi-Barak, among others, claims that the slave narrative is a hybrid genre "offering a mediated rendering of reality."[44] Each of the neoslave narratives explored in this chapter engages with mediated versions of law. This is not necessarily in explicit detail (as the eponymous heroine notes in *Dessa Rose*, "She had no idea what a 'court' was"[45]), but in each of the books, the "law" has a mythical meaning and panoptical control over the lives of the protagonists. J. California Cooper's *Family* (1991), Toni Morrison's *Beloved* (1987), and Sherley Anne Williams's *Dessa Rose* (1986) take the slave mother as their main focal point, whereas Valerie Martin's *Property* (2003) purposely sidelines the slave mother to focus on the slaveholder's wife.[46] Cooper suggests that courts do not exist for slaves and so extralegal remedies such as covert theft and kidnapping must be employed. Morrison "rememories" slave mothers whose claims to their children are offset by the property rights of their owners; indeed, *Beloved* limns the fate of a slave mother who chooses to commit infanticide rather than return her children to slavery, an act that puts her beyond the reach of property law. Williams meditates on the fate of a fictionalized slave, constructed from the historical account of a woman who—temporarily—escaped the death penalty in order that

she could give birth to another slave, and Martin's novel contrasts the position of the privileged white woman who is legally bound to her husband with Sarah, her misnamed "servant." Martin's comparison between the women does not recapitulate suspect white feminist assertions of common slavery; rather, it unpacks them, by showing the way in which such asserted commonalities require a violent denial of the truths of the conditions of slavery.

In the most accomplished of these texts, Williams's and Morrison's, sexual abuse and assault are reconfigured; the stereotypical rape of the young slave woman is notably presented offstage in these accounts. Only *Family* requires the reader to view voyeuristically the dehumanizing effects of such violence. Williams offers a momentary (if shifting) alliance between a white and a black woman when the former is at risk of assault, and Morrison displaces the almost obligatory scene of heterosexual rape with two other violently sexualized encounters: the theft of Sethe's breast milk, and the oral rape of male workers on a chain gang. Admittedly, the sexual abuse of a female slave is central to *Property*, but the narrator purposely denies the reality of Sarah's relationship with the slaveholder, and the one example of abuse that is specifically detailed includes, as in Morrison's text, the theft of a mother's milk. In the sections that follow, I will explore in more detail the ways in which these texts engage with—or resist— constructions of the law. I will begin by focusing on *Family*, which is the shortest and perhaps least technically complex of the novels, before moving onto the by now canonical *Beloved* and *Dessa Rose*, and ending with *Property*, which reinscribes a number of the issues explored in the earlier texts.

Family was written after both *Beloved* and *Dessa Rose*, and appears to be reliant on their narratives for its own. The decision to analyze it before its predecessors may therefore appear strange, but my argument rests on the assumption that chronology is less important than narrative complexity in this chapter. Moreover, I place it here to engage with issues of the canon and interpretation, and to support my argument, articulated in the introduction, that literary criticism is not or should not be confined entirely to those texts which are judged to be "excellent." In his text *Poethics and Other*

Strategies of Law and Literature, Richard Weisberg argues that the law and literature focus on the Great Books tradition is pedagogically justified, since this focus is not meant "to exclude lesser-known voices but to prepare for their full integration."[47] Weisberg does not mention when this mythical integration should occur (nor does he explore the resistance to integration that his argument does not even take account of), and indeed he fairly quickly sets aside any discussion of lesser-known voices altogether. His argument is that "[t]here can be no principled evasion of excellent literature, no matter how worthy the claims of lesser-known artists, in an environment in which few people are being exposed to the traditional texts."[48] Although all literary critics wish that students read more (and better) texts, not all critics rank these "better" texts in the same way, and not all see tradition as the most valuable teacher, especially when tradition is used to deny the existence of other, contemporaneous voices. My argument with Weisberg's Great Books premise is familiar to literary critics and much rehearsed: the Great Books have been defined as such in part as a way of maintaining critical consensus around similarity, figured primarily as white, male, and middle class. My position is not one that denies the worth of such texts; indeed, given the way in which postmodern texts in particular write back to canonical texts, it would be foolish in the extreme to disregard them. But it is also imprudent to rely on these voices alone.

A second law and literature critical perspective which I take issue with here is Ronald Dworkin's "aesthetic hypothesis." Dworkin argues that "an interpretation of a piece of literature attempts to show which way of reading (or speaking or directing or acting) the text reveals it as the best work of art."[49] I would contend that this is an overly simplistic and problematic view of what a critic does. Indeed, in the case of feminist interpretations, especially of canonical texts held in such high esteem by Weisberg, the aim is not to show the work as the "best work of art" at all, but to unpack the text, often opening up its gaps and elisions. Indeed, it is sometimes in exploring the way that the text works *badly,* as it were, that one can assess its worth or status.

Dworkin's thesis rests on the idea that most literary critics begin with and stay loyal to an idea of authorial intention. As a result, he

sets up a straw man which he then easily dismantles. Generous critics will acknowledge that Dworkin's misunderstanding of literary criticism was a product of its time: his essay "How Law Is Like Literature" was first published in the early 1980s (though anthologized in Lenora Ledwon's edited collection without comment or revision in 1996). At the same time, though, it remains disappointing that his article makes little or no reference to contemporary theories which undermine the idea of intentionality, especially as the article appeared during the infamous "theory wars" of the 1980s.

Dworkin argues that if "particular political issues count in deciding how good some novel or play or poem is, then they must also count in deciding, among particular interpretations of these works, which is the best interpretation. Or so they must if my argument is sound."[50] There's no doubt that political positions shape both tastes and interpretations, but few literary critics would suggest that one single interpretation of the text is unarguably the best. For one thing, such a stance would shut down, rather than open up, texts and debates. While lawyers and judges may need to pretend that a particular judgment is final or the best judgment, even in law such interpretations are subject to review (and overturning).

In relation to literature, there is no final resting point, nor, I believe, should one concentrate solely on aesthetically pleasing literature, which would mean that many actual and neoslave narratives would remain unread, their stories considered insufficiently beautiful or enriching. One should also not forget that aestheticized depictions of violence entail a morally problematic reading experience (as indeed, the following texts themselves reveal); the overseer's whip may create a beautiful scar (in *Beloved*, a chokecherry tree), and images of violence are sometimes offered from a detached, distanced perspective, but neither of these factors should blind readers to the fact that there is a political point being made in this very aestheticization. For example, Sethe's memories of Sweet Home, which was neither sweet nor home, resonate with beauty that makes her want to scream: "it rolled itself out before her in shameless beauty. It never looked as terrible as it was and it made her wonder if hell was a pretty place too" (6). As Morrison reveals, such aestheticization must even-

tually be resisted and abandoned; Paul D traces Sethe's scar lovingly at first, but later considers it "a revolting clump of scars" (21)—as indeed it is.

Fred D'Aguiar argues that "[t]he act of revisiting the slave narrative form in fiction is, simultaneously, an act of memory and an act of the historical imagination."[51] It is clear that none of these texts purports to be a true story; but they do hint at truthfulness and an uncovering of historical wrongs and silences. They draw the reader's attention to the historical bodies of slave women (and men) while suggesting a "pivotal relationship to the present."[52]

Family: *"[A] slave didn't have no court to go to"*

Taking into account the issues above, J. California Cooper's novel offers the law and literature critic an opportunity to explore the continuing resonance of neoslave narratives in American literature and their negotiations with the law without requiring it to be a text that is structurally or aesthetically superior to the texts that predate it. *Family* is narrated by a ghost mother, Clora, who had intended to kill both herself and her children in order to protect them from slavery (a theme that is more fully developed in *Beloved*). She is only partially successful, in that she dies but her children live, and she is forced to exist in a liminal space, becoming a metaphorical overseer. The irony of this role is not lost on the reader, who understands the hostile relationship this position has vis-à-vis the slave population. Of course, Clora is a benevolent overseer, who views her children's fate but cannot change them; in this respect, she retains her position as a slave mother.

Here, she is almost parallel to the historical Harriet Jacobs, who, in her authentic slave narrative *Incidents in the Life of a Slave Girl* (1861), records the escape plan that led to incarceration in an attic for almost seven years in order to elude capture. During that time, "year after year, I peeped at my children's faces, and heard their sweet voices, with a heart yearning all the while to say, 'Your mother is here.' Sometimes it appeared to me as if ages had rolled away since I entered upon that gloomy, monotonous existence."[53] Cooper's fictional Clora also

appears to live in a timeless space, but the horror of her tale rests upon her inability to stop terrible events from happening to her offspring.

For example, Clora watches her youngest daughter, Plum, die in horrible circumstances, crushed to death by a wagon that takes her oldest, Always, to a new plantation. Two sons die accidentally as babies, unprotected from the natural environment while their mother works in the fields. The middle children escape slavery, though in different ways. Sun runs away, "passes" as white, works hard for a Frenchman, and manages to marry the Frenchman's daughter. Eventually he creates a brood of his own. The middle daughter, Peach, is sold to a Scot who falls in love with her, marries her, and takes her to Scotland to live; she spends the rest of her life also passing as white. Sun and Peach are never unmasked as former slaves, despite creating a new generation of children themselves. Having escaped into the white world, these characters are rarely mentioned again.

However, Clora's oldest child, Always, remains a slave until the end of the war and becomes the focal point for the novel. Always remains permanently defined by the destruction both of her kin and of kinship with her siblings. As Hortense Spillers argues, "The destructive loss of the natural mother, whose biological/genetic relationship to the child remains unique and unambiguous, opens the enslaved young to social ambiguity and chaos: the ambiguity of his/her fatherhood and to a structure of other relational elements, now threatened, that would declare the young's connection to a genetic and historic future by way of their own siblings."[54] Always eventually becomes a lost mother herself and participates in a willful manipulation of legal kinship ties, as we shall see below.

In this text, the law is clearly aligned with white privilege, fabricated for the benefit of the slaveholders, and in this, it is opposed to divine law. As Clora notes of white people, "I knew most of em I seen and heard of didn't blive in Him right noway, cause of all the devilish things they would do under them laws they made up for themselves" (18). From the perspective of an overseeing ghost, Clora can view the courts, something she would not have been allowed to do in life: "The courts is full and will always be full of people and the grievances they put on each other til the end of our time." She rightly

notes, though, that "a slave didn't have no court to go to. The Masters of the Land made the law . . . so the law could not hurt them" (53; ellipsis in original). She aligns the law with an amorphous (but clearly white) THEY who control her firstborn's fate: "THEY had done decided she would never go to school, never learn to read and count, never be married in the right way in front of the Lord and man, never be in love cause she don't know how long fore they be sellin her man-love, never have a new store-bought dress was nice, a new pretty doll . . . just never nothin she wanted" (17–18; ellipsis in original). Here, of course, the law is ambiguously placed in relation to marriage; there is a "right way in front of the Lord" to get married, but this option is not open for the slave, and therefore the opposition between divine law and human law gets muddled. This passage also jumbles up a variety of wants, from owning a doll to receiving education; however, the very nature of the jumble is instructive. A slave cannot own even her own labor, much less a product in a store, and the insidious nature of the institution of slavery is shown in the ways in which it disrupts normal human relationships between potential lovers or between mothers and their children. The very idea of ownership takes on greater resonance later in the text, where siblings own each other, and where property and inheritance become debated concepts.

In moments of breaking the law, the text offers its most interesting critique. Once she is sold away from her birthplace, Always persuades a fellow slave, Poon, to ask Master Jason, the crippled brother of the slaveholder, to teach them to read. Poon knows that this is against the law, but Always answers, "'What he care bout the law? He's a white man'" (115). Master Jason's physical incapacity signals his place on the plantation as further down the hierarchy of power than his brother, but his whiteness offers him security not extended to the slaves.

Yet Jason is only marginally more "white" than Always herself, who is the product of Clora's rape by her white master. Cooper explores, albeit briefly and with little real conviction, constructions of racial identity; she notes, for example, that Always realizes, while she is working for Young Mistress in the house and therefore has access to a mirror, that "she was white. Most white as her mistresses. Always got mad and stayed mad from then on" (41). It is apparently only in see-

ing her own face that Always registers her skin color and the mismatch between it and her lack of privilege.

The most courageous breaking of the law comes not from access to knowledge, but the subversion of inheritance and property. Always swaps her son with the "legitimate" heir to the plantation, born the same day, both conceived by the master of the plantation. Always's son, whose startling blue eyes convince everyone that he is the legitimate heir, becomes Doak Jr., while the other boy becomes Soon, a slave. It is no coincidence that Always's son is born just after the legitimate heir; by swapping the children, she disrupts not only racial legitimacy, but birth order, too.

Eventually, the "mother" of Doak Jr., Mistress Sue, dies, to be replaced by a second wife, Loretta, Always's white half-sister. Loretta tries to break the bond between the young boys that was fostered by Always. At first it seems as if Cooper is making an essentialist argument in relation to racial heritage. Doak Jr., for example, "took to helpin Soon with his chores, so they could get back to playin" (144); he is "naturally" nice, helpful, and unaware of racial difference. However, Cooper eventually changes perspective, when Doak Jr. becomes a cruel and hard man, having fought for the Confederates and lost the war. When Always reveals her true relationship to him, he rejects his birth mother and feels revulsion at the thought of his black racial inheritance. Eventually, he even takes a small part in a Ku Klux Klan terror campaign against Always and her family.

The swapping of legitimate and illegitimate heirs is a familiar motif in literature from around the world, presented sometimes in relation to changelings and the work of the fairies, other times as a way of securing favorable treatment. Here, it acts as a way of acknowledging the invented nature of inherited racial characteristics; the plot is never foiled and never revealed (except to Doak Jr. himself). Soon himself, as "rightful" heir, is never privy to the information regarding his lost inheritance. What is even more interesting is that the "birthmark" that Always uses to convince Doak of their blood relationship is itself false; she has branded both the baby and herself near the hip and passed the mark off as a natural one. Here, then, a sign of slavery—a brand—is reinvented as something else.[55]

Cooper's text also complicates notions of property. Always argues that the land that she has slaved on, much of which was bought by selling her children, therefore belongs rightly to her: "'All my babies you done give me . . . been sold by this master to buy this land. This land I hold here in my hands. If that don't make it mine, Lord, what do?'" (201, ellipsis in original). Always eventually becomes mistress of her own land, by blackmailing her son into helping her buy the deeds to a neighboring plantation. She goes so far as to build shacks for ex-slaves to live in "for life, long as they worked til they couldn't. She encouraged them to have gardens of their own, thereby saving her stuff for market" (212).

There's something uncomfortable about Always's entrepreneurship, which is built on the back of ex-slave labor, as well as the reality of her tenants' working relationship with her. She lends their labor to her white neighbors and allows her workers to keep 90 percent of their wages (212–13). The fact that she owns even 10 percent of her tenants' labor is uncomfortable but never treated as such by Cooper, who appears to revel in Always's mastery of the so-called American dream and economic ownership.

Thus, this is a text with unresolved tensions. With her incorporation of facile interjections like, "Listen to me. The end is almost never far off any time at all!" (104), Cooper undermines her own narrative. The voice of the ghostly ex-slave is presented as ignorant through lack of education, but knowing in the ways of the world; however, fatuous statements such as the above do not provide evidence of this. A somewhat unlikely family reunion and an optimistic message that "we" are all "family" end the novel. However, some children remain unfound—Always's children—and this is, as least, historically accurate: African American genealogies include significant gaps as a result of American slavery. As Hortense Spillers powerfully argues, "to overlap *kinlessness* on the requirements of property might enlarge our view of the conditions of enslavement."[56] This tension between kinlessness and property operates overtly in each of the texts under analysis here.

Carole Boyce Davies argues that "[m]otherhood is both annihilation and empowerment; marking and renaming; the locus of change

and growth but as well of pain and loss."[57] In *Family*, motherhood is contested, as often as not the result of rape, and the children that resulted were marked as black and enslaved (even despite appearances), while being related to children who had mastery over them. In *Beloved*, motherhood is even more complexly negotiated. As Spillers contends, "if 'kinship' were possible, the property relations would be undermined, since the offspring would then 'belong' to a mother and a father."[58] It is this concept of "belonging" that is most contested in Morrison's novel. While Sethe has the opportunity to choose her children's father, and she usurps the right to choose their fate, her control over their racial inheritance is forever held in tension with the property rights of her owner.

Beloved: *"Unless carefree, motherlove was a killer"*

Toni Morrison's prize-winning and canonical novel, *Beloved*, is much more technically complex than Cooper's novel and is one of the few texts by an African American woman to become part of the law and literature canon. Marie Ashe argues that the novel can reveal the ways in which "bad mothers" are constructed and help law students recognize their own potential prejudices, and Tonya Plank suggests that it reveals how women who abuse have agency—even if it is misdirected.[59] As early as four years after it was published, Richard Delgado and Jean Stefancic argued that *Beloved* should be considered canonical, and it seems that their view was prescient;[60] even when critics limit their focus to "great works," which historically marginalize African American writers, *Beloved* appears with regularity on law and literature syllabuses, a somewhat surprising fact given its nonlinearity and nonrealist style. Morrison's novel offers a narrative voice that *refrains* from telling in the same proportion as Cooper's narrative overtells. Indeed, one could go so far as to say that Morrison explodes notions of narrative voice in *Beloved*. The central scene of the novel, the killing of a small child by Sethe, a woman who has escaped slavery, is deferred until more than halfway through the novel, and then only circuitously approached, though the ghost of the baby who was killed is present from the very beginning.

The novel is told elliptically, with scenes of slavery revisited and retold, sometimes to other listeners in the text and sometimes to the reader alone. As Kristin Boudreau argues, "the characters in Morrison's novel have no access to the methods of ordered narrative."[61] Thus, the text unfolds in a circular fashion, refusing to fill all of the gaps. Indeed, Kimberly Chabot Davis argues that "*Beloved*'s disjointed narrative, composed of phrases with no punctuation, calls attention to the visual spaces on the page, a metaphor for the gaps in the story-telling." Davis further argues that Morrison's circular narrative has been read multiply, but most often as a way "to subvert a linear reading of time and history."[62] This is in part because the effects of slavery remain; as one of the characters in the novel, Baby Suggs, argues, "'Not a house in the country ain't packed to the rafters with some dead Negro's grief'" (5). Thus, *Beloved* is named not for the slave mother, Sethe, but for her missing, misnamed child whose absence and ghostly reappearance are central to the text.

The novel is based on the historical Margaret Garner, who in 1856 killed one of her four children in order to prevent the child from being reenslaved. Ashraf H. A. Rushdy argues that the Margaret Garner story acts as *Beloved*'s "historical analogue."[63] Like Sethe, Margaret Garner chose to commit infanticide rather than return her children to slavery (though in this context, "choice" is perhaps too strong a word), and like Sethe, she was "successful" in causing the death of one of her children. Morrison also signals the connections between Sethe and Margaret Garner by naming the Sweet Home plantation owners Mr. and Mrs. Garner. Helena Woodard argues that the contemporary media sensationalized the story, constructing it "as the calculating crime of a bestial mother, effectively displacing slavery as an abusive, murderous institution."[64] In doing so, the media participated in the same sort of activity that haunts contemporary mothers whose behavior toward their children is deemed to be inexplicable.[65]

Morrison challenges this historical sleight of hand by focusing on the horrors of slavery and the many instances of gross bodily harm that are not constituted as unlawful within the pages of the text, but which are seen, from a twenty-first-century perspective, to be criminal acts. These include sexual assault, beatings, scarring, hangings,

and violent public humiliation such as when Paul D is forced to have the bit between his teeth, or fellate prison guards in a perverse call for "breakfast."[66] Early in the text, Sethe is described as "the one who never looked away, who when a man got stomped to death by a mare right in front of Sawyer's restaurant did not look away; and when a sow began eating her own litter did not look away then either" (12). It is this refusal to look away that forms the basis of the text, that makes it more than just the story of one historical woman. Yet these very images—a man being killed, a mother destroying her young—act as ghostly reminders of the events that precede the present day of the text, but which have yet to be revealed to the reader.

Maria Aristodemou argues that in relation to Sethe/Margaret Garner's story,

it is no longer possible to disentangle "real" from "fictitious" events not only because of Morrison's intervention but because the so-called real events surrounding Margaret Garner's story were already mediated by fiction: the law's and white journalists' attempts to write the story could only be couched in terms that the law and the papers' readership could understand and explain. The story was also far from complete: in newspaper accounts it "ends" when the law pronounced its guilty verdict, beyond which there is more conjecture and rumours.[67]

Morrison self-consciously refers to these newspaper mediations when she reveals Sethe's crime to her lover, Paul D. Paul D is illiterate and thus can read only the images and not the words of the newspaper clipping that draws Sethe's past to his attention. However, he knows enough to recognize that any clipping from a newspaper that required a "black face" to tell its story was telling a story that he did not want to hear. Thus, he chooses to misread the sketch of Sethe as someone else:

Because there was no way in hell a black face could appear in a newspaper if the story was about something anybody wanted to hear. A whip of fear broke through the heart chambers as soon as you saw a Negro's face in a paper, since the face was not there because the person had a healthy baby, or outran a street mob. Nor was it there because the person had been killed, or maimed or caught or burned or jailed or whipped or evicted or stomped or raped or cheated, since that could hardly qualify as news in a newspaper. (155–56)

Kimberly Chabot Davis argues that this scene, in which Paul D willfully misreads Sethe's act, reveals the "slippage between signifier and signified" and "calls attention to the fact that the past is only available to us through textual traces."[68] Indeed, only traces of the newspaper article are available to Sethe, who "could recognize only seventy-five printed words (half of which appeared in the newspaper clipping) but she knew that the words she did not understand hadn't any more power than she had to explain" (161). Are the words "slavery," "murder," or "abolition" among the words that Sethe recognizes? Morrison leaves this purposefully vague; she refuses to fill in the gaps because, historically, these gaps remain unfilled.

Garner was charged not with murder but with destruction of property, and her case became a cause célèbre of the abolitionist movement. Aristodemou traces the legal arguments, put forward by abolitionists, that Garner should be tried for murder: "That would have assumed that she was responsible for her own actions as well as for her children as legally a slave woman and her children were the property of her slaveowner."[69] Such a strategy failed—but it was bound to, for it worked against a definition of the slave as less than human, a fantasy that the law could not give up without risk to its construction of reality. Moreover, as is discussed more fully in chapter 3, few women who kill their children are ever assumed to be fully responsible, whatever their ethnic origin: such a view goes against strongly held misconceptions about women's supposedly innate nurturing roles. In addition, it was impossible for the court to recognize Garner's act as a loving one, meant to rescue her child from a life that was not, in the mother's eyes, worth living. Most critics suggest that Garner was eventually sold to another plantation somewhere in the deep south, though as Aristodemou notes, this remains little more than conjecture.

Morrison's novel writes in the gaps of the historical text but refuses to close others. It is also a text not just about Margaret Garner, but about, as Morrison's epigraph denotes, the "Sixty Million and more" who are estimated to have died in slavery. Beloved, the ghost who haunts the text, is not just the murdered daughter of Sethe, but all murdered slaves whose deaths went unrecorded by official history.

Moreover, Beloved's two brothers, who were injured but not killed by their mother, also eventually disappear from the text, forever after unaccounted for—like their father, Halle, who is last seen with clabber on his face, his mind torn from him, or their extended family, who remain un- (or mis-)named. Even their beloved grandmother, Baby Suggs, is known for most of her life by a name she does not own. It is only after Halle buys her freedom that she feels able to ask her former owner why he calls her Jenny. His response, "'Cause that's what's on your sales ticket, gal,'" reinforces the historical facts of untraceable genealogies, and Baby Suggs rejects the name, choosing to call herself a combination of her husband's pet name for her and his own name, despite counsel against it. Garner contends that "'Mrs. Baby Suggs ain't no name for a freed Negro,'" but Baby Suggs knows that without this name, her missing husband could never find her: "He got his chance [to escape], and since she never heard otherwise she believed he made it. Now how could he find or hear tell of her if she was calling herself some bill-of-sale name?" (142). Both names are a fiction, but one measure of her freedom is Baby Suggs's ability to choose.

Choice is, however, constantly contested in the novel. Sethe is the only young woman slave on the Kentucky plantation, and therefore the object of lust and wonderment, but the men on the plantation leave her alone even though they spend their time "dreaming of rape" (11). Paul D argues that they can make the choice not to rape Sethe because they were "Sweet Home men" (10), but this fiction—that they are seen as men in the eyes of the law—is eventually stripped from them when Garner dies. Before this happens, Sethe chooses Halle as her husband, and is allowed to "marry" him. She makes a travesty of a wedding dress, created from scraps that do not match, and they celebrate their union in a cornfield. As in Cooper's text—and Williams's text, below—this marriage is allowed but not recognized by law. This fits in with Spillers's argument that "legal enslavement removed the African-American male not so much from sight as from *mimetic* view as a partner in the prevailing social fiction of the Father's name, the Father's law."[70] Yet the present day of the text reveals that this choice is not a lasting one; it is unable to survive slavery and the

degradations of systematic abuse. Halle's lasting absence from the present day of the text recalls his absence of power and his inability to call his children his own, or his wife his kin.

Other choices are also compromised. Sethe's mother chooses to name her after her father but refuses to name any of her other children, who are born of rape. As the wetnurse Nan tells Sethe, "'She threw them all away but you. The one from the crew she threw away on the island. The others from more whites she also threw away. Without names, she threw them. You she gave the name of the black man. She put her arms around you'" (62). It is primarily in relation to family life that choice becomes an oxymoron, because as Baby Suggs reveals, being a slave meant dealing with "the nastiness of life" or "the shock she received upon learning that nobody stopped playing checkers just because the pieces included her children" (23). It is in this context that Sethe's act of infanticide must be set.

Caroline Rody asks, "Why focus on an astonishing act of violence committed not *upon* but *by* a slave woman?"[71] The answer is to bring to the fore the lie that choice had anything to do with what occurred. Sethe's act of infanticide is almost predetermined by the events that precede it. Slavery and its attendant violence are the originating causes of her crime. To get to that point, Sethe first has to escape from slavery. This escape is partly planned, partly accidental: the plot is real enough, but the enactment of it is compromised by miscommunication and the ugly fact of physical assault. Her repeated pregnancies keep her enslaved, but, eventually, she sends her three small children ahead of her, hoping to join them early enough to ensure that her youngest child remains unweaned. With Garner dead and his wife incapacitated through illness, the plantation is run by Schoolteacher, a sadistic man who teaches his nephews to delineate the human and animal characteristics of the slaves, all the while ensuring animal behavior in his young charges. In a gross act of indecency, the two boys steal Sethe's breast milk while he looks on.

Pamela E. Barnett argues that "[w]hen the enslaved persons' bodies were violated, their reproductive potential was commodified."[72] As noted above, Morrison refuses to subject Sethe to the stereotypical rape by a white master; instead, she defamiliarizes sexual violence,

thereby shocking the reader even more. This enforced milking becomes, as Rody argues, "a virtual rape of Sethe's motherhood."[73] If black slave women historically acted as wetnurses for white babies, this repeatedly returned-to scene evokes the horror of the violation. When Sethe dares to complain, they dig a hole for her pregnant belly, force her to lie down, and whip her until a scar shaped like a tree sprouts on her back.

Rody suggests that "if history is an ordinary woman giving birth, distortions of the normal birth plot reflect the impact of bad history on ordinary women."[74] This "bad history" comes to the fore when Sethe effects her escape. Her late pregnancy impedes her, her injuries slow her, and her leaking breast milk makes her easily trackable. Yet somehow she survives to reach Baby Suggs's home in Cincinnati, bringing with her a newborn, Denver, named after a runaway indentured white girl who helped to birth her. Sethe arrives to find her older daughter, referred to as her "crawling-already? baby" (93) and her two sons alive and well. But this happy family reunion—already compromised by the missing father—cannot last. Lorraine Liscio argues that Sethe's nickname for her child "signifies the child's age in a maternal expression of wonderment and grants her an identity open to redefinition with each new stage of growth."[75] Yet there are no new stages of growth to come. Precisely twenty-eight days later, the crawling-already? baby is dead. Bernard W. Bell suggests that this twenty-eight-day period is mimicked in the twenty-eight sections of the text, which correspond to a stereotypical monthly menstrual cycle.[76] Thus, on every level of the text, womanhood is inscribed. This is, however, just the start of the "bad history" that follows.

The Fugitive Slave Act of 1850, approved on September 18 of that year, placed an obligation on citizens to help slave owners recapture their "property." Although the Fugitive Slave Law of 1793 fined anyone who harbored a known runaway, it was loosely enforced, and some state legislatures reacted by passing "personal liberty laws" which made it harder for slave catchers to conduct their "business." The Act of 1850 was thus a stronger measure, and doubled the fine imposed on anyone aiding or abetting a runaway slave. It also expressly forbade an alleged fugitive from offering testimony on his or her

behalf, thereby effectively rendering many free blacks subject to erroneous detainment and permanent loss of liberty. Slave catchers were allowed to use "such reasonable force and restraints as may be necessary, under the circumstances of the case, to take and remove such fugitive person back to the State or Territory when he or she may have escaped. . . . In no trial or hearing under this act shall the testimony of such alleged fugitive be admitted in evidence."[77] Many critics have argued that the existence of a law cannot presuppose its widespread support; as the tales of the Underground Railroad make clear, a substantial number of Northerners were willing to break what they saw as an unjust law. Nevertheless, this is also the legal context in which we must place Sethe's recapture.

The day before the slave catchers arrive on Baby Suggs's rented property, the joyful family throws a party. This is their very undoing, because the black community at large, though it participates in the party, finds it unseemly, an example of pride, and, therefore, they do nothing when the slave catchers arrive in town. Admittedly, helping the family would have amounted to breaking the law, but at the same time, many of the people who do not help them had actually participated in their escape. When the slave catchers arrive to reenslave their "property," the scene that awaits them is one of *property loss*:

Inside, two boys bled in the sawdust and dirt at the feet of a nigger woman holding a blood-soaked child to her chest with one hand and an infant by the heels in the other. She did not look at them; she simply swung the baby toward the wall planks, missed and tried to connect a second time. . . . Right off it was clear . . . that there was nothing there to claim. . . . Two were lying open-eyed in sawdust; a third pumped blood down the dress of the main one. . . . The sheriff turned, then said to the other[s], "You all better go on. Look like your business is over. Mine's started now." (149–50).

Morrison's text has been read as a "critique of legal discourse"[78] and as a space to discuss the unspeakable. The death of a child is thus oddly placed between two legal discourses—those of murder and of theft—but neither articulates precisely the events that occurred. Indeed, the trope of the unspeakable is an insistent one in legal fictions and facts. These events are so unspeakable that when Sethe tries, eighteen years later, to explain them to Paul D, a Sweet Home

companion and now her lover, she cannot find the words. As Tobin reveals, "Sethe's murder of her own child becomes an act of struggle over language. It represents the process of renaming—of herself as mother and of her child as a human being and as property owned by another. That Sethe must destroy her beloved child to claim their relationship and assert her motherhood suggests the extent of the master's power to define."[79]

Schoolteacher reads the scene before him as "testimony to the results of a little so-called freedom imposed on people who needed every care and guidance in the world to keep them from the cannibal life they preferred" (151). He argues that this is what happens "when you overbeat creatures God had given you the responsibility of—the trouble it was, and the loss. The whole lot was lost now. Five. He could claim the baby struggling in the arms of the mewing old man, but who'd tend her? Because the woman—something was wrong with her." (150). Like the journalists and lawmakers in the Garner case, he and the sheriff read the scene not as evidence of slavery's evil, but of the slave's immorality. Alan Rice argues that in this passage and elsewhere in the novel, "Morrison highlights white fears of the bestial other . . . how these fears make 'whitefolk' act in uncivilized ways towards the African and the debilitating effect of such a stereotyping discourse not only on those who are stereotyped but also on those who frame such a limited vision."[80] This argument, like Tobin's above, recalls the fact that Schoolteacher beats a slave in order to enforce his own meaning on him, to define him as enslaved, and to manifest his power to define in a physical manner (190).

How is infanticide read in this text? Jean Wyatt argues that Beloved "withholds judgment on Sethe's act and persuades the reader to do the same, presenting the infanticide as the ultimate contradiction of mothering under slavery."[81] This contradiction is reinforced when Sethe suckles her remaining daughter, Denver, with her breasts covered in the blood of her dead daughter, property no more: "Sethe was aiming a bloody nipple into the baby's mouth. . . . So Denver took her mother's milk right along with the blood of her sister" (152). Here as elsewhere, Sethe's breasts act as the site of contested womanhood. However, not all critics read Sethe's act as unproblematic. Mary Jane

Suero Elliott, for example, argues that by killing her daughter, Sethe remains trapped in a colonial discourse. Moreover, this murder reveals Sethe's "internalization of the lessons of commodification" and her desire to see her children as her own "possessions" to dispose of as she wishes.[82] Ironically, however, by killing her daughter she sets herself and her remaining children free; after all, even though she could conceivably continue to bear children for several years, Schoolteacher no longer wants to claim his property. She is no longer "property that reproduced itself without cost" (228), but a criminal who trespassed against her owner by damaging his goods.

Elizabeth Fox-Genovese argues that, historically, infanticide was not always apparent, given the many causes of infant death on a slave plantation. She also suggests that, in some instances, slave women chose to cause their children's deaths in order to "reclaim" the children for themselves.[83] Indeed,

For women who loved their children, infanticide and even abortion constituted costly forms of resistance. Whether women turned to such desperate measures depended upon a variety of factors that defy generalization, but those who did were, at whatever pain to themselves, resisting from the center of their experience as women. More, they were implicitly calling to account the slaveholders, who protected the sexuality and revered the motherhood of white ladies while denying black women both.[84]

Aristodemou follows Fox-Genovese when she asserts that "[m]ore than an exceptional act of resignation, infanticide can therefore be seen as an act of resistance, one of the *few* acts of resistance available to the powerless."[85] Indeed, as we have seen, Sethe is not alone in this act. Her mother before her used infanticide as a method of protest against her victimization, and Ella, a woman who initially helped Sethe, "had delivered, but would not nurse, a hairy white thing, fathered by 'the lowest yet.' It lived five days never making a sound" (258–59). In another example of contested motherhood, Paul D recalls that a black woman was hanged for stealing ducks, which, in her confused state, she thought were her own children (66). The maternal relationship is here misrecognized; but this example only proves how far from "normal" women's relationships with their offspring could be under a law that purposely disrupted this relationship.

As Sethe herself notes, when asked by Paul D to bear his child, "she was frightened by the thought of having a baby once more. Needing to be good enough, alert enough, strong enough, *that* caring—again. Having to stay alive just that much longer. O Lord, she thought, deliver me. Unless carefree, motherlove was a killer" (132; italics in original). Sethe has interpellated the construction of the good mother, while recognizing that no one who knew her past would expect her to fulfill this role.

When Paul D asks her to have his child, he is unaware of her role in her daughter's death, and he is, in any case, attempting to redirect his own sexual energies away from Beloved, who has vampirically enticed him from Sethe's bed. His discovery of the infanticide is the excuse he needs to leave Sethe's haunted house, and proof that Sethe continues to "pay" for her crime even though she is technically free. Fox-Genovese argues that infanticide and other "extreme forms [of resistance] captured the essence of self-definition: You cannot do that to me, whatever the price I must pay to prevent you."[86]

One of the prices that Sethe pays is extreme social isolation; thus, she is not surprised at Paul D's departure. As Aristodemou argues, "Sethe is therefore judged and punished not only by the white man's legal system but by the black community whose own version of imprisonment is social ostracism."[87] Her only defense against this ostracism is her care of her remaining family. Liscio argues that the bond between mother and daughter is "a doubly invisible participant in white patriarchal history,"[88] but Morrison highlights this bond in her retelling of the Garner story and in her construction of the fantastical connection between Sethe and the ghost of her murdered daughter, Beloved, who has come back to haunt her in embodied, adult form.

At first this seems a welcome haunting, and Sethe tries to explain to her daughter what even Paul D could not understand: that she was attempting to save the child from a fate worse than death. Stereotypically, a fate worse than death is rape: but what Sethe protects her from is not one criminal act but a lifetime of inhumane acts that were not criminalized under the law. However, Beloved will not be assuaged, and Sethe cannot exorcise her own guilt anyway: "It was as though Sethe didn't really want forgiveness given; she wanted it refused. And Beloved

helped her out" (252).When Sethe attempts to "be the unquestioned mother whose word was law and who knew what was best," Beloved reacts as the toddler she "really" is: "Beloved slammed things, wiped the table clean of plates, threw salt on the floor, broke a windowpane" (242). There is no easy resolution to this family's life; the infanticide looms too large (as Beloved herself grows into a fat, if not pregnant, presence). There is no law that can save Sethe from Beloved's vengeance.

The resolution of the text—if such it is—reveals another violent encounter between white and black and the disappearance and misre-membrance of Beloved. The women of the community finally draw together to exorcise the ghost, though Morrison's text does not ensure her absolute banishment. At the same time, the white owners of Sethe's home come to collect Denver to work for them, and Sethe finds the repetition of a white man coming to take away her daughter too much to bear. She lashes out with an ice pick, but her attempt to kill him is thwarted, and she is saved, yet again, from the gallows.

Such an ending does not speak of harmony, beauty, or light; it is not aesthetically pleasing, nor does it speak with a voice of clarity. It is, rather, "not a story to pass on" (275), an injunction which has been read not only as not a story to pass to the next generation, but also as not a story to pass by without taking it into account. In relation to the law, it is a story that circles around the law and asks questions of it (how should the death of a slave child be recorded? How should any slave's death be recorded?). It acknowledges bad law (the Fugitive Slave Act), contests the lack of law's protection (against assault and rape), and asks readers to participate in the recovery of the slave's multiply defined narrative voice.

Dessa Rose:
"I now own a summer in the 19th century"

If Morrison's novel contests the law through reference to infanti-cide and the Fugitive Slave Act, Sherley Anne Williams's novel *Dessa Rose* traces legal questions over slave rebellion, murder, property loss, and fraud. It uses pregnancy as a temporary stay of execution and sets up the slave body as evidence against itself. It also revisits questions

about mothering: Dessa contemplates infanticide and records evidence of both contraception and abortion, evidence dismissed by the white authorities as unlikely actions for slaves to undertake. Like *Beloved*, it is a text that law and literature critics have begun to explore, though unlike *Beloved*, it has not fully moved into the realm of the canonical.

The novel is divided into five sections—the prologue, "The Darky," "The Wench," "The Negress," and the epilogue—and is characterized by heteroglossia as defined by Mikhail Bakhtin: its many voices compete and sometimes override each other. Rushdy argues that *Dessa Rose* is "ambiguously first-person, suspicious of the coherent subject of narration, and inviting of others' voices."[89] This invitation to collectivity is not incidental: it is only when Dessa Rose acts collectively with others that she manages to move beyond the confining definition imposed on the slave.

The prologue revisits Dessa's happier days in love with Kaine, the father of her unborn child, but this is only a short interlude before the reality of Dessa's situation becomes clear. Waking from her dream, she finds herself in chains, awaiting execution. "The Darky" is narrated by Adam Nehemiah, a fanciful man who wants to become part of Southern high society by writing about slave rebellions; his intended book, *The Roots of Rebellion in the Slave Population and Some Means of Eradicating Them*, is shortened to *Roots*, which is surely an ironic nod to Alex Haley's influential book. This section maintains a third-person narrator with occasional first-person interjections, particularly in relation to the journal Nehemiah keeps. Even here, though, Dessa's voice rings out, and her perspective is utilized in disruptive ways, not least in the way that she refuses to tell the story he wants to hear. He focuses on her participation in the slave rebellion that has resulted in her death sentence; she focuses on more personal rebellions, such as choosing to love despite slavery's constraints. Nehemiah considers Dessa's pregnancy "a stroke of luck; the rest of the ringleaders had been hanged by the time he had heard of the uprising" (19). She is no more than material to Nehemiah, her story useful only so far as it confirms his own ideas about slaves. The section ends with Dessa's escape.

"The Wench" is narrated by Miz Rufel, a lone white woman who appears not to be entirely aware of her role in harboring runaway slaves, of which Dessa becomes one. Dessa recovers from giving birth at the plantation Sutton Glen, while her fellow fugitive slaves concoct a daring plan to subvert slavery. In this section, racialized roles are partially reversed: Rufel nurses Dessa's son and conducts an affair with Nathan, one of the runaway slaves. Rufel even suggests that she seeks Nathan out because "he at least treated her like a person" (148), in an ironic reversal of identities. Williams's text is more complicated than a simple reversal of roles, however; Rufel embodies a position combining ignorance of slavery and reliance on it, and she maintains a skeptical stance toward stories of slavery's violence, wrapped up in her white privilege despite the fact that she is abandoned by her husband and living close to poverty herself.

"The Negress" is narrated by Dessa Rose, as are the prologue and epilogue, though the prologue is written in third person. Ironically, it is in "The Negress" that Dessa plays a slave again, contributing to an elaborate con game whereby she helps Miz Rufel "sell" their black companions repeatedly, to ensure that they make money at slavery's expense. At the end of the text, the reader is confronted with the fact that this is a retold, oral tale, transcribed by *Dessa Rose's* descendants and written in her own voice, despite the contrast between standard English and slave dialect. As Marta E. Sánchez asserts, "What readers have to grasp here is that the boundary between third- and first-person narrators is porous rather than fixed." Thus, as Sánchez notes, there is a movement between the positions of narrator and narrated subject, and it is only in "The Negress" that Dessa takes full control of the narrative voice.[90]

Deborah McDowell reads the narrative slightly differently, arguing that *Dessa Rose* "plots the progressive movements away from Nehemiah's *written* 'authoritative discourse' within which Dessa is framed (with all of the multiple valences of that term), and the emergence of Dessa's own story, *spoken* without Nehemiah's mediation in her own words, and with her own inflections."[91] McDowell, among others, records the appropriateness of Adam Nehemiah's name, reflecting not only the historical Nehemiah Adams, a slavery apologist, but also the

way in which his name inscribes his preoccupation: Adam as namer and Nehemiah as chronicler.[92] Yet despite his apparent authority (he is within his rights to abuse Dessa physically to confirm his legal power over her), Dessa retains the power to circumvent his inspections. She subversively tells Nehemiah a "culturally coded tale which he completely misunderstands."[93] Andrée-Anne Kekeh suggests that the way that Williams has Dessa Rose frame the tale in both the prologue and epilogue acts as a historical counterpoint to actual slave narratives, which were framed by others' authoritative voices.[94] It is crucial to recall that all of this takes place in a context in which slaves cannot give evidence and cannot have their word taken as (or in) law. Dessa's own experience of the law is at one remove, despite its ability to define and contain her:

> She had no idea what a "court" was; she had never been more than five miles from where she was born before being sold, nor seen more than three or four white people together, except at a distance. She had no words to describe much of what she had experienced, or what those experiences had forced her to see. She understood "court" as white folks trying to figure out if everyone on the coffle had been caught. She wanted to know this herself, so she watched and listened. (55)

Nehemiah notes that Sheriff Hughes had been helpful in "securing permission for Nehemiah to read the court records—sealed after the trials as too inflammatory for general perusal" (26). Clearly, only the white male has authority. As noted in the introduction to this chapter, Sherley Anne Williams used her text to write back to William Styron, to offer what she saw as a more accurate perspective on slave rebellions and the slave's lived life (it is no coincidence that Williams's white chronicler, Nehemiah, is a fool). Here, again, the ethnicity of authorship becomes an important issue that must be (re)addressed. Nicole R. King sets out the argument thus: "As intellectuals we understand that it is foolishness bordering on racism to believe that a black woman writer or a white male writer or any writer who speaks from a particular racial or gender position *cannot* inhabit a cultural persona other than his or her own. As readers, as Gates states, we still quibble, however secretively, about a writer's real ability to do so."[95] Similarly, bell hooks suggests that there are "spaces

white theorists [and creative writers?] cannot occupy. Without rein-scribing an essentialist standpoint, it is crucial that we neither ignore nor deny that such locations exist."[96] One such location would appear to be that of the African American slave. Certainly it is clear that Williams argues that Nehemiah can never understand this location. (Nor, truthfully, does he want to. He wants to be able to define and curtail the slave's behavior, but he never wants to attain intrinsic understanding.)

In her article, hooks calls for an interrogation of whiteness, some-thing that Valerie Martin takes up, as will be discussed below, and it is intriguing to see that Sherley Anne Williams also heeds this call, per-haps more relevantly to hooks's agenda. The reader witnesses Miz Rufel performing her whiteness when she acts as a quasi slave mistress on her rundown plantation and when she more overtly stages her per-formance of "feeble" white womanhood, both on the journey she undertakes in the plan to set up the false selling of "her" slaves and when they reach their final destination. Williams also has Dessa sug-gest that behavior is racially produced: "'Was I white, I might woulda fainted when Emmalina told me Masa done gone upside Kaine head, nelly bout kilt him iff'n he wa'n't dead already'" (17). Dessa recog-nizes what Nehemiah cannot: here, what is encoded as feminine behavior (fainting) is also encoded as white. Instead of reacting with a passive denial of reality (a response conditioned in Miz Rufel, for example), Dessa reacts with violence and attacks the man who killed her lover, even though such behavior ensures that violence will be visited upon her. As a result, she is whipped so forcibly between her legs (her "rump" and "flanks" to Nehemiah) that she is permanently scarred. Nehemiah suggests that locating her punishment on her gen-itals is a means of fooling an unsuspecting buyer into purchasing a dangerous slave and suggests that "to omit mention of a darky's mean streak went beyond sharp dealing and bordered on outright fraud" (21). This early mention of fraud sets the scene for the later confidence trick, as does a careful recounting of the economic cost of the slave rebellion; by the time Dessa and Rufel are through with the plot of selling their companions, they have made almost as much money as Wilson, the slave trader at the center of the rebellion, loses.

Ann E. Trapasso argues that Nehemiah's misreading of Dessa's scars is evidence that he cannot move outside his own construction of race: "By reading Dessa's scars as a sign of her 'misconduct' and 'savagery' rather than of the savagery of the system, he keeps the power to define those enslaved as subhuman creatures and to represent them as such to his readers."[97] He even asks rhetorically, "How many others on Wilson's ill-fated slave coffle had carried a similar history writ about their privates?" (21). For the slave, of course, nothing is "private" (indeed, Dessa's scars are revisited several times in the text), and the reader understands a second message underlying Nehemiah's economic argument: that Dessa is punished at the site of her womanhood because she is thought to be a threat to white males; her female slave body is read as lustful, uncontrollable, and, therefore, in need of punishment.[98] This is despite the fact that white males as a group are consistently shown to be the most threatening and most violent of any grouping in the text. When the slaves rebel against their enforced marching on the coffle, for example, they do so in part because of the repeated sexual abuse of a young woman by the guards. Their repeated raping of her is not constructed as unlawful, only her violent response; she kills the guard and sets off the rebellion: "the toll in life and property had been horrifying. Five white men had been killed. Wilson himself had lost an arm. Thirty-one slaves had been killed or executed; nineteen branded or flogged: some thirty-eight thousand dollars in property destroyed or damaged" (21–22). This is Nehemiah's recounting of the "costs" of the rebellion, and it is telling that he contrasts white life with property, and that ten times more slaves than white men had been harmed or killed.

Throughout, slavery is shown to be an experience that whites control but then misrecognize. Miscommunication—sometimes deliberate, sometimes accidental—characterizes white and black exchanges. When Rufel asks Dessa why she ran away, Dessa answers truthfully that she did not want her child to be enslaved; but this is not the question Rufel thought she was asking: "'I mean, why your mistress use you so?'" Dessa answers, simply, "'Cause she can'" (139). Dessa recognizes what Rufel cannot, that slavery is a system of legitimated violence. Yet throughout, violence is misattributed to the slaves themselves. Nehe-

miah sees Dessa in animal terms, considering her pregnancy in terms of "whelping" and "breeding" (21), and compares her to a wildcat, "apparently unconcerned about the harm her actions might cause her unborn child" (23). His own concern is ironic; why should Dessa care about "property" that she doesn't own herself? Yet Dessa does care, hence her escape attempt itself.

Nehemiah is given access to Dessa, but, as he notes, "It is not to my liking to be required to request *permission* each time I want to talk with the gal" (51; italics in original). Here, as elsewhere, those with nominal power resent and resist those who have power over them; they misread their own privileged positions in relation to the slave. This is certainly the case at Sutton Glen, where Rufel acts like a slave mistress despite the fact that she has no legal authority over most of the people on the plantation. Harrison argues that at Sutton Glen, "[s]lavery thus becomes a performance that these escaped slaves enact to guard the modicum of freedom they have attained."[99]

Rufel attempts at several points to witness Dessa's scars and doubts the story told about her: "'She must have done something pretty bad,' she said, unable herself to imagine such a crime." Nathan's response is, "'Whatever she'd done, it wasn't enough to "impair her value"'" (136), but Rufel is only partly able to understand what he is suggesting. Here, the contradiction of the slave's legal position is highlighted; how can property be accused of a crime? How can punishment be effected in ways that do not reflect negatively on resale value? According to Carol Henderson, "the very language of slavery inscripted on the body of Dessa Rose—present in the form of those horrid scars she bears—is part of th[e] storytelling process." The scars represent Dessa's resistance to bondage, and this visual language, Henderson suggests, "articulates that which cannot be seen, the *motive* will of the slave."[100] Rufel is, at this early point in the section, unable to understand either Dessa or her scars.

Rufel is also amused that Dessa appears to be afraid of her: "Like I was the criminal; her mouth quirked involuntarily" (140). Yet at this point, Rufel is indeed a criminal: she is harboring runaway slaves, so even under the Fugitive Slave Act of 1793, her actions are constructed as illegal.

This section marks a turning point for Rufel, however. She nurses Dessa's infant son because Dessa is unable to, an act that everyone on the plantation apparently finds abhorrent; the former slaves are unable to adjust to this reversal of roles. Attracting even more consternation, she embarks on a sexual affair with Nathan, a man whose first sexual experiences were also with a white woman. His former slave mistress had required him to have sex with her, but this is not presented as particularly coerced behavior (though the one time that he initiates contact, he is rebuffed). Williams's inclusion of this storyline might suggest that she subscribes to the suspect notion that only women are harmed by sexual coercion. Alternatively, she is possibly addressing the stereotypical fear of the white man: that the black man has more sexual prowess. As Mae Henderson makes very clear, in this section the novel engages with pornography; Henderson goes so far as to link the text to *The Story of O*.[101] Particularly in relation to Nathan's first sexual encounters, the black male body is sexualized and aesthetically contrasted with the white woman's body.

Williams must recognize the potency of this image and the way in which fantasies about such coupling have led to extralegal punishments in U.S. history or have been the staple of pornographic images the world over: witness the controversy over the recent rerelease of *Black Snake* (1973), an ill-advised porn film "starring" Anouska Hempel (known as Lady Weinberg since her marriage to Sir Mark Weinberg) that takes the terrain of the slave plantation as its backdrop. According to newspaper accounts, Hempel plays a dominatrix slave mistress who whips her male slaves in the film, who then take revenge by raping her. The racial and gender politics of the film are, at best, problematic, and it is not surprising that Hempel tried (unsuccessfully) to stop the distribution of the film in the United Kingdom in 2005.[102] This is the context, then, in which Williams foregrounds interracial sexual liaisons; *Dessa Rose* is not just a writing back to Styron, but is also a rewriting of sensationalist and popular narratives.

This also allows Williams to contrast the legal and illegal readings of such activities. Had Nathan been caught having sex with his mistress, he would no doubt have been killed without compunction; the same may be true of his relationship with Rufel, but everyone on the

plantation is subject to more far-reaching laws, so no betrayal is likely, despite the fact that Dessa finds their relationship quite literally beyond the pale.

This transgressive, but chosen, relationship is set in contrast to the sexual vulnerability of both black and white women. Dorcas, known as Mammy to Rufel, tells her that "'men can do things a *lady* can't even guess at'" (92; italics in original). Rufel soon learns that all women are vulnerable, despite the formal protection that white women could claim under law.[103] In "The Wench," Rufel is saved from a feeble attempted rape by Dessa's presence; together they overpower a drunk man who had let them stay the night on his plantation. For Dessa, this is an eye-opening event: "The white woman was subject to the same ravishment as me. . . . I hadn't knowed white mens could use a white woman like that, just take her by force same as they could with us" (201). She also recognizes that she alone can offer Miz Rufel protection: "I knew they would kill a black man for loving a white woman; would they kill a black man for keeping a white man off a white woman? I didn't know; and didn't want to find out" (201).

From this point onward, Dessa and Rufel form an uneasy alliance based on gender, made necessary by the plot to sell their companions in order to make money. Dessa contends that money "would put us beyond the reach of any slave law and the more we had, the better" (213). To make money, the group heads west, and Rufel repeatedly sells the slaves, who arrange to escape and meet back up with Dessa and Rufel at a later point in the journey. McDowell argues that in the plot they enact, "she and her comrades turn the 'authoritative' texts of slavery back on themselves. They use all the recognizable signs of those texts but strip them of their meaning and power."[104] In performing the roles of slave mistress and faithful companion, Dessa and Rufel "exploit Southern law and custom and faithfully enact the narrow roles it assigns slaves and women."[105] By using the law against itself, Dessa Rose and Rufel strip the law of any regulatory meaning.

At every level, this is an act of fraud, but Rushdy argues that it is not criminal: "the act would be criminal only if [Rufel] believed that the economic exchange in human bodies were legal; rather, this marks her revolutionary tendency, her understanding that any act

which decimates the system is a worthy one."[106] This is, thus, a way of depleting the financial resources that keep slavery viable.

A final illegal act marks the end of the text. Dessa is discovered by Nehemiah, who takes her to a local prison in order to inspect her, to reclaim her as lost property (and thereby reclaim his own lost text). This offers Dessa an opportunity never before presented. As McDowell notes, Dessa " pleads her case."[107] If this is a fantasy, it is a persuasive one. She play-acts that she is another slave entirely, who belongs to Miz Carlisle, the pseudonym given to Rufel. Dessa believes that she will be safe because someone else will be speaking for her, too, when her own words do not count: "Cept for them scars, it was the word of a crazy white man against a respectable white lady" (226). The scars, however, won't go away, and the sheriff orders an inspection of her body. Chinn argues that historically, "bodies were recruited to testify against themselves to support systems of subordination that viewed racially marked bodies as evidence for their own marginalization."[108] Once again, though, the law is overturned; the black woman brought in to inspect Dessa will not use Dessa's body against her: she is free to go and, after that, free at last. Holloway argues that there is a "persistent historical reality that black women's bodies are a site of public negotiation and private loss."[109] Williams's text both acknowledges this and overturns such knowledge.

The novel thus contests a number of laws and social norms, including murder (of white men), theft (of property, as in the misrecognized body of the slave), torture (as in Dessa's whipping), fraud, and social laws against racial transgression (white wetnursing of a black child, sexual relations between two consenting adults). The novel celebrates the transgression of these laws. Dessa did indeed attack her master and was indeed guilty of murder while on the coffle, yet she goes free; her body, which she does not own, works to her benefit, not the law's (pregnancy delays her execution long enough for her to escape), even as it has slavery inscribed upon it. Dessa enacts the role of slave in order to be free of slavery.

Williams argues that as a result of writing *Dessa Rose*, she "now own[s] a summer in the 19th century" (6). Such a sentiment cannot help but recall how other acts of "ownership" defined both the novel

and the historical reality on which it was based. Williams has, however-er, offered a new definition of ownership here and finishes her novel with Dessa's recollections and desires: *"I hope [our children] never have to pay what it cost us to own ourselves"* (236; italics in original).

Property: *"Had it not been for slavery, he would have been a better man, and his wife a happier woman"*

The above quotation, taken from Harriet Jacobs's authethic slave narrative, *Incidents in the Life of a Slave Girl*, accurately sums up the final novel under analysis here, *Property*. Valerie Martin's novel is a text which is not so much a neoslave narrative as a historical novel that undermines the institution of slavery through its apparent support of it. Told from the first-person perspective of Manon Gaudet, a New Orleans debutante, it traces how her marriage to a "planter" (in this case, as in many others, people are misnamed) becomes unstuck when he prefers sexual relations with Sarah, a slave, with whom he has an "idiot" child. Throughout the novel, slaves are also repeatedly misnamed as servants, a cunning denial of their true state. The novel contrasts Manon's own legal subordination to her husband with her slave's total subservience, sexual and otherwise. While Manon cannot recognize her superior position (or indeed her own culpability in the institution of slavery), the reader does, and thereby questions the frequently made comparisons between white women and slaves of which even informed academics have been guilty. Kari J. Winter traces these connections:

First, feminists have shown repeatedly that in patriarchal cultures women are perpetually and violently dominated by men. Second, like slaves throughout history, women often have been defined as socially dead: persons who do not exist except in relation to fathers, husbands, or brothers. Laws forbidding women to own property, to control money, to witness in court indicate the legal denial of women's independent existence. Third, women live in a condition of general dishonor in patriarchal cultures, despite mystifications of women's status such as the Victorian ideology of the angel in the house and the southern cult of true womanhood.[110]

Martin's novel does not deny Manon's legal subordination; it does, however, show that her case for equal justice does not invalidate the more pressing case of the slave. It also reveals how she is culpable and guilty in relation to the violence of slavery and its dehumanizing effects. A relatively recent text, *Property* has already claimed some limited attention from law and literature scholars. Jane B. Baron, for example, uses the text to explore the distinctions between those who own property and those who do not, focusing as much on the contemporary homeless as she does on the novel. Baron suggests that Manon and Sarah "are what they own — or, more accurately, what they do not and cannot own"; in this way, the text ensures that issues to do with property (who has it, who does not, and what effect this has) move beyond the novel's historical circumstances to be of relevance today.[111]

The novel opens with Manon Gaudet witnessing her husband's possession of his slaves' bodies; he plays a "game" with them, "running his hands over the shoulders of the other, which made the boy cower and study the ground." In the game, the slaveholder forces the boys to "play" for his own benefit: they swing on a rope into the river, "their lithe young bodies displayed to him in various positions" (4). Eventually, since the naked boys have increasing bodily contact, one or another of the boys ends up with an erection, and Gaudet beats them for it. The slave's body is thus used against himself.

The pleasure that Gaudet takes in controlling his slaves' bodies is also evident in his sexual possession of Sarah, Manon's "wedding gift" from her Aunt Lelia, who gave the slave away in order to protect her own marriage, so tempting is Sarah considered to be. Gaudet also regularly "visits" the slave quarters to have forced sex with the slaves considered the most pretty. The only slave whom Gaudet cannot control is his own son, Walter, a deaf and mentally disabled boy of seven; he is the uncontrollable evidence of Gaudet's sexual appetite, and he stands in stark contrast to Manon's childlessness, which is at least partially self-induced. Near the end of the text, after Gaudet has been killed in a slave uprising, Walter is the one piece of "property" that no one wants to take, not even to settle old debts (150).

Although the novel details several instances of what twenty-first-century readers would consider crimes, they pass almost without com-

ment from the characters themselves, or are described as examples of
moral failings rather than criminal activities. A case in point is
Gaudet's possession of Sarah. Spillers argues that "the official mis-
tresses of slavery's 'masters' constitute a privileged class of the torment-
ed,"[112] and later events attest to Sarah's resistance to her "favored" posi-
tion. Manon is aware that Sarah sleeps in Gaudet's room, but does not
know whether Sarah is pleased or disturbed by his proximity. Manon's
only reaction is repugnance for her husband's choices. Summary jus-
tice for uprisings is also detailed; torture and murder are common.
While on the plantation, Manon hears the men circulating rumors of
slave revolts and uprisings and notes, "This is how rumors turn into
dead negroes" (46). Certainly rumors of armed slaves lead to one
death and two cases of severe injury, even though the slaves them-
selves hadn't been armed; as Gaudet says dismissively of a fellow
slaveholder: "'Now he's grumbling that he'll be out two thousand dol-
lars if we kill them. Not one man on the patrol is going to risk his life
to save one of these damned runaways. If we can find them, they'll be
better off dead than dragged back to Borden's overseer, and I've no
doubt they know it'" (11).

Manon's husband, who is never given a first name in order to
indicate that he is (ironically, given their legal positions) seen in the
text only in relation to her and as a generic slaveholder, fights cruelty
with cruelty; he enjoys the chase and appears to live for the excite-
ment that such uprisings entail. After the murder of a "stableboy" by
two fugitives who use machetes to cut off his arms and legs as a mes-
sage to the planter, he asks, "'What are we to do? . . . Open our
larders to every runaway who is tired of working that those who are
faithful will not be murdered? What can they possibly imagine will
be the result of such unconscionable savagery?'" (57). The stableboy
is considered to be "murdered" only when a fugitive slave is the
apparent culprit (similar treatment by "patrols" goes unremarked).
The runaways are constructed as both lazy and savage; as we have
seen elsewhere, the effects of slavery are misrecognized by those who
benefit from it.

But in this text, it is mostly in relation to gender that the law is
invoked. Manon is deeply unhappy in her marriage. She is aware that

she, and her belongings, are little more than property to her husband, to dispose of as he wishes. When her mother dies in New Orleans, she fantasizes about staying there to live in her mother's house and thinks longingly both of divorce and, more wistfully, of her husband's death. She covets the title of widow, unaware that such a designation will constrict her as much as being a wife does. Manon notes, "I was too proud to beg for my freedom, my husband too absorbed in his own passion to notice my suffering" (60).

Manon has no desire to have children and, as a result, is misread by others as unfeminine. When she is first confronted by the question of children, she is taken aback: "What sort of woman doesn't want children?" (40). Her answer—a woman like herself—surprises even her. Her desire to escape childbearing is hard to disassociate from her repugnance toward her husband: whether childlessness is a state she would prefer in any case is impossible to say, for she had never, before being asked, questioned herself about procreation. As she explains to the doctor charged with exploring her fertility, she despises Gaudet because he has had a child—a damaged child—with Sarah. Dr. Sanchez reacts with a shrug and says it is not uncommon, to which she replies: "'That is precisely my grievance. . . . That it is common'" (41). For the doctor, the fact is worth no more than a shrug; for Manon, such behavior ensures her childlessness and desire for escape. As a result, Manon is considered "unbalanced" both by the doctor and her husband, a diagnosis she reads sardonically: "So that was the name they had for a woman who could not pretend a villain was as good as a decent man" (61). Even here, though, what Manon objects to is her husband's lust, not the fact that he resorts to rape.

Manon longs to be free of her husband, and traces the case of one Sally Pemberly, who had divorced her husband "because he was so cruel even the servants pitied her." Sally's husband, a gambler, had debts, much as Gaudet does; however, as Manon notes, Sally "sued to have her marriage portion, which was considerable, exempted from his creditors and restored to her. By some miracle, she has won. Now she has her own income and she is free of her detestable husband. Fortunate woman!" (47). Later, Manon decides to get the name of her

lawyer, but events intercede, her mother dies, and Manon has more pressing legal matters, such as what to do with her mother's estate and how to dispose of unwanted slaves. As the lawyer makes clear, Manon cannot legally withhold her inheritance from her husband: "As we left the lawyer's office I observed to my aunt, 'The laws in this state are designed to provoke citizens to murder'" (90). Again, however, her words are never explicitly connected to the slave's position, and murder here as fantasy is far away from murder in reality that attends to the institution of slavery.

One bit of unwanted property is her mother's cook, Peek. Manon and her aunt Lelia agree between them that Peek "'has little value'" (91) and would not sell for one hundred dollars. Perplexed, they cannot come up with a suitable plan, until Lelia suggests that they ask Peek herself, an option that had never occurred to Manon, so ingrained is her sense that slaves are senseless.[113] To Manon's surprise, Peek had a clear plan, opting to be sold to a woman a few blocks away. When Manon agrees to the plan, Peek "nodded her head a few times and went out, folding her handkerchief and smoothing her skirt, without so much as a word of thanks" (92).

Manon deliberately or unconsciously misreads the slave's position. When she and Sarah return to the plantation, tired, Sarah avoids Gaudet's entreaties whereas Manon endures them: "The slave's blessing, I thought, forever exempt from the duties of greeting" (106). The "niceties" that Manon values—please and thank you, considerate greetings—are outrageously inappropriate expectations under the circumstances. Manon is so deluded about slavery that she thinks, when fugitive slaves ransack her house and kill her husband, that there would be no reason for *her* slaves to do anything but protect her (125). While the historical record acknowledges the fact that some slaves did protect their "owners" in similar situations, Manon's inability to think about, let alone recognize, the context within which this might occur is key here. She is also uncomprehending of Sarah's subsequent flight: "My husband is dead, I thought. Why would she run now, when she was safe from him? It didn't make sense" (137). Manon has conveniently forgotten that she herself has recently abused Sarah.

In one of the most disturbing passages in the book, Manon suckles at Sarah's breast after Sarah feeds her own child:

The drop of milk still clung to the dark flesh of her nipple; it seemed a wonder to me that it should. I dropped to my knees on the carpet before her and rested my hands upon her wrists. I could feel the smooth, round bones through the thin cloth of her sleeve. I leaned forward until my mouth was close to her breast, then put out my tongue to capture the drop.

It dissolved instantly, leaving only a trace of sweetness. I raised my hand, cupping her breast, which was lighter than I would have thought. It seemed to slip away from my fingers, but I guided the nipple to my lips and sucked gently. Nothing happened. I took it more deeply into my mouth and sucked from my cheeks. This is what he does, I thought. At once a sharp, warm jet hit my throat and I swallowed to keep from choking. How thin it was, how sweet! A sensation of utter strangeness came over me, and I struggled not to swoon. (81)

This passage works on a number of levels. Manon's sexual abuse of Sarah reconfigures the character of the Mammy, or black wetnurse who suckles and "loves" the white child; just prior to this passage, Manon's own mother has passed away, leaving her in a state of lovelessness. Her move toward the bodily comfort of another woman must be seen partly in this light: she considers it her right to seek and find pleasure in Sarah's body. She thus neither asks for nor obtains permission; like her husband, she simply takes. Her theft of Sarah's milk also recalls the violent theft of breast milk detailed in *Beloved*. Manon's apparent gentleness does not obviate the invasion of Sarah's body that Manon enacts. Manon, after all, holds Sarah down with her "hands upon her wrists." The theft is also deeply sexualized, with undertones of lesbian pleasure for Manon. At the same time, the release of breast milk into Manon's mouth is detailed in terms that recall ejaculation: "a sharp, warm jet hit my throat and I swallowed to keep from choking" (81). Manon is on her knees in a stereotypical posture of subordination, but she has control of the situation and Sarah does not. Manon even misrepresents Sarah's reaction. "I was aware of a sound, a sigh, but I was not sure if it came from me or from Sarah. How wonderful I felt, how entirely free" (82). "Free" is not a term that could describe Sarah's position at this moment (remembering the hands upon her wrists), nor is she experiencing pleasure. Afterward,

Sarah's body language makes clear her reaction to Manon's suckling: "She had lifted her chin as far away from me as she could, her mouth was set in a thin, hard line and her eyes were focused intently on the arm of the settee. She's afraid to look at me, I thought. And she's right to be. If she looked at me, I would slap her" (82).

This, then, is the context in which Sarah escapes from the Gaudet plantation. Whether her escape was part of the uprising or a happy coincidence is unclear, but she manages to take her baby with her and steal a horse, riding away to safety—at least for a time. Although Manon concedes the plantation and all its debts to her brother-in-law, she is determined to track Sarah down and reclaim her. It later becomes clear that a free man, Mr. Roget, who had once asked for permission to marry Sarah when she still worked for Manon's aunt Lelia, had a hand in her escape. He approaches Manon with an offer to buy Sarah, at twice her market price, should she be returned. Manon, who considers this offer no more than blackmail, responds with a cruel counteroffer. She won't sell Sarah, but she will allow the man to marry her—"His children would be mine, to do with as I pleased" (185)—an offer he naturally refuses. Manon considers that Sarah is hers, "by right and by law" (186). She also argues, "'I don't think of her as having run away, you see, I think of her as having been stolen. She would never take such a risk had she not been encouraged by someone who has no respect for the law, who is so morally derelict that he fails to comprehend the difference between purchase and blackmail'" (185–86). As Manon reminds Mr. Roget, she does, indeed, have the law on her side. Eventually, Sarah is recaptured, and her elaborate con of traveling as an ill white man, with a black slave and small baby as a companion, is unveiled. Martin is here indebted to the real-life story of Ellen and William Craft, who executed a similar plot, though they were successful in their venture. Roget claimed that Manon would never find Sarah, though in an irony worthy of some note, he goes to some expense to reclaim his own slave, Midge, Sarah's traveling companion, who had escaped when Sarah was caught (206).

Manon's victory over Sarah is thus nearly complete, but it is telling that Manon covets what she can never have, what Sarah her-

self experienced in the time that she was free. Speaking to her aunt, Manon notes that Sarah "'has tasted a freedom you and I will never know. . . . She has traveled about the country as a free white man'" (205). Manon's jealousy of Sarah is not, therefore, related to her favored status as her master's unofficial mistress, but of her mythical status as a stand-in man. Even for the slaveowner's wife, Martin suggests, the law enacts measures that constrain the female and limit her power. Baron suggests that "[a]s objects of property, Manon and Sarah's agency must be denied, but because they are also breathing subjects, their agency cannot be suppressed."[114] Baron thus compares the women as both subject to the law, if not equally, but it seems to me that Martin is even more subversive than this in her new form of neoslave narrative. Here, Martin offers a first-person narration of a slave owner, not a slave; indeed, Sarah herself rarely speaks, and when she does, it is to misdirect Manon in some way. In literature as in law, truth is contested, voices are disbelieved, and perspectives are considered suspect. In *Property*, a neoslave narrative in which other suppressed voices are represented, they compete in order to belie the myth of common oppression so unhelpfully (and naively) propagated by some feminists.

Rushdy argues that it is "disturbing" that the late twentieth-century debate about who can (and how to) write in the first person about slavery "hauntingly echoes the nineteenth-century debate over the political truth contained in antebellum slave narratives and the early-twentieth-century debate over the documentary truth value of the autobiographies of slaves or the American historical profession."[115] Though the debate continues, Martin adds her own particular invented voice—that of a cold, bitter slaveowning woman—to keep the debates about authority and ownership alive.

Aristodemou argues that "the stories we tell are constructions rather than facts, provisional rather than final, partial rather than total. Furthermore, the language at our disposal is not neutral but arises from the same culture that it addresses."[116] The rise of neoslave narratives in the late twentieth century, and their reworkings again in the early twenty-first, speak to the ongoing engagement with racial politics in literature and in law and to the need to continue to offer voices to those who have been historically silent.

The next chapter, focusing specifically on motherhood, moves firmly into the twentieth century and primarily explores lower-middle-class white women's negotiations of the mothering position. Spillers reminds us that "[o]ne treads dangerous ground in suggesting an equation between female gender and mothering; in fact, feminist inquiry/praxis and the actual day-to-day living of numberless American women—black and white—have gone far to break the enthrallment of the female subject-position to the theoretical and actual situation of maternity."[117] As true as this may be, women are frequently depicted in fiction in relation to their mothering role, and legal narratives of women's lives continue to inscribe a restrictive identity that foregrounds their responsibilities to others above themselves.

Chapter Three

"Mother Knows Best"
Women, Children, and the Law

*To whatever degree the reality of or potentiality for motherhood defines
ourselves, women's lives are relational, not autonomous. As mothers we
nurture the weak and we depend on the strong. As mothers we nurture
and are nurtured by an interdependent and hierarchical natural web
of others.*

— Robin West, *Narrative, Authority, and Law*[1]

Legal stories about contested motherhood stretch as far back as
biblical narratives and offer rich sources for twentieth-century texts:
in just two examples, Bertholt Brecht updates the King Solomon dis-
pute in his 1944 play, *The Caucasian Chalk Circle*, and Margaret
Atwood rewrites the pact between Rachel and Bilhah (or, more accu-
rately, Rachel and Jacob) in her 1985 novel *The Handmaid's Tale*.
That authors return frequently to the contested nature of mother-
hood speaks volumes about its place in the twentieth century: no oth-
er subject is more frequently explored in feminist texts.

Nan Goodman argues that "whether complementary, subversive,
or reflective of each other, taken together, legal and literary narratives
can illuminate the way the culture constructs itself through narrative
without privileging either the ostensibly real or the imaginary, the
ostensibly true or the morally ambiguous."[2] Goodman's recognition
of the multiple components interacting in the construction of culture
is particularly resonant for literary and legal texts that focus on moth-
erhood. Motherhood, or more particularly, the position of mothers, is
an integral and contested element of feminism and the law, subject to

a variety of frames of reference moving from the "natural," ever-loving "good mother" to the abusive woman who fails to keep her child from harm.[3] Such visions of motherhood extend across a range of popular culture texts. For example, the slightly above-average psychological thriller The Forgotten (2005), starring Julianne Moore, argues that mother love is so strong, and the bond between mother and child so unbreakable, that it can metaphorically bring children back from the dead—or, in this case, government-condoned alien abduction. In Jackie Kay's moving collection of poems, The Adoption Papers, the position of two (white) mothers—and implicitly their relationship to the law as well as to the mixed-race child that one mothers and the other gives up—is revealed through an interwoven series of voices. The competing voices of two white woman reveal that neither is wholly a "good mother" or a "bad mother," and that both are at least partially imagined by their daughter, whose experiences of racism accord with neither adult's own experiences.[4]

Most literature on motherhood and the law reflects not the success of the individual woman but her overt policing (a topic touched on in The Adoption Papers when the adoptive mother seeks to define herself as unexceptional to the social worker in order to receive her much-wanted child).[5] This chapter explores how the law (and literature about the law) represents the woman-as-mother as somehow more closely monitored—and more often condemned—than other members of society. Here, it is vital to maintain a postegalitarian stance, given that the female defendant's gender (through her very position as mother) is foregrounded rather than ignored, as it impinges on the reasons behind as well as the reception of any crime she may have committed. A postegalitarian feminist stance maintains that women constitute a "special case" under law, a viewpoint that potentially essentializes women's position, concentrating on the similarity between individual women, but their difference from men (a stance which has been extensively critiqued within Anglo-American literary and social feminism). However, a number of incisive feminist essays argue that "[n]eutral treatment in a gendered world or within a gendered institution does not operate in a neutral manner."[6] Moreover, recognizing that all women are potentially subject to the law in

ways that men are not does not entail suggesting that all women are subject to the law in exactly the same way; as a number of feminist critics have pointed out, African American, Latina, or Chicana mothers, poor mothers, disabled mothers, and lesbian mothers (or any combination thereof) are often framed in particular ways in relation to the law, and their actions are read in ways that confirm the dominant culture's suspicions about such women and set them in opposition to class-privileged, heterosexual, white women.

Such a realization makes it doubly imperative that the intersection of gender and the law be explored fully. Like Martha Fineman, I am interested in "the role of law in the construction and perpetuation of a gendered social existence."[7] Women's experiences of the law *are* gendered (in Britain, for example, infanticide is defined as an act that can be committed only by a mother), and this chapter interrogates the dilemma of whether women as mothers should indeed be seen as constituting a "special case" in law and literature about the law. Anne Worrall argues that although courts do not "consciously take systematic account of differential circumstances and experience arising from the social construction of masculinity or femininity," they do "constantly struggle to reconcile notions of formal gender-neutrality with evidence of substantive gender-inequality in the lives of the women who appear before them."[8] The competing claims of gender neutrality and gender difference thus have a material importance, in that they have real (if sometimes unacknowledged) effects. Dorothy E. Roberts echoes many when she argues that "[a]lthough the law treats mothers who commit general crimes relatively leniently so that they may fulfill their traditional role, it treats women who commit crimes as mothers the harshest for violating the traditional role. The criminal justice system punishes female defendants according to the extent to which their acts deviate from appropriate female behavior."[9] This recognition is as true of literature as it is of law. Thus, after examining a number of cases where motherhood is negotiated and judged, this chapter analyzes the position of fictional women as caregivers, mothers, and midwives, exploring how women's guilt is seemingly transferable across a range of "crimes."

In *A Map of the World* (1996), by Jane Hamilton, for example, a farm woman who negligently causes a child's death is later accused of

child sexual abuse; the move from accident to deliberate harm is seemingly unquestioned by those who accuse her, and her trial is read as a ritual "purging" for the community. In addition, each of the mothers in the text is subject to a questioning of her position in a way that the principal fathers are not. In *The Good Mother* (1986), by Sue Miller, a mother's position *as* mother is seen to be contaminated by her sexual relationship with a man who is not the father of her child; even she sees herself as guilty for having imagined a life that did not revolve around her daughter. Her punishment—the removal of her child—ensures that she will forever covet the space of motherhood now denied her: she is defined by its absence, her moral worth intimately bound up in an event that occurred when she herself was not at home. As we shall see, a mother's role is seen as essential in a court of law even when she has left someone else in charge of her child. Finally, in *Midwives* (1997), by Chris Bohjalian, an unlicensed midwife is accused of manslaughter in relation to the death of her patient, and her teenage daughter is forced to confront the age-old image of the unconventional, wise woman as witch in the lead-up to the trial. Labeled an outlaw and a rebel, the woman on trial finds her every movement reexamined for guilt and her livelihood questioned. In some U.S. states, planning a home birth is an illegal act in itself, a phenomenal change to women's regulated lives over the course of the twentieth century. In *Midwives*, as in the other texts, both guilt and crime take on a variety of meanings. In all three texts, trials are central to the narratives, but, more important, each in some way interrogates the way that motherhood itself is regulated.[10]

Framing the Evidence: The Cultural Regulation of Motherhood

The regulation of motherhood takes a variety of forms. In March 2005, Scotland passed the Breastfeeding (Scotland) Bill, which makes it an offense for anyone to stop a woman from breastfeeding her child in a public place or feeding milk to toddlers in licensed premises where children are already allowed. This follows legislation in some U.S. states and Canadian provinces which is designed to promote

breastfeeding. The bill references an Infant Feeding Action Coalition (INFACT) poster from Canada which proclaims, "Don't think of it as a woman's right to breastfeed. Think of it as a baby's right to eat." That the rights of the child are juxtaposed with the rights of the mother as if one has a greater claim to protection *even when their aim is the same* strikes me as problematic. Over the latter decades of the twentieth century, children's rights became the focus of law, and society's awareness of children's rights was significantly raised. But the fact that these rights came sometimes at the cost of women's rights is a matter of concern. What also intrigues me is the way in which this law is constructed as a social engineering measure, designed specifically to increase rates of breastfeeding in Scotland, which are below the U.K. average and government targets. On the face of it, this seems a noble endeavor: breastfeeding is good for babies and for many mothers, too. What is less clear is whether a law can make a person do something she would not otherwise do. A law may act as a deterrent (though even this is questionable), but can a law encourage behavior rather than deter it?[11] This law is aimed at "good mothers"—or is attempting to make women into "good mothers" as defined by a variety of pressure groups ranging from feminists to "family values" politicians. Indeed, the fact that women's issues create unlikely coalitions (witness the way in which radical feminists and religious fundamentalists share platforms in opposing pornography, for example) has been a cause of concern for many who are engaged in women's rights.

Far more laws appear to target "bad mothers." If the good mother naturally breastfeeds her child (though requiring a law to enforce or recognize this "natural" behavior), the bad mother offers her child no protection at all. In several U.S. states, women have been convicted of murder on the basis of "failure to protect," even when—or especially when—they themselves are victims of domestic violence. As Michelle S. Jacobs argues, "These women may have either a justification or an excuse defense available to them but are effectively precluded from taking advantage of such defenses either through the ignorance of their lawyers or by gender bias in the application of criminal law."[12] Jacobs calls for a recognition that these women faced death or serious harm if they intervened; they should, she argues, be

covered by the acknowledged limits of the duty of care, whereby "one cannot be held criminally liable for failing to do an act which she is physically incapable of doing."[13] Just as in the image above of the good mother, where the child's legal position is held to be more worthy—or at least more palatable—than the mother's, so, too, in cases of the "bad mother" are there conflicts between the rights of members of the same family. Jacobs suggests that public awareness was raised about both child abuse and domestic violence at the same time, but not with the same results: "In fact, the mother's encounter with violence in a sense heightens her dilemma. The courts reason that since she is aware of the violence that occurs in the home, she should do more to ensure that her children are shielded from that violence."[14] Too often, according to Jacobs, the mother's own experience of abuse is deemed "irrelevant" to her defense.

An Associated Press article entitled "Moms Are Held Accountable" detailed four cases of women who were charged with murder in 2004 alone, despite the fact that, in at least one case, the mother was not even home when her child's death occurred: Lena Buhr was visiting her father in the hospital when her son was fatally injured. Nevertheless, she was sentenced to thirty years in prison.[15] In this context, blame is shifted from the perpetrators of violence to those who may themselves be suffering from violence, or whose economic dependence, religious feelings, or other cultural factors prevent them from either acknowledging the abuse or being able to protect their children from it. Jacobs records how Pauline Zile's acknowledgment of regret for her daughter's death at the hands of her abusive husband was used by the prosecution as evidence of Zile's own guilt.[16]

Katherine Taylor finds other evidence of courts and the law attempting to "mandate a legal duty of self-sacrifice" in relation to women: "Thirty-six [U.S.] states mandate, through their advance directive statutes, that an incompetent pregnant woman be kept alive under certain circumstances, despite her earlier wishes expressed in a living will, or, in many states, the wishes of her designated healthcare decisionmaker . . . [in many cases] *regardless* of such critical factors as her own pain and suffering, the fetus's age, or its prognosis for either a live birth or a healthy life after birth."[17] Taylor argues that such man-

dates are "patently unconstitutional," not least because they "literally conscript the bodies of incompetent pregnant women to serve as fetal incubators for the state."[18] Other critics explore the contested legal issues of "drug trafficking" charges against pregnant drug users, or surrogacy, both of which may have class as well as gender implications.[19] For instance, Elizabeth Tobin notes that almost half of surrogate mothers are unemployed,[20] whereas most families seeking surrogacy arrangements are by definition middle class, if only in that they can afford this "service." Finally, in Britain, it is a legal requirement that women undergoing IVF or other fertility treatment produce a note from their doctors attesting to the fact that they would be suitable parents; without such official authorization, women cannot commence treatment. The Human Fertilisation and Embryology Act 1990 explicitly states: "A woman shall not be provided with treatment services unless account has been taken of the welfare of any child who may be born as a result of treatment (including the need of that child for a father) and of any other child who may be affected by the birth."[21] Thus, in some cases, even before they become mothers, women are subject to regulations and conditions which determine whether or not they are considered "good mothers." Laws controlling abortion services are also relevant here. Kim Dayton acknowledges that women's position in relation to law is still related principally to whether they are married, whether they want or can bear children, and how they work out the competing demands of childcare and career.[22]

Given this context, it is key that in both fictional and factual cases an emphasis is placed on how narratives about mothers are constructed. Nowhere is this more evident than in cases of mothers killing their children. This ultimate social taboo evinces strong public reactions and, in the United States at least, calls for the death sentence to be invoked. Janet Ford argues that there are five categories of filial homicide: infanticide (the killing of a child shortly after birth); accidental death resulting from child abuse (which Ford notes is unintentional, and thus sometimes leads to a manslaughter charge, but should perhaps be treated more harshly given the extent and duration of abuse prior to death); "cold and callous murder" perpetrated by

sociopaths; "cultural or sociological homicides" that relate to cultural backgrounds, such as honor killings; and the "least explicable," which she terms the "Susan Smith" category, after the South Carolina woman who drowned her two sons in a local lake and claimed they had been abducted by a "black man."[23]

As we saw in chapter 2, considerations of race and/or ethnicity also come into play in relation to mothers who murder; in Britain, the rise of so-called honor killings in the British Asian population led the Crown Prosecution Service to host a conference on the phenomenon in December 2004, and the Metropolitan Police launched a review of hundreds of "suicides" which they now consider to be more sinister. In the United States, a high-profile case in 2002 concerned a mentally ill white woman from Minnesota, Donna Anderson, who killed her mixed-race son. Anderson's delusions concerning her son's vulnerability to child pornographers almost certainly led to his death. Anderson, a medical professional, pleaded guilty but refused to give a full explanation of her actions. An earlier attempt by her court-appointed attorney to silence her through invoking an insanity defense was unsuccessful, and she won the dubious right to represent herself, thus ensuring her own condemnation.[24] This case, too, falls into the category "inexplicable" as outlined by Ford.

Other critics argue that neonaticide, or the killing of a child within twenty-four hours of birth, should be seen as a crime separate from other infanticides or child homicides. Shannon Farley even posits the existence of a Neonaticide Syndrome, characterized by a sudden psychotic break that manifests itself when the shock of childbirth means that what the woman (or, more likely, the girl) has been denying—her pregnancy—can no longer be denied. Farley argues that this syndrome should be used as a legal defense to ensure that women or girls who kill their newborns are treated fairly or equitably. Her argument is that in denying the existence of such a syndrome, despite the narratives that clearly show a correlation between social factors, "the trier of fact is left with the impression that the accused mother's actions were unique and impermissibly heinous."[25] The reality is something different. Michelle Oberman argues that a sex-specific defense of involuntary manslaughter should be made available to

women who commit neonaticide. Oberman's argument does not extend to other forms of infanticide, which is variously defined in the United States, as she believes a defense of "extreme emotional disturbance" should be available in these cases for the child's primary caregiver, whether male or female.[26] Michael L. Perlin contends that women who commit neonaticide while suffering from postpartum psychosis represent a "numerically unimportant but politically significant" subset of defendants seeking the insanity defense.[27] Thus, it is not the number of women who commit neonaticide that merits attention, but the defense they seek and the public's reaction to their crime.

Homicides of children by their parents are the only crimes in which women's rates of offending are nearly the same as men, and for some forms of the crime, such as neonaticide, the perpetrators are virtually always female. Allison Morris and Ania Wilczynski studied almost five hundred homicides of children whose parents were the main suspects, over an eight-year period in the 1980s, and their study has been used as the basis for several others. They were surprised by the fact that mothers accounted for about half of the defendants in cases of child deaths.[28] Given this context, Ford convincingly argues that "the killing of one's children, or filial homicide, is a women's issue, and a matter appropriate for feminist inquiry."[29] Such inquiry is not unproblematic, however. As Roberts notes, "Even feminists may find it difficult to identify with criminal mothers who harm children because of feminism's uncompromising opposition to male violence against women and children."[30] Indeed, such is this problem with identification that Marie Ashe counsels that law students should read literature about women accused of child abuse in order to counter their own, ingrained resistance to such women clients.[31] Morris and Wilczynski, noting the huge difference in feminist exploration of violence *against* or *by* women, suggest that feminists find it difficult to assess whether women's violence "betrays or supports feminist causes."[32]

Such a tangled response to women's crimes is perhaps not surprising. Many feminists view prostitution, for example, as exploitation (often economic exploitation) or even abuse (particularly for the young woman or girl); women's most common crimes are shoplifting

and theft, crimes that speak of economic deprivation rather than sociopathology. Such crimes can be understood or forgiven more readily than crimes that appear to mimic male patterns of violence.

Historically, criminologists argued against women's political empowerment precisely because they believed that empowered women were more likely to commit criminal offenses. Such a hypothesis has never been proven. In fact, as Ford argues, there is no established link between "liberated feminist ideology and criminality." Instead, Ford suggests that most female prisoners are poor, undereducated, and "more likely guided by prevailing gender-biased social mores."[33] It is precisely the difficult cases, though, that must be addressed, and in the next section, I examine two high-profile cases of women who kill, each of which has been referenced in over one hundred articles in law journals or reviews,[34] as well as compulsively recorded in newspaper articles, magazines, and television programs.

Mothers Who Kill:
Susan Smith and Andrea Pia Yates

The case of Susan Smith is so notorious that, as stated above, Ford argues that a whole category of "inexplicable" child homicides can be linked to the case, and Perlin argues that the case, and anger over it, has led to all women who kill children being seen as less worthy of sympathy and more worthy of punishment.[35] Indeed, the case has become so well known that Praeger's five-volume series *Famous American Crimes and Trials* devotes an entire chapter to the crime.[36]

The notoriety of the Susan Smith case rests more on the fact that Smith initially offered a false explanation of her children's disappearance, an explanation that cost law enforcement officials time and resources. Smith, a young South Carolina mother, claimed in October 1994 that her two sons, Michael and Alex, had been abducted by a black man who hijacked her car. Ford calls this the "big lie" and argues that the creation of this story, rather than setting Smith apart from other mothers who kill, in fact links them; some women even begin believing their fabricated stories because facing the reality of their actions is too difficult.[37] Smith stuck to the story for several days

before revealing that she had driven her car into John D. Long Lake herself, initially intending to commit suicide.

Reactions to the case were strong, as much for the lie that Smith told as for her crime. Perlin goes so far as to suggest that calls for Smith's execution were based as much on the fact that people felt "conned" by her as on the crime itself.[38] During the trial, the prosecutor and her defense lawyer told markedly different stories about Smith: in the prosecutor's story, she was an evil woman who calculatingly killed her children for the love of a man, Tom Findlay, who had considered her children obstacles to their relationship; in the defense version, Smith was an abused, mentally ill woman whose past life experiences, including witnessing her father's suicide and being sexually abused by her stepfather, led her to contemplate and attempt suicide. According to the defense, it was at the last minute, and after several false starts, that Smith rolled her car into the lake with only her two sons strapped inside.[39] Though there were widespread calls for Smith's life in the wake of information about the case, the jury in the end decided on a prison term instead, and Smith was sentenced to thirty years to life.

A number of critics note that when women commit "inexplicable" crimes, they are frequently labeled mad or bad, their actions considered deviant in order to protect society's view of women, especially its views of mothers. Pamela Bridgewater ably articulates this phenomenon:

"How could a mother do such a thing?" In some respects the question is a legitimate one, because it is reasonable to expect more information about such troubling situations. However, this question is superficial, albeit legitimate, in that it effectively limits the terms and scope of the inquiry. In asking this question, we, the confused, shocked and detached public, only consider the woman's status as "mother" and the aberrant conduct of "such a thing." Further, the question renders the conditions surrounding the lives of the women and their children irrelevant non-issues.[40]

In the Smith case, it appears that the jury took into account the material conditions of Smith's life and her difficult past. As Oberman suggests, "When it finally came time for the jury to rule, it seemed to view her as both mad and bad rather than choose between these two images. They saw her life in context."[41] Oberman does not use the

term "mad" in a legally defined sense of insane; rather, she uses the designation fluidly as a way to explain juries' reactions to women's seemingly inexplicable behavior—they must be "mad." "Madness" here reflects a sort of social shorthand, or what Perlin would call "Ordinary Common Sense."

Oberman further argues that "[t]here is a false dichotomy inherent in societal assumptions about motherhood—one is either wholly capable of assuming the tasks of motherhood, or wholly incapable." This dichotomy, she suggests, is partially responsible for infanticide, where women who need or could benefit from assistance are not given it. Oberman's profoundly challenging conclusion is that mothers who kill do so in part because of the way that American society organizes mothering: as an experience of isolation.[42] Clearly, only a relatively small percentage of mothers kill their children, but Oberman and others argue that if the circumstances which permit isolation and exacerbate mental illness are not rectified, then society needs to consider these factors in sentencing women who *do* kill. Ford suggests that except in the case of "callous and coldly deliberated filial homicides," women's punishments for these crimes, though necessary, "should not replace or detract from the efforts required to address the social problems that generated much of the problem in the first place."[43] This acknowledgment of the material conditions of mothering is hardly new ground for feminists, but the fact that such calls continue to be made suggests that these conditions remain somehow misrecognized. As Oberman argues,

The intensity and exclusivity of our focus on the wisdom of punishing the defendant channels society's attention away from the remarkably patterned circumstances that surround these crimes. Thus, despite the patterned nature of these circumstances, each case generates the same tired dialogue regarding the defendant's culpability and the merit and utility of punishment. Society becomes trapped in this ongoing dialogue and, therefore, never comes to grips with the role played by families and communities in contributing to these infants' deaths.[44]

One case in which the role of the family was seen to play a part was the widely publicized trial of Andrea Pia Yates.[45] In her article "Hard Cases, Easy Cases and Weird Cases: Canon Formation in Law and Literature," Susan Sage Heinzelman argues that lawyers make

distinctions between three kinds of cases, distinctions that rest on an idea of language as generally transparent and only occasionally opaque (an idea that literary scholars dispute). Thus, in "easy" cases, "language speaks for itself" whereas in "hard" cases "the judge is called upon to intervene between the language of law and the actions of those before the court"—essentially, hard cases require the interpretation of rules. "Weird" cases, by contrast, are ones in which "the language is clear, but hypothetical events can always be made to intervene and confuse the interpretation."[46] Heinzelman argues that "[t]he designation of certain cases as hard, easy or weird determines what texts the legal and literary canons acknowledge and what texts they silence: consistently the woman's case is marginalized as weird."[47] I wish to address these designations by examining Yates's trial, which was staged almost as a media event but which had, at its center, a series of silences.

It was a trial in which spectators jostled for seats, displacing family members from a privileged row behind the accused woman. It was a case that generated hysterical, daily media coverage and comment. And like the case of O. J. Simpson, it was a case that divided communities, though not, in this instance, along ethnic lines, but almost along biblical ones: the Old Testament need to exact revenge for a terrible crime—the drowning of five small children—or the New Testament desire for forgiveness and repentance. Such a focus on Christianity as a framework was an inevitable part of the trial, because Andrea Yates was a fundamentalist Christian woman, and in one sense, it was her family's desire for Christian, patriarchal order that was on trial with her.[48] Indeed, at the center of the trial, depending on one's viewpoint, was either a woman who failed to conform successfully to the full-time mother and home schooling ideal of her Christian community—or, her five dead children. One's perspective determined whether one called for mercy or revenge. On June 20, 2001, thirty-six-year-old Andrea Pia Yates, suffering from severe postnatal depression, systematically killed her five children, ranging in age from six months to seven years. After calling both the police and her husband to let them know what had happened, she was immediately arrested and soon became the figure of intense media speculation.

For many in the United States, the case was more than a little reminiscent of the Smith case. However, Yates confessed immediately—and it was this fact, as well as the scale of her crime, that made the trial so (for want of a better word) popular. Eventually, Judge Belinda Hill ordered a gag order to prevent the lawyers and witnesses from offering interviews that might be deemed prejudicial, such was the level of interest in the case.

The Texas case rested not on whether Andrea Yates was mentally ill—of that there appeared to be no dispute—but on whether she understood her actions to be wrong—the legal definition of insanity in Texas. As Dr. Neil Kaye, a forensic psychiatrist, opined in an article in the *Houston Chronicle*, "If everybody agreed, there wouldn't need to be a trial."[49] Here, the law's role in *settling disputes* is clear; what is not clear is how to weigh the opinions of different psychiatrists against each other. Yates killed her children; again, that is not in dispute. What was at stake was the degree of responsibility for her actions that could be assigned to her. Yates was badly failed by the medical community and perhaps even by her family, who refused to interpret signs of her increasing mental illness; Debbie Holmes, Yates's best friend, was even told, prior to the tragedy, "You need to write this down in case something bad happens."[50] This need for evidence—and the need for the written text—reveals the connections between the law and literary analysis that are at the heart of the law and literature movement.

The Yates trial depended on two opposing readings of mental health, and one psychiatrist, Park Dietz, hired by the prosecution, was instrumental in her eventual conviction.[51] During the trial, Kaye commented that Dietz "will stick to an easy story there. He can demonstrate purposeful behavior, because she had to get the first child in the bathroom, then the second, then the third, then the fourth and she chased down the fifth. That looks like she knew what she was doing."[52] This "easy story" omits details of delusions, hallucinations, and visions oddly reminiscent of Charlotte Perkins Gilman's famous postpartum depression short story, "The Yellow Wallpaper." (Like Gilman's narrator, Yates saw figures creeping behind the walls of her home.)[53] Yates's "confession" that she had to kill her children

to save them from eternal damnation was also used against her, to show an "easy" story that pitted right against wrong.

The media circus that accompanied the trial is worthy of examination in its own right, and various Associated Press journalists wrote accounts of the events. Pam Easton recorded that the defendant's husband, Rusty Yates, "sometimes rocked nervously on the witness stand, [and] described what he thought were his wife's nervous habits, such as picking at her hair and constantly carrying around their latest baby."[54] This "objective" account is hardly objective, linking Rusty Yates with his wife and her behavior. He "rocked nervously," as if in concert with his wife's "nervous habits." Moreover, the qualifier *what he thought* were his wife's nervous habits" suggests that these nervous habits were something else indeed—manifestations of serious mental illness rather than a habit or a tic. Reading the media, and reading the trial as one would a novel or play, provides a fruitful comparison and an important reminder of the *staging* or performance of guilt or innocence, as well as the multiple interpretations available to anyone who sits in judgment, aspects that are even further developed in the next chapter on drama.

Susan Ayres used the television interviews that Rusty Yates took part in as source material to claim that "Rusty continued to project his gaze upon Andrea as the perfect mother despite her psychotic self-identification as a bad mother." Ayres further argues that "[b]ecause of all the media attention, we know much more about Andrea's life and marriage than we do about almost any other Texas mother who has killed her children. But even with a plethora of information, the discourse surrounding a mother who has killed her children may objectify her—by silencing her, by specularizing her, and by labeling her as mad."[55] What is painfully clear from this case is that, as Oberman notes, infanticide is not simply the result of mental disturbance, but of the failure of others to recognize the mother's symptoms before tragedy takes place. Yates manifested many of the symptoms of postpartum psychosis: psychotic mothers "tend to isolate themselves, they stop talking to others, and they are observed talking to themselves in an agitated fashion. They are severely sleep-deprived and emotionally labile."[56] What is most striking about the Yates case was Andrea Yates's

silence. She was not called as witness, probably rightly given her mental state, but she was also invariably described as "mute," even by family members. This almost uncanny silence is hardly specific to Yates alone; indeed, the silent woman appears as a regular prop in fictional or fictionalized accounts of women on trial, and issues of silence and voice are at the heart of feminist analyses of both law and literature.

The Yates's case points up another difficulty for feminist analysis. Ayres suggests that Yates was "specularized as a 'good' mother, but her trial and news stories objectified her as both 'mad' and 'bad.' The seeming inconsistency between being a 'good mother' and yet 'mad' can be explained by her mental illness."[57] Yet the very label of mental illness—as appropriate as it clearly is in this case—offers only an explanation and not a cure. Moreover, the desire to explain women's crimes as "pathological" again hides the material conditions that foster such behavior: not only poverty but also the impossible demands for perfection which society places on mothers.[58]

The myth of perfection and (as Oberman suggests above) the pattern of isolated mothering currently practiced in the United States, the United Kingdom, and elsewhere, reflect society's preoccupation with a version of motherhood that does not fit its reality. Such myths do not, of course, inevitably lead to filicide; but in some cases they set the scene for tragedy. Women's hidden experiences of family life then explode onto the front pages of newspapers and become fodder for media speculation. Yet these women continue to be seen as deviant, other, mad. The lessons that might be learned from these cases do not become part of transferable knowledge. Instead, they are resurrected—briefly—only after another tragedy occurs. The next section deals with how narrating the unnarratable (family dysfunction) does not itself always lead to justice.

Hidden Crimes, Uncovered Crimes: Rereading the Family

Issues of silence and voice—issues at the heart of the Yates's trial—reflect not just the hidden nature of family life in an era of myths

about the perfect mother, but also larger feminist concerns to do with how language reflects—or does not reflect—experience. Sue Lees argues that "[t]he lack of language to express experience may well lead to women sounding incoherent, and being dubbed irrational as a result."[59] Indeed, several critics, from academic linguists to pop psychologists, suggest that women and men speak essentially different languages.[60] The effect of these differing languages—particularly when one includes the language of the court—could be profound. Robin West argues that a postegalitarian stance with respect to women's issues and the family needs to be constructed carefully: "We need more than just acceptance of our differences [from men]; we need a vocabulary in which to articulate and then evaluate them, as well as the power to reject or affirm them"[61]—thus, the importance of naming sexual harassment, assault, incest, domestic violence, or other crimes against women. Once they are named as crimes, they can be policed, and, theoretically at least, individual women can be protected or find justice. As noted above, however, recognition of crimes against women does not necessarily ensure that women's experiences are seen as relevant to any crimes they themselves may commit. In addition, any legal protection remains more theoretical than real when it comes to domestic abuse: witness the numerous cases of women murdered by partners despite having secured restraining orders against them.

Yet at the same time, the act of naming experience is never entirely fixed; events and experiences become renamed and re-viewed depending on the cultural context of the time. Murray Edelman suggests that the social world is "a kaleidoscope of potential realities, any of which can be readily evoked by altering the ways in which observations are framed and categorized."[62] Such categorization relies on political will and cultural agreement. For example, educational, medical, and media recognition, particularly in the 1970s, that incest occurred in some families—perhaps many more families than at first thought possible—quickly led to what many people viewed as a twentieth-century witch hunt: the search for the sexual predator, and the uncovering, years later, of suppressed memories of abuse. In the 1980s, this became linked to stories of organized, Satanic rituals and hysteri-

cal accounts of mass sexual abuse before a recognition that "recovered memories" could indeed be "false" or "suggested" memories. This led to yet another new syndrome: Recovered Memory Syndrome, which in turn led to the founding of organizations such as the False Memory Syndrome Foundation in the United States (1992) and the British False Memory Society (1993), groups combating what they saw as destructive, manufactured memories designed by uncritical professionals with a political agenda. (In some of its more virulent forms, blame gets attached to "feminists," an undifferentiated group apparently bent on the destruction of the nuclear family.) Eventually, organizations such as the American Psychiatric Association and the American Psychological Association offered guidance to practitioners and patients about how memory itself is constructed. In 1995, the American Psychological Association released a statement noting that there was no scientific basis for claims that particular groups of symptoms related to sexual abuse. This statement, made in conjunction with the APA Working Group on the Investigation of Memories of Childhood Abuse, made it clear that some practitioners *did* believe that memories could be suppressed and then recovered, but also noted strongly that most people who were abused remembered the abuse, if not in complete detail, then at least in part. It also observed that *any* memory was subject to suggestion.[63] A factsheet produced by the American Psychiatric Association in 2000 cautioned against automatically believing in uncorroborated "new" memories of child sexual abuse and suggested that practitioners should instead assist patients "in coming to their own conclusions about the accuracy of their memories or in adapting to uncertainty regarding what actually occurred."[64]

Elaine Showalter convincingly argues that claims of ritual sexual abuse and multiple personality disorders are examples of twentieth-century fin-de-siecle hysterias (which is not to say that they disappeared at the advent of the twenty-first century). In *Hystories*, her critically contested book, Showalter defines hystories as the "cultural narratives of hysteria" and argues that these hystories "multiply rapidly and uncontrollably in the era of mass media, telecommunications, and e-mail," particularly as they "interact with social forces such as religious beliefs, political agendas, and rumor panics."[65] In her text,

Showalter comes across as a concerned feminist who argues that we should look for corroborating evidence in relation to any outrageous claims; she is scathingly critical of feminists who latch onto narratives of abuse without considering how such narratives—or hystories—are constructed. In particular, Showalter notes that "[w]e must exercise caution as a society when hystories take on that political, judicial form, when they stop being therapeutic and cross the line into accusation and prosecution."[66]

While most of the recovered memories of child sexual abuse focus on male parents, some mothers are sued for negligence on the basis of "allowing" their children to be abused; indeed, many of the defendants in sex abuse cases are not the alleged perpetrators at all, but "bystanders" in a "special relationship" with the accused: often wives and mothers.[67] As Helena Kennedy argues, "Mothers so often are held ultimately responsible for a number of reasons: failing to provide conjugal fulfillment; failing to protect her child; condoning abusive behaviour."[68]

The impact of cultural narratives about child abuse and memory has led to an explosion of texts about this topic, some purporting to be true stories of survivors, and many exploring the also-contested terrain of multiple personality disorder, the most famous of which is *Sybil* (1973), by Flora Rheta Schreiber.[69] A more literary example, Jane Smiley's *A Thousand Acres* (1991), explores the impact of an adult memory of sexual abuse in its recounting of the King Lear story.[70] Smiley's Pulitzer Prize-winning novel uses blocked memories of abuse to update the story of a powerful man who diminishes his power by giving it away to his daughters. In Shakespeare's version, the two oldest daughters are simply evil; in Smiley's version, the women have motive. As Marina Leslie reveals, "Placing the unnarratable trauma of incest at the dramatic and critical center of the novel, Smiley recasts King Lear in ways that destabilize the father's narrative in both novel and play. In mid-narrative the novel performs its own retrospective reading, requiring us to reassess what we know—or think we know—and when we knew it."[71]

Leslie is also careful to point out that Ginny's perspective is "partial, tentative, speculative, neither unmediated nor of her own making."[72] In

this text, recovered memories of abuse are corroborated by Rose, Ginny's middle sister; this is perhaps an early nod to concerns raised by new memories which did not have any other evidence attached to them. A later backlash against such stories is evident in popular thrillers such as Nicci French's *The Memory Game* (1997), where a woman's recovered memories are shown to be false. So prevalent are such stories that, as Amy Adler notes sardonically, "Now instead of movies of the week about child abuse, we have movies of the week about people who were falsely accused of committing child abuse."[73]

Stories in which the principal abuser is not the father but the mother generally rest on other grounds, most commonly Munchausen's Syndrome by Proxy (MSP), whereby a carer, generally the mother, manufactures illnesses in her child in order to receive attention, sometimes causing health professionals to undertake expensive and invasive investigations on the child. First coined in 1977 by Sir Roy Meadow, a high-profile British pediatrician, MSP quickly became a diagnosis that led to children being taken away from mothers suspected of having the syndrome; concerned parents who brought sick children to the emergency room had their behavior taped, and in Britain, some families lost children as the result of family court decisions to which they were not privy. There is currently a government review of such practices.

The prevalence of Munchausen's Syndrome by Proxy as an explanation for child death became so prominent in the 1990s that M. Night Shyamalan's film *Sixth Sense* (1999) featured a ghost who materialized in order to tell her father that her mother had poisoned her; in some respects, her death appeared more horrifying than those experienced by the other victims of abuse that populated the film, despite the clear, visual evidence of their violent deaths. Best-selling crime novelist Patricia Cornwell wrote about a beautiful and deadly mother, Denesa Steiner, in her 1994 book *The Body Farm*. Cornwell's intrepid medical examiner, Kay Scarpetta,[74] initially suspects the woman when Mrs. Steiner recalls that her first child died of Sudden Infant Death Syndrome (SIDS) at well over a year old: an age at which such deaths are rare. Here, the link between SIDS and Munchausen's Syndrome by Proxy is one of a simple clue, leading to the

discovery of multiple murders; in reality, the link can be much more problematic, as witnessed by recent cases in the United Kingdom where mothers accused of murdering their children have been released on appeal or had their convictions quashed. Medical evidence and expert witnesses pointed to guilt, and, infamously, Professor Meadow proclaimed, "One sudden infant death is a tragedy, two is suspicious and three is murder, unless proven otherwise." This statement, which became popularly known as "Meadow's Law" and repeated *ad infinitum* in newspaper accounts of the trials and their appeals, reversed the long-held assumption of innocence, putting the burden of proof on the defendant and not the state. Unsurprisingly, this led to several miscarriages of justice, including the cases of Angela Cannings and Sally Clark; Trupti Patel, also on trial for murdering her children, was acquitted when Meadow was discredited as an expert witness and his statistical analysis reviewed.[75]

Although Showalter does not take on Munchausen's Syndrome by Proxy, confining her medical cases to Chronic Fatigue Syndrome and Gulf War Syndrome,[76] it is clear that MSP could be one such twentieth-century hysteria. After all, according to Showalter, "A doctor must first define, name, and publicize the disorder and then attract patients into its community"[77] — or, in the case of MSP, attract health-care practitioners to the idea that a heretofore unknown syndrome offers an explanation for childhood illness. Mothers really *are* guilty of harming their children, all in the name of attention, and concerned or pushy mothers are particularly suspect. An episode of the nostalgic Yorkshire television show *Heartbeat*, which aired on March 20, 2005, portrayed a woman who, in an effort to keep her straying husband's attention, made her child sick by feeding her laxatives; the woman also inserted drops of her own blood into the child's urine. These are stereotypical examples of MSP, as defined by Meadow. That a television show aired in the early part of the twenty-first century references a syndrome "discovered" in 1977 while being set a decade earlier shows the power of cultural and medical narratives to determine new and different ways of assessing women's guilt.

Thus, many of the concerns of our time—physical and sexual abuse among them—form the basis of cultural texts that explore the

relationship between mothers and the law. Pierre Bourdieu argued that "[t]he law, an intrinsically powerful discourse coupled with the physical means to impose compliance on others, can be seen as a quintessential instrument of normalization."[78] Here, what constitutes "normal" seems outside the reach of both fictional and real women as they struggle with motherhood and the guilt that is attached to the role. All of this sets the context in which we can explore literary representations of contested motherhood.

"I Hurt Everyone": Jane Hamilton's A Map of the World

Jane Hamilton's *A Map of the World* begins on the day that Alice Goodwin, part-time school nurse and full-time farm wife, confronts the spectacle of her failure as a caregiver, though the novel's retrospective account also blurs the lines of "now" and "then" as it traces the time "last summer" when the world went awry. To put it in its most benign form, Alice is "challenged" by her oldest daughter, Emma, a five-year-old who does not accept deviance from any preestablished routine; for example, when Alice absent-mindedly pours milk on Emma's cereal, rather than allowing Emma to do it herself, the result is a tantrum that cannot be contained. Alice's response is to attempt reasoning, try punishing, and effect escape, leaving the children to their ruined breakfasts while she remains outside; her very position outside the domestic sphere is key to reading this scene.

Alice muses that she is "no good at mothering" (25), an admission that cannot be voiced out loud, particularly as she compares herself to her too-good-to-be-true neighbor and friend, Theresa Collins. Alice likes to think of Theresa and herself as inhabiting a space similar to that of Laura Petrie and Millie Helper of *The Dick Van Dyke Show*; they "delight" in each other's company, but it is also clear that when she visits Theresa, Alice "always took care to wipe [her] feet and check [her] hands and fingernails" (14). That Alice might be inspected—and found wanting—is the clear undertone of their relationship, or at least Alice's view of it. Theresa, also a working mother of two daughters, floats effortlessly through her days, coping not only

with her own children, but also with Alice's, every other Monday morning when they babysit for each other and take responsibility for all four children.

One Monday morning in June, it is Alice's turn, and the fact that it begins with simulated violence is not accidental. Alice transfers her anger from Emma to the cat, going so far as to mime strangling it, but even this display of emotion is unseemly and enough to rouse her husband from his chores to check that she is doing everything right. Her response comes in two forms, audible and inaudible, as if she recognizes that some things cannot be said aloud: "'I'm handling it fine, Howard, I really think I am.' I sometimes felt dismayed because he didn't seem to trust me the way he should have. 'I'm pretty sure I'm doing the right thing,' I said under my breath, 'strangling the cat instead of Emma'" (9). Later, Alice admits, "I tried my best to be a good farm wife, to live up to Howard's expectations" (12). These admissions—that she is uncomfortable with the roles of wife and mother, that she feels inadequate as a friend and a babysitter—set the scene for the tragedy that unfolds.

Not long after Theresa drops her children off, the youngest, Lizzy, wanders off by herself to the pond and drowns. In accounting for her own movements and the gap in the time during which she was watchful, Alice compresses time, "edits out" her random, daily tasks, her immersion in her own space and memories, her life outside of looking after the children in her care (36). This gap is never probed, but haunts Alice, who sees only her own negligence as the reason for Lizzy's death.

What happens as a result is that Alice's position as wife and mother is at first questioned, then relinquished: Alice refuses to dress, care for the children, or feed them. Clearly suffering from the aftereffects of Lizzy's death, Alice is unable to cope at all. Temporarily, Howard's mother Nellie steps in, herself a caregiver and nurse who encouraged Alice in that role. Again, a distinction is set up between Alice's slapdash housekeeping on the farm and the way that the world should work (it is no coincidence that Theresa lives in what counts as sweet suburbia in Prairie Center). Returning from the hospital, Alice finds "[t]he lingering smell of fresh bread, the abundance of food made

from scratch, the sink scrubbed clean, the place mats that had been cleared off the table and stacked neatly in a pile on the cold wood stove, the saltshaker filled to the brim—every one of those details made me feel a stranger in my own kitchen" (45). Already she is displaced; already her domestic sphere is found wanting and her response is to escape into the self, or to leave the domestic scene entirely. At one point, she leaves the house to hide in the orchard and be judged by the trees rather than by people, though it is significant that she anthropomorphizes the trees as old men (71).

Alice's escape mechanisms are ineffectual (it is no coincidence that she rubs the perfume "Escape" on her wrists before attending Lizzy's funeral), but they set up a pattern that actually allows her to adjust to prison when she is arrested for a seemingly unrelated crime. The shock of her arrest for sexually abusing a young boy named Robbie Mackessy, supposedly when she tended to him as a school nurse, is such that the novel switches perspective the moment she is taken away by the police. The middle section of the text, which covers the months Alice is in prison awaiting her trial, is narrated by Howard, her husband, as he tries to cope with farming, loneliness and social ostracism, the care of his children, and his own growing attraction to Theresa as the "perfect" woman he cannot have. This switch in narrators, if nothing else, reveals the importance of multiple perspectives, within both law and literature, and how they work together—or don't work together—to form a whole.

What becomes clear in Howard's section is his final inability to say whether or not his wife committed the crime of which she was accused. He is stunned when he learns of her "confession," "'I hurt everybody'" (103), made before she is read her rights, a confession that her lawyer tries unsuccessfully to have stricken. Though this "confession" is multiply read in the text—the reader sees it as evidence of Alice's feelings of maternal inadequacy and culpability in Lizzy's death, and Theresa reads it as "Alice expressing what was a feeling, not a fact" (179)—it remains one of the most damaging pieces of evidence against her. A woman who could not acknowledge to her husband her perceived inadequacy as a mother somehow breaks the codes of acceptable behavior by blurting it out to police officers.

Howard's response — "If a person could gag her. If only a person could gag her! She should not have said those things! It was wrong of her to have aired her dirty laundry to a police officer" (179) — reveals the gap between their visions of her behavior. Once again, she fails to live up to expectations.

Alice romanticizes her silent farmer husband, seeing him as an image of solidity (an image he himself rejects). When the narrative returns to her perspective, however, Alice recognizes that her view may have been partial. The experience of being judged allows her to perceive the other ways in which her position as caregiver has *always* been judged: "He seemed never to have forgiven me for myself; he had led me to believe that I was unforgivable, that there was no hope for change. I had thought all along that it wasn't in his nature to judge, and yet in his silence he was judging continuously, always standing back with his arms folded, looking askance" (286).

During Howard's section, the reader witnesses the process of Howard's judgment, or fear of making judgments. At one point, he argues, "It was very probable she'd done it. I don't think I would have thought her guilty if dozens of children had come forward with far-fetched stories. She had always spoken of Robbie with an anger that seemed beyond reason. She wouldn't hurt people in mass quantities — but one. She could have hurt just one" (240). Later, Howard admits, "Doubt has determined all that I had taken for granted. I hated the fact that I would never really know what was true. There were reasons not to believe either side" (266). It is perhaps this doubt that leads Ilene Durst to suggest that Howard is the more damaged of the two Goodwins at the end of the text, the one least likely to recover.[79] In his last judgment on Alice's guilt or innocence, Howard contends, "It is better, I think, never to finally decide. In a weak moment I once tried to ask Alice, to tell her that I wasn't sure. She stopped me. It is probably for the best that I didn't give voice to my gravest doubt. Because I tell myself that I don't know and will never know, I can almost fool myself at times" (267). (Howard's inability to decide on innocence, and his need to voice his fear, is repeated in Chris Bohjalian's *Midwives*, discussed below, which also features a husband who feels the need to vocalize his fears even when his wife has asked

for silence.) I quote the above passages at length because they provide evidence of indeterminacy, both in accessing and in assessing the "truth," but also in literary time. *A Map of the World* is a retrospective account of "last summer"; as such, where does this confession stand? It is impossible to determine whether Howard ever moves beyond doubt, ever reaches certainty of his wife's innocence. She is, therefore, always caught in the liminal space of the woman-to-be-judged, never released from the taint of accusation. It is no coincidence that the Goodwins must sell their livelihood and move even before the trial is complete; they never "recover" from their encounter with the law (even as their lawyer suggests they move for damages).[80]

All of this also points to the nature of the law. Heilbrun and Resnik argue that "recreation and distortion" are an integral part of law texts, more relevant than their "monologic voice and declarative tone."[81] Kim Lane Scheppele goes even further:

Stories may diverge, then, not because one is true and another false, but rather because they are self-believed descriptions coming from different points of view informed by different background assumptions about how to make sense of events. In law, the adoption of some stories rather than others, the acceptance of some accounts as fact and others as falsehood, cannot *ever* be the result of matching evidence against the real world to figure out which story is true.[82]

"Truth," in law as in literature, is an unstable concept, something that Alice understands even if Howard does not: "'You don't realize about this. I'm in here now and it's going to take more than the truth to get me out'" (121). What interests me in this novel is not just the question of Alice's guilt in relation to abuse, but also how mothers are interchangeably "guilty" in the eyes of the court and the small town of Prairie Center. At one point, Alice rejects a potential lawyer, Mr. Finn, because he was a judge for the local Miss Dairyland contest. Alice recognizes that women should not be judged on appearances; Howard, on the other hand, hopes that the judge in Alice's case will be swayed by her beauty: "It didn't matter to me how she got away" (177). Here, men can act in judgment: Howard, Judge Peterson, the lawyer Finn. Women must, on the other hand, be judged: as beauty contestants, as mothers.[83] Even where judgment is due the men in question, they don't receive it. For example, Howard's housekeeping

is no better than Alice's and in many ways much worse; he is unable to make nutritious meals, comb his children's hair, or keep them clean. He also leaves the children with wildly unsuitable caregivers when he visits Alice in prison. His incompetence is somehow read as "natural," his helplessness evidence again of what Alice has "done" to their family by failing to fight her case more proactively. Howard is rescued only by Theresa, who willingly takes in his children—and Howard—during the days that Alice is locked up and Theresa's own husband, Dan, is working late.

Theresa alone among the mothers of the text escapes judgment. She is a good Catholic, a forgiving friend, and a caregiver par excellence who testifies on Alice's behalf at the trial; she even resists an affair with Howard despite falling in love with him, and she is rewarded at the end with a new and legitimate pregnancy. Every other mother—Howard's elderly mother included—is judged wanting. Nellie never really understands Howard and offers little help during the imprisonment and trial phase of the text; her caregiving extends to Romanian orphans but not to her own flesh and blood. The women who share Alice's prison wing are almost all mothers, too, a fact that could be seen to bind them, but does not. Indeed, Alice mentally asserts her difference from the other prison mothers, whose children are in the care of social services or being looked after by relatives (that Alice cannot read their situation as the same speaks volumes). Finally, it is surely not accidental that Alice's cell mate, Debbie Clark, "had had the misfortune to bear twins in her mother's car and then accidentally do away with them" (278). Unloved, overweight, and lonely, Debbie compulsively repeats the story of this "accident" despite legal cautions not to; indeed, the idea of pregnancy itself as "accident" underlines her unpreparedness for the role.

Even local "respectable" mothers are not immune. When a group of women attempts to gain access to the courtroom where Alice's preliminary hearing takes place, they are turned away. Howard observes, "I could see a swarm of mothers, their big heads bubbling up and down as they called to one another. . . . Suburban rebels, storming the citadel. They were armed with their long, sharp earrings, their heavy necklaces and bracelets, their clean, white canine teeth, their

steel-colored helmet hair" (175). This description of irate mothers has some basis in fact; trials that feature accused child molesters or murderers almost always evoke a strong reaction from the public, with women just as likely as men to hurl stones at prison vans.[84] What is key here, though, is the way in which these mothers are assessed as monstrous warriors. Dehumanized, they assume Alice's guilt, and act as crusaders against her moral impurity.

Perhaps the most disturbing element of mother guilt, though, relates to Mrs. Mackessy, the troubled boy's mother. In order for Alice to be "not guilty," another mother has to be found guilty. Mrs. Mackessy, who is referred to most often by her married name though it is clear that she is no longer married, must be shown to be responsible for her son's condition. Alice's lawyer constructs a story whereby Robbie witnesses his mother engaging in violent (though consensual) sex; this, and not a fabricated story of the school nurse as monstrous abuser, accounts for his disturbed state of mind. Alice is complicit in this construction; indeed, even before this view of Mrs. Mackessy is put forward in court, she herself thinks of Carol Mackessy as deeply inadequate, blaming her for Robbie's constant ill health: "He was frequently sick, because of his mother, I thought, because of her negligence" (24). That this explanation comes in the hospital, when Alice is awaiting news of Lizzy, is not coincidental. Negligent herself, she transfers her guilt onto another source.

Carol Mackessy even *looks* like a bad mother: "She was squinting, as if she couldn't stand to have her eyes wide open" (24). She has an "ugly mouth" and a "sneer" (24) and wears inappropriate clothing, including "Jesus sandals in gold lame" (106). In one encounter, when Mrs. Mackessy is late picking up her sick child from school, she and Alice accuse and threaten to report each other. Neither, it appears, does right by Robbie; the truth is that Alice *is* guilty in relation to Robbie—not of sexual molestation, but of an incident of physical abuse. She slaps him, an act that she reconfigures in her mind as less damaging than it may have been and one which he provoked: "I could talk myself into thinking I hadn't really hurt him, make small adjustments to the picture to alter the angle of my hand and the force of the stroke" (105). In her own view, she strokes him, a loving gesture, rather

than slaps him, though she also admitted that she "smacked" him (105) and uses the terms "hit," "blow," and "sting" to describe the movement (107).

To name this experience as abuse requires Alice to confront her behavior publicly, something that she refuses to do, until forced to by the court of law. By the time she does so, though, it is Carol Mackessy who is figuratively on trial. As Alice observes, "Carol had brought a suit against me without thinking about her past. Had she believed that modesty or politeness would keep her unconventional behavior out of the evidence?" (371). Here, Mrs. Mackessy is given her first name, and made therefore into an equal, a person in her own right; naming her as "Carol" reflects intimacy and closeness. This is perhaps a recognition, at last, that Alice and Carol share a common bond: they are mothers whose very position as "good women" is under attack.

Kim Dayton argues that

[l]egal images of the bad mother are engendered in part by the inability of certain women—perhaps most women who become entangled with legal institutions—to demonstrate their location within a traditional, patriarchal family structure. But they are also products of the law's need to produce winners and losers, its demand for black and white answers in a world that is cast in the shades of gray.[85]

The end result of this contest over who is a good mother is that Alice is acquitted. This acquittal occurs between chapters of the book, only to be revisited by Alice at a later date. This fits with the structure of the book as a whole, which circles back to key moments: the drowning, Alice's life in prison, and finally, the juridical opinion that sets her free. Ironically, at the end of this encounter with the law, Alice ends up a full-time mother. She is brought back into line with a traditional family structure that always felt alien to her. This is thus an unusual result and something of an ironic coda to the trial, though as Roberts argues, "Since middle-class white women fit society's notion of the ideal mother, criminal law more easily restores them to conforming motherhood."[86] However, in many instances where women come in conflict with the law, their rights to motherhood are at risk, as we see in Sue Miller's novel *The Good Mother*.

"You're in charge of her. And you let him":
Sue Miller's The Good Mother

The title of Miller's novel is not accidental; as we have seen, constructions of the "good" and "bad" mother permeate the courts, literature, and popular culture. Miller's cognizance of legal issues surrounding motherhood is acute, and she even includes a minor character, Ursula, who can't find time to practice her piano lessons because "she was writing a book on female infanticide and had reached what she called 'the good part'" (89). More important, though, *The Good Mother* responds to concerns about child sexual abuse highlighted in the 1970s and 1980s, and to the context of "duty of care" that was discussed above, whereby a mother is seen to be culpable when her child is abused—or seemingly abused—even when the incidents take place without her knowledge or consent. In an early review on the novel, Carol Sanger suggests that because it is a "good" rather than "great" book, it may "fall outside the law and literature net." However, the novel has begun to be cited by feminist law and literature critics who explore custody battles and the limits of maternal responsibility.[87]

Miller's novel traces the story of a part-time piano teacher and unlikely rat trainer, Anna Dunlap, who escapes from a suitable but dull marriage and embarks on a passionate love affair with a local artist, Leo Cutter. Miller emphasizes that Anna's marriage to her husband Brian was sexually unfulfilling but otherwise unobjectionable; it seems to fit the pattern that Carol Weisbrod traces of "companionate" marriage, wherein the emphasis is placed on normality. This notion of normality "suggests an entire sanctioning system outside the legal system, one based on norms of health and well-being, and one that took as its basic position an opposition to difference."[88] Marriage is thus, according to Weisbrod, an expression of social integration and a public display of the fact that "one had met the demands of that community, enforced by the legal system, by the social system, and by the immediate demands of one's own family."[89] It is not surprising, then, that when Anna seeks to dissolve this marriage, she first encounters legal opposition (the man whom she pays to notarize her divorce papers at first refuses to do so on moral grounds) and familial opposition (her

mother is ashamed of the decision, and wants neither to discuss it with Anna nor to be responsible for relating the news to relatives).

In contrast to her relationship with Brian, what defines her relationship with Leo is its unconventionality and its sexual nature; when Anna becomes accidentally pregnant, for example, there is no pretense that they will become a happy family unit. Instead, Anna chooses to have an abortion, though perhaps in this case, the choice is less individually made than expected by Leo. Anna, who fantasizes about having the child, nevertheless goes through with the abortion and refuses painkillers afterward: "what I thought I was buying with my suffering was the right to my happiness with Leo. Every slow convulsion of my womb seemed like part of the purchase price, and I grunted softly, as I had early in labor with Molly, and counted up my treasures" (140).

Here, then, Anna connects pain with parenthood, and already in the narrative, her sexual relationship is at odds with motherhood. At first, Anna keeps the knowledge of her relationship with Leo from her daughter Molly, requiring Leo to slip from her bed before Molly wakes up. Leo easily follows Anna's lead in relation to her child. It was, Anna suggests,

a fatal part of his sweetness to follow me, even in my confusion, to assume always that I knew what I was doing with her, around her. I fostered it. I never articulated to him my anxiety, the sudden rush of feeling I sometimes had with her that I was doing everything wrong. He saw my mothering her, her relationship to me, as implacably monolithic, a given, what was meant to be, and took all his cues from me. (122)

Here, Anna is specularized as a good mother in much the same way as Ayres suggested Yates was specularized as a good mother by her partner. Anna's mothering is read as instinctual, even as she herself sees it as provisional, fraught, or inadequate. This also links back to Alice's mothering in A Map of the World. It is this very myth that Anna can do no wrong that perhaps sets up the blurring of mother love and sexual love that creates the atmosphere in which Molly is read as "at risk" and taken from Anna.

One night, disturbed by her daughter when they are making love, Anna welcomes Molly into her bed even though her lover is still physically inside her vagina. She enacts the motherly role of calming

the child after a nightmare, embracing her while remaining sexually in tune with Leo. As the child drifts off to sleep, Anna notes,

Leo moved sometimes, and then lay still. I can remember feeling a sense of completion, as though I had everything I wanted held close, held inside me; as though I had finally found a way to have everything. We seemed fused, the three of us, all the boundaries between us dissolved; and I felt the medium for that. In my sleepiness I thought of myself as simply a *way* for Leo and Molly and me to be together, as *clear*, as translucent. I drifted off. (124)

Though read by Anna as a loving act, it is also a transgressive one that blurs the boundaries of her roles. Such blurring continues into the next morning: "When I bent to kiss her good morning, my tongue touched the little ridges my teeth had made on the insides of my lips when I sucked Leo off" (125). This juxtaposition is shocking, disruptive, taboo, and almost abject;[90] it is not accidental that it comes at the end of a chapter. Throughout the novel, Miller utilizes a technique of narrative suspension to highlight particular events, to force her readers into acknowledging aspects of the text that are challenging of societal norms. The most significant example of this comes after Brian accuses Anna of allowing Leo to abuse their daughter. Anna and Leo make love, experimenting for the first time with sodomy, after which Anna broaches the subject of the abuse:

"Leo," I asked, "Leo, did you ever touch Molly, her body I mean. Did she ever touch you? Wake up," I said.
His fingers reached towards my face, felt my wet hair, my open mouth. We lay in the garish silence a minute.
"Yes," he said. (165)

This is the end of chapter 7, and the blank page at the end signifies omission. Chapter 8 begins with the words, "When I called my lawyer on Monday, he was reassuring" (169). The reader is left in the gap of what happened, not understanding how Leo, who before this confession has been presented as a good and decent man, can have been guilty of the abuse of which Brian accuses him. Indeed, the reader does not get an explanation until Leo himself is in front of Anna's lawyer, several days later. In her first discussions with her lawyer, Mr. Muth, Anna does not reveal the basis of Brian's threat to seek custody. She can already, it seems, be construed as *withholding evidence*, and

the reader's allegiance is tested. After her second telephone discussion with the lawyer, Anna is still unwilling to be explicit. Leo says, "'I'd like to be able to talk about this stuff, Anna. It's like you keep wishing it will all go away if we don't discuss it. That's hard for me. It doesn't help me. Or *anything*,'" but Anna's response is, "'I don't want to talk about it . . . I don't see how that would help. It's done. I don't *blame* you'" (173; italics in original).

Anna could here be read as the enabling mother, the mother who simply refuses to see abuse since this would disrupt her own partnership and happiness. Such a vision would make her into a stereotypically bad mother. Miller's delaying tactics allow the reader to question everything, to consider Anna as an unreliable narrator who only fraudently gained our earlier sympathy.

The first telling of the story is in the lawyer's office. Anna notes with some surprise, when she hears Leo speak, "*Why, he's practiced this*" (176; italics in original). Already, then, a story is being constructed with a view to its legal presentation, a presentation that Muth then himself reconstructs to help Anna's case for custody. It is worth quoting the passage about the event in full:

"When I pushed the [shower] curtain back and started drying off, I noticed Molly was staring at me, at my"—there was the slightest hesitation as Leo chose the word—"penis. But she'd seen me naked before, I didn't think much of it. I was fooling around, you know, dancing."

"Dancing," Muth repeated.

"Yeah. I was dancing and singing actually." Leo's voice had begun to sound angry. I leaned forward. He looked up at me, then moved uncomfortably in his chair. When he spoke again, his voice was calm. "Singing 'Singin' in the Rain.' She liked that." He shrugged. "And then I finished, and I was just drying off, and she said, out of the blue, 'That's your penis.'" He cleared his throat. "You know, she was learning that stuff, those words. She had a book that talked about it, and they did the body parts at day care. Her mother—Anna—had talked about it some too, telling her the names of stuff." He shrugged again. "So I said yeah. She was, she was standing up, she'd gotten closer to the tub. I was, actually, a little uncomfortable about it. But I'd seen how relaxed Anna was about it all, and I didn't want to screw that up or anything. So I tried to seem natural, not cover up or anything."

"But then she said, 'Can I touch it?'"

Muth looked up sharply at Leo, his pencil still on the yellow pad.

"I honestly didn't think about it for more than a second. I just said sure. And, um, she did. She . . . held it for a second. And just the contact, I guess. The contact, and I think, the kind of . . . weirdness of the situation made me . . . that is, I started to get an erection. And I said, 'That's enough, Molly,' and I turned away. I put the towel on. She made some other comment, some question about my . . . about it getting big. And I told her that sometimes happened with men. And then I went and got dressed." He looked at Muth, as if awaiting judgment. (177; ellipses in original)

Muth records and judges while Leo arranges and revises, admitting that he failed to tell Anna of the incident. Muth asks the logical question—Why didn't Leo say no?—and Leo responds, "I didn't think that's what Anna—Mrs. Dunlap—would have wanted me to do . . . I thought she'd want me to be as relaxed, as natural with Molly, as she was. About her body and that kind of thing" (178). Here Anna is renamed, given her (now no longer relevant) married title. In the simulated courtroom setting—in at least a setting of legal judgment—Anna and Leo become official versions of themselves. Muth begins immediately revising Leo's testimony:

"So you might say you misunderstood the rules."
Leo shrugged. "I thought I understood them."
There was a long pause. Then Muth said, "I think when the time comes, Mr. Cutter, it'd be better for Mrs. Dunlap in the situation we've got here, if you just said you *mis*understood them." (178; italics in original)

Although most of the published criticism on this text is weak, the exception is Dawn Drzal's incisive article on the construction of the feminine mystique. Drzal recognizes that "Anna and Leo are taught the harsh lesson that by refusing to play by society's rules, they have forfeited its protection, all the subtle and not-so-subtle benefits accorded those who pay their dues through years of uncomplaining conformity."[91] In contrast, Roberta White's article takes an avowedly "humanistic" approach and sentimentalizes motherhood—and Miller's heroine—uncritically. Moreover, White slips into an essentialist position on mothering; she talks of Anna's "scrupulous concern, natural enough in a mother,"[92] when the narrative itself takes pains to show that the mothering position is *not* natural, and that Anna is constantly under surveillance and self-surveillance as a mother, not just when she is before the court.

White also crudely argues that the reader identifies with Anna because of her "ability to take responsibility and to feel shame."[93] However, Anna, a passive character who primarily resides in interior spaces both literally and metaphorically, is interesting because she takes responsibility for something that isn't her responsibility at all, namely her boyfriend's inappropriate behavior with her child. In claiming responsibility, Anna confesses, "It was a chain of events set in motion by me, by my euphoric forgetfulness of all the rules" (280). That Leo honestly believes his actions were justified, or reflected Anna's wishes, neither absolves him nor places the blame on her.[94] That society and law do, however, shows the limits of juridical understandings of the "family" and how it works.

By the time the custody battle reaches court, Anna has agreed to stop seeing Leo if it is a condition of reinstating custody; she has moved from a position of blurring her family boundaries to one more akin to societal myths of the celibate mother who selflessly denies herself for the sake of her child. Such a strategy does not work: once labeled a transgressive mother, Anna is subject to the full judicial gaze and finds that the courtroom neither sees nor hears her as a "good mother": "I felt an impulse to stand up and shout out some truth, to begin this again from the start, to change the vocabulary" (273). Anna's inability to use the language of the court reflects what Pierre Bourdieu has long recognized:

the institution of a "judicial space" implies the establishment of a borderline between actors [dividing] those qualified to participate in the game and those who, though they may find themselves in the middle of it, are in fact excluded by their inability to accomplish the conversion of mental space—and particularly of linguistic stance—which is presumed by entry into this social space.[95]

It is not accidental, then, that Anna's ex-husband is a lawyer; as Drzal points out, this reveals his comfort before the law and Anna's attendant discomfort.[96] Anna's outsider status allows her to recognize that the courtroom is an arena for acting, for utilizing an "elaborate language of blame and justification" (272) that had nothing to do with the reality of the case. Instead, it is more about performance:

They were *acting* now, I realized; as I had acted, in my fancy dress and my

repudiation of Leo; as Brian had acted, in his indignation; as Leo had acted in his haircut, his new jacket. Only Payne [the psychiatrist] had been himself, had escaped playing some part. The rest was all a kind of elaborate charade, it had nothing to do with who we really were or what really ought to happen. (273; italics in original)

Such recognition, however, is of no use. After the decision is made to award permanent custody to Brian, Anna is informed that Judge Sullivan was "strict about sexual issues" and that both her lawyer and the psychiatrist he had hired had known this prior to the trial. They had deliberately kept this information from her because they didn't want her to "worry" (277). Anna is thus doubly alienated from the courtroom: she cannot speak its language, and the men she has hired to speak for her have "protected" her from the facts, done the job that she has seemingly failed to do in protecting her daughter from knowledge of adult sexuality. But Anna is an adult; to conceal knowledge from her as a form of protection reveals the extent of social conditioning about men's and women's places in the world.

White suggests that the novel "does not pit the individual against the system; Anna refuses to fight the system because all she wants is Molly. Her love and her need for her daughter seem more important even than the truth."[97] I would argue that the individual is indeed pitted against the system, and that Anna's failure to fight the system, rather than setting her up as a heroine, indicates a more troubling regression and dependency that mediates against a positive reading of this character's (in)actions. That Anna tells this story retrospectively, and castigates herself for failing to keep Molly at the center of her waking consciousness, speaks volumes: "Surely I always thought of her, I never took her growth, her happiness, for granted" (123). Anna has been reeducated into viewing the mothering role as constant and all-consuming, since anything less than perfection is grounds for revoking custody.[98] Anna doesn't even allow herself a momentary mental diversion, a daydream or sexual fantasy, without harshly reprimanding herself for her lack of attention: "the sense of blankness about Molly that thinking of Leo conjures for me now is . . . horrifying"(123). Indeed, all intimacy, except for intimacy with her lost child, is now refigured as wrong; she considers the officials of the court to have forced a "terrible" legal intimacy upon her.[99]

In an article on the filmed version of *The Good Mother* and *Stella*, Lynda Haas contends that "[o]ur inability to be 'good mothers' unless we masochistically accept our place seals the closed theater of female subjectivity. It is difficult to look 'inside' to find other options, or to turn away, since a mother's identity is relational."[100] Anna thus becomes the "good mother" of the title only when her child is taken away; she remains locked into her child's wants and needs while being simultaneously forbidden from taking care of her.

The Body as Evidence: Chris Bohjalian's Midwives

In contrast to the two novels above, *Midwives* is narrated from the position of the daughter, not the mother. Although it is a retrospective account that occasionally gives the reader a clue to Connie Danforth's current adult position, it primarily relates events that occurred when she was an adolescent, when her mother, Sibyl, a midwife, was accused of involuntary manslaughter: "Throughout the long summer before my mother's trial began, and then during those crisp days in the fall when her life was paraded publicly before the county—her character lynched, her wisdom impugned—I overheard much more than my parents realized, and I understood more than they would have liked" (3). The first line of the novel thus indicates the centrality of the trial to the narrative, but also the ways in which the protagonist's mother is judged with and against a whole line of other midwives. Indeed, even the title, with its stress on the plural (despite the fact that the novel is principally about one woman) indicates a line of descent. The words which particularly interest me here are "lynched," given its relation to summary "justice"; "paraded," more than a little reminiscent of a Puritan ideology to do with public humiliation; and "wisdom," as attached to midwives. Public displays of condemnation are set in contrast to "women's ways of knowing," and the novel pits the individual against an authorizing narrative of legal and medical intervention. On trial with Sibyl for the manslaughter death of Charlotte Fugett Bedford is the whole institution of home birth; Sibyl is clearly made an example of, her profession questioned and her ideology considered suspect. Indeed, even before

the trial, Sibyl is seen as suspect: Connie is aware that other children's parents didn't always like her to play with their children, certainly not at her home. These parents feared their children would be subjected to a home birth, or that "among the strange herbs and tinctures that were [her] mother's idea of medical intervention were marijuana, hashish, and hallucinogenic mushrooms" (10–11). The imagery of midwife as witch is pervasive.

Pamela E. Klassen notes that in many states and provinces in North America, home birthing either is illegal or has "ambiguous legal status." As a result, "for some women, choosing to give birth at home with a midwife is a decision to break what they see as an unjust law."[101] Although home birthing—even by unlicensed midwives such as Sibyl—is not illegal in Vermont, where the novel is set (indeed, Vermont has one of the highest rates of home birth in the country), it is still almost by definition seen as a radical act, since it challenges societal norms and narratives about "healthy" places to give birth. Klassen argues that women who choose to have a home birth thus "inhabit 'postbiomedical' bodies—bodies that do not entirely deny the usefulness of biomedicine but challenge its hegemony via alternative systems of knowledge, such as religion."[102] Indeed, Klassen links home birthing to spirituality and religiosity, either of a New Age variety or of traditional nature, and it is no accident that the pregnant woman at the center of the trial was married to a fundamentalist minister, nor that Sibyl Danforth, the midwife in charge of her delivery, inhabits a "hippie" framework.

From chapter 2 onward, the mother's (written) voice precedes each chapter, in short passages that are glossed as coming "from the notebooks of Sibyl Danforth, midwife." It is in these passages that the midwife's "hippie" language is most apparent, as well as her failure to conform to conventional ways of reading childbirth: contractions are read as "aura surges" (45), for example, and conception is read as an egg and a sperm meeting to "groove together" (19) and go on a "cool little pilgrimage to the uterus" (33). Language such as this contributes to the state's depiction of Sibyl as "'by nature an outlaw, someone who cavalierly puts women—and babies—at risk on a daily basis for no other reason than a mindless and backward distaste for the proto-

cols of modern medicine'" (209). Significantly, prosecutor Bill Tan-
ner's language is not left unchallenged; the judge cautions Tanner
against such hyperbole, but as in other cases, both language—what is
said and what is not—and performance furnish the basis of the trial.

Bohjalian records an entire backstory for this case, noting, for
instance, that Sibyl took one of twenty-five mothers to the hospital
(73). Such "facts" stand in opposition to less clear readings of what
occurred on March 14, 1981, the date of Charlotte Bedford's death
and Veil Bedford's birth. The reader encounters the first court "tran-
script" in chapter 4, whereas the plotted narrative of events—from
Sibyl's perspective, retold by Connie—comes a chapter later.

STATE ATTORNEY WILLIAM TANNER: So you asked Reverend Bedford to bring
you a knife?

SIBYL DANFORTH: Yes.

TANNER: You didn't just ask for any knife. You asked for a sharp knife, didn't
you?

DANFORTH: Probably. I don't think I would have asked for a dull one.

TANNER: Both Reverend Bedford and your apprentice recall you requested
"the sharpest knife in the house." Were those your words?

DANFORTH: Those might have been my words. (45)

Already, language is contested; Sibyl does not pretend to remem-
ber precisely the words she used, though the court arena generally
requires almost total recall of events and speech.

What is clear is that during Charlotte Bedford's labor, the sickly
woman becomes so ill that Sibyl suggests that they take her to the
hospital, a change in plans that is thwarted by bad weather. Sibyl
attempts to drive her car closer to the house to pick Charlotte up, but
the icy conditions do not allow it. Worse, telephone lines are down,
so Sibyl, her apprentice Anne, Charlotte, and Charlotte's husband
Asa become trapped. Eventually, it appears that Charlotte has had a
stoke. Sibyl tries to resuscitate her to no avail and decides that the
night will only produce one death, not two: hence the request for a
knife and the emergency caesarian section—an operation, the state
contends, Sibyl performed on a live patient, thereby causing her
death. It is no accident that Sibyl's lawyer arranges for Sibyl to be

photographed, exposing the ugly bruises she sustained when falling on the icy path in her attempt to get Charlotte to the hospital, not long after the incident occurs: both lawyers now rely on a body as evidence to show different stories about that fatal night.

In his examination of Sibyl, Bill Tanner asks mockingly, "Do you believe surgeons possess a special expertise that you as a midwife do not?" to which Sibyl rightfully replies, "Good Lord, don't you think so?" (46). Sibyl's disregard for court etiquette, her voicing of "ordinary common sense" when asked a patently emotive question, continues to position her as a legal outsider.

All of this contributes to Bourdieu's vision of the courtroom as one that is defined by insider-outsider status, where insiders maintain their position through legal language, by "redefining problems expressed in ordinary language as *legal* problems, translating them into the language of the law and proposing a prospective evaluation of the chances for success of different strategies."[103] Both Tanner and Sibyl's lawyer, Stephen Hastings, collude in this performance. Early in the proceedings, before it has been determined whether the charge against Sibyl will be murder or involuntary manslaughter, Sibyl's husband Rand expresses his impotence in the face of legalese in a telephone conversation with their lawyer:

"I know what the words intentional and involuntary mean to a normal person," my father was saying. "I want to know what the hell they mean to lawyers . . . I see . . . A precedent? Are you telling me this sort of thing has happened before? . . . Uh-huh . . . The woman was already dead, for God's sake. Why would Sibyl have thought a C-section would kill her?" (182; ellipses in original)

Bourdieu argues that "the technical mastery of a sophisticated body of knowledge that often runs contrary to the simple counsels of common sense, entails the disqualification of the non-specialists' sense of fairness, and the revocation of their naïve understanding of the facts, of their 'view of the case.'"[104] Indeed, viewpoint—or more accurately, perspective—becomes a vital part of the trial. Stephen argues that "the issue became one of mere staging and lighting: logistics, not pathology"; he was concerned with "blocking, and where Asa Bedford and Anne Austin were standing when my mother took a kitchen knife and first pierced Charlotte's skin" (162–63).

In the "transcript" that follows, Stephen cross-examines Asa Bedford, setting out how his vision was obscured. More than that, however, Stephen uses emotive language, as when he asks, "And is this the light Sibyl switched on just before she rescued your baby?" (165). Sibyl is always "Sibyl" to Stephen, not Mrs. Hastings (as we have seen, the use of official titles versus personal names weighs heavily in each of these fictional texts), and his emphasis is on the healthy child born as a result of Sibyl's medical intervention.

When Sibyl tells Asa that she is going to save his baby, both Asa and Anne believe her voice is "shrill," and in court, Asa suggests it was "hysterical" (84). It is just this sort of characterization that Stephen must counter when he puts Sibyl on the stand, in the middle of his defense, making of her an "'accessible presence, a woman with a voice'" (336). This represents what Bourdieu calls "a paradigmatic staging of the symbolic struggle inherent in the social world: a struggle in which differing, indeed antagonistic world-views confront each other. Each, with its individual authority, seeks general recognition and thereby its own self-realization."[105] This struggle is also about naming the victim of the tragedy, something that Connie's retrospective narrative makes clear: for her family, Sibyl is the victim; for the Bedfords, Charlotte is.

In *Midwives*, as in the other novels, other mothers play an important role in the trial. Both lawyers have strong views regarding jury selection, questioning potential female jury members on their maternal status, and in the courtroom itself, mothers make their presence known, with a group of breastfeeding women lining the back bench of the courtroom. Their presence requires an odd simultaneous acknowledgement and disavowal: "some of the reporters, even the female ones, were trying desperately to talk to members of the group during the recess without allowing their eyes to fall below the nursing mothers' foreheads. It was as if they were trying to interview the wall behind them" (257).

Finally, of course, Sibyl is herself a mother, and Connie's narrative is intimately bound up in assessing the connection between them. Indeed, the narrative as a whole becomes a narrative of guilt, where Connie oversteps the boundaries of legality in helping her

mother. Sibyl accidentally reveals on the witness stand that she keeps a journal, and, unsurprisingly, the prosecution demands that the notebooks become evidence. The judge decides he will read them instead, to judge whether they are material to the case. Connie volunteers to retrieve the notebooks, having surreptitiously read them beforehand, and she makes a decision to act illegally: "I was shaking as I worked [removing potentially incriminating evidence], a precursor of sorts to the trembling I'd experience while we awaited the verdict. I wasn't sure what law I was breaking, but I knew what I was doing was illegal. And I knew what I was doing was wrong" (351). Connie is successful: no one detects her removal of entries, at least until after the trial, and the notebooks are, therefore, deemed to have "little relevance to the issues under examination" (355). Sibyl Danforth is found not guilty of manslaughter—though guilty of a lesser charge, the misdemeanor offense of practicing medicine without a license.

The matter does not, however, rest there. In response to her mother's trial, and her own crime, Connie decides to become an obstetrician gynecologist, a decision that appears to undermine her mother's chosen profession, though Connie argues that it does not. Instead, her complicated decision to become a doctor relates to "[a]tonement. . . . Reparation. Compensation. Justice" (365).

Finally, though we begin with Connie's words, we end with her mother's, a change of viewpoint that alters our entire reading of the book. The final chapter of the book is devoted entirely to an entry in Sibyl's notebooks from March 15, 1981, the only entry to be dated, and the one that Connie removed. It reflects what Sibyl believed had happened in that bedroom when Charlotte Fugett Bedford died. Thus, we end on Sibyl's words, words that challenge our position, after the fact of the trial, when a retrial is no longer possible:

I don't think anyone but me saw the body flinch. At the time I just thought it was one of those horrible post-mortem reflexes that you hear about in some animals, and so I went on. I thought the same thing when there was all that blood, and it just kept flowing.

After all, I'd checked for a pulse and I'd checked for a heartbeat, and there hadn't been one. So how could she have been alive? That fact is she couldn't, I thought to myself, and she wasn't. That's what I thought as I drew the knife down, and I know I was absolutely sure of that then.

But looking back on it now—a day later, after I've gotten some sleep—I just don't know. Whenever I think of that flinch, I just don't know . . . (372; italics and ellipsis in original)

"Mother Knows Best": Inconclusive Factors and Contested Convictions

In all these fictional texts and in the factual cases or contexts I have explored, it is clear that women as mothers experience their relation to the law in gendered terms. Carol Smart argues that instead of focusing on the idea that law is sexist or male, we should recognize that the law is gendered, so that "we can begin to see the way in which law insists on a specific version of gender differentiation, without having to posit our own form of differentiation as some kind of starting or finishing point."[106] Such a stance may appear to be a cop-out; yet, if nothing else, this chapter has revealed the difficulties of assessing the merits or drawbacks of a postegalitarian position. Do women, especially women who are mothers, constitute a special case? Is motherhood either a defense or a provocation for women in conflict with the law, and should their own reactions to their apparent failure to live up to societal expectations be taken into account in sentencing them?

Tonya Plank suggests that the answer is sometimes (though not always) yes. In relation particularly to child abuse, Plank suggests that some cases do have a gender element to them: cases where women's prior abuse should be taken into account as a mitigating factor (though she stops short of calling for a full recognition of "battered woman's syndrome" as a complete justification for a crime).[107] Oberman argues that "history teaches that there is reason for caution and skepticism whenever the law determines that women should be treated differently from men—even if such determination arises out of an ostensibly benevolent impulse,"[108] yet she ends up arguing for at least a partial recognition of gender in infanticide defenses. Conversely, Shelley Gavigan cautions that defenses which rely on women's biology—premenstrual syndrome, pregnancy, and the like—illustrate that "attempts to understand women and crime have never lost their inti-

mate connection to an analysis of the inherent nature of women."[109] Feminist critique of law and literature is thus fraught with difficulties and seemingly irresolvable tensions, and indeed some would argue that feminism itself is also subject to these strains.

Regina Graycar offers one way forward, suggesting that feminists must "challenge law's stories and, in particular, the stock stories routinely told about women, but we need also to dismantle and rearrange the framework within which those stories are told."[110] Exploring literary stories of women's legislated lives, unpicking the narratives that lock them into position as wives and mothers, and doing so in relation to real-life cases that preoccupy the public or make legal history, offers one such avenue for change. In addition, according to Naomi Cahn, it may be necessary for mothers to give up some limited power within their homes in order to achieve more power outside them, though Cahn admits that this is a difficult challenge and one fraught with pitfalls.[111]

The turn to literature offers spaces for considering these different narrative futures. For Kim Dayton, the pairing of law and literature in the classroom "seemed to generate in [her] students an understanding of the abstractions of feminist legal theory that even the best of the 'real' narratives [she] had used in the past could not."[112] Literature, which foregrounds its constructed nature, thus makes apparent the construction of other narratives: legal, societal, cultural. The women of these literary texts mostly perform their motherhood badly, or feel inadequate in this "natural" role; their interior monologues, their questions, and their self-justification (and judgment) offer the reader a space to consider society's general silence over these issues, broken only to condemn the deviant mother who cannot hide her departure from the "norm."

Elizabeth Tobin argues that "[t]he literary work is only valuable in its relation to law if it is read alongside the 'real' as a way to respond to the various narratives that both the legal and the literary voices provide."[113] These novels do not provide "true stories," nor are their delineations of courtroom scenes necessarily true to life; however, they do mimic the juridical gaze and respond to cultural narratives about mothers, offering readers the opportunity to re-view the ways in which the law tells conflicting stories about such women.

In the next chapter, the gaze returns to the courtroom, where guilt still remains to be determined. Given that the courtroom resembles a theater, it is doubly appropriate that the focus should fall on dramatic texts. Concentrating on the performance of femininity and the usurpation of women's voices, chapter 4 details a variety of dramatic texts and explores the complicated arena in which women stage their guilt or innocence.

Staging the Scene
Women, Drama, and the Law

The juridical field is the site of a competition for monopoly of the right to determine the law. Within this field there occurs a confrontation among actors possessing a technical competence which is inevitably social and which consists essentially in the socially recognized capacity to interpret a corpus of texts sanctifying a correct or legitimized vision of the social world.[1]

Pierre Bourdieu's use of the word "actor" here is not accidental: it highlights the ways in which law courts and the stage have much in common and how each individual plays a role. It is in relation to the staging of guilt or innocence that the connection between these arenas becomes clearest. For example, drama foregrounds the constructed nature of power relations through such factors as lighting, stagecraft, and dialogue. Whether largely "realist" or experimental, theater interrogates the (not so hidden) gender roles that determine how one's daily performances are received. It is no surprise, then, that playwrights are attracted to the courtroom—whether metaphorical or "real"—as a setting for their plays, and that law and literature critics explore how women's guilt and innocence are staged.

The connections between the sites are clear. First, they contain multiple narratives. The contestatory nature of the courtroom and the theater are thus linked, although, as Steven Connor points out, "whereas in the theatre a script is turned into a performance, in the courtroom, a performance is turned into a script."[2] Second, the performance of roles is foregrounded—and adjudicated—in both arenas.

It is worth returning to a quotation from Kim Lane Scheppele: "Those whose stories are believed have the power to create fact; those whose stories are not believed live in a legally sanctioned 'reality' that does not match their perceptions."[3] Third, in both cases there are (more or less) prepared scripts from which one should not stray. And finally, there are at least two levels of audience. In courtrooms, the jury, lawyers, and judge act as one audience, while the spectators (including reporters) occupy a second position. In plays about the courtroom, a third "actual" audience is also included. This level of mediation and distance is integral to how meaning is constructed. Such connections are hardly new: Jeremy Bentham envisioned his panopticon as a theater in the late eighteenth century, and his "post-script" to *The Panopticon Letters* explicitly references theatrical conventions.[4]

It is particularly with the staging of *women's* guilt or innocence that this chapter concerns itself, not least because of the way that the display of traditional femininity is seen as a performance itself. In Judith Butler's words, gender is "*a corporeal style*, an 'act,' as it were, which is both intentional and performative, where '*performative*' suggests a dramatic and contingent construction of meaning."[5] Thus, while I acknowledge throughout this book that the term "women" may be seen as a convenient fiction that elides differences, it is still the case that twentieth-century dramatists evoke the figure of "woman" in order to explore her gendered experience of the law. In three of the plays analyzed below, historical (white) women were the plays' dramatic analogues, though only in one—*Blood Relations*—is the connection so clear that it would be more complicated (though not impossible) to stage a cross-ethnic production.

A number of twentieth-century plays evoke "unruly" or outlaw women and overtly stage their guilt or innocence within the space of a real or a metaphorical courtroom setting. In dramatic texts, as I articulated in the introduction, women as subjects of courtroom dialogue and debate become translated into objects on display, and their voices become contained or controlled by narratives to which they have only limited access. Indeed, as Judith Resnik argues, "Women literally lacked juridical voice. Until quite recently, women were the

objects of the discussion, as property, as victims, as defendants, but not the authors, the speakers, the witnesses, the lawyers, the judges, or the jurors."[6] This partial or occluded voice preoccupied feminist critics and playwrights for most of the last century, and representative plays that engage with this idea include Sophie Treadwell's *Machinal*, Susan Glaspell's *Trifles*, Sharon Pollock's *Blood Relations*, and Sarah Daniels's *Masterpieces*. Thus, in this chapter I explore what Jennifer Wood describes as "usurpatory ventriloquism"—the authority to speak and act for others—that is inscribed in the asymmetrical power relations of the court and played out on the stage.[7]

The filmed version of the musical *Chicago* makes this ventriloquism visually central, in that at one point, the accused (and guilty) Roxie Hart, played by Renée Zellweger, sits on her lawyer's knee and mouths the words he sings. Her overdone makeup encodes her position as a puppet, with Richard Gere as her puppet master. Roxie's lawyer not only provides her spoken words (becoming angry when she strays from his script), but also manufactures her *written* words. At a crucial moment in the trial, Roxie's diary is produced, and in it is a confession of guilt. Because it is written in legal language (the inclusion of the word "erroneous" causes the most uproar), the diary is considered suspect—an interesting inversion of the law itself. As a result, Roxie's supposed "confession" is judged inadmissible. At each level, then, the accused woman's texts (her written words, her speech acts, and her code of dress) are subject to manipulation. This ventriloquism is successful—but at a clear cost.

Treadwell's *Machinal* also shows a ventriloquist lawyer attempting to provide a verbal script of innocence, but in this case, the woman on trial breaks her silence and denies her lawyer's version of events on the night that her husband died. In doing so, she forfeits her life. Lizzie Borden's guilt or innocence is interrogated in Pollock's play, with both a shadowy Defence Lawyer and an accomplished Actress taking up Lizzie's words. Finally, Daniels's *Masterpieces* maintains its contemporary relevance by asking actors to insert references to current court cases which offer men short sentences for murdering their wives while women are convicted of murder and imprisoned for life. In *Masterpieces*, the woman on trial for murder refuses to appoint a

lawyer to ventriloquize for her—only to find her words (mis)interpret-
ed by the judge and prosecuting lawyer instead.

Although speaking from and to different cultures, these texts are
connected through their feminist explorations of women's lived exis-
tence as gendered bodies subject to the law. These feminist explo-
rations do not rest on an essentialist notion of Woman or Womanhood,
but they do point to the ways in which the courts themselves are guilty
of essentialist constructions of gender. Indeed, the courtroom normal-
izes the separation of the "good" woman and the "bad" woman, even
as the language of the court more often than not blurs this distinction
and makes the search for "truth" a complicated and unstable affair.[8]
Clearly, however, guilt and innocence are "staged," and the theater
itself offers a complicated arena in which to explore women's relation-
ship to the law. Maria Aristodemou suggests that "[t]heatre can remind
us that we are always playing a part to an audience of others who play
at accepting us as being the role we play."[9] Thus, the experience of
consuming drama may lead us to recognize the drama in our own
existences, the role-play we may be only partially aware of as it is con-
stituted, and the ways in which scripts are offered to us on the basis of
our gender, our ethnicity, or other identity markers.

Moreover, Carol Smart argues that "Woman is a gendered subject
position which legal discourse brings into being."[10] Such ideas are
important when examining whether justice is gender blind or gender
neutral, and whether such a stance is indeed in women's best inter-
ests. Smart argues that the goal of gender neutrality is one that is at
best a utopian fiction, and at worst a form of blindness that discounts
important factors in the social construction of women's lives. This dis-
counting of women's social lives becomes key to how they are judged,
and what they are allowed to say or are kept from saying while under
oath. In the discourse of the court, there are two general verdicts:
"guilty" and "not guilty" (not "innocent" as is so often proclaimed on
courtroom steps).[11]

There are also regulated ways in which the stories of guilt become
accessible. Connor argues that

[i]n the trial, the accused, the plaintiff and those giving testimony are
required to speak when they do speak, *inpropria persona*, and *viva voce*, with

their own living voices. But this does not confer the right to speak with their own words. Those who speak in the courtroom must use the language of the court, must give voice to the formal, inscribed language of the law, that unspoken and in a sense unspeakable language whose very nature is to strain and disdain the mouths of women and men.[12]

In his article, Connor quotes from a trial transcript where the defendant, unaware of the language of the court, refuses to say "guilty" or "not guilty" when questioned how he pleads, but instead insists that he did it. The clerk and magistrate cannot accept this admission, because it does not fit in with procedure. As Connor notes, "Guilt is not a matter of saying yes, it is a matter of conformity to the manner of saying yes prescribed by legal process."[13] Thus, how one admits guilt is also regulated and codified.

James Boyd White takes another perspective when he suggests that the explicitly *unsaid* has an impact on law's discourse, not only when individuals refused to speak, but in other circumstances, too: "The denial of standing, which silences a particular voice; the adoption of a rule excluding certain evidence or denying a particular jury instruction, which renders a claim unsayable; the denial of a cause of action—all these are speech acts that incorporate for the moment what they will exclude."[14] How, then, do playwrights deal with the unsayable? Jennifer Jones suggests that playwrights explicitly evoke the unsayable in order to sway public opinion. Jones goes so far as to say, for example, that Treadwell's play "is the testimony, disallowed by the court of law, that Treadwell wished to introduce to the court of public opinion,"[15] and Robin West suggests that Glaspell was compelled by similar motives to pen her one-act play *Trifles*.

Perhaps recognizing the nature of the law to suppress the voice of woman, West argues that one can propose the theoretical figure of "literary woman," whom she opposes to the "economic man" model that is prevalent in case studies of law. For West, the literary woman is a figure who contains both men and women, thus reversing the normative generic male figure. West argues that she does so because "women's moral voice seems to be distinctively tied to the moral value of empathy,"[16] and thus it is empathetic and not economic concerns that can and should determine some cases. Although one could

take issue with West's overarching framework, which suggests an essential view of women and potentially presupposes a monolithic view of an entire gender as somehow homogeneous, it is also important to realize that her construction is just that: a construction, meant as much to set into relief an image of the normative male as to suggest some sort of normative female. It is certainly the case that, with this proviso in mind, West's argument can be put to good effect in relation to *Trifles*, which uses the value of empathy as a higher moral value than so-called justice.

"Something to Make a Story About": Trifles *and* Machinal

Based on a real case in the early part of the twentieth century, *Trifles* has become a feminist dramatic classic and a canonical law and literature text.[17] Also called "A Jury of Her Peers" in its short story format, Glaspell's one-act play includes a metaphorical rather than a "real" courtroom scene. In place of a witness stand, there is an empty rocking chair. The principal character, Minnie Foster Wright, is kept offstage and never allowed a voice—indeed, she is never embodied at all. And the final judgment on her guilt or innocence is an extralegal one, not subject to the strict rules of admissible or inadmissible evidence.

Trifles opens after the death of John Wright, apparently strangled in his sleep. His wife, Minnie, is being held in the local jail, and various lawmen arrive at the Wrights' lonely farmhouse to assign motive and thus ensure a guilty verdict. Accompanying them are their wives, Mrs. Peters and Mrs. Hale, who have promised to gather up a few small treasures for Minnie, including her apron, so that she can be comforted in jail. Minnie clings to her feminine uniform, and this is initially enough evidence for the women to believe her to be innocent: they are interpellated into their husbands' ideology, and therefore, "know" that a woman who knows her place could not be guilty of such a disturbing crime. In contrast to this is their husbands' "evidence" against Minnie: that she is a poor housekeeper and lacks the "instinct" for homemaking. In the men's eyes, a rejection of feminin-

ity is a rejection of the natural order of the world; embracing chaos and disorder leads, by implication, to an embracing of crime. Thus, the men know her to be guilty (they read evidence of it in her apparently slovenly housekeeping), but they need something more than "trifles" for a conviction.

The very tracing of Minnie's contested femininity is not incidental but crucial here. Renee Heberle argues that "[w]hen women commit violence in the private sphere, they are breaking the rules of gender and must be either refeminized—often a difficult task—or severely sanctioned. When men commit violence in the private sphere, they are in a sense fulfilling the grim assumptions society holds about masculinity."[18] John Wright's masculinity is never in question, and in fact he is seen as a repository of all that is "good"—at least by his fellow men, who remain metaphorically blind to the real clues on the stage. What the lawmen miss in this recitation of Minnie's faults is the way that the domestic space provides evidence of her crime, clues that the untrained women uncover—and subsequently cover over.

To reveal the evidence is to offer proof of "sudden feeling,"[19] enough to convict the absent woman of murder. As the county attorney notes, he needs "something to make a story about" (85). A story could be—and is—made by the women on stage, who find a dead canary with a broken neck. They immediately "know" that John Wright, a bully and a tyrant, killed the canary—and that Minnie Foster Wright, a woman who sang sweetly in the church choir before she married, killed him as a result. This, they decide, is a story that *won't* be told.

In contemporary trials, such confirmation of "sudden feeling" might work in the accused woman's favor as evidence of battered wife syndrome; however, in the historical case upon which *Trifles* is based, the contrary position was taken. In fact, the *prosecution* tried to introduce evidence of domestic abuse, so as to convince the jury of a motive and thus secure a conviction; the accused woman tried just as hard to present the picture of a "contented" marriage.[20] Robin West argues that Glaspell, covering the trial as a journalist, was disturbed by the "unjust alignment of tactic and end result" in the trial and decided to write her own version, and other law and literature critics

suggest that the text offers the opportunity to explore the position of a battered wife in a court of law, as well as the silences that surround such a woman.[21]

Glaspell revises the whole concept of crime in *Trifles*, as the women begin to feel their own guilt at leaving Minnie Wright to her lonesome and possibly abused existence on an isolated farm. As Mrs. Hale says, "Oh, I *wish* I'd come over here once in a while! That was a crime! That was a crime! Who's going to punish that?" (84; italics in original). This recognition of their own culpability is ironically set against their husbands' contention that Minnie is likely to "get off" because "You know juries when it comes to women" (85). The positioning of women's guilt is thus contested here, and the lawmen reiterate the so-called "chivalry" thesis that suggests that women do indeed get away with murder.[22]

Trifles is read in opposing ways by law and literature experts. West, like other feminist critics, argues that Glaspell's metaphorical trial is a corrective to a justice system that pretends to be gender-blind, where motive is motive, and the end result means punishment, and Marina Angel has argued in several contexts that the text is an important one in relation to the law and literature canon.[23] Similarly, Sherri Hallgren argues that the play is an example of "a parallel system of justice, one in which women can be judged according to context and truly by their peers."[24] Richard Posner, in contrast, reads the actions of Mrs. Hale and Mrs. Peters as guilty actions which make them "accessories after the fact" to Mr. Wright's murder.[25] As Posner further notes, the play, "[r]ead literally, . . . endorses a 'battered wife' defense to murder so encompassing as to place most husbands outside the protection of the law."[26] This legalistic reading, which judges a text on the way in which it conforms to "real" law, reads against the grain of the text to such an extent as to warp its message. As has already been noted, Posner is an influential critic of the law and literature movement, who dismisses feminists under the term "postmodernist critics" and who believes that American law has what he calls "troubled encounters" with women.[27] That the message he receives from the play, then, is that men are potential victims of women's homicidal rage, and that mitigating circumstances should be discounted, actually confirms

what Stanley Fish argues about how meaning is constructed in texts and courts. Fish suggests that it is not only possible but *likely* that participants in a trial will end up "pointing to the same 'stretch of language' (no longer the same, since each [side] would be characterizing it differently) and claiming it as a 'fact' in support of opposing interpretations."[28] Without such differences of opinion, trials could not proceed.

In perhaps an even more relevant argument, Jacqueline St. Joan contends that we must recognize the "tinted narrative lens" of the law, since by doing so, we can comprehend "how law reinforces the views of the powerful through the continual retelling of stories from the dominant perspective." St. Joan argues that judges rely on this dominant perspective both because it is "familiar" and because "legal precedent usually is grounded in that point of view."[29] Given that legal precedents may stretch back to a time before women were able to participate in law-making and law-meaning, such a fundamental aspect of the law needs perhaps to be revisited. In exploring dramatic moments, women dramatists may well be offering such a challenge.

It is certainly clear in the expressionistic play *Machinal*, by Sophie Treadwell, that legal logic obscures the female experience.[30] First performed in 1928, Treadwell's play is divided into nine "episodes" with the following preface:

THE PLOT is the story of a woman who murders her husband—an ordinary young woman, any woman. THE PLAN is to tell this story by showing the different phases of life that the woman comes into contact with, and in none of which she finds any place, any peace. . . . THE HOPE is to create a stage production that will have "style," and at the same time, by the story's own innate drama, by the directness of its telling, by the variety and quick changingness of its scenes, and the excitement of its sounds, to create an interesting play.[31]

That Treadwell uses the word "hope" is significant here, given the absence of hope from the play as a whole. Instead, the audience sees the mechanized life of an unhappy woman, first in a job she dislikes, then when she tries to speak to her mother about love, and during her honeymoon where she cannot bear to be touched by her new husband. Episode Four is ironically entitled "Maternal," since it reveals the woman as anything but. This is quickly followed by an

episode entitled "Prohibited," a scene in a bar where the young woman meets up with a strange man in a bid for comfort or connection, and "Intimate" where she and her lover recognize their opposing views about the nature of their bond. The scene that follows, "Domestic," offers a portrait of a woman silenced by her position as wife and longing for release. For the purposes of this chapter, I will focus primarily on the penultimate episode, "The Law," while acknowledging that in the final scene, "The Machine" (which relates to the woman's execution), her last words are metaphorically cut off mid-syllable, thus again reasserting the metaphorical importance of the unsayable.

As in *Trifles*, then, a woman is accused of murdering her husband; in contrast, however, a "real" courtroom trial takes place. In a nod to actual practice, the name of the accused woman is revealed during the trial scene, though throughout the rest of the play she is primarily known as "Young Woman." Her address, too, is supplied, though obscured; when asked (for the record) where she lives, she replies, "In prison" (235), a truthful response which nonetheless offers no further information.

As in *Trifles*, those in charge of prosecuting the crime can find no motive for the murder, nor are any witnesses brought forward (237). This leaves the Young Woman's defense lawyer the space to construct her as a "devoted daughter" wrongfully imprisoned, a "devoted wife and a devoted mother" (236) who, but for the law, would be back at home where she belonged. In stressing her familial ties, the lawyer implicitly sets up her innocence. In addition, throughout the trial, he "clarifies" her testimony so that it supports his version of her innocence. In contrast, the lawyer for the prosecution attempts to rattle the defendant, but she maintains a story of innocence until an affidavit from Mexico (from her one-time lover) disrupts her story. The defense lawyer tries to suppress the affidavit on the grounds that it was issued outside the United States and because the man who swore the affidavit would not appear in person to offer his testimony. However, the judge allows it: what he says is recordable, even as what she refuses to say is not. It is this evidence—written, not offered orally, and from a distance, outside what the defense lawyer at least sees as the

jurisdiction of the court—that provokes the woman's confession. She screams, "I did it!" at least four times in this scene—but even when directly questioned by the judge, she refuses to answer the question "why." On this matter, she chooses silence, and the result is condemnation.

If read through Posner's legalistic viewpoint, there are at least two issues for this play. First, due process would suggest the ability to cross-examine one's accusers (if through the medium of the lawyer), something denied the woman on trial here. Her lawyer's misguided objection—which rests, it seems, on a notion of law outside the United States as somehow outside modes of true justice—is not the objection that he should lodge. In addition, after her confession, the judge asks why she didn't just divorce her husband; but this trial, based loosely on Ruth Snyder's trial in New York (the first woman to die in the electric chair in that state), is set in a time in which divorce was difficult to obtain in New York and could not be initiated by a "guilty" party.

Like Glaspell's play, however, *Machinal* is not meant to be read literally as a clear and careful application of the law; if it were, it would be at the very least a realist text, not an expressionist one, since such texts include flat characters, symbolic names, and episodic structures, aspects that are unlikely to provoke allegiance or emotional connections. What Treadwell does, though, like Glaspell, is highlight the position of the accused woman, the way in which her gender influences her trial, and way in which her femininity is at stake as much as her supposed guilt or innocence. It is perhaps not coincidental that Treadwell, like Glaspell, was a journalist, and that she carefully records three journalists' eyewitness accounts of the trial as it progresses. Each viewpoint "sees" a different defendant, who is described as "pale and trembling" by one reporter, only to be considered "flushed but calm" by another (245). Indeed, even the confession is reported in banner headlines that betray different agendas: "Murderess confesses," "Paramour brings confession," and "I did it! Woman cries!" (248).

Marie Fox argues that the stories told about women who kill are "pre-scripted." Such women, according to Fox, are considered "inher-

ently bad, mad or not really a criminal at all"—they become types rather than individuals in conflict with the law. Furthermore, Fox argues that female offenders in general but violent women in particular may find that "[i]n court their stories are unable to be told as they are controlled by the lawyers and other experts who may well be unable to transcend the influence of myths about violent women."[32] Role play, performance, script—the words themselves are indicative of the "staging" of guilt or innocence, and the way in which the "reality" of the female criminal's position is difficult to unravel. Such is the case in Pollock's 1981 play *Blood Relations*, where, true to the case on which it was based, that of Lizzie Borden, the principal character is legally innocent—but presumed guilty.

"Lizzie Borden is not mad. Gentlemen, Lizzie Borden is not guilty"

Blood Relations is divided into two acts, but the scenes themselves are not differentiated; rather, the characters move from present to past and back again, adopting roles as necessary and being prompted by interjections from an anonymous defense lawyer. The stage directions note that "*The* DEFENCE *may actually be seen, may be a shadow, or a figure behind a scrim.*"[33] The play, then, follows the telling and reenactment of the murders of Lizzie Borden's father and stepmother. In the stage directions, Pollock indicates clearly that all of the characters are imaginary, apart from three: Miss Lizzie herself; Emma, Lizzie's sister; and the Actress, who plays the notorious woman on stage. The Actress visits Lizzie for the purpose of "soaking up the ambience" (94) of the parlor in order to make her own performance somehow more "real." These three characters are set in the "real" time of 1902. The acts of 1892—the time leading up to and including the murders themselves, which account for the main portion of the play—are in fact *re*enactments, much as a trial seeks to reenact events in order to construct a case. After all, "[j]udges and jurors are not witnesses to the events at issue; they are witnesses to stories about the events."[34] At many levels, then, this piece of drama offers an interpretation of legal frameworks.

Twice a children's singsong is heard:

> Lizzie Borden took an axe
> Gave her mother forty whacks,
> When the job was nicely done,
> She gave her father forty-one.

That the rhyme is factually inaccurate does not matter; its repetition underlies the societal notion that Borden is indeed a murderess. The first time we hear these words, they are recited by the Actress. Miss Lizzie challenges the Actress about her encounter with local children, asking, "Did you stop them?" The answer is no; instead, the Actress reports that she shut the window to keep the noise out, as it was disturbing her rehearsals. She does, however, comment that she stopped the children when they were torturing a cat (94). Pollock's use of this opening is deliberate: Lizzie Borden is not considered a helpless victim, and no mercy is afforded her.

The central unresolved question of the play—which is enticingly offered at several points as if an answer is forthcoming—is whether Lizzie Borden was indeed innocent or guilty. In relation to this "did she/didn't she" question, the Actress notes, "If you didn't I should be disappointed . . . and if you did I should be horrified" (96; ellipsis in original), to which Miss Lizzie replies, "And which is worse?" The Actress responds, "To have murdered one's parents, or to be a pretentious small-town spinster? I don't know" (96). Either stance is unattractive—un*feminine*—and either way, Lizzie Borden is guilty.

Lizzie's inability to perform her femininity appropriately—the sense that she is "unnatural" (105)—is reiterated throughout the play. She recollects a childhood moment when she noted the absence of scabs from her knees. These scabs had been seen as evidence that she was not containable within the strict confines of feminine behavior, but Lizzie ruefully notes that their absence merely indicated better physical balance, not the promised transformation that her family desired:

Do you suppose . . . do you suppose there's a formula, a magic formula for being "a woman"? Do you suppose every girl baby receives it at birth, it's the last thing that happens just before birth, the magic formula is stamped indelibly on the brain—Ka Thud! (*Her mood of amusement changes.*) . . .

and . . . through some terrible oversight . . . perhaps the death of my moth-
er . . . I didn't get that Ka Thud!! I was born . . . defective . . . (104; ellipses
in original)

It is not incidental that this "Ka Thud" replicates the motion and
sound of an axe.

Jean S. Filetti argues that the historical Borden did not, at the
beginning of her trial, display any "feminine" attributes and may have
"simply learned to act the part" since "her behavior soon became
more ladylike [as the trial progressed]. By weeping, calling for water,
and fainting in court, she publicly proved her womanhood."[35] Indeed,
a contemporary newspaper account, in the *New York Sun* of June 13,
1893, proclaimed that "'Miss Borden's womanhood was fully estab-
lished when she burst into tears.'"[36] In Pollock's play, this shift is rep-
resented not through any performance Lizzie herself offers, but
through her defense lawyer's ventriloquizing summary:

Gentlemen! If this gentlewoman is capable of such an act—I say to you—
look to your daughters—if this gentlewoman is capable of such an act, which
of us can lie abed at night, hear a step upon the stairs, a rustle in the hall, a
creak outside the door . . . Which of you can plump your pillow, nudge your
wife, close your eyes, and sleep? Gentlemen, Lizzie Borden is not mad.
Gentlemen, Lizzie Borden is not guilty. (105; ellipsis in original)

The equation of madness with crime reiterates Marie Fox's point
above, and the Defence's argument is curiously circular. To admit
Borden's guilt is to become afraid; to deny her guilt and, therefore, to
find her innocent, is to return to innocence itself. Here, it is not so
much that Justice is blind, but that her principal actors are. Lizzie
Borden is innocent *by default*. Her gender and her class combine to
ensure that guilt is a state she cannot "logically" inhabit. Indeed,
Cara W. Robertson, exploring Borden's historical trial, notes the
absence of motive offered by the prosecutors. Although there appar-
ently may have been a clear motive for murder—the chance to inher-
it a small fortune—the prosecution did not argue that this was why
the Bordens were killed. Instead, the prosecution argued that Lizzie
detested her stepmother and therefore killed her, but that Lizzie's
father was killed because he unexpectedly returned home early that
morning, before Lizzie Borden had a chance to construct her full ali-

bi. As Robertson sardonically notes, "Desire for independent wealth clearly fell outside the purview of feminine ambition."[37] This refusal to explore the reasons behind the murders may have ensured Lizzie Borden's acquittal. Robertson explores Borden's kleptomania, the "menstruation" evidence that accounted for blood found on Borden's skirt (evidence only obliquely explored in the trial, despite the nineteenth-century "common sense" notion that menstruating women were somehow unbalanced), as well as recent "fashionable" explanations of Borden's crime, such as incest. These various rationalizations of Borden's guilt offer clues to how women are read differently depending on cultural circumstances as well as the time frame in which a potential motive is explored.

As Peter Hutchings acknowledges, women in the nineteenth century were rarely "construed as responsible criminal subjects" and, as a result, "women are not reflected in murder's mirror."[38] This emphasis on mirrors is also at the heart of Pollock's multilayered play. For instance, Lizzie resents her stepmother's insistence on behavior that masks her true feelings: "I'm supposed to be a mirror. I'm supposed to reflect what you want to see, but everyone wants something different. If no one looks into the mirror, I'm not even there, I don't exist!" (106). More theatrically, the women in the play mirror each other: the Actress plays Lizzie Borden, and Lizzie plays her own maid, Bridget, each checking the other's performances against a barometer of "truthfulness." Their exchanges are charged by the knowledge that each is playing a part. "Bridget" subtly corrects "Lizzie" at first, particularly in regard to the nature of Mr. Borden:

BRIDGET: Oh Lizzie, what language! What would your father say if he heard you?

LIZZIE: Well . . . I've never used a word I didn't hear from him first.

BRIDGET: Do you think he'd be congratulatin' you?

LIZZIE: Possibly. (BRIDGET *gives a subtle shake of her head.*) Not.

BRIDGET: Possibly not is right. . . . (98)

Pollock suggests that in writing her play, she wanted to "maintain the ambiguity; and play upon the nature of theatre itself" (123). Thus,

audiences become implicitly and explicitly involved in the mediated levels of performance offered, and their perceptions are, therefore, manipulated. Pollock's frequent use of ellipsis, indicating hesitation, concealment, or the unsayable, contributes to this sense of ambiguity. The nature of truth and the questions over Lizzie Borden's story are explored in subtle and complex ways, and the idea of fabrication is both implicit and explicit in the text. At one point, Miss Lizzie (in the guise of Bridget) confesses, "I'm telling a lie" (102). The lie itself is immaterial, but suggests the manufacturing of a story to the best effect.

The courtroom here intrudes only occasionally, but it is clear that Lizzie Borden is still being judged, ten years on, in the present tense sections of the play. Pollock's play offers us several motives for Lizzie to kill her stepmother, including financial ruin and jealousy, and one for killing her father: he slaughtered her beloved birds in the yard in order to assert his authority and break Lizzie's will. As in *Trifles*, then, caged birds represent the position of the women themselves. Also as in *Trifles*, though, the murders are not revealed on stage: the moment that Lizzie (played by the Actress) raises the axe, a blackout descends. After the blackout, the body is gone, and Lizzie and the Actress subtly revert to their original roles.

Throughout, then, the Actress has been mouthing Lizzie's words, just as the Defence has done. What happens next, though, comes from Lizzie's own mouth. Asked once again by her sister Emma if she was responsible for their father's death, Lizzie replies,

It was you who brought me up, like a mother to me. Almost like a mother. Did you ever stop and think that I was like a puppet, your puppet. My head your hand, yes, your hand working my mouth, me saying all the things you felt like saying, me doing all the things you felt like doing, me spewing forth, me hitting out, and you, you—! (121–22)

In this reading, then, Lizzie is less an actor than a reactor, less her own person than a dummy still worked on by others—and her guilt is a collective one. That this may be yet another subterfuge, another refusal or deferral, is finally left unresolved, but the ambiguity points out and away from the singularity of her role as murderess.

The Right to Silence:
Sarah Daniels's Masterpieces

Karlene Faith argues that "[t]he reasons attributed to women's low violence rates relate to the low rank of females on the power scale, fear of the generally greater physical strength of men, a desire for social approval, and habits from years of strict gender training."[39] Thus, although women are not inherently nonviolent, they have learned to behave as if they are. They have learned how to perform their gender roles convincingly—apart from an "aberrant" few. It is no coincidence that a scholarly text devoted to women and the law is entitled *Too Few to Count.*[40] Such a designation relates not only to the statistically small number of female offenders, but also to their inability to be properly heard. Faith argues that the woman who isn't heard in court is the woman society wishes to deny, the "unruly" woman whose "appearance, actions and attitudes have been offensive to the dominant discourses which define, classify, regulate and set penalties for deviance. She is socially constructed as undeserving of the 'protections' of the woman who is confined within the parameters of gender conformity."[41]

In Sarah Daniels's *Masterpieces* (1981), the barrier between "unruly" women (including prostitutes) and middle-class, "normal" women is purposely blurred, and, as in the plays above, the concept of crime is also taken apart. *Masterpieces*, like *Blood Relations* and *Trifles*, offers a move to collective guilt, not least through the double-casting of actors to point out the ubiquity of the roles of victims and perpetrators of violence. Set in London between 1982 and 1983, the play actually expands beyond its time frame by the playwright's written instructions to insert references to contemporary court cases in the penultimate scene.

Masterpieces concerns the consciousness-raising journey of a social worker, Rowena, in the face of both subtle and intense misogyny. Interweaving distasteful jokes, references to pornography (including "snuff" films), and sexual assault, the play culminates in a murder trial in which Rowena is presumably found guilty of the murder of a stranger, a man who accosted her in an underground subway station.

Influenced by Andrea Dworkin's polemical *Pornography* as well as by the threat to distribute *Snuff* (an American-made film purporting to show the actual dismemberment and death of an actress in order to stimulate the sexual pleasure of men) in the United Kingdom, Daniels produced an effective, angry piece of drama that catalogues a series of crimes against women, only to punish a woman for reacting to the threat of crime itself.

Like *Machinal*, *Masterpieces* is episodic, and this is what makes the cataloging of crime so effective: over seventeen scenes, the audience is transported from an uncomfortable dinner in which the entertainment seems to rely on the denigration of women; to concerns about the effects of pornography; to scenes exploring rape, women's fear of walking alone, and workplace harassment (and to an exploration of why some women take up prostitution). Interspersed are scenes of the courtroom and the psychiatrist's office, and these scenes act as an inverse of Rowena's experience. In the courtroom and the psychiatrist's office, Rowena is contained, misheard, and misidentified; by contrast, the other scenes suggest a metaphorical opposition: that is, crimes against women are not contained, not heard, and not identified as crimes.

Elaine Aston suggests that the play's "stylistic shifts, shifts in narrative time, monologues, and direct address, operate multi-directionally and correlatively as a materialist montage exposing the violence enacted against women in male systems of representation."[42] Daniels's message is clear and uncompromising. As Tracy Davis notes, the play is "message-oriented," and while this may potentially make it appear overly didactic,[43] *Masterpieces'* episodic structure does not produce the same effect that Treadwell's expressionist play does. If *Machinal* potentially leaves the viewer cold, *Masterpieces* invites angry confrontation and rebellion.

Again, however, the tension between what is sayable and what is left unsaid (or unheard) is at the heart of this play. From the very first scene, a dinner party, we witness ventriloquism:

ROWENA: You were saying you weren't enjoying teaching much these days.

YVONNE: Actually Ron said that.

RON: Well it's true, isn't it?[44]

This sort of speaking for another is common practice in couples, and in and of itself, hardly worth remarking on. However, subtle though this is, it sets up a pattern of voicelessness or misattribution throughout the rest of the play. Yvonne tries to steer the conversation away from her unhappiness at work, but it eventually comes out that her teenage pupils engage in inappropriate sexualizing behavior in the classroom. They distribute pornographic magazines and compare Yvonne's body with the models' bodies. Yvonne has no reply for this behavior, yet no one takes seriously her discomfiture, her rage, or her conviction that pornography equates with violence against women. One of the men at the party, Clive, admits to a stack of pornographic videos but suggests that he "couldn't bear the idea of children and animals used like that" (172). That women are also *used* appears not to have occurred to him.

Juxtaposed with the dinner party scene is the first courtroom scene, in which Rowena is forced to declare herself guilty or not guilty (after first attempting silence, she later chooses "not guilty" as the only answer she can give). She is determined to represent herself, a decision that causes the judge, a woman, to question her sanity and to delay the trial until after a psychiatric assessment is made. Rowena's encounter with the psychiatrist occurs in scene 9, and the courtroom reappears in scenes 16 and 17. However, there are repeated references to the law throughout the text. In one example, a woman working for Rowena's husband Trevor had a dog that was killed in a house fire. But leading up to the fire—which appears suspicious—the dog had fought with and killed her neighbor's dog, and the neighbors had been taking legal action against it. Trevor's response—"How could you take a dog to court? What would it say when it got there? Alec reckons it would take a bow wow" (189)—points up the problematics of viewing the courtroom as a site of truth.

The law intrudes in other ways, too, though rarely with justice for the female. One of Yvonne's students is convicted of raping a girl, and the boy's mother rethinks her decision to allow him pornography, though she protests that the girl had "only been raped but was unharmed" (180). One of Rowena's clients, a former prostitute, is sexually assaulted by Yvonne's husband but gets no recompense. At

some level, then, these women's stories are not believed, and even the girl who was raped does not really find justice.

Rowena's session with the psychiatrist backs up this denial of women's words. When Rowena is asked about her reaction to pornography—a reaction considered extreme by the psychiatrist—Rowena replies, "I felt sexually assaulted every time I went out—adverts for everything from oranges to Opels, all sold with women's breasts." The psychiatrist's gloss on this is clear: "You became prudish?" (207). He is unable to understand Rowena's response, in part, it seems, because Rowena has never been *physically* assaulted; he has no physical "evidence" for her experience. Moreover, he notes that she is wearing a skirt—thus in his eyes, she is a normal (read heterosexual) woman. Again, the uniform of femininity, as in *Trifles*, is read as evidence. Rowena's response is biting but misunderstood: "I could say, I can continuously compromise my iconoclasm with conformist clothing camouflage when complying with the correctness demanded of ceremonies such as these" (207–8). The psychiatrist's response is perhaps inevitable, as he oversteps his boundaries, rephrasing her words and diagnosing her in the process: "Would you concede that your opinionated and dogmatic nature shows an insecure assertiveness?" (209).

Davis argues that "Daniels does not trust the legally democratic, responsible, and impartial institutions of society to render Justice."[45] It is thus doubly important that a crucial scene in the play is done in pantomime. The crime scene (so to speak) is short and silent. A man approaches Rowena twice in an underground subway station, whispering in her ear words that the audience cannot hear. We must gauge them from her reaction, which is one of initial retreat. When he continues to pursue her, aggressively, she reacts with equal aggression. Rowena does indeed push him onto the underground line, thereby causing his death, but this is an accident, not murder. As Davis comments, "The irony that Daniels concentrates on is that the only 'true' victim society accepts is the Underground fatality; incest, threats, rape, sexual harassment, domestic violence, and sexual assault go unnoticed and unacknowledged, yet a fatal shove into the path of an oncoming train could not fail to be reported and successfully prosecuted."[46] Davis's point about the ubiquity but concealment

of crimes against women appears to be Daniels's main target. What woman, like Rowena, has not walked alone at night (as she does in scene 4) and felt herself a potential victim, with a running monologue about her own potential culpability in an imagined crime against her? What West defines as "gender-specific injuries" are trivialized or degendered in ways that mask their power over women's lives.[47]

The penultimate scene is the judgment scene, and this begins with the Judge recounting the evidence against Rowena, evidence that is biased, subjective, and irrelevant to the crime itself: "We have heard evidence, including extensive psychiatric reports which suggest you are removed, vague, uninvolved, and failed to maintain normal, acceptable patterns of communication. Prudish to the point of being sexually repressed—frigid. Is there anything you would like to say?" (226). Rowena's response—to cite court cases where men who have killed their partners received sentences for manslaughter on the basis of mitigating circumstances such as nagging—is deemed irrelevant by the court. That she is articulating the patriarchy of the court must be denied legal standing or relevance.[48] Daniels's stage directions make clear that *"In future productions more up-to-date examples can be substituted for these"* (226; italics in original), an acknowledgment both that the women who have been killed will be forgotten and that others will take their place. Clearly, it is assumed that the cycle of leniency toward men who murder their partners will continue, whereas the weight of the law will be positioned against women who murder.

Sue Lees argues that "the double standard of sexual reputation acts both as a form of disciplinary power over women's bodies, constricting their independence; and, as the basis for assessing a woman's credibility in legal trials, it serves as an institutionalized norm within the legal system to legitimate male violence in the name of scientific objectivity, impartiality, and neutrality."[49] While Lees' words relate primarily to rape trials, they are also relevant here: Rowena's apparently "frigid" nature is used against her to suggest her irrationality. Lees further argues that "the only foolproof mitigating circumstances that have been used by women convicted of murder relate to postna-

tal depression and premenstrual tension, epitomizing the tendency to treat female conforming behaviour as healthy and nonconforming behaviour as sick or mad."[50] Female fear is not judged to be sufficient cause; male aggression is not judged to be sufficient cause; only female irrationality (seeing the world as a sexist place) can explain (but not explain away) Rowena's guilt.

Gabriele Griffin argues that in Daniels's play, "women are the victims of a patriarchal structure in which their abuse is condoned by institutions which judge *them* rather than the perpetrators."[51] This appears to be true of all of the plays examined here, which then grapple with the question of whether to allow someone else to speak *for* a woman as well as how to enact the most appropriate closure to the cases. In all these cases, closure is neither neat nor unproblematic, and some crimes (overwhelmingly, those against women) go unpunished. In *Trifles*, Minnie Wright gets away with murder; in *Machinal*, the Young Woman does not. The former play relies on the erasure of the woman's real story, whereas the latter ensures a central gap regarding motive. The men judging the Young Woman cannot see the truth. There is some evidence that the historical Ruth Snyder was herself a victim of violence who believed that her all-male jury would not look for the truth or understand the case.[52] In *Machinal*, the Young Woman's last lines are "Somebody, somebody," but her voice is cut off midword, thus metaphorically and literally suggesting the unsaid.

In *Blood Relations* and in *Masterpieces*, women's words are transformed, and motives are deliberately misconstrued. Lizzie Borden's clear *theatrical* guilt is reenacted even as her trial itself admits no such guilt, whereas Rowena's innocence is left unnarrated, enclosed by texts which read her wrongly. For the characters in these plays, the message is clear: there is alternative justice (women concealing evidence) or no justice at all (women wrongly charged with murder).

What these plays have in common, despite differences in style and country of origin, is a focus on the gendered reception of the law and the way in which women's stories of guilt or innocence become entwined with their "appearance" before the court. As these plays suggest, both the theater and the courtroom are arenas of "inherent

specularity,"[53] where women are viewed and re-viewed, and where power (or lack of it) is manifested. In these plays, guilt and innocence are "staged," and justice itself is blind only in the sense of refusing to see gender's impact in the courtroom. If gender *is* taken into account, it is only to ensure that femininity acts as a foil to guilt; the feminine woman is by definition innocent (indeed, her very femininity depends on her innocence). There is no objective search for truth, just a variety of interpretations to show defendants in the best light, all of them mouthed by others.

Angela P. Harris argues that the so-called objective voice of the law is "ultimately authoritarian and coercive in its attempt to speak for everyone."[54] As these plays reveal, however, such ventriloquism is inappropriate, masking as it does women's voices, women's motives, and women's (various) gendered experiences of the law. If these women's stories remain incomprehensible to the court, they are not incomprehensible to the audience, who recognize the ways in which each text provokes a political response. The asymmetrical power relations of the court make for compelling viewing on the stage and offer a myriad of opportunities for audiences and readers to review the scripts of women's lives—and the justice they do or do not receive. In the final chapter, we move from the stage to the screen, and return to a focus on the appearance of guilt—and innocence.

Chapter Five

Spectacular Expectations
Women, Film, and the Law

The relation between women and the law is insistently explored in film and television serials. Indeed, in general terms, the law and film link is perhaps even more apparent than the law-literature connection. Mainstream cinema offers summer blockbusters by John Grisham and Scott Turow, social-conscience films about the law, such as *Erin Brockovich, Class Action, Philadelphia, A Civil Action,* and *The Insider,* and comedies such as *Legally Blonde* and *Laws of Attraction.* Hollywood has long been fond of the courtroom, offering early women's law films including *I'm No Angel* (1933), starring Mae West; *Adam's Rib* (1949), a comedy vehicle for Katharine Hepburn and Spencer Tracy; as well as the musical *The Lady Objects* (1938) and the melodramatic *I Want to Live!* (1958), based on the real-life story of Barbara Graham, sentenced to death for her part in murdering an elderly widow.

David A. Langford and Peter Robson suggest that there are as many as 750 mainstream films in which lawyers or the law play a part, with about 10 percent of those films specifically focusing on lawyers. Not surprisingly, given these figures, entire books have been devoted to the intersections between law and film. Here, too, academics have attempted to delimit the definitions employed in the law and film subdiscipline, so as to provide both critical consensus (a not uncommon project among lawyers) and a coherent body of texts on which to focus.[1]

Stephen Greenfield, Guy Osborn, and Peter Robson have argued that defining precisely what the "law film" is can be tricky, given that,

on the whole, films in this category are less concerned with the law per se, and more involved with "the penumbra of law, the places of law and the people of law." It would be a mistake, they feel, to define law films solely as those which employ a courtroom setting, since some films which do so have their critical focus elsewhere. Their wider definition of the law film requires that "the geography of law, the language and dress of law, legal personnel and the authority of law" must be apparent in some shape or form within the film.[2]

This definition works well in relation to the texts analyzed in this chapter. It is worth noting, however, that this definition does not highlight film theory as in any way essential to a reading of law films. Indeed, most law-film critics (myself included) do not come from the academic discipline of film studies, and few grapple with the theoretical stances of auteur theory, star theory, psychoanalysis, or technical film criticism in their explorations of law films. Rather, most law-film critics explore the first half of this hyphenated term, seeing film as an "accessible" space for teaching law students, or as part of popular culture's negotiation with the law. As such, we are vulnerable to charges of misreading films or of underemphasizing their technical aspects, although these charges can be successfully countered by setting out the parameters of the research being undertaken. John Denvir, for example, in his edited collection *Legal Reelism: Movies as Legal Texts* (1996), is upfront about his critical position in relation to films: he and his contributors "use film as a tool to get better purchase on their study of how law operates in the larger culture."[3] Like Denvir, I read films as *texts* and as part of the cultural production of law in society. I also explore television programs next to films not because I believe they are the same medium—they are not—but because the representation of lawyers and the law is perhaps even more popular in relation to television (though in some respects, just as difficult to define: do "cop shows" count as legal texts?).

Thus, on the smaller screen, television serials such as *Perry Mason, L.A. Law, Murder One, The Practice, Ally McBeal*, and, in Britain, the short-lived but much revered *This Life* focus on lawyers, explore the mechanisms of the law, and interrogate women's place within it. In this chapter, I read a series of visual texts ranging from

melodrama to comedy but focus my examination primarily on the films *I Want to Live!*, *Adam's Rib*, and *Legally Blonde*, as well as the television series *Ally McBeal*. To me, these are key visual texts that interrogate the position of the woman as tragic lawbreaker or comedic lawmaker and move the argument of this book (though not unproblematically) to its final conclusion, that of courting success. The rationale for including both film and television in this chapter is to find the common ground they share in relation to women and the law. Such an aim is underlined by Greenfield, Osborn, and Robson's discussion of film classification: "The theoretical point of the doctrine of *stare decisis* is to find common ground and make future decisions on the basis of this original case. So, in a sense, we might usefully compare the process of the classification of films with the classification of cases, and an essential part of this action is finding out the meaning in both."[4] The "common ground" between film and television, from my perspective, is the relationship constructed between women and the law. In both media, women often occupy central roles either as lawyers or as women in conflict with the law, despite the fact that, statistically speaking, fewer women come before the court—or present cases to it. They do, however, make "good copy" and are offered up as spectacles (for men), role models (for women), or lessons in what happens when women overstep their feminine roles (for both).[5] Richard K. Sherwin argues that "Law is both a co-producer and a by-product of mainstream culture. The stamp of the latter continually falls upon the meanings the law produces."[6] Thus, it is not surprising that visual representations of women in the courtroom are so popular (Rennard Strickland has argued that in the 1930s, women lawyers on screen outnumbered their real-life counterparts[7]) nor that it is often "real-life" cases (as in theater) that take center stage.

Television and the Female Killer

The attraction of the law on contemporary television is clear: the programming schedule of Britain's new ITV3 channel is primarily made up of law series reruns: *L.A. Law*, *The Practice*, *Inspector Morse*.[8]

In the United States, real life takes center stage: trials are often televised as if the law is or should be primarily a spectacle. The power of televisual impact was made clear in January 2005, when Andrea Pia Yates's conviction for killing her children was overturned on appeal by the Court of Appeals for the First District of Texas. Yates, a Texan mother who drowned her five children in the bath in the summer of 2001, while suffering from postpartum psychosis, was caught in an odd legalistic bind: though acknowledged as mentally ill, even severely so, she was also deemed to have known right from wrong at the time of her actions, proof, under Texan law, that she was sane.

Andrea Yates was charged with the deaths of just three of her children, a fact that initially appears perplexing. It was only after she had been convicted and sentenced to life imprisonment that the reasoning behind this apparent discrepancy became clear: had she been acquitted, the prosecution could have tried her again. So much for double jeopardy. Yates was always already guilty under Texan law.

During the trial, a psychiatrist, Dr. Park Dietz, a consultant for *Law and Order*, gave false evidence that there had been an episode of *Law and Order*, aired shortly before Yates killed her children, in which a woman drowned her children in the bath, claimed postpartum depression, and got away with murder. Such an episode never existed. In overturning the conviction, the Court of Appeals reported:

The State argues that Dr. Dietz's testimony regarding the "Law & Order" episode was not material. The State asserts that "there is no reasonable likelihood" that the testimony "could have affected the judgment of the jury," but does not make any argument to support such a conclusory statement. We conclude that the testimony . . . was material. . . . [as] evidenced by the fact that appellant's attorney felt compelled to address it in his own closing argument.

The State also asserts that Dr. Dietz did not suggest that appellant used the plot of the show to plan killing her children. Although it is true that Dr. Dietz did not make such a suggestion, the State did in its closing argument.

Five mental health experts testified that appellant did not know right from wrong or that she thought what she did was right. Dr. Dietz was the only mental health expert who testified that the appellant knew right from wrong. Therefore, his testimony was critical to establish the State's case. Although the record does not show that Dr. Dietz intentionally lied in his testimony, his false testimony undoubtedly gave greater weight to his opinion.

On the other hand, had the jury known prior to their deliberations in the guilt-innocence phase of the trial, that Dr. Dietz's testimony regarding the "Law & Order" episode was false, the jury would likely have considered him, the State's only mental health expert, to be less credible.[9]

There are few cases in which such overt linkages between television and the outcome of a court case can be proved, but media coverage of women's crimes has long been considered potentially prejudicial, and the public's appetite for these stories does not appear to be assuaged. American made-for-television movies revel in stories about women in conflict not only with the law, but with their supposedly natural feminine selves; violent women make great television. Thus, in the early 1990s a spate of television movies about "real life" cases aired on terrestrial TV, the best-known of which were the Amy Fisher story (about a sixteen-year-old girl who attempted to kill her older lover's wife) and the Betty Broderick story (about a Californian woman who shot and killed her wealthy ex-husband and his new young wife). The fact that these were "stories" is clear: of the three versions of the Fisher story broadcast, two had the word "story" in the title, while the third title referenced *Lolita*),[10] and the movie about Broderick, *A Woman Scorned: The Betty Broderick Story*, had a voiceover from Meredith Baxter to lend credence to the claim that this was, indeed, *her* story (a claim the real Broderick denies). As Stephanie Savage argues, "Despite Baxter's occasional voice-over, any enunciative power that the Betty character might have is undermined by the fact that we are not encouraged to identify with her. We are thus positioned more voyeuristically (looking at Betty and the spectacles she creates) than subjectively (seeing 'with' her, from her point of view)."[11] Fisher, released from prison and now a respectable mother and newspaper reporter herself, has capitalized on her story by writing her own version and appearing on television shows like *Oprah Winfrey* in order to discuss her case. Broderick remains in prison, serving a sentence for second-degree murder. Broderick's story in particular is an interesting case study in how television copes—or perhaps more accurately, does not cope—with a narrative of womanly rage.

Helen Birch claimed that in the 1990s, when these television movies were shown, audiences had become increasingly "image-liter-

ate"; the result, Birch argues, is that "the always shifting boundaries between fact and fiction, reality and representation, have in some cases become so blurred as to be almost indistinguishable. And precisely because she is relatively rare, the woman killer presents a far more dramatic spectacle than her male counterpart. Male violence is, after all, old news."[12] It is perhaps not surprising, then, that the television presentation of Broderick was "gleefully misogynistic." At the same time, there is a ghostly narrative underneath this story of the woman scorned, a narrative not recorded in this program, but in the programs around the actual case itself. Savage traces a series of responses to the Broderick trial which show that the media reactions to the real trial were mixed and could not be articulated in a two-hour made-for-television movie. Broderick's original trial resulted in a hung jury that "could not be convinced of a unified, coherent story that established what happened and who was responsible for it after listening to an entire month of testimony." Rather than deal with these ambiguities, the movie instead wrote a completely different "true" story; in it, Baxter as Broderick enacts a premeditated crime that could only be read as first-degree murder. However, in "real life," Broderick was eventually convicted of second-degree murder in recognition of the fact that she had *not* planned her victims' deaths.[13]

In her reading of the made-for-television movie, Savage offers a compelling caution:

Instead of trying to focus our energy and resources on discovering how-to-build-a-better-Betty-Broderick-story, I would suggest that we need to be wary of television's seemingly insatiable appetite for real-life which eats up the experience of real women and spits them out in its own co-opted, pathologized form. Any sites of negotiation these narratives might open up can be easily closed, critiquing not the system, but the women that it fails.[14]

The larger screen, too, is interested in "real-life" stories of women killers. One of the latest films in this genre is *Monster* (2003), starring Charlize Theron (who won an Academy Award for her performance). *Monster* tells the (overtold?) story of Aileen Wuornos, a Florida prostitute executed in 2002 for killing seven men during the late 1980s and early 1990s. Wuornos has the dubious honor of being called—inaccurately—the United States' first female serial killer, but

Wuornos herself claimed that she killed the men in self-defense: they had all attempted to attack or rape her. However, in the eyes of many, the number of men killed, and Wuornos's profession—she was a highway prostitute—made her claims unlikely (despite the fact that this very profession actually put her at a much higher risk of sexual assault than women who are not prostitutes). Miriam Basilio argues that "[t]he police and media stress on the singularity of Wuornos as a female serial killer veils both the routine incidence of violence against women and the potential threat embodied in the possibility of women defending themselves."[15]

Moreover, the fact that Wuornos was in a lesbian relationship at the time of the killings appeared to suggest that she was a stereotypical man-hater, and the images of her that circulated in the press reinforced the ideas of her sexual pathology. Such images "intersect with gendered and classed terms to reveal deep-seated anxieties about attempts to redefine social and legal categories."[16] Lynda Hart goes even further:

Thus the ultimate violation of the social instinct, murder, and the perversion of the sexual instinct, same-sex desire, were linked as limits that marked the boundaries of femininity. Crossing either one of those borders constituted a transgression from which there was no return. Women who killed, and women who loved other women, passed through the mirror of oppositional gender discourse and landed on the other side.[17]

What is clear is that Wuornos, as a prostitute and a lesbian, did not fit comfortably into the stereotypes of the feminine victim, and as a result, she found herself outside of the protection of the judicial system and "normal" society.

Prior to the release of *Monster*, whose title encodes the fact that Wuornos was seen as beyond the boundaries of normal feminine behavior, Wuornos was the subject of two documentaries by Nick Broomfield, *Aileen Wuornos: The Selling Of A Serial Killer* (1992) and *Aileen: Life And Death Of A Serial Killer* (2003), as well as a TV movie (*Overkill*, 1992). Despite the suggestion of her aberrance, Wuornos was much like many women in jail. As Karlene Faith suggests, such women are usually "exceptionally desperate, foolish, or unlucky. Their lawbreaking is a futile response to the continuum of

private and/or social abuse to which females are commonly subjected."[18] This is not to suggest that Wuornos is a feminist heroine—she is not (though her case was belatedly taken up by some feminists in a bid to make visible the incredible risks and violence of the life of a sex worker).

Wuornos effectively became a killer not because she was powerful, but because she was *powerless*. This, according to Candice Skrapec, makes her like many other serial killers. Skrapec sees no substantial difference between the motives of male or female serial killers: they do what they do in order to fight perceived powerlessness and to assert some sense of self.[19] What is only hinted at in *Monster*—but is more apparent in the documentaries in which Wuornos herself had a voice—is that she was also struggling with mental health issues.[20]

By the time *Monster* was released, Hollywood has its ending already written; Wuornos had been executed the year before. The irony of the film's title becomes clear when the viewer sees the relentless victimhood of the central protagonist; this lesbian killer is nothing like the beautified and sexy bisexual that Sharon Stone played in *Basic Instinct* (1992), but rather a drab, slightly overweight, and defiantly ill-kempt woman whose sense of right and wrong had been skewed by a violent background. This made *Monster* unlike many other filmic depictions of female killers, who are routinely portrayed as beautiful and deadly. As Christine Holmlund argues, "the murderesses in these films are, to a woman, white, lithe and lovely, because Hollywood sees female violence as erotic and defines 'erotic' within narrow parameters."[21] *Basic Instinct* fits this mold, as does the earlier film *Nuts!* (1987), starring Barbra Streisand as a high-class hooker who kills a john in self-defense. *Monster* turns it on its head, with Theron famously gaining weight to play the part, and wearing make-up and prosthetics to disguise her beauty.

If, in the early part of the twenty-first century, Hollywood actresses routinely take up the challenge of appearing "ugly"—witness Nicole Kidman transformed into Virginia Woolf by way of a prosthetic nose in *The Hours* (2002), Renée Zellweger gaining enough weight to play a neurotic singleton in the *Bridget Jones* films (2001 and 2004), and Gwyneth Paltrow sporting a fat suit in *Shallow Hal* (2001)—mid-

twentieth-century films generally capitalized on an actress's beauty in order to secure audience identification and sympathy. A case in point is *I Want to Live!*, a Hollywood biopic which starred Susan Hayward as the condemned woman Barbara Graham.

I Want To Live!
"Good-looking girl, too. Kinda fools you"

Unlike contemporary films, *I Want to Live!* had to abide by the 1930 Motion Picture Production Code, or Hays Code as it was known, which governed the moral messages of films and forced filmmakers to ensure a "proper" reading of the law (that is, one in which moral messages were promoted, and criminals were caught). At the same time, the film had a clear message: capital punishment was wrong. As a result of these two factors, the story of Barbara Graham, though emphasized as "factual" in both the opening and the closing shots of the film, is transformed into the narrative of a woman who, if not exactly an "innocent," is nevertheless not guilty of the crime of which she has been accused. The real story of Graham is perhaps more complicated than its celluloid version, and in order to unpick why, I need to explore how the Hays Code worked with and against a narrative of the wrongly imprisoned woman.

Under the Hays Code, named for Will Hays, a former U.S. Postmaster General, the motion picture industry self-regulated (in order to avoid more stringent federal regulation), and the code argued that "[i]f motion pictures present stories that will affect lives for the better, they can become the most powerful force for the improvement of mankind." The noninclusive language used here is an indication of the time frame in which it was produced, but is also evidence, subtly, of the way in which the code promoted the gendered status quo. In the code, the rules for what could be represented (and how) were laid out in three general principles, with elaborated subsets and supplementary explanations.

Principle 3 focused on the law and particularly on crime. Its purpose was to protect representations of the law (whether "human" or "natural") from ridicule. This principle appears to have had two basic

premises: that representation of crime might lead to its enactment, and that it is morally reprehensible to show crime in the first place (the rationale for this being that since it was difficult if not impossible to segregate audiences by class—read intelligence—then filmmakers needed to protect those who were most vulnerable to the negative messages of a film). The code proclaimed that crimes against the law "shall never be presented in such a way as to throw sympathy with the crime as against the law and justice or to inspire others with a desire for imitation."[22] There was specific guidance for particular crimes; in relation to murder, for example, the code forbade the portrayal of techniques that might lend themselves to easy imitation. In addition, brutal killings could not be shown in detail, and revenge plots could only be located in historical times (where, presumably, they were more appropriate). The code governed how far the methods of crimes could be detailed (again with the emphasis on preventing imitation) and the presence of guns. The code suggested that no mention should be made of drug trafficking, and even the representation of alcohol was subject to restrictions.

Also covered under the code were restrictions on sex, vulgarity, obscenity, profanity, religion, national feeling, dances, locations, titles, and nudity (under a section entitled "Costume"). The final "particular application" dealt with what the code called "Repellent Subjects." These, the code noted, "must be treated within the careful limits of good taste." The first of the seven subjects listed (which also included brutality, cruelty to children and animals, and the "sale of women, or a woman selling her virtue"), was "[a]ctual hangings or electrocutions as legal punishments for crime." Quite how hanging or electrocution fell under the "limits of good taste" is hard to ascertain; but the presence of the Hays Code is visible in the melodrama *I Want to Live!* which, though telling a "true" story, necessarily omitted parts of Barbara Graham's life. Conveniently, these omissions also satisfied the filmmakers' desires to show the story of a woman "wrongly" accused.

The Hays Code obviously affected how films regarding crime were made and also ensured that "cultural realities were altered": good guys always won, and crime never paid.[23] Later revisions in the

late 1960s eased some of the difficulties filmmakers had encountered. The imagined audience that the Hays Code sought to protect was youthful, easily swayed, unable to tell right from wrong, and caught up in the allure of the apparently real lives presented before them. Their critical faculties were few and damaged through mass congregation. People from small towns were particularly susceptible to the wrong kinds of messages and, therefore, required protection, as did individuals from lower and "criminal" classes. The code presupposed that a film "builds character, develops right ideals, inculcates correct principles, and all this in attractive story form."[24] Within this framework, the story of Barbara Graham was inevitably altered.

Barbara Graham was a petty criminal and "good time" girl who had a string of convictions for minor crimes such as vagrancy and soliciting. Her most significant crime up until the time of her arrest for the murder of Mabel Monahan was perjury: she provided a false alibi for two friends, to her own eventual detriment. As the film proclaims, "One thing about you, Bonnie. You never let your pals down." This refrain comes to haunt the screen version of Barbara (Bonnie) Graham, as she struggles to balance the competing demands of friendship and survival, all the while assuming that her own "pals" will help her out. Graham was convicted alongside Emmett Perkins and John Santo of Monahan's March 1953 murder, committed during a failed robbery attempt, while a fourth member of the team, John True, turned state's evidence and was instrumental in identifying Graham as the main culprit. Graham appealed her conviction but was sentenced to death. She was executed on June 3, 1955. Three years later, Walter Wanger's film I Want to Live! portrayed Graham as wrongly imprisoned. Susan Hayward won an Academy Award for her performance as "Bloody Babs." The film is remarkable on two accounts: the "performance" of Hayward as Graham and its depiction of the ways in which the media made a spectacle out of the accused woman.

The audience is introduced to Graham as a smart, feisty woman who has scant regard for the law; we witness her gambling, driving a getaway car, and passing bad checks. We also see her attempting to give up this life of crime when she gets married to Hank Graham. On being informed of her desire to go straight, Emmett Perkins replies,

"You've been married three times now. Let's assume divorced as many. You oughta have it figured by now no white knight's gonna come riding through your life." During this speech, he constructs a house of cards; when she leaves, with her fingers crossed for a better way of life, he knocks the house down. As elsewhere in the film, the symbolism is far from subtle; shortly after this scene, the audience witnesses Graham also being knocked around, and any fantasy of a better life is shown to be just that: a fantasy. This also sets up a running theme: Graham as (unreliable) fantasist, performer of a series of roles that never quite fit.

The film works best by juxtaposing performance and omission. In order to tell its story of the wrongly accused, it avoids the scene of the central crime altogether; instead, we are witness to the moment that the team is arrested. In the filmed version, this occurs because Graham was followed by the police after visiting her small child, and the entire event is stage-managed, with spectators and the press in abundance. On the way to the scene, one policeman says in a bemused manner that Graham is a "good-looking girl, too. Kinda fools you." Here, her beauty is coded as a disguise; she isn't really the beautiful wife and mother that she appears to be. Rather, she is an archetypal femme fatale. Mary Ann Doane argues that such women have a peculiar kind of power,

insofar as it is usually not subject to her conscious will, hence appearing to blur the opposition between passivity and activity. She is an ambivalent figure because she is not the subject of power but its *carrier* (the connotations of disease are appropriate here). Indeed, if the femme fatale overrepresents the body it is because she is attributed with a body which is itself given agency independently of consciousness. In a sense, she has power *despite herself*.[25]

It is worth considering this idea further, particularly in relation to Hayward's acting, which, Dennis Bingham argues, "employs performance codes that collide not only with the stereotypes of the dangerous, transgressive woman but also with expectations of how a beaten, trampled-upon victim would act."[26] These two stereotypes are presented side by side during the arrest sequence. Surrounded by the police, the team is told to give themselves up, one by one. Perkins

leaves first. Jack Santo is so enraged that they have been discovered that he beats Graham up before admitting defeat. Barbara is thus last to leave: she rises, combs her hair, and picks up her son Bobby's toy tiger. She knows enough to look presentable, but holding the toy tiger, which is later used to great effect (a newspaper catches her growling like a tiger herself), appears at least initially to be simply another representation of her love for her child. However, when she exits the building, it is as if she has arrived on stage. She initially refuses to put her hands above her head but instead stands stylishly, looking at her audience, and being rewarded with the flash of many photographers' bulbs. Bingham notes, "As Graham, Hayward's movements look studied and deliberate, as if the character were thinking out every move before she makes it. Is it Hayward or Graham who physically mimes cool, frustration, defiance, hopelessness, or joy?"[27] This deliberate confusion of the actress-as-Graham and Graham-as-actress is essential for a reading of the accused woman as caught up in a part larger than herself.

The idea of performance continues right up until the night before the execution. After the nurse on suicide watch admires her clothes, Graham replies, "I mustn't disappoint my public. I can just imagine what those papers are gonna say. Bloody Babs spent her last night decked out in lounging pajamas of her favorite color: flaming scarlet! That's what they always call red when I wear it." This self-conscious awareness of an audience is in part determined by the press's involvement—indeed, fascination—with her case. Bingham argues that Barbara Graham's victimization was "spectacularly invasive, or invasively spectacular."[28] At this point, it is worth returning to the Hays Code, in which there is a specific contrast made between newspapers, which are characterized as "after the fact and present things as having taken place," and film, which "gives the events in the process of enactment and with apparent reality of life."[29] In relation to I Want to Live! this contrast is instructive, given that the film details the many stories of Barbara Graham that circulated in the press and, though always "after the fact," were not necessarily after the "facts."

On one level, then, it could be argued that, in the film, the media is as much on trial as Graham is; Bingham goes so far as to suggest

that the film virtually suggests a conspiracy between the court and the press.[30] Presumably real newspaper headlines appear with regularity in the film, and one of the main characters is Ed Montgomery, a journalist from the *San Francisco Examiner* whose words both introduce and conclude the film:

You are about to see a FACTUAL STORY. It is based on articles I wrote, other newspaper and magazine articles, court records, legal and private correspondence, investigative reports, personal interviews—and the letters of Barbara Graham.

These words are accompanied by his signature, as well as the gloss "Pulitzer Prize winner, *San Francisco Examiner.*" Montgomery is originally shown as participating in the media spectacularization of Graham. As his on-screen character calls in a story to an editor, he notes that he will put "Babs" in the lead and keep the men in the background, because she is the one who will sell papers. He even creates an off-the-cuff headline, "Titian Topped Tigress," and opines, "It's Mrs. Graham's tough luck to be young, attractive, belligerent, immoral—and guilty as hell." As the case continues, though, Montgomery changes his stance in relation to the question of her guilt or innocence and eventually starts writing pieces on her behalf; thus, he becomes metaphorically cut off from the apparent conspiracy against Graham and becomes instead a figure aligned with justice.[31]

Certainly justice—or lack of it—becomes an issue in the case. For example, it appears that Graham was duped into trying to secure a false alibi by an undercover policeman, Samuel Sirianni. (In the film, the officer's name is reported as Ben Miranda, and it is noteworthy that his surname coincidentally becomes synonymous with the failure to inform suspects of their rights.)[32] The film sets up the exchange (which the officer taped) in a way that suggests Graham's innocence, though in the court case itself (and in the film's reenactment of the trial), this evidence is crucial in finding Graham guilty. Clearly, the film audience is offered a visual representation of the exchange, which allows for—even encourages—a specific reading of Graham, whereas both the film and the trial juries must rely on words alone and recollections rather than enactments of events. Graham, who in real life had been having a sexual relationship with a fel-

low prisoner, is here shown to be reliant on her "friend" Rita, who sets up the entrapment (and who benefits by being released from prison herself). After setting up an alibi in which Graham agrees to the lie that they spent the night of the murder in a hotel room—clearly, Graham was not afraid of appearing to be "immoral"—Miranda pretends to back out unless she offers him solid information on her actual whereabouts that night:

MIRANDA: "You were there, weren't you."

BARBARA: "Is that all you'll believe?"

MIRANDA: "It would be an easy thing to believe, and I wouldn't have to worry."

BARBARA: "I'll double your money." [Miranda walks away, but Graham calls him back.] "Ben. Have it your way."

MIRANDA: "You were with them? With Perkins and Santo? Because if you were, it's okay. It'll be my story against Bruce King's. You were with them, hunh?"

BARBARA: "All right, all right, all right, I was with them."

MIRANDA: "Then from here on in you relax. You're a cinch to beat the cyanide."

Reading the body language of the two actors, the audience is led to believe that Graham is a foolish innocent who has unwittingly entrapped herself. When the evidence is played in court, Graham reacts with passion:

BARBARA: "I was desperate—"

PROSECUTOR: "Mrs. Graham!"

BARBARA: "Have you ever been desperate? Do you know what it's like?"

JUDGE, slapping his hand on the desk: "Mrs. Graham!"

PROSECUTOR: "Your honor, I move that be stricken!"

JUDGE: "So ordered. And Mrs. Graham, you have to be—"

BARBARA: "I know, I'm sorry. I know."

JUDGE: "Proceed."

As is clear from this exchange, which occurs within the confines of the courtroom and, therefore, must conform to appropriate standards (as, apparently, the entrapment did not), the law cannot deal with what Alison Jaggar calls "outlaw" emotions.[33] It can read Graham's actions only as evidence of guilt (a reading given extra weight when allied with her prior conviction for perjury). The judge requires Graham to conduct herself with decorum—hence, the admonishment against emotion. An emotional woman can be read as a feminine woman, and here, Graham is only partially allowed this descriptor. As has been noted elsewhere, a woman who performs her femininity "appropriately" is more likely to be considered innocent. This reading of Graham was never offered; she was always already guilty in the eyes of the court (with even her own lawyer asking to be released from the case).

The press also took this stance and used Graham's femininity against her. Indeed, Sheila O'Hare notes that reporters variously described her hair color, clothes, and body to suggest that her character was suspect; even when she appeared more ladylike, it was suggested that this was just a disguise. Moreover, reporters "tended to disregard legally significant developments in favor of speculative or sensational articles."[34] Such charges have also been laid against journalists in relation to the trials of Grace Marks, Ruth Synder, and indeed Andrea Pia Yates, thus suggesting that the potentially problematic link between the media and the court is an ongoing issue for women in conflict with the law.

Bingham suggests that there is a tension in *I Want to Live!* between "contradictory pulls towards documentary and melodrama,"[35] though it is clear that the director eventually veers towards the latter. The film spends an inordinate amount of time on the preparations for the execution, following them faithfully. The film also makes much of the true-to-life last-minute stays of execution which prolonged Graham's final moments. At the same time, the film does not entirely suggest her innocence; rather, it allows for lacunae in her story that can be filled in a number of ways. For example, she asks the prison's Catholic priest to hear her confession, and we later see a logbook indicating that he had stayed with the prisoner for three hours:

long enough to confess to a number of crimes, not just the one of which she was convicted. As is appropriate, though, such confidential information is withheld.

It seems almost certain that the historical Graham was involved in the attempted robbery that preceded the murder, but whether she struck the fatal blow is unknowable, perhaps even improbable: the prosecution claimed that Mrs. Monahan had been killed by a right-handed person, but Graham herself was left-handed. Graham's lawyer did not address this issue in the original trial, thus making this evidence inadmissible in the appeal. Those who were in a position to know the "truth" chose not to contradict the official version: John True had struck a deal, and Santo and Perkins were hoping to avoid execution themselves. As Graham quips in the film, "Just this once I wish it wasn't ladies first."

But "lady" is a term that sits uneasily on Graham, and even the film which suggests her innocence cannot entirely gloss over the sensational past that makes "lady" an unlikely tag. She was a "good time" girl, not a "good" girl. After serving a sentence for perjury, for example, she is warned against violating her parole. The matron reads out a list of ten convictions and notes as well that Graham had spent two years at the Ventura Reform School for Girls. Graham responds, "As long as you're adding up the score, my mother was in Ventura before me. That oughta be worth extra points." Here, heredity and breeding are set up as ironically suspect. The matron tries again: "What I'm trying to say is you *do* have a choice. People have managed to be fairly happy by not getting into trouble. Get a job! Maybe get married." Graham's response—"I have been. Occasionally"—is humorous but accurate. Other facts from her life cannot be so easily shrugged off: not only had Graham been married four times, but she was probably a drug addict, a bisexual, and had three children, rather than just the lovable toddler of the film; however, to show Graham as an unfit mother would do the film's case no good. She must instead be shown to be visiting her son (hence her capture), ruing his loss, and anxious to reestablish a family network.

Bingham argues that the film worked by "identifying with her and by seeing the specific ways in which her femininity, made synony-

mous with her criminality, rendered her an object of invasion and dehumanization by the media and the law."[36] In a final twist on the spectacularization of the female criminal, Graham asked for and received a mask to wear to her execution. In the filmic version, this mask, which protects her from the stares of the witnesses to her execution, also disables her: she is forced to lean on the men taking her to the gas chamber. In this shot, the director finally confirms Graham's femininity—a confirmation that comes too late to save her. It is, therefore, not accidental that the director focuses on how the men's hands shake as they strap her in.

Here, of course, as with *Monster* above, the ending is already written. Although there are stays of execution, there is no last-minute reprieve, and in the film and real life, Graham went to her death.

The Other Spectacle on Display:
Woman as Lawyer

There is, of course, another side to the story of the spectacle of women and the law: female lawyers. Several studies have concluded that women lawyers are not represented in a positive light in the majority of Hollywood films.[37] Paul Bergman and Michael Asimow go so far as to ask: "Would you want to hire a woman trial lawyer for your law firm or to represent you in a criminal case? Would you want to fall in love with one? Definitely not, if you base your decision on what you've seen in the movies. Almost without exception, trial movies present women lawyers in viciously stereotypical terms."[38] Similarly, Carolyn Lisa Miller argues that, in films, women lawyers "have been presented as an oxymoron: they have two identities— 'female' and 'attorney'—which cannot logically coexist." Instead, their initial successes in the courtroom must be overshadowed by their "empty" personal lives.[39] Although Miller focuses specifically on the films *Suspect, Jagged Edge,* and *Guilty as Sin,* her observations are also applicable to a range of other films and TV series (*Ally McBeal* is a case in point, and one to which I will return later).

Greenfield, Osborn, and Robson suggest that blanket statements about the role of women lawyers in film are premature and indeed inac-

curate; they challenge feminist readings of women lawyers by noting that male lawyers are also poorly represented or shown to be working outside the strict guidance of the law on occasions. That said, they do acknowledge several instances in which women as lawyers receive particularly bad press—chiefly in relation to falling in love and "professional burnout."[40] Perhaps it is not accidental that these frames are also cultural ways of reading women's lives; daily broadsheets and tabloids often reiterate the impossibility, for women, of combining careers and families effectively, or the ways in which they are overly swayed by a romantic impulse. These and other issues are explored below.

Adam's Rib: *"Win the case, and lose my husband"*

One of the best-known early comedies to feature a lawyer whose personal and professional lives clash is *Adam's Rib* (1949), a vehicle for Katharine Hepburn and Spencer Tracy that was no doubt enlivened by their offscreen relationship. Hepburn played Amanda Bonner, a successful defense lawyer, and Tracy played her husband, Adam Bonner, the assistant district attorney. Although the film starts with Doris Attinger (played by Judy Holliday) attempting to murder (or perhaps just scare) her philandering husband, and although her trial is ostensibly the central focus for the film, it is really about Amanda and Adam's relationship. Doris's trial is no more than an excuse for their antics, as is clearly seen in the way her story is controlled by Amanda or not even allowed to be told at all.

The audience is introduced to Doris on her way to shoot her husband, and in the long scene that follows, she is mostly silent. She eats a chocolate bar, looking nervous, scared, and teary, but respectable, and follows her husband, Warren Attinger (played by Tom Ewell), who is leaving work. He is completely unaware of her presence, and whistles at a pretty girl. Doris, in contrast, is ill at ease. Jostled, she drops a bag, revealing the gun she is carrying. She is then bundled into the subway almost against her will, as she has lost sight of husband. Clearly, she doesn't belong here.

Doris manages to find her way to her husband's love nest and follows him inside. When she gets her gun out in the hallway of the

apartment block, she has to read the directions and points it accidentally at herself as if trying to figure out how it works. Eventually, she shoots through the ajar door, where her husband is embracing a woman in black chiffon lingerie. Although her husband tries to reason with her, Doris responds, "Shut up you! Shut up! *My dear husband*," and shoots five times, without ever opening her eyes. Warren is hit in the chest on the third attempt, at which point his lover shouts for help and runs away. Then Doris opens her eyes, sees what she has done, and embraces her husband. This is the central scene which forms the basis of the court trial; the audience has seen exactly what has happened: premeditation and attempted murder. It would be, it seems, an open-and-shut case; in fact, lawyers in the district attorney's office call it "the kind of case you take your knitting. A cinch." But that's where Amanda Bonner gets involved.

As in the melodrama *I Want to Live!* newspapers play a key role in this film. The audience sees the *New York Chronicle* front-page headline—"Wife Shoots Fickle Mate in Presence of Love Rival; Arrested on Assault Charge"—along with a picture of Doris embracing what looks like a dead body, next to pictures of the lover looking sultry and a photograph of a man with a hand over his face. Later newspapers, which make much of the fact that the Bonners face each other in court, provide segues between scenes.

In this first instance, Amanda reads the paper in bed, while she and Adam are having breakfast. It is not accidental that Adam daintily drinks tea, while Amanda downs a glass of juice almost greedily, with an open mouth, and exclaims "Hot dog!" when she sees the headline. Already gender roles are apparently confused: Adam is feminized, while Amanda is voracious (later, when describing her feelings on the day that she shoots her husband, Doris reiterates over and over that despite eating a lot, she felt "hungry." Clearly, having an appetite is a code for something more in this film). Adam and Amanda's first verbal exchange in the film is crucial and worth quoting in full:

AMANDA: Woman shot her husband.

ADAM: Kill him?

AMANDA: Wait a second. I think she ah. . . . [she has to look to the next page] Let's see. Nope. Nope.

ADAM: That's a shame.

AMANDA: Condition critical though.

ADAM: Congratulations.

AMANDA: Wow. Find it in yours. [Adam looks at his own separate paper.]

ADAM: It isn't in here.

AMANDA: He was playing her fast and loose so she caught him out and popped him a few .32 calibers.

ADAM: Who?

AMANDA: This lady, this lady I've been telling you about.

ADAM: Some lady.

AMANDA: Serves him right, the little two-timer.

ADAM: Says here he's 5'11; weighs 180. Some little.

AMANDA: Little in spirit I mean, of course, little in spirit.

ADAM: I don't approve of people rushing around carrying loaded revolvers.

AMANDA: Depends on who they're rushing at.

ADAM: Is that what they taught you at Yale Law School? [Amanda laughs.] That's not funny, you know. Contempt for the law, you know, is the first thing that—

At this point, they are interrupted by the maid, who picks up the paper and says, "Atta girl." This exchange points up almost all of the issues that will arise subsequently. Adam and Amanda are clearly on different sides. This is indicated by the fact that they read different newspapers and by their relationship to the law as a whole: Adam's stance on the law as constant and serious is contrasted with Amanda's more flexible attitude toward justice and her penchant for comedy, a penchant that will be exploited—at Adam's expense—in the trial itself. In addition, they use language in different ways. Adam clearly feels that a "lady" wouldn't shoot her husband, a viewpoint we have already encountered in a variety of plays and novels, whereas Amanda, no "lady" herself despite her clear class privilege, uses slang and

seems to relish the prospect of a good fight. The errant husband in the case is also considered differently by Amanda and Adam, as "little" in spirit but large in life, and so physical gender differences are emphasized, a point that will also be returned to in the trial itself.

In the next scene, Amanda drives them both to work, again taking a stereotypically male role (though she does so badly and is called a "lady driver" as a result, a factor that seems to restore her feminized position). Amanda argues firmly that Doris Attinger, in shooting her husband, was merely trying to keep her home intact, an argument that Adam does not accept. Amanda says, "All I'm trying to say is, there's lots of things a man can do, and in society's eyes it's all hunky dory. A woman does the same thing, the same, mind you, and she's an outcast. . . . Now I'm not blaming you personally, Adam, because this is so." Amanda further notes, "All I'm saying is, why let this deplorable system seep into our courts of law where women are *supposed* to be equal?" Amanda clearly indicates a desire for egalitarian feminism.

Adam replies, "Mostly I think females get advantages," and Amanda retorts, "We don't want advantages. And we don't want prejudices." As elsewhere, the chivalry thesis is presented and, in the trial, is set to be tested. The film then alternates between scenes in the lawyers' respective offices. Adam is surrounded by other male lawyers, who banter about the woman who shot her husband, while Amanda is presented with a female secretary, Grace. Amanda is clearly at ease with legalese as she dictates a message to Grace (and it is intriguing that her lawyerly nature is best exemplified in a sex-segregated space). She then asks Grace about unfaithfulness. The secretary replies that it's "not nice" in a man but "something terrible" in a woman. When questioned why, the secretary says, "I don't make the rules," but Amanda rightly answers, "Sure you do. We all do."

Although the film is, at heart, a revival of the screwball comedies of the 1930s,[41] it offers up occasional sobering messages that expand beyond its comic framework. Amanda's recognition of individual participation in the making of societal rules is crucial, as is her decision, eventually, to break or at least bend legal rules in her defense of Doris Attinger. When Adam subsequently phones to tell Amanda that he has been assigned the case as well, she becomes angry, and he replies

that she "sounds cute when she gets causey," at which point Amanda hangs up. The battle of the sexes is clearly not between Mr. and Mrs. Attinger, but between Mr. and Mrs. Bonner.

Later, Adam visits Mr. Attinger in the hospital and is clearly discomfited by Warren Attinger's aggressive nature. Warren suggests that the only explanation for what happened was that Doris was "plain crazy. . . . A fruitcake," and he wants her put away. Adam slows him down: "You're running way ahead of yourself. You just give us the facts and the background. We'll get a conviction on attempted murder or first-degree assault or however else the office wishes to proceed. . . . You just tell us the truth, as clearly and as accurately as you can." Adam's desire for orderly information and clear facts sets him up as the pedantic lawyer who will do a professional job of representing the law even in the face of a victim who, in many respects, appears to have "asked for it." Not surprisingly, given his moral stance, Adam reserves his greatest contempt for the lover, Beryl Caighn (played by Jean Hagen). Adam's view on the place of women (and his name as an indicator of origin) is constantly contested in the film.

Adam then begins to ask Warren the facts (his name, his address, his occupation), but before Warren answers, the film cuts to Amanda doing the same for Doris. Doris replies, "Nothing. No occupation." Amanda here acts as in the ventriloquist role, offering the label "Housewife." She reminds Doris that she is also a mother. Doris here looks to other people for answers, for confirmation of her role and identity. Although the ostensible victim is Warren, it is made clear here and throughout that the battered Doris is really the victim, though not very much is made of the fact that Warren was violent with her and even abandoned her on more than one occasion. When Amanda offers her a cigarette, Doris says she doesn't think women should smoke: "It's not feminine." Amanda will clearly need to battle not just with Adam here, but also with a woman inculcated into her role as a downtrodden wife.

When Amanda asks about the "accident," Doris says, "Oh no accident. I wanted to shoot him." Amanda skillfully tries to steer Doris away from such confessions, responding, "Suppose we decide later

just what you *wanted* to do." Although Doris considers this "silly," Amanda notes, "The difference between ten years in prison and freedom is not silly, Mrs. Attinger," and their following exchange shows their different positions of power:

DORIS: Call me Doris.

AMANDA: Now, you pay attention to what I'm saying.

DORIS: I don't care what happens to me.

AMANDA: Do you care what happens to Warren and Alan and Trudie?

DORIS: Yes I do. I want to go home. Can you fix it so I should go home?

AMANDA: Not right now. But we're working on it.

Amanda's tactics reveal that focusing her client's mind on her home, children, and even her husband—in a sense, seeing herself only in relational terms—is the only way to ensure that Doris will cooperate. It is clear that in order to defend her successfully, Amanda will have to look outside of Doris's viewpoint and overlay her own sense of societal injustice on a case that perhaps cannot withstand such intervention.

The contrast with the following scene—a domestic scene at the Bonners' impressive home—is instructive. Here, Amanda Bonner enacts the role of a feminine woman, preparing for a dinner party (though it is clear that servants do the actual work). She and Adam dress in separate rooms, mishear each other occasionally (again, this works as a metaphor for miscommunication between the sexes in general), and enjoy a close, affectionate, physical relationship. Adam even apparently play-slaps her on her bottom, though this occurs offstage. This physical act is reenacted later in the film, with different consequences, after the Bonners have become partially estranged from each other. In the later scene, Adam's physical contact with her is received as aggressive: "It felt not only as though you meant it, but as though you had a right to," Amanda retorts, before first crying and then responding with physical violence herself, kicking him and saying, "Let's all be manly." The battle for control of language and gesture extends beyond the courtroom into their own home, with potentially disastrous consequences.

In this earlier scene, however, their physical contact is playful, and Amanda is delighted with a new hat that Adam has bought her. The audience at first considers her pleasure as a sign that she is truly feminine at heart, despite her obvious desire for competition and confrontation; it is only later, when Doris is revealed as wearing the hat in court, that Amanda's delight in the gift becomes clear. She understands the need to appear feminine—not for *herself*, but for her client.

Like *I Want to Live!* the film is far from subtle: the first view of the court building, for example, focuses on the words carved on the front of it: "EQUAL AND EXACT JUSTICE TO ALL MEN OF WHATEVER STATE OR PERSUASION." The tension between the two potential readings of the word "men" (whether it encompasses or excludes women) is clearly a focus here and throughout.

The jury selection part of the proceedings again represents the Bonners' different approaches to the law. Adam asks factual questions, but Amanda opens with, "Do you believe in equal rights for women?" Although Adam raises an objection, Amanda is adamant that her question is relevant: "May it please the court, I submit that my entire line of defense is based on the proposition that persons of the female sex should be dealt with before the law as the equals of persons of the male sex. I submit that I cannot hope to argue this line before minds hostile to and prejudiced against the female sex."

Later, at home, Amanda compares the case to the Boston Tea Party, saying that what the protesters did was "dramatize an injustice," which is exactly what she is trying to do. And dramatize she does: her entire defense of Mrs. Attinger rests upon how to perform femininity. For example, she asks Beryl, the presumed lover, to attest to her costume on the day of Mr. Attinger's visit: she wore slippers, but no stockings, a negligee, and a hair ribbon, and when Beryl suggests that Warren arrived to sell her health and accident insurance, Amanda makes a joke that this showed remarkable foresight. Adam immediately objects to her "sly and feminine hints to the jury," and she withdraws the statement, on the condition that "feminine" is struck from the record. Although playing with (and against) femininity, she resents its application to herself.

Yet it is Doris's very femininity that Amanda uses in the case. She sets Warren up to admit that he physically and verbally abused his wife but continued to consider himself a "good husband." This almost backfires when Warren suggests that his wife gave as good as she got, but Amanda rescues this by again helping to make her client seem small, fragile, and helpless. In the story they have rehearsed, Doris only meant to scare Beryl Caighn, in order to restore her family and her home, and had no intention of hurting or frightening her husband. (Doris nearly gives the game away through her nonverbal clues, by almost imperceptibly nodding when asked if she intended to kill her love rival, but her performance of astonished innocence overrides this.)

Again, however, constructions of femininity become problematic: when Doris cries on the stand, Adam begins almost to bully her, asking her who she is crying for: Beryl, the woman he constructs as an innocent bystander to Doris's "sordid domestic failure," or her husband, "driven ill by your shrewishness," or the couple's children, "cursed with an unstable and irresponsible mother." Here, again, Doris as "guilty" is set up as feminine only in the worst sense: unstable, irresponsible, shrewish. When Amanda objects to the questioning as prejudicial, the elderly male judge lets it stand, as he cannot see "that it much matters." Yet, of course, the characterization of the female defendant in any of these terms is prejudicial.

To counter this, Amanda again focuses on gender and again looks outside Doris for evidence to support her case. She indicates that she has a number of witnesses to call who would help her make the point that women and men are equal and should be treated as such in a court of law. Her witnesses, she suggests, represent different aspects of "American womanhood" in order to show that "not only one woman is on trial here, but all women." Adam rightly notes that these women have no direct bearing on the case, but Amanda replies, "For years women have been ridiculed, pampered, chucked under the chin. I ask you on behalf of us all, be fair to the fair sex."

Instructed to use only three witnesses of the many that she wished to parade before the court, Amanda selects a successful chemist with a Ph.D.; a female "foreman" in charge of over three hundred people;

and a circus performer, Miss Lafea, who does a tumbling act in court, as representations of American womanhood. Unlike Doris, all are successful, working women. When Miss Lafea is asked if she could lift a man, she proceeds to pick Adam up, much to his consternation and to the considerable enjoyment of the court. Unsurprisingly, this is picked up in the media with the headline, "Asst. D.A. Rises to New Heights. Up in the Air!"

This signals the beginning of the end of the Bonners' happy marriage. Adam is outraged not only because he has been made the butt of a visual joke, but also because he thinks that Amanda has no respect for the law. He illustrates his point by saying that marriage itself is a contract:

It's the law. Are you going to outsmart that the way you've outsmarted all other laws? That's clever. That's very clever. You've outsmarted yourself and you've outsmarted me and you've outsmarted everything. You get yourself set on some dimwitted cause, and you go ahead regardless. You don't care what it does to me, or does to you or does to anybody. . . . Just what blow you've struck for women's rights or what have you I'm sure I don't know. But you certainly have fouled us up beyond all recognition. You split us right down the middle.

Although Adam had promised to stay with Amanda for better or for worse, he acknowledges that "this is too worse. This is basic. I'm old-fashioned. I like two sexes! And another thing, all of a sudden I don't like being married to what is known as a new woman. I want a wife, not a competitor. Competitor! Competitor! You want to be a big he-woman, go and be it, but not with me." After this, Adam moves out.

David R. Shumway argues that Adam's speech is reminiscent of other leading actor speeches in screwball comedies: "Rather than speaking seductively, the males in screwball comedies typically scold, lecture, admonish, or preach. In the codes of the screwball comedy, what this tells us is that the man cares, but it also mimics rational persuasion."[42] Thus, Adam represents not just his own position as a man married to a working woman, and not just the position of a lawyer (a role with which Tracy was to become very familiar, playing a lawyer six times in his acting career[43]), but also the position demanded by the genre to which *Adam's Rib* belongs.

Critics argue over whether the film represents a revival of the screwball comedy of the 1930s in a more conservative era, or whether

it represents a genuine extension of this genre, moving from a position where feminist issues are highlighted in order to "restrain women's independent leanings" to a position where they are foregrounded.[44] For example, Anita La Cruz argues that Adam's earlier apparent ease with Amanda's success is little more than a façade: "His concept of monogamy knows no bounds; Adam wants his wife all to himself, not just 'to the exclusion of all others' but to the exclusion of everything else." Furthermore, La Cruz suggests that the film as a whole is "a battle field where the struggle between sexual/social difference and sexual/social equality is acted out, each position embodied respectively by the characters of Adam and Amanda."[45]

Perhaps the most famous embodiment of the film, however, is that which is enacted in the final scenes of the trial, in Amanda's summing up. Arguing that "here you are asked to judge not whether or not these acts were committed, but to what extent they were justified," Amanda also asks the jury to imagine a different scenario: Doris as a man, defending his home against a male sexual predator:

Think of her as a man sitting there accused of a like crime. A husband, who was only trying to protect his home. Now hold it, hold that impression and look at Beryl Caighn. Look at her, look at her hard, a man, a slick home-wrecker, a third party, a wolf. You know the type. All right, hold that impression, and look at Mr. Attinger and suppose him a woman. Try, try hard. Ah yes, there she is. The guilty wife. Look at her. Does she arouse your sympathy? All right. Now you have it. Judge it so. An unwritten law stands back of a man who fights to defend his home. Apply this same law to this maltreated wife, and neglected woman. We ask you no more: equality.

The film backs up this speech by transforming the characters into their imagined other sexes. For the women, Doris and Beryl, this is accomplished solely through costume changes. Only in the final "change" (from male to female) does the actor actually make gestures that "reveal" his femininity: Mr. Attinger shifts in his seat, raises an arm in a coy gesture, and lifts an eyebrow. Mary Ann Doane suggests that this

graphically demonstrates this ease of female transvestism. . . . What characterizes the sequence is the marked facility of the transformation of the two women into men in contradistinction to a certain resistance in the case of the man. . . . [T]he male reversal . . . seems capable of representation only

in terms of farce. Male transvestism is an occasion for laughter; female transvestism only another occasion for desire.[46]

Doane's point is crucial here. If women can be "turned into men" but men cannot be successfully turned into women, what does that say about the position of the female in the courtroom? Hasn't Amanda been herself characterized—relatively successfully—as manly herself? And hasn't Amanda focused, almost despite herself, on capitalizing on Doris's gender? Adam's summation makes clear the artifice of this characterization:

Now let's take the character of this Doris Attinger. I'm afraid that's going to be a little difficult, because we haven't been told much about it in here. And we certainly haven't seen Doris Attinger in this courtroom. What we have seen is a performance, complete with make up and costume. Coached by the counsel for the defense, she has presented a sweet face, what a sweet face. Crowned by a tenderly trimmed bonnet. I find it a little difficult to be taken in, ladies and gentlemen, because I happen to be the fellow who paid for the bonnet!

And yet this is a performance and masquerade that has worked: Doris is found not guilty by a unanimous vote, and the newspapers get involved again. Photographs are staged with the Attingers apparently reunited and Beryl a literal outsider. If not quite a happy ending, it is one that will wrap the story up—for them.

Of course, for the viewers, a happy ending for the Bonners is also desired. In a deliberate reenactment of the opening confrontation, Adam surreptitiously enters the apartment of their neighbor, Kip, who has been ironically (and unsuccessfully) courting Amanda over the course of the film. Amanda is bemoaning the fact that she is in the uncomfortable position of "Win the case. Lose my husband," when Adam appears with a gun. But this is repetition with a difference: the guilty Warren Attinger tried to save himself; the innocent Amanda acts to shield Kip physically from Adam's apparent wrath. Yet it is all a ruse: the gun is made of licorice, and Adam is only making a point, that no one should have the license to pull a gun on another human being, whatever the circumstances.

In the final scenes of the film, the Bonners are reunited, both perhaps a little wiser about the ways of the opposite sex (Adam has play-acted tears to get his way, and Amanda has learned to respect the law

more), but their battle continues: he has been selected to run for county judge for the Republicans, and she intimates that she may well run against him as a Democrat. Shumway suggests that this ending does not really resolve the central tensions of the film, since "the problems the film raises about the difficulties of two genuinely adult professionals living together as equals gets papered over. The narrative displaces the social conflict onto an individual marriage. Furthermore, the patriarchal status quo is restored by Adam's impending election to a judgeship—where he will represent, rather than merely practice, the law."[47] Of course, it would be asking too much of a film (particularly of a comedy) for it to engage fully with and to solve the problems of gender equality and difference that are played out in actual courtroom scenes and everyday life. What this film does is "dramatize an injustice" within a comic frame, where couples are reunited and there is a claim to celebrate gender differences at the end (in contrast to Amanda's stated desire for equal treatment).

Yet even Amanda is proved to be unable to treat men and women the same; her search for equality is occasioned through spectacular women, not ordinary Doris Attingers, and through recourse to fantastic narratives of Amazonian women. The ordinary Doris Attingers of the world need pretty hats and costumes, coaching in tears and helplessness, and a silencing of true desire (revenge, death of a love rival, and inflicting pain on the straying husband) in order to be accorded a verdict of not guilty—a verdict that Adam shows to be an unfair one in his subsequent reenactment of the first scene.

In *Adam's Rib*, however, the emphasis is placed as much on Amanda as lawyer as on Doris as defendant, and her own flirtations with (and rejections of) femininity. In order to explore the opposite stance—the embracing of femininity in a female lawyer—I now turn to more recent comedies: *Legally Blonde* and the TV series *Ally McBeal*.

"The rules of hair care are simple and finite; any Cosmo girl would have known"

Legally Blonde is one of several recent comedies that have attempted to re-view the female lawyer, focusing on her style and

femininity (and her ability to get the man) as much as on her legal acumen in a postfeminist reversal of codes.[48] In it Reese Witherspoon plays Elle Woods, whose name encodes her femininity—as well as her connection to fashion.[49] Elle decides to attend law school on a whim, hoping by doing so to convince her ex-boyfriend Warner Huntington III of her qualifications to be his bride. In this venture, she has little support: her sorority sisters from Delta Nu can't understand her need to study for the LSAT, and her father intones, "Law school is for people who are boring, and ugly, and serious. And you, button, are none of those things."

However, Elle attempts to secure a place at Harvard Law School using the unorthodox method of a promotional video. The all-white, all-male admissions committee, though divided on the merits of her case, test their competing readings of her application in a mock trial of the woman-as-defendant (here, defending her right to enter the hallowed halls of Harvard).[50] Some lobby for her acceptance, presumably because of her physique (she wears a small bikini in her video, and the audience is encouraged to believe that the committee members' desire for her is bodily, not cerebral), while others are concerned about maintaining standards. However, Elle has met the standards: she has a 4.0 grade point average, has four more points than she needs on the LSAT, and has demonstrated and documented several instances of leadership during her undergraduate years. The case against her rests on the facts that her major was fashion, that she clearly doesn't understand the codes of law school applications, and that she appears to be frivolous. Indeed, in her video application, she notes, "I feel comfortable using legal jargon in everyday life," while walking down the street. A man whistles at her and pinches her bottom. Her reply, "I object!" is followed by a smile directed at the camera.

However, these negative points are countered by the yes voters. Her fashion degree, one member argues, is evidence of "diversity," a stated admissions goal. In addition, her extracurricular accomplishments are renamed by the members of the committee: designing faux-fur underwear for a charity project becomes evidence that she is a friend to the animals and a philanthropist; the fact that she was in a Ricky Martin video shows she has an outside interest in music. As a

result, Elle gains a place. The comedy thus nods to issues that concern law school admissions but takes them out of a political framework and into a comedic one (affirmative action legislation is thus in a sense invoked here, but not as one would expect: a rich white girl benefits from Harvard's diversity admissions policies).

When Warner is surprised at Elle's appearance at Harvard Law School (their meeting is carefully stage-managed), she retorts, "What, like it's hard to get in?" Elle's biggest rival at law school is another woman, Vivian Kensington, Warner's new fiancée, played by Selma Blair. Thus, immediately this mousy-looking (though not unattractive) and conservatively dressed young woman is set up as the stereotypically serious brunette against whom the apparently dumb blonde Elle will be contrasted. However, since the "dumb blonde" stereotype has been challenged in quirky ways throughout, the viewer is aware that this battle between the beautiful blonde and the brainy brunette will not quite go according to plan. (In the first full scene of the film, Elle is shopping with friends for a dress to get engaged in; the sales assistant who tries to serve her announces in an aside, "I love a dumb blonde with daddy's plastic," but Elle reveals intricate knowledge of fashion that puts this professional woman in her place.) The dumb blonde image is thus, from the first, both set up and dismantled. It is certainly never entirely set aside: Elle is called Malibu Barbie when she arrives at Harvard, and she ends up having a short debate about the merits and drawbacks of blonde locks with a male lawyer, who claims that being blonde "is actually a pretty powerful thing." Indeed, this particular combination, "pretty powerful," is not accidental and fits in with a postfeminist construction of comedy as one that plays with the power of femininity and the potential positive benefits that might result.

Though initially spurned by her snobbish Harvard classmates, who are not susceptible to Elle's particular brand of happy femininity (they refuse offers of muffins artfully displayed in a beautiful basket and find her clothes inappropriate and their wearer flighty), Elle never relinquishes her focus on style or good looks. She does, however, tone down her outfits, avoiding her signature pink during much of the film, as if recognizing that she is required to "look the part" of a law school student. As a result of her failure to fit in, Elle spends more

time with "real" people, including her nail technician Paulette, who benefits from Elle's intervention in securing the return of her dog from her former partner, as well as her tips on how to secure a new man in her life. Indeed, Elle offers Paulette a space to voice her story of betrayal and disappointment, and although Elle's lawyerly intervention is not accurate (she mixes up her Latin phrases, for example, and stumbles through the explanation of why Paulette should have custody of the dog), Elle does ensure that Paulette seeks redress—and gets it, something she would not have had the courage to do on her own. It is significant, though, that Paulette's strong language has the eventual desired effect, while Elle's convoluted legalese is incomprehensible to Paulette's ex-lover (and probably Paulette herself), reminding us of Maria Aristodemou's claim that "legal language aims to conceal its artificial origins."[51]

Within the law school itself, Elle is puzzled by the failure of tactics which have in other arenas led her to success, and there are moments when she clearly begins to doubt herself. Indeed, at one point, Elle is seriously misread in the film (a fellow intern in a law office observes her being sexually harassed by the professor in charge of her internship, but reads this as Elle's tactic of sleeping her way into the role), and at this point, Elle decides to quit fighting what she sees as the discrimination she faces as a blonde. However, demonstrating what William H. Simon would call "moral pluck"—a "combination of transgression and resourcefulness in the vindication of justice"[52]—Elle eventually returns to the law, ousting her tenured professor (a partner in a criminal defense law firm) in order to defend fitness guru Brooke Taylor Wyndham on murder charges.

Just before and throughout the trial, Elle's knowledge of fitness and fashion is mocked but shown to be accurate; she discovers Brooke's alibi but refuses to divulge it since it would implicate Brooke in a different way (the woman was having liposuction on the day her husband was murdered, but she cannot reveal this without injuring her reputation as the designer of "Brooke's Butt-Buster Workout"). Indeed, Brooke melodramatically claims, "I'd rather go to jail than lose my reputation," a comedic twist on the innocent woman who would rather die than have her virtue besmirched.

It is also through her knowledge of fashion that Elle discovers that the pool boy Enrique, who claims to have been conducting an affair with Brooke, is lying. His damaging assertion seems to point to Brooke's guilt—but Elle, who believes sincerely in the defendant's innocence, is not convinced. After all, she says, using deductive logic: "Exercise gives you endorphins. Endorphins make you happy. Happy people just don't shoot their husbands." Although Elle was not apparently familiar with Aristotle at the beginning of her law school career, she is using Aristotelian logic here, even if her premises appear somewhat frivolous. Elle is able to crack Enrique's assertion because he makes a tactical error: he comments on her Prada shoes—evidence, in her mind at least, that Enrique is actually gay. Though her discovery is dismissed by the lead attorney when he hears her source, the second-in-command, Emmett Richmond (Elle's eventual partner) takes her seriously enough to ensure that this information is revealed in court.

Elle's fashion knowledge is shown to be vital a final time when she ends up trying Brooke's case. She arrives in court finally clothed in her signature pink, and for all intents and purposes she looks the part of a Hollywood starlet or trust-fund dolly. (In contrast, her client Brooke was originally depicted as wearing a suit jacket made of material that looked like newsprint, itself perhaps a comment on the role of the media in the construction of her as a defendant: she is a beautiful young woman married to an older man. Her circumstances mean that she is easily "read" as a gold-digging murderess.) Here, as has been clear throughout, appearances matter.

However, it is at this point that the case commonly made against female lawyers is seemingly set up again: Elle certainly does not come across as confident in the courtroom once she is on the actual courtroom floor, nor does she appear to have a brilliant legal mind. She is unsure, repetitive, and hesitant in front of the judge and jury. She is what she appears to be: a first-year law student, with no trial experience. Only on the topic of fashion does Elle come into her own, finding her confident voice, and not only shredding the circumstantial evidence against her client, but also discovering the identity of the real murderer: the rich man's spoiled daughter. Elle recognizes that Chut-

ney Wyndham is lying because her alibi—that she was in the shower when her father was murdered—is incompatible with the evidence: Chutney had just returned from getting her hair permed. Elle recognizes the cardinal rule that permed hair should not get wet for at least twenty-four hours to avoid curl loss, and she even uses complex scientific language to back up this claim. Fashion knowledge saves the day.

From here, of course, the fantasy of the feminine lawyer is complete. Elle goes on to become the designated speaker at graduation, thus suggesting that women can indeed have it all: a law career, fabulous clothes, and the engagement that she appeared to want so desperately—though not to the object of her original quest. *Legally Blonde*, it seems, is another refashioning of Hollywood's screwball comedies. As such, however, it does not have a univocal message. Instead, it plays with ideas about what women want and how they can get it.

The audience sees a series of stereotypes set up and only partially dismantled. Women want to get married: even Elle's serious rival is after a rock. At a party that she and a friend have conned Elle into attending as a Playboy bunny, a confrontation with Elle makes Vivian feel miserable. But as her friend notes, "You've got the ring, sweetie." The camera then settles on both Vivian and her friend gazing longingly on the proof of desire, or at least proof of an upcoming contract. Elle and Vivian may want to be lawyers, but clearly they both would rather be Mrs. Warner Huntington III. Another scene shows Elle helping a socially maladjusted man get a date. When he is humiliated by a beautiful woman who claims she would never go out with him, Elle performs the role of spurned lover. She slaps the man, claims that he has broken her heart by never calling after their one-night stand, and walks away, sure in the knowledge that this play-acting will reel the other woman in, as indeed it does. Here is that old chestnut: every woman loves a bastard.

These retrograde moments ensure that the film is never univocally feminist, despite its feminine triumph. Texts like *Legally Blonde* fit more comfortably in the contested terrain of postfeminism. As I have elsewhere argued, postfeminism is a problematic position that

is most frequently seen as a depoliticized incorporation of feminist ideas. This incorporation—literally, taking into the body—leads perhaps to a *con-*

sumption of feminist ideals, but not a continuation of them. To consume is to make invisible, in a way, and indeed one of the most frequent charges against postfeminism is that it takes the platforms and slogans of feminism and makes them appear ridiculous and old-fashioned. Postfeminism is Spice Girls' "Girl Power," an "ironic" flaunting of sexuality, a refusal to engage with feminism—even [potentially] a denial of it. It uses the words of the feminist movement—choice, equality, power—but inserts them into facile spaces: the choice to wear a short or long skirt; . . . the power to be "in your face" (so long as one's face is prettily made-up).[53]

What *Legally Blonde* does is challenge some aspects of filmic narrative conventions, while leaving others in place. It also reaches into the gaps in a feminist narrative which would privilege career above love as a central goal. Both are seen as equally valid ambitions in the text, and it is no coincidence that on the very day of her law school graduation, Elle also finally wins her man, asserting (pace Aristotle), "Passion is a key ingredient to the study of law—and life."

As a postfeminist film, *Legally Blonde* privileges comedy and entertainment above a serious inquiry into the role that female spectacle plays in the notions of guilt or innocence, competence or incompetence. If, as Miller suggests, "Female attorneys on film are compromised by the conflation of and conflict between their two identities, since embracing the male province of law challenges their traditional feminine sides,"[54] then this film acknowledges that this may be so, but goes on to offer a triumphant, excessive vision of femininity that apparently is not incompatible with the law. Instead, it suggests that one can consider *Cosmo* as the Bible, but still understand the concept of *mens rea*.

The film takes fashion—an important part of many women's lives, whether as a hobby or as a vocation—and revalues it, showing how an intricate knowledge of beauty can, in fact, save a life. At the same time, it also acknowledges that the images of beauty set up by Hollywood are impossible to attain for the majority of people and only deceptively maintained by a beauty elite: hence, the "shameful" alibi that Brooke feels forced to hide. It is thus a text of contradictions: it promotes the power of beauty, while at the same time poking fun at the images it portrays. Finally, it engages with women like Paulette, the nail technician, and her customers, women who by and

large are not beautiful, not powerful, and not used to voicing their own agendas, or even recognizing the politics behind their personal pain. Involved at the lower end of the beauty industry, these women—who service and thus benefit from other women's inculcated needs—are also offered at least a marginal voice here (with the assumption that Elle's law school classmates, who promote a series of worthy causes, would not consider their causes worthy enough). Paulette gets her man as much as Elle gets hers, though he is a delivery man, while Elle's partner is a law associate. The film thus acknowledges—perhaps even reinscribes—class issues, but never really unpicks them to any great extent. It is a comedy, after all, both in the sense of promoting humor, and in the patterned formation of couples at the end.[55]

Ally McBeal: "A *Victim of My Own Choices*"

Ally McBeal, perhaps an even more challenging postfeminist text, returns us to television. David E. Kelley's "dramedy" about a Boston law firm, Cage, Fish and Associates, ran from 1997 until 2002. Like many other law serials, *Ally McBeal* glides between courtroom scenes and life scenes, and shows the intimate connections between the law and "human nature." Ally is like most television lawyers in that she wins the vast majority of her cases, though unlike most television lawyers, she does so even when the law is against her. As Rachel Mosely and Jacinda Read note, Ally wins her cases "most often through applying the logic of her personal life to her professional role. Cases are often won by asking the jury to empathise, to apply their own experience to the case under consideration."[56] Reminding us of Miller's point that a woman lawyer cannot be successful in both the personal and the professional realms of her life, Ally as a woman finds it hard to sift the relevant from the irrelevant (and the fantastical from the real), though, as a lawyer, she apparently manages the task (if in part through misdirection).

Controversial from the start, the program starred Calista Flock-hart as the eponymous heroine, whose desire to practice law was, like Elle Woods's, originally triggered by love. In the pilot, a flashback

and voiceover explain that Ally followed her boyfriend Billy (played by Gil Bellows) to Harvard and law school: "I . . . I didn't even want to be a lawyer. I . . . I just . . . um." From the first, then, Ally is characterized as hesitant and indecisive, a characterization that, if anything, ends up being reinforced as the series progresses. Although their relationship did not last, Ally remained as committed to the law as she could be, given her evident commitment phobia (a trait more often associated with men in popular culture texts). The pilot episode also shows how Ally began working for the same law firm as Billy, with whom she was still in love, and the effect that learning he was married to the beautiful lawyer Georgia (played by Courtney Thorne-Smith) had on her. This never-to-be-(re)consummated love lasted until Billy's sudden death midway through season three.

Blending fantasy elements with humor that was purposefully engaged in order to highlight unconscious desires, *Ally McBeal* offered an array of female (and variously feminine) lawyers working in or with the male-dominated law firm, including the icy Nelle, the frightening Ling, the gorgeous Georgia, the sexy Renee, and the sexually explicit Elaine, as well as a number of characters who appeared and disappeared from episode to episode; at all times, however, the primary focus was on Ally herself. Even the opening credits reveal this: while featuring the names of all the principal actors, the only images shown were of Ally.

A running theme throughout the series—and one that in another context could have signaled a commitment to feminism—is sexual harassment. Indeed, it is through harassment that Ally ends up working for the firm. At her first firm, a senior partner starts to "like" her. As with most sexual harassment, the physical infringement is at first minor, staged to make the woman feel that she is imagining it. When it becomes blatant, Ally reacts, he is subsequently fired, and then he sues, forcing the firm to give him his job back. Ally countersues, but he ups the stakes by claiming that his Obsessive Compulsive Disorder (OCD) makes him squeeze women's bottoms. In order to back up his claim to a bizarre form of disability (another key theme throughout the series), the partner effectively makes a victim out of each of the women in the firm. Ally's only recourse, she believes, is to

quit. Cage, Fish and Associates not only take on her case, but also give her a job, and after they successfully dismantle the fake OCD defense, the firm becomes known as one specializing in sexual harassment.

Yet these are sexual harassment cases with a twist (as will be explored below), and the firm itself is far from politically correct. One partner, John Cage, is arrested for propositioning a prostitute but argues that although his actions were "technically illegal," he feels that he was "morally on higher ground" by sleeping with a prostitute rather than getting emotionally involved with a woman who might ask for more. Richard Fish, the other partner, notes that Ally was brought in as "estrogen" and that he hopes she'll flirt with clients. The office is sexualized (in one episode, a female mail carrier sues the women in the office for making her feel uncomfortable about being considered beautiful), a female judge (Dyan Cannon) sleeps with Fish in an on-again off-again romance, and individuals fall into and out of each others' beds on a rotating, sometimes unpredictable, basis. In addition, the most private experiences end up being shared: the firm has a unisex bathroom that functions as a space to air griev- ances and private hurts which are almost always overheard. The image that accompanies this bathroom—a female figure and a male figure side by side (with a wheelchair on the male side)—indicates a confusion of separation and equality; a line divides the male and female figures, but the bathroom itself requires the men and women to share a space that is normally sex-segregated. As Moseley and Read argue, "The unisex literalises questions of equal opportunities in the workplace and the interweaving of the personal and the professional, the private and the public."[57]

In what follows, I propose to concentrate primarily on the first sea- son because this season set up most of what followed in the next four. In addition, the narrative was allowed to grow unfettered in the first season. It is easy to forget that a television serial is not necessarily pro- duced with a clear trajectory, and that outside influences can deter- mine the story line to a large extent. Consider, for example, Robert Downey Jr.'s long battle with drug dependency; his eventual depar- ture from the show, in season 4, while confirming the idea that Ally

cannot keep a man, or that when she is in love, the man decides to leave (a recurring topic), was precipitated not by the demands of the plot, but by his arrests and detention, which interrupted his ability to take part in filming. Hence, also, the absence of Ally's roommate Renee Radick (Lisa Nicole Carson) in the fifth and final season—an absence that the series never attempted to explain.

For all the media hype that surrounded the series, *Ally McBeal* has received little incisive commentary. What scholarship exists often has a basis in empirical studies of viewers' habits or considers the images of women and ethnic minorities in the series.[58] Tracey Owens Patton, for example, criticizes the show for reinforcing negative racial and gender stereotypes. Patton asks us to recognize our complicity in accepting passively what the media offers us,[59] but this perspective— the audience as passive receptacles of the media's power and influence—has been rightly challenged for decades, and her criticism regarding the way individuals or groups are represented in many respects misses the point. Yes, Ling, the only Asian American character, is constructed as inscrutable; yes, Renee, an African American, is represented as voraciously sexy; yes, Ally is constructed as a little girl—but the entire postfeminist point of *Ally McBeal* is to offer overblown stereotypes in order to engage with the vexed question of femininity, feminism, and difference. Part of the guilty allure of the show is the disjuncture between the politically correct forum apparently presented (lawyers' offices, the courtroom) and the "reality" of the complicated arenas in which these women work. As Moseley and Read suggest, "The show has been uncertain of its own position, and this uncertainty is repeatedly articulated through such tensions and contradictions." They further argue that "it is on a complex terrain between fantasy and reality that the show negotiates the relationship between feminism (realism) and femininity (fantasy)."[60] That these two aspects are held in tension suggests one of the problems of postfeminism: in what ways can femininity be recuperated without jeopardizing a political commitment to changing women's social lives?

Kathleen Kelly Baum articulates the problem thus: "On one hand, the series highlights the complexities of contemporary social interaction, but, on the other hand, it serves to complicate behavioral

roles by satirizing those stereotypes and deconstructing the shifting nature of social identity and conventional social boundaries, especially gender roles."[61] In order to address these issues further, the following analysis will focus on cases having to do with sexual harassment and the eventual defense offered by Richard Fish of women's gender disability.

When Ally first arrives at the law firm, her new secretary, Elaine, who appears to fulfill every stereotype of the woman who upholds male power, announces, "I'm trying to get some information on her cycle." From the start, then, the focus is on Ally as a woman first, and lawyer second, and it is assumed that her body is the measure of her success or failure. In her first criminal case (defending the partner John Cage on charges of procuring a prostitute in episode one of the first series), Judge Happy Boyle makes Ally show him her teeth in order to rule on a case, because "hygiene" is important; he also calls her Billy's "little friend." Ally's body is compartmentalized, with body parts standing in for meaning. She is also literally shrunk in several episodes to reinforce the image of a little girl playing at a grown-up job.

When Ally and Georgia team up in episode two to try a sexual discrimination case, it appears as if we are moving into a familiar feminist arena. An older, attractive woman, Barbara Cooker (played by Kate Jackson),[62] is ousted as a news anchor and replaced by a younger woman. Fish accuses Ally of personalizing the case, a viewpoint reinforced in the episode by the fact that both Ally and Georgia become concerned about losing their looks. As Georgia says, "We've got to win this case—for piece of mind if nothing else," a statement that hardly accords with a feminist outlook.

Out of the courtroom, Ally is attempting to see other men to get her mind off Billy and is distressed that her date offers her only a peck and not a passionate kiss: "I am a sexual object, for God's sake. He couldn't give me a little grope?" Ally asks Renee. Here, as elsewhere, Ally voices apparently unsayable things: desire is complicated and sometimes at odds with professed beliefs; in this context, men find women difficult to read, and, of course, Ally's admission comes only in the privacy of her own apartment, away from the object of her affections. After they win the case, Georgia and Ally go dancing in the

bar which features strongly throughout the series as a space for plot resolution. Yet this resolution is uncomfortable: though Ally and Georgia are both dancing with men, Ally notes in a voiceover, "Who says I'll end up alone?" before the shot pans to Barbara Cooker, by herself at the table. Here, then, issues of concern to feminists become re-viewed through a perspective of confusion, where the questions about how to juggle career fulfillment and personal fulfillment collide, and where the issues in the courtroom are refigured as issues also apparent in the real world.

In episode four, it is Ally who comes before the court, not as lawyer but as defendant, after apparently accosting a woman in a supermarket and accidentally shoplifting some contraceptive jelly. In order to appease Happy Boyle, Billy submits Ally's dental records as "evidence" of her good character, and Ally notes, "This would actually be funny if justice wasn't truly this arbitrary." She is then brought before the board to judge her fitness to be a lawyer. Ally finds it difficult to control her anger at the events that unfold, and while one judge suggests that she should feel free to express her anger, Ally's response indicates that she knows how female anger would be received:

But you would judge me for it, your honor. It'd be wiser for me to sit here politely and privately pray that you should happen by me doing groceries. Now imagine a young lawyer, her future lying in your hands. Who would say such a thing? She would either have to be enormously crazy or you would have to be enough of an ass to deserve the remark, no matter what the risk. And since you're the judge, I'm going to let you decide, but not until I finish. And I haven't finished. That woman abused me in that supermarket. Now yes I overreacted but there was a context. And as for all the other evidence against me, that . . . that . . . that stuff about me being *emotional*, falling in love with men whose bottoms I've smelled, submitting xrays to a judge who has a tooth fetish and sleeps with hookers, snapping at pedestrians who think that a square shoulder can be mitigated by "I'm sorry," I am human, I am temperamental, I am guilty. NOW I'm finished.

After this outburst, Elaine suggests pleading PMS, and Billy advises that she start the next day by apologizing and being respectful, by staying "contained." Both responses indicate that she should become more stereotypically "feminine" and banish her outlaw emotions.

Baum notes that viewers have seen Ally as "one who is seemingly inherently incapable of assimilating the codes of professional behavior, and unable to focus on the business at hand because she is continually being distracted by her personal insecurities, especially as a woman."[63] However, Ally does recognize the codes but sees them as constrictive and artificial. Like Elle Woods, she understands that beauty is always already an issue when she is in the courtroom, and though she plays up to this by wearing short skirts and pretty clothes, she paradoxically undermines beauty by being almost *too* feminine, bordering on the hysterical. Nevertheless, she does exactly what Billy counsels, and the next day, states, "I would ask you to trust me, and the members of my firm to ensure that no matter what my personal struggles may be, that the competent representation of our clients will never be compromised." It is almost as if the scriptwriters for *Ally McBeal* had read the scholarly articles on female lawyers and got their defense in first. Yet Ally's contrite speech is not enough for the board, who recommend that she undergo psychiatric evaluation, at which point Judge Whipper Cone intervenes: "A man acts passionate, we call him impassioned. A woman, she's emotional. . . . Why don't we just admit it? She stands most guilty of being female. Young and attractive and how dare she be aggressive on top of that?" Though this is a powerful speech, it, too, is undercut: the main judge attacks Whipper and tells her to "go tease her hair." Even powerful women, it appears, cannot be treated as professionals first; even *their* appearance before the court is judged.

The next episode again focuses on the women's appearance and the contested terrain of female behavior. Ally is asked to defend a prostitute, and ironically, given his past encounters with prostitutes, Cage is also engaged. Cage's closing argument is that hypocrisy troubles him, and he cites the fact that Hollywood actresses simulate full sex but actually participate in other sexual activities on screen for money. In addition, he notes, "Women marry for money—we don't jail them. The truth is, sex has always been a currency for women. Always—though often at a quid pro blurry quo. My client was honest. She told the truth to that man, and to you." Although Ally is appalled by Cage's views, they win the case, despite clear evidence that guilt

had been established. As is clear throughout the series, justice is arbitrary in this fictional Boston courtroom, and juries can be swayed by persuasive arguments to ignore the facts. As Cage reveals to Ally, "There was a reason I made that argument. . . . I was paid to." Here, the lawyer as prostitute is invoked, and Ally's disillusionment with how the law and lawyer deal with women—guilty or innocent—is extended: "We celebrate hookers under the guise of feminine autonomy." (It is significant that she does not say "feminist autonomy," because even in the confusion between feminism, femininity, and postfeminism, Ally recognizes that her client's act was no political blow for the rights of women.)

In episode six, Georgia transfers from her own law firm to Cage, Fish and Associates; she is fired because the boss's wife does not like him working with her, a beautiful woman. It is significant that yet another woman lawyer in this series faces the court herself. John Cage argues against suing because to do so may make Georgia unhireable elsewhere: "You can make a point for womankind, or you can do what is probably best in your own self-interest." That Georgia decides to sue thus shows her commitment to the framework of feminist interests, but it also allows the program to air some home truths about the way that sex discrimination cases can be perceived by the general public.

Georgia's boss articulates this position well: "I sense a waning public appetite with sex discrimination laws. . . . I think these safeguards insult women, make them look weak, even. I also sense a waning appetite with people who sue who haven't really been hurt." The definition of hurt returns us to Robin West's catalogue of women's "gender-specific injuries" which are, she argues, "variously dismissed as trivial (sexual harassment on the street); [or] consensual (sexual harassment on the job)."[64] Georgia, as a beautiful woman who has quickly secured another job, does not *appear* to be suffering from what happened, and the way in which this case can be seemingly dismissed is echoed in newspaper accounts of high-profile women working in finance in the United States and the United Kingdom who sue for damages; when they win (sometimes securing a sizable final payout), critics, both pro- and anti-feminist, frequently argue that they

damage the wider case for women who suffer *real* pain and anguish, as if there is a measurable continuum on which to gauge personal and professional suffering.

Georgia's former boss also suggests that, in firing Georgia at his wife's request, he champions his right to put family first. Again the language of feminism is used against itself. In a later episode, Renee and Ally debate the mixed messages society offers young women about the necessity to have a career if they are intelligent, while at the same time insisting that women should also have children and stay at home to raise them. Kathleen Newman suggests that "Ally McBeal's problems are in some ways feminist problems: What do we do when we offer women the opportunity to become successful, ambitious, powerful actors in the public sphere without removing our presumption that women are incomplete without a man and natural caregivers?"[65] In a view that is reminiscent of *Adam's Rib*, but with a twist in the end, Ally argues, "Society is made up of more women then men, and if women really wanted to change society, they could do it. I plan to change it. I just want to get married first." Perhaps that is what worked in Amanda Bonner's favor: she married first, and tried to change the world second; thus, she was not scarily independent when she fought her case (though she risked being so afterward).

Martha P. Nochimson contends that "looking at Ally as a role model was inappropriate in a show in which the feminism was located not in Ally, but between characters, in new relational paradigms."[66] Nochimson's argument rightly notes that any comparison between constructed characters and "real life" is facile, as is a claim to want only positive role models presented. Moreover, how feminism (or postfeminism) is articulated is often in the gaps between vision and action. Ally's great career success (by the end of the series she is a partner in the law firm) never obviates her eternal search for love. What keeps the series going is Ally's lack of fulfillment; a happy, well-adjusted individual who is part of a stable family unit cannot sustain viewer interest, though the promise of fulfillment (held out but never achieved) keeps the viewers coming back.

Later episodes continue the focus on contested sexual terrain and the limits of the law in dealing with them. In episodes nineteen and

twenty, Renee is accused of assault when she kickboxes a man she is dating after he becomes too aggressively sexual, thus completing the trio of female lawyers who find themselves on the other side of the courtroom in the first season. The opposing counsel argues that Renee's defense is that "she's a girl." He also claims she started the sexual assault and provoked the violent assault, and if she were a man, she would be going to jail: "Same fact pattern, in reverse—he's gone. But—hey—she's a girl." This role reversal, used to such effect in *Adam's Rib*, does not work for the opposing counsel, and Renee is acquitted.

A very real and often frightening experience of being physically overpowered ends not with Renee as victim, but with her potential aggressor as one. However, this reversal cannot be read unproblematically as feminist, especially as the viewers are persuaded to have some sympathy for Renee's attacker: she has clearly "led him on," and the defense that she is "just a girl" cannot withstand critical scrutiny. A postegalitarian feminist stance would argue that Renee is rightly treated different here: she fought off a sexual attack and, as such, cannot be compared to a man in a barroom brawl. Yet even Renee is uncomfortable with the tactics used to secure her not guilty verdict: "The strategy was to undermine the seriousness of it all. The strategy was not to turn this thing into a joke." Yet that is the overall strategy of *Ally McBeal*: to use cases that might have spawned impassioned debates in, say, *L.A. Law*, in order to defamiliarize the events and force a rethinking of firmly held principles—before asking audiences to disregard the uncomfortable position they find themselves in and choose to laugh instead.

Other cases focusing on sexual behavior or mores involve defending a transvestite accused of solicitation (episode nine), representing a man who wants to commit bigamy (episode ten), trying to secure conjugal rights for a prisoner in maximum security (episode thirteen), defending a senator who is sued for breaking up a marriage (episode fifteen), defending a man accused of stalking (episode eighteen), representing a straight man who pretended to be gay in order to secure a job as a waiter (episode nineteen), and representing a jilted bride who wants to sue her ex-fiancé (episode twenty-one), a case

Fish says the firm should take only if the woman is ugly, since if she is pretty, she will be asked again. As can be seen by this catalogue of cases, Cage, Fish and Associates sometimes appear to be on the "right" side of the law but, at other times, defend untenable positions. They are, it seems, making arguments because they are paid to: it is not accidental that Richard Fish's first allegiance is to money.

While these episodes are interesting in and of themselves, an episode that comes near the end of the first season offers more space for a sustained analysis of issues of sex discrimination. Episode seventeen, "The Playing Field," offers another take on sexual harassment: a woman sues her boss because he has *not* attempted to sleep with her. Her argument is that three other women in the firm were promoted after having affairs with him, but that she never got the opportunity. Although Richard handles the case, he also has Georgia on the team because, he argues, "It's important we speak not only from strength, but estrogen." Georgia does not want the case, but Richard insists, though when she attempts to speak to him about it, he claims that he has cramps—and that to think otherwise constitutes gender bias. Richard's use of his body to forestall further discussion is an overt manifestation of what is covertly part of the series throughout: bodies matter, and how one deals with the body of the lawyer is as important as how one deals with the body of law.

Richard's lack of trial experience (a recurring topic) is apparent in how he argues the case and ends up alienating most of the people in the courtroom: "Your honor, personally, I hate sexual harassment laws. The original force behind them were disgruntled lesbians who felt they weren't given the same opportunity to get ahead . . . along with ugly women who were jealous because pretty girls got all the breaks in the workplace. If you look at the majority of women that bring these suits—ugly." Richard's emphasis on the woman as spectacle, here reversing the image to one of unattractiveness, maintains the series' focus on image. In a longer argument, he sets out his case:

My cause of action is premised on the notion that women are victims, your honor. They need special help. When you look at the evolution of these sexual harassment laws, what we're really saying is that women should qualify under the federal disabilities act. They are less able, they cannot cope with romance in the office place, they cannot contend with having to do a job

and have a man smile at them. It's too much. Look where we are, judge. It used to be quid pro quo, then it became hostile environment, now it's *Seinfeld* episodes. Women can't take it. They bruise. The laws of this land are here to protect the weakest, most vulnerable members of our society. She's a woman. Protect her!

Lawyers in *Ally McBeal* are given license to say the unsayable, to provoke with arguments that force the audience to reexamine how they view the world. Nochimson suggests that this works by "surprising us by brief identifications with an offbeat, or even base, point of view. Its most exciting moments occurred when all normative perspectives were shaken."[67] Richard's argument feeds off a version of feminism that seeks special protection for women, but shows how this desire for special protection can be coopted by a patriarchal viewpoint that would succeed only in reinstating a hierarchal sphere in which women were disadvantaged. While John Cage makes arguments primarily to win a case and withholds his own personal feelings to a great extent, even occasionally arguing against his own moral principles, Richard, the other partner, apparently has no morals; however, he argues (as Ally does) on the basis of his own feelings. It is simply that his feelings—such as they are—are almost always skewed. But his argument about women's disability is extended even further in the next scene. Georgia is appalled by Richard's argument and, in an elevator with him and Billy, confronts Richard about his behavior:

GEORGIA: Did you really expect that to be persuasive?

RICHARD: Yes.

BILLY: She's a woman, therefore disabled?

RICHARD: Georgia, give me your shoe.

GEORGIA: Excuse me?

RICHARD: May I just hold it for a second? I promise it's not a fetish.

[Georgia takes off her elegant black suede heel.]

RICHARD: Why would a grown person walk around in something like this? These are hugely uncomfortable, they make it easier to fall, plus they cause back problems. But hey, just call it fashion. [Richard sniffs it, and Billy takes it back.] What kind of person would spend the equivalent of two years painting her face, pluck out her eyebrow hairs and plant silicone or saline into her

chest? There is a name for this kind of person. Woman. She does all these things because men—we like it! Don't talk to me about equality. Don't tell me you're not disabled.

By defamiliarizing a professional woman's attire and beauty façade, Richard offers again a stark truth: women's uncomfortable clothes and painful beauty regimes, which have been frequently and more professionally critiqued by feminists, can be read as visible represen- tations of their inculcation of lack. There is indeed a feminist mes- sage lurking here, one potentially reaching a much larger audience than, say, Naomi Wolf's *The Beauty Myth*.[68] It is not accidental that this is the same episode in which Georgia cuts her long, tumbling hair, so that she will never be called a Barbie Doll again; even this act is viewed with suspicion. Ally's psychoanalyst, Tracy, dismisses Geor- gia's anger: "Yes, you don't need me. All you need for a life change is a haircut, and a cheap one at that." In this world, whether women do or do not conform to rigid codes of beauty (and by and large, they do), they cannot stop the way that others will "read" their actions and their appearances. Richard, for example, claims that Georgia was never a victim of sexual harassment even though she saw herself as such. At this point, Georgia and Ally offer a strong resistance to Richard's messages:

GEORGIA: The law didn't beat my old boss, Richard. I beat him. I took him on. I kicked ass. There's nothing disabled about me or women.

ALLY: And it is unacceptable for you to stand up in court and call women dis- abled.

GEORGIA: Unacceptable for you to sniff my shoe.

ALLY: Or objectify people by their wattles.

GEORGIA: I am not going to sit in court as token estrogen.

ALLY: And I am not going to flirt with clients.

GEORGIA: You are going to start showing respect for us.

ALLY: And this firm.

GEORGIA: You get that?

This strong, feminist union, this display of power, cannot be the last- ing message of the episode, however; to allow it would undercut all of

the mixed messages about women's power and beauty that the series tosses up—hence Richard's retort, "I do. I'm also aroused."

This comic deflation is both the strength and the weakness of *Ally McBeal*, a series that wore itself out through repetition of visual jokes (Ally frequently lost her balance and fell, and body parts rose to gigantic proportions) and through more and more outrageous lawsuits and unconvincing "wins" in the face of unreasonable odds. It was a series that worked intertextually, weaving in not only reference to other television shows like *Seinfeld* above, but also borrowed plots (in season three, John spanks Nelle as foreplay to sex, in a scene somewhat reminiscent of *Adam's Rib*) and, in one memorable instance, used the cast from *The Practice* to help work on a case.[69] Music is also used throughout to offer a commentary on individual viewpoints. Baum suggests that David E. Kelley's "stylistic strategy of structuring the series self-reflexively and intertextually also works to demystify the ambiguous and precarious nature of the cultural authority obtaining in the centering trope of the law, as a social institution, by suggesting it is subject to the permutations and arbitrary displacements characteristic of other forms of cultural production, such as imaginative literature and popular music."[70] The law is indeed permutable in *Ally McBeal*. No univocal position on women and the law is offered (unless one counts the multiply defined postfeminism so touted in the late 1990s). Again, though it is considered a hybrid form, a "dramedy," *Ally McBeal* could not (and should not be asked to) resolve the tensions at the heart of the series. A successful woman who longs for love above all else, Ally eventually discovers a practically virgin-birth daughter (conceived through her donated egg) just as she is made partner; in the final season, she juggles working motherhood and the desire for a man; and she eventually gives it all up to move to New York and start again, focusing on her newfound child. Thus, even in resolution, there is no resolution: there is simply the move to another location, another set of issues for modern womanhood (and for the law: even defining herself as legal mother is problematic).

From female murderers to female lawyers, women have been subject to the gaze of the courtroom, a gaze made more spectacular when it is on the small or large screen. If, as Greenfield, Osborn, and Robson argue, "much 'public' understanding of law is gleaned from

cultural *representations* of the law,"[71] then the importance of the media cannot be overplayed. How the relationship between women and the law is portrayed by the media depends on a number of factors: whether it occurs on television, in print, or on film; whether the purpose of the tale is melodrama or comedy; whether it is proto- or postfeminist in nature; whether it is based on real life or fantasy. Whatever factor is important, though, what is crucial is how women are seen before the imagined court.

Lenora Ledwon argues that "while the figure of Justice is sightless, it is also a representation meant to be looked at, an object of the gaze,"[72] whereas Anthony Chase contends that Justice became blind-folded in order to avoid the "dazzlement" of spectacle.[73] Finally, Greenfield et al argue that the "visual metaphor of justice as something that must be visible and seen enacted has a striking poignancy in that it captures the paramount symbolic presence of the law as a façade, a drama played out before the eyes of those subject to it."[74] As we have already seen, Justice may be blind, but audiences are not, and when it comes to women defendants, they look closely at the spectacles they make—or are made into.

But also on the other side of the courtroom women are judged by appearances. In this chapter, I have also explored the comic female lawyer as representing—and contesting—femininity. Carol Gilligan famously argued that women have a different ethical framework than men: whereas men offer an ethics of justice, women, she says, offer an ethics of care.[75] This framework has been apparently borne out in the texts under analysis here: Amanda Bonner bends the law (as does Ally McBeal, on numerous occasions) in order to get the "right" outcome, a process also undertaken by the wives of the law in *Trifles*, discussed in the previous chapter. These female lawyers (or lawyerly stand-ins) stand in opposition to the men who uphold the law more forcefully (Adam Bonner, the lawmen of *Trifles*, or a host of opposing counsel in *Ally McBeal*).[76]

Particularly in their postfeminist frameworks, these texts become unstable ones. Their engagement with the law is meant not to be accurate but amusing or provoking, as the case may be. Both beautiful and ugly defendants and beautiful lawyers are paraded before us,

successful in some arenas, clear failures in others. It is not accidental that season two of *Ally McBeal* opened with Ally waking up in bed, saying it was all real, to which her roommate Renee replied, "Here we go again." Ally's response "Oh God, I hope not," speaks volumes. Trapped in the cycle of repetition (a necessary ingredient for a television serial), *Ally McBeal* could only reenact a script that was itself a reaction to contemporary views of women lawyers and the law. Ally's place as a fragile, insecure lawyer, inhabiting the body of a girl/woman but never quite able to have these identity markers coalesce, offers a supreme example of how complicated a picture women are seen to represent.

Returning to Heilbrun and Resnik, I note that some of their desires, articulated in the foreword to *Beyond Portia*, have begun to be explored. For example, in the visual texts above, we have witnessed women's "right to anger, their use of power" and even (though not uniformly so) "their noncomplicity in the role of sex object."[77] To explore further how such elements become part of women's narratives in the twenty-first century, I turn, in my conclusion, to a case study of Joan Barfoot's *Critical Injuries*, a text that takes on issues to do with restorative justice and grace.

Conclusion

Courting Success

*We need to flood the market with our own stories until we get one sim-
ple point across: men's narrative story and phenomenological descrip-
tion of law is not women's story and phenomenology of law. We need
to dislodge legal theorists' confidence that they speak for women, and
we need to fill the gap that will develop when we succeed in doing
so. . . . [F]eminist legal theorists need to show through stories the value
of intimacy—not just to women, but to the community—and the dam-
age done—again, not just to women, but to the community—by the
law's refusal to reflect that value.*
—Robin West, "Jurisprudence and Gender"[1]

Just as the title *Courting Failure* conjures up a host of meanings, so,
too, does the title of this conclusion, "Courting Success." It suggests
not a final accomplishment, but a process, and signals at least an opti-
mistic stance toward the future. Throughout this book, I have
explored a myriad of issues to do with women and the law, reading
real-life trials against fictional texts (and vice versa) and closely read-
ing the responses to women's perceived femininity. In many places,
these readings offer uncomfortable examples of women's pain and
unfairly differentiated treatment before the courts. To leave the mes-
sage here would, I think, be to reinforce critical perceptions of
women's ultimate inability to be treated appropriately. Yet it is impor-
tant to trace the path taken to get here.

Criminology has long treated the female offender as "other," and
feminist analyses are a necessary counterpoint to this one-sided por-
trait. Interdisciplinary studies such as law and literature also make a
much-needed contribution to this debate. *Courting Failure* has been

an attempt to explore just a few of the implications of the space accorded the female offender and to analyze some aspects of confinement and release that characterize her position.

Karlene Faith acknowledges the gendered implications of crime in her scholarly text, *Unruly Women: The Politics of Resistance and Confinement*. The "unruly woman," she argues,

> is a product of the bourgeois imagination and the politics of patriarchal relations. Her crimes are the impolite crimes of the woman who lacks the resources to wrap herself in the cloaks of middle-class femininity. The "bad girl" of cultural stereotyping is the product of class-biased, racist and heterosexist myths. Historically and to the present, her appearance, actions and attitudes have been offensive to the dominant discourses which define, classify, regulate and set penalties for deviance.[2]

Faith argues that, in this context, even the relatively benign terms used for such women (such as "women in conflict with the law," a phrase I have used throughout) are problematic, given that they do not suggest the inequality of the relationship. As Faith notes, "One cannot be simply 'in conflict' with power to which one is subordinate."[3]

Despite fears that the women's movement would increase female criminal activity (on the basis that the more women had access to power and the public sphere, the more they would abuse such privileges), studies suggest that it is not women's access to power but their barring from it that causes crime. As Faith notes, the crimes women are most often convicted of in North America are stealing, writing bad checks, and cheating on welfare claims—hardly crimes of "independence" or "empowerment." Faith also reports that women's crimes *are* in some ways, perhaps, linked to their femininity: women who steal or shoplift most frequently take lipstick, clothes, and household goods.[4] Holly Johnson and Karen Rodgers further argue that many Canadian women prisoners' only crime is poverty; almost a third of women prisoners are jailed for failure to pay fines.[5] Women in conflict with the law most often come from lower socioeconomic groups, suffer from a lack of education, experience physical abuse and substance abuse, and are from ethnic minorities. As Johnson and Rodgers note, "This description is remote from the image of a 'liberated' woman attempting to imitate the behaviour of men." Similarly, Faith argues that women's "lawbreaking is a futile response to the

continuum of private and/or social abuse to which females are commonly subjected."[6] And yet women's very subordination, which is reiterated in a variety of ways by feminists who examine the experiences of female offenders, is not a sufficient explanation of their crimes — or indeed of the critical responses to these crimes.

Media representations of female criminals do not conform to the reality addressed above. Instead, they manipulate the image of women in prison to conform to stories about their so-called masculine (read lesbian) nature, their uncontrollable violence (especially sexual violence), and their wily and manipulative manner. That some women are violent and that some women are manipulative is not in dispute. After all, to assume the innocence of women on the basis of their gender is not feminist but antifeminist in nature, as I have repeatedly shown. Paradoxically, however, this antifeminist assumption of a feminine woman's innocence is set in a context whereby she suffers disproportionate condemnation of her crimes when they are proven and a pathologizing of her "aberrant" behavior. Statistically speaking, female criminals are in the minority, and violent female criminals make up an even smaller proportion of those statistics, at roughly 9 percent of incarcerated women in Canada, for example.[7] However, vehement responses to women's crime are disproportionately high. Canada's Karla Homolka, who along with her husband Paul Bernardo was responsible for the so-called Ken and Barbie Murders, was subject to an Internet Death Pool, with bets taken on the date that she would die. Britain's Myra Hindley was, of course, a prime example of a demonized woman (with questions over her possible release from jail always combined with fears for her personal safety if she had been discharged, her ill health and subsequent death in prison provoked relief, rather than regret, since these difficult decisions could be forever set aside — at least, in relation to her). Women in the United States who have been convicted of killing their children provoke sustained Web responses and emotionally laden arguments about women who kill.

In almost all these cases, gender plays a key role. Justice is not really blind, and individuals and communities beyond the juries who sit in judgment also appear to sentence women who fail to conform to received and approved images of the nurturing woman. Such judg-

ments focus on physical appearance (Homolka and Hindley providing the contrasting beauty and the beast examples) and role play or performance. Is the woman on trial convincing in her role as victim, or abused innocent, or madwoman? Such considerations play an important role in determining guilt or innocence for both real and fictional women in conflict with the law.

Susan Sage Heinzelman goes even further, arguing that "in literature a woman's testimony has only the appearance of credibility, and that her credibility, rather than testifying to the authenticity of her experience, paradoxically confirms the fictionality of that genre—that is, a woman's legitimacy is only tolerated when she speaks under the sign of the imaginary, when her voice is confined within the boundaries of a discourse marked as fictional, as not true."[8] As we have seen, even the search for truth is complicated. Atwood, Carter, and Waters offer portraits of potentially or almost certainly guilty women, who experience their confinement (and, in some cases, release) in various ways, or who see the eyes of society as always determining their activities and views. Williams, Morrison, Cooper, and Martin offer portraits of women who are marked—sometimes quite literally—by slavery. These marked women cannot offer testimony, and the evidence that is written on their bodies is consistently misread. The guilty mothers of chapter 3 are guilty in individual ways: guilty of desiring sexual fulfillment, guilty of nonconformity to traditional gender roles, guilty of contesting the medical establishment's treatment of laboring women. Yet collectively they remain guilty mostly of being seen as women who are not "natural" mothers, just as a number of the cases of real-life trials focus on how women relate to their position as mothers and detail the moments leading up to a perceived break between motherhood and womanhood. Yet these women's testimonies are contested repeatedly, and their words, in some cases, are used against them. This is also true in relation to the plays by Pollock, Glaspell, Treadwell, and Daniels, where the women on trial are spoken for (as are all defendants in criminal cases). What is key here, though, is that their own testimony is disbelieved or misunderstood—witness the inability of the jury in *Machinal* to understand the Young Woman's decision to murder her husband rather than "hurt" him. In the final

chapter, my exploration of women and the law moved to visual representations and, in the case of *I Want to Live!* showed how a "confession" could be multiply read. Peter Brooks argues that

Everything we have observed in confessions, "real" or "fictional" (the borders tend to blur here) tends to suggest that confessions rarely are products of a free and rational will. They arise in situations of constraint, whether physical or psychological. They are motivated by inextricable layers of shame, guilt, disgrace, contempt, self-loathing, propitiation, and expiation. Their "truth" is often not straightforward but deviated from its apparent reference: a truth of performance and dialogue, a truth created by the bond of confessant and confessor and the confessional situation.[9]

Brooks's recognition of the multiple valences of confessions can be linked to my recognition of the multiple expressions of guilt. In many texts explored in *Courting Failure*, guilt acts as a cover for something else: for the failure to be "truly" feminine or for desires that cannot be contained.

The links between these diverse chapters are multiple but focus primarily on gender and gendered responses to women's apparent crimes. Lenora Ledwon argues that "the jurisdiction of both law and literature is the realm where language, story, and human experience meet,"[10] and this has been a primary focus; hence the movement, in some chapters, between discussions of trials and close analysis of literary texts. It has also been my contention, articulated most explicitly in the introduction, that law and literature needs literary critics to read a variety of texts to ensure that the focus of the discipline does not reside fully with the Great Books tradition. There is a tension between the two branches of the law and literature field, a tension that requires scholars from both disciplinary fields to explore the law and literature enterprise. As Kenji Yoshino argues, "Law's simultaneous need and inability to banish literature makes law and literature a distinctively fraught enterprise. Banished from law as a polluted discourse, literature keeps surfacing in the wake of its enforced departure."[11]

In the context of the Great Books tradition, the idea of a banished text takes on even more resonance: too often the banished text is the woman's text. Ilene Durst is not surprised that lawyers resist fiction that focuses on women, because these stories suggest an alteration in

method or "urge attorneys to temper their rule-based reasoning with consideration for personal relationships."[12] Critics who explore "other" texts—primarily, but not exclusively, texts by women—contribute substantially to debates about representation, as well as the tricky debates about postegalitarian feminism articulated so well by critics such as Martha Fineman and Robin West. West suggests that "[w]e need more than just acceptance of our differences [from men]; we need a vocabulary in which to articulate and then evaluate them, as well as the power to reject or affirm them."[13] Such a vocabulary is never going to be easily implemented; it will always be resisted (especially by those feminists who argue that equality, since it has never been attained, remains a number one priority). West's focus on empowerment is, however, key to these debates.

It is in this context that I want to move on to a final literary example, that of Joan Barfoot's *Critical Injuries*. This text very carefully moves the argument away from examples of a woman's position before the court as the one who is judged, to the consequences of criminal actions for a woman and her family. In fact, within the text, the only characters who are ever tried in a court of law are men, and all three are convicted. It is Isla's fate to be attached to each of these cases, as wife, mother, or victim, a fact that would seem to inscribe her secondary position and reinforce ideas about women's subordinate roles. What Barfoot does, however, is show how a female character grows beyond these designations and how she enters a state of grace and forgiveness. This is not a lasting, beatific state, but a shifting, problematic, and ultimately life-affirming *decision*. Its relevance for this discussion of law and literature is that it embraces the concept of reparative or restorative justice, in that it looks beyond incarceration as punishment and more toward the values of intimacy and connection so eloquently expressed by Robin West in the opening quotation of this conclusion. It courts *success*, in whatever limited form such success is available.

Critical Injuries focuses on Roddy, a drifting high school student, and Isla, a divorced (and remarried) mother of two grown, troubled children. Isla's life has been derailed on more than one occasion by encounters with the law, first when her first husband was convicted of

unlawful sex with a minor, and then when her son was convicted of drug offenses. In her latest, happy incarnation, Isla's connections with the law are more positive, including marriage to Lyle, a lawyer. On a celebratory whim, Isla and Lyle make a trip to a local store, Goldie's, to buy ice cream, and Isla unwittingly enters the store just as the young assistant, Mike, is making plans with Roddy, his childhood friend, to rob the place. Startled, Roddy fires his loaded gun and hits Isla in the spine before running away. The novel thus begins with what ends up being referred to as their "encounter" and moves backward to earlier legal entanglements, while offering parallel accounts of Roddy's and Isla's lives.

The reader is only cautiously let in to details of Isla's previous existence; for most of the novel, she is in limbo, unable to move, completely paralyzed by the bullet still lodged in her spine. In fact, the narratives of Roddy and Isla run parallel, as both are incarcerated (though in different ways) as the result of their "encounter."

Barfoot is careful to ensure that Roddy's narrative is sad, though not tragic. His manic-depressive mother attempted suicide, at which point his father took him to live with his grandmother; eventually, Roddy's mother succeeds in killing herself, though this information is withheld from him at the time. Roddy grows up without clear goals, apart from wanting to run away with Mike and live in a high-rise apartment in the city. He is seventeen at the time of the shooting, and most of these facts are retold in the trial, with different emphases depending on whether the words come from the prosecutor or the defense. Even Roddy recognizes that both versions are simply stories and do not capture the essence of the act, and I quote the passage in full because of the way it replicates the strategies adopted by lawyers to ensure that their story is the believable (and believed) one:

The one against him goes on about vicious crime, youthful violence, brutal, reckless behaviour, innocent victim, the need for harsh penalties to set an example. It sounds to Roddy sort of general; like it's not really directed at him.

Ed Conrad is different. For one thing, he talks slowly and softly about Roddy's mother, and what does he know about her? He talks about a boy wrenched from one place and set of people to another due to family tragedy. A hard-working but difficult family situation, loving grandmother and father

doing their best, a good sturdy outlook for someone with that kind of support. A reckless, immature, tragic act, he says, by a boy still with promise, who might be destroyed by harsh punishment. "He did a terrible thing," Ed Conrad says. "But he's not a terrible boy. One out-of-character act should not destroy so much potential."

What does he think he knows about Roddy's character? Roddy has no good idea of it himself. Nor about potential. He doesn't want to think about that word at all. It means a future that's lost. What he could have done, whatever that might have been if he'd ever worked out such a thing.[14]

In contrast to Roddy, Isla is forty-nine and finally successful. She had also lost a parent as a child and had been unsure of herself at Roddy's age. She married young, to a man who betrayed her, and coped with her son's drug dependency. Now, however, she is the co-owner of an advertising agency, financially secure, and clearly in love. That the two main characters have such different perspectives on life is not accidental, though their encounter is. It is significant that each perspective is given equal space in the novel (though here, I will be concentrating primarily on Isla).

At the end of the first chapter, when the characters (and thus potentially the readers) are still in a state of confusion and partial information about the significant events of the shooting, Lyle asks of a doctor, "'What does that mean? What will it mean?'" and Isla's internal dialogue is instructive: "Bless him, he speaks for her, takes the words right out of her mouth and in addition, more than she can do at the moment, apparently, makes sense of them, makes them come out right, not mangled, like her" (12). Both Isla's words and her body are mangled here, and it is not accidental that Barfoot constructs the sentence thus. The rest of the novel works to untangle the events, but very little can be done for Isla herself. Throughout the first part of the narrative, there is sufficient hope that Isla will regain movement, since it does not seem possible that such a random event could have such lasting consequences. By the end of the novel, though, it is clear that Isla will be forever altered by this event—as will Roddy himself. Neither victim nor aggressor—though that word seems strong for what Roddy represents—can escape the consequences of these actions.

If Isla is grateful for Lyle's early ventriloquism, she is less happy as the novel progresses; indeed, she comments that "[f]or a lawyer, he

doesn't tell a story very coherently" (52). She is, however, initially dependent on him to ensure that she knows what happened. Even as he speaks, though, Isla recognizes that his description of events would not equate with hers:

Lyle's version is different. Not necessarily less volatile or catastrophic than hers, but—he wasn't there. His account has to be second-hand, third-hand, picked up from running from the truck into the disarrayed scene at Goldie's, then from experts: ambulance attendants, cops, nurses, doctors. He is, it seems doomed to observer status. . . . In any case now he seems reduced, with his anxious eyes and fretful mouth: a recounter, a teller, not the actor, or the acted upon. (51)

As Isla grows impatient with this version, and with the fact that others speak for her, she is in no position to alter these factors. Indeed, when she does react with anger, her family and her doctors conspire to sedate her: she is thus unable, at the beginning, to express unfeminine reactions or outlaw emotions, because to do so risks annihilation and unconsciousness. Though she learns to keep her voice in check, she does not censor her thoughts, which are full of vengeance and a call for swift—and painful—punishment of her attacker.

Thus, Isla's position is full of tensions: between behaving in ways that others expect and her own frustration; between being seen as a forgiving, maternal figure—indeed, during her first bewildering encounter with the law, she notes that "performing acts of motherhood gave her something to do" (156)—and her catastrophic sense of injustice. When Lyle tells her that he ensured that law officials were aware that the boy who attacked her was frightened, she is puzzled: "This seems excessively merciful. What about vengeance? How about loyalty? Isla would shoot the son of a bitch herself, if it would undo what happened. If it would just get her up on her feet, she would shoot him. If for no other reason than simple, straightforward balance: this for that" (55). Lyle's view is, however, that at that point, it would be bad luck for anything to happen to the boy; in relation to the law at least, the issue is "repairable, somehow" (55).

This very subtle introduction of reparation, positioned as it is next to a call for retribution, sets up the competing notions of justice that the novel examines. Implicitly, this juxtaposition introduces the concept of restorative justice. Restorative justice aims to bring together

victims, offenders, and significant others, including family members and the community at large, in order to address wrongdoing and compensation or restoration, combining "what may be seen as legislative, prosecutorial, defence, judicial, and correctional functions."[15] Restorative justice, which may be informal, includes mediation and family conferences and focuses on alternatives to prison itself. Barfoot's text, then, does not explore a formal mechanism for restoration (Roddy does go to jail for his crime), but it does explore the benefits of moving away from a position based on retribution alone, for both Roddy and Isla.

Even before he is sentenced, Roddy understands the principle behind restorative justice, even if he cannot articulate it precisely:

> What Roddy thinks the people who run the place should do at the start of the day if they really want to make guys feel bad about the trouble they're in, is make them stay in bed for a while after the buzzer goes. Everybody'd have to lie there looking at the bleak, stupid hours ahead, and it would make at least some of them feel bleak and stupid themselves. Which would be pretty good punishment. (134)

Yet he is unable fully to accept his own responsibility, and even unfairly shifts it onto Isla: "He hopes she's not a nice woman. He hopes she maybe even deserves what has happened, so that maybe this isn't so much to do with him, but with her being punished for something, and he just got picked for no particular reason to punish her" (146). Roddy's rationalizations bespeak his immaturity and his unwillingness to confront the shooting as only partially accidental; after all, if he had not planned a mock-robbery and brought along a gun for a prop, he would not have shot Isla.

While Isla's family members are offered the chance to make Victim Impact Statements on her behalf (it is significant that she is still immobilized in the hospital when the legal apparatus takes over), and Roddy is eventually imprisoned, he pleads guilty only to armed robbery; the attempted murder charge is dropped. In many ways, this seems an expedient decision, and even Isla realizes that the term "attempted murder" does not quite fit the crime, though she does not know what else would: "no doubt there isn't a specific charge that covers being startled, frightened, shocked into shooting" (106). What is clear, though, is that Roddy is punished for the crime against socie-

ty, not the crime specifically against Isla, and, therefore, he remains, at one level, unpunished and unforgiven. Thus, even when he is released from prison, and Isla is released from the hospital, their story cannot finish until a second encounter is arranged by Isla's daughter, Alix, as a gesture neither quite understands; it is an encounter both of them resist.

Kent Roach rightfully notes that feminists express ambivalent feelings toward restorative justice. While some feminists may support nonpunitive forms of rehabilitation for offenders, others are concerned that restorative justice may be used inappropriately—for example, in domestic abuse cases: "[F]eminists have fought to have sexual and domestic violence recognized as true crimes that deserve public attention and punishment. Restorative justice has the potential to place these gains in jeopardy by allowing such crimes to be discussed in private settings where women may suffer from a power imbalance and perhaps be blamed for the crimes."[16] It is, therefore, significant that Barfoot's text does not go down this route fully; for each of the crimes committed, the men responsible are offered custodial sentences. However, eventually, each finds a form of peace attached to the acknowledgment of harm. Isla's son Jamie plans to work with drug abusers and returns to education to do so; Isla's first husband reaches out with sympathy when hearing of her current situation; and Roddy is persuaded to meet with Isla, on her terms, in her own home, to face the results of his actions.

It is also key that Isla's and Roddy's concurrent periods of intense rehabilitation (both physical and societal) remain virtually undelineated in the novel. In fact, Isla's rehabilitation is covered by a few sentences: "*Rehabilitation*, that sterile, unfreighted word that amounted, mainly, to anguished learning of new tricks, compensating ways of hauling herself up, down and along. Boring *and* painful, an especially unfortunate combination" (287; italics in original). Similarly, the attention given to Roddy's time in prison is primarily focused on his initial incarceration, not the period of time after his sentencing, when rehabilitation may be said to commence (or at least be held out as a possible positive consequence of imprisonment). Karlene Faith reminds us that the "French word *habiller* means 'to dress,' or 'to wrap

up'; to be *re*habilitated is to start life anew, once again fully 'clothed' in the garb of respectability with one's dignity restored."[17] Both Roddy and Isla must contend with these factors: it is not accidental that when they meet again, Roddy is dressed uncomfortably in formal attire, and Isla has discovered that her very visible disability confers upon her a respect and level of solicitation that she had never before experienced.

In their first face-to-face encounter, on the very day that Isla's family celebrates her own homecoming, Isla realizes that Roddy is suffering, and her initial response is, "Well good." She then further contemplates the scene: "Could this possibly be what Alix intended? Has she, alone among all of them, set herself to revenge, is she the clever one who has figured out, and put into action, a plan to torture this boy so exquisitely, so subtly and carefully, that it can appear, even to him, like an act of love, or even redemption?" (322). Yet it is clear that this is Isla's perspective, not Alix's, and that Isla, like Roddy, still needs to learn what justice really is. To do so, she needs to confront the fact that Roddy really was a young man who made mistakes, just as his lawyer had painted him; he is not the demon of her imagination:

> She didn't exactly mean to make tears come to his eyes. She thought he'd be tougher. He had a gun, after all. He shot her, didn't he?
>
> She thought she'd be tougher, too. Maybe this is what Alix meant: that in person, right up close, he is no monstrosity.
>
> Then who will haunt her, what looming figure can she call on, who can she reliably regard as a representative of doom grand and powerful enough to have cost her her legs, crucial movement, necessary sensation? This boy? His insignificance, his meekness, his frank fear, altogether make her doom seem small, her suffering minor, her struggles paltry. What an insult, what a blow. (324)

Although Isla pushes Roddy to admit that without his friend Mike—who was spared punishment through Roddy's silence—Roddy would not have been in the situation in the first place, their communication is not smooth. For example, during their exchange, Isla cannot understand or interpret Roddy's admission of guilt: "[I]s he insisting on ownership of his big, bold, bad deed, or claiming penitence all for himself?" (326). In this exchange and others, it is clear that reparation is not an easy act; Isla will not take up the mantle of a saint and offer

forgiveness without anything in return. She admits to anger at his deeds; he admits to anger, too. And in this mutual recognition, they discover the importance of this necessary confrontation:

> They are not exactly twinned souls. Nor are they twined exactly by circumstance, nor has she ceased regretting his existence. As, possibly, he regrets hers. But it's far more than she could have imagined.
>
> In this moment, this glimpse, the terrible bitterness of punishment, the onerous weight of revenge have lifted to make a space for—what? The word for this might, she thinks, after all be *grace*. (333; italics in original)

It is on this uneasy note of grace—something that Isla recognizes cannot be sustained indefinitely or without effort—that the book concludes. The hope for a miraculous medical outcome, sustained for much of the book, is shown to be unattainable, and it becomes clear that this is what crime does: it changes. One is not restored to what one was before. One remains injured, critically, and this cannot be rectified. But what one does have control over is the response to this critical injury, and here, both Isla and Roddy court the success of intimacy.

The relevance of this text for a discussion of women's law and literature narratives is, I hope, clear. As women writers in particular engage with the space of legislated patriarchy and subvert further the grounds on which women are judged, they open up spaces in the courtrooms that will not be filled with women's silence but, as we have repeatedly seen, with women's "right to anger, their use of power . . . [and] their noncomplicity in the role of sex object."[18] Isla is angry and allowed to vent that anger; Isla is powerful and discovers the importance of moving beyond revenge; Isla also discovers that justice comes not in a courtroom but on her porch, talking to her attacker and confronting their entwined, changed lives. Texts like *Critical Injuries* open out, rather than close down, the arena in which women tackle the law.

Hilary Allen argues that "what *is* potentially oppressive to women—criminal or otherwise—is for the frailties and disadvantages that do tend to characterise their position in society to be treated as exhaustive of their condition as social or legal subjects."[19] In *Critical Injuries*, Isla's position is one that could easily be read as one of oppression, disadvantage, and frailty. The text, however, ensures that

this reading is counterbalanced by another, a reading in which Isla is given agency, even as her body itself is less able. Isla's ultimate grace—her willingness to participate in restorative justice—suggests the value of intimacy that West urges us to consider in women's stories of law and literature. It is through intimacy that Isla becomes attached to two men who abuse that trust—her first husband and her son—but she nevertheless reaches toward intimacy again, with Lyle. It is her awareness of intimacy as a strategy for renewal that allows her to speak to, and engage with, the man (or rather, the boy) who shot her. This intimacy does not preclude anger, nor does it suggest a saintly version of femininity that reinscribes patriarchal representations. Rather, this intimacy is one that recognizes the contradictions inherent in women's legal lives. As West argues, women are "people who value intimacy, fear separation, dread invasion, and crave individuation."[20] These multiple, contradictory desires need, West argues, to be recognized in law (and, one might argue, literature about the law), just as women's stories need to be recognized as gendered and different—though not collectively so.

The story of women and the law is a multiple story, offered in different contexts and genres, with different frames of reference. As a character on the September 4, 1990 episode of the short-lived television sitcom *On the Up* said, "Women is a plural noun, not a collective consciousness." This potentially profound yet equally self-evident statement suggests the impact of feminism on popular culture, and beyond. Women's legal lives may be similar in ways to do with gendered experiences, but different in terms of class, positions of mothering, ethnicity, age, and sexuality. The recognition of these differences should not preclude an examination of their similarities—but it does suggest that this examination should be more three-dimensional.

Peter Brooks suggests that "[a]t its most potent, the 'law and literature movement' summons the law to be accountable to a critique from outside its hermetic closure, one that insists that legal language and legal business as usual implicate master narratives, ideologies, and concepts that have a place in other domains of culture as well, and cannot be insulated and protected purely as legal terms of art."[21] If we follow Brooks here and move discussions of the law outside the

courtroom and law schools, we enter into debates about the impact of law on individuals and their individual stories. Martha Fineman acknowledges that law as an institution is meant to have universal application, and that it works by "tying 'like things' together in a web of consistent and coherent doctrine."[22] Where things get more complicated is where these "like things" offer not only similarity but difference, where patterns of legal opinion appear to treat as the same things that remain radically different. Maria Aristodemou goes so far as to argue that "[f]or women to enter the legal fortress and participate in its continuing growth they need not only different laws but a different language; one that acknowledges their different aspirations, languages, dreams, and journeys."[23] West, too, explores how language means, and the effect of using the legal language of, say, harm in relation to abortion, invasion in relation to rape, and other terms borrowed from specific sets of circumstances for a wider use.

These discussions can only be preliminary; a new language—if indeed one is really needed—cannot be created overnight. But the signs of some success are there: success, for example, in ensuring that issues of language are at least on the agenda. Richard Posner argued that "[t]he attempt by some feminists to coerce the adoption of a 'gender neutral' vocabulary is an attempt at censorship,"[24] and indeed his own words remain fascinating for the very play of violence they suggest. Feminists "coerce," and in this phraseology are identified with immense (perhaps even malevolent) power. What also remains intriguing is the very fact that in some areas neutral language remains a goal even as movements beyond neutrality spark other battles. As Fineman suggests, "Arguing for a theory of difference questions the presumed neutrality of institutions, calling into question their legitimacy because they are reflective of primarily male experiences and concerns. In that way, a theory of difference has the potential to empower women."[25]

Courting Failure has explored the myriad ways in which women's difference is highlighted—to their detriment as well as to their benefit—in both courts of law and the pages of texts. It has done this in order to explore opportunities for power—and ways to move beyond a language of exclusion.

Notes

Introduction

1. Jacqueline St. Joan, "Sex, Sense, and Sensibility: Trespassing into the Culture of Domestic Abuse," *Harvard Women's Law Journal* 20 (1997): 288.

2. Carolyn G. Heilbrun and Judith Resnik, foreword to *Beyond Portia: Women, Law, and Literature in the United States*, ed. Jacqueline St. Joan and Annette Bennington McElhiney (Boston: Northeastern University Press, 1997), xii.

3. Richard H. Weisberg, "Literature's Twenty-Year Crossing into the Domain of Law: Continuing Trespass or Right by Adverse Possession?" in *Law and Literature*, Current Legal Studies, vol. 2, ed. Michael Freeman and Andrew D. Lewis (Oxford: Oxford University Press, 1999), 50.

4. Tony Sharpe, "(Per)Versions of Law in Literature," in *Law and Literature*, Current Legal Studies, vol. 2, ed. Michael Freeman and Andrew D. Lewis (Oxford: Oxford University Press, 1999), 91.

5. Sharpe, "(Per)Versions," 91.

6. Richard Posner, "Law and Literature: A Relation Reargued," in *Law and Literature: Text and Theory*, ed. Lenora Ledwon (New York: Garland, 1996), 64.

7. Dieter Paul Polloczek, *Literature and Legal Discourse: Equity and Ethics from Sterne to Conrad* (Cambridge: Cambridge University Press, 1999), 14.

8. Weisberg, "Literature's Twenty-Year," 58.

9. Robert A. Ferguson, *Law and Letters in American Culture* (Cambridge, MA: Harvard University Press, 1984), 5.

10. Theodore Ziolkowski, *The Mirror of Justice: Literary Reflections of Legal Crises* (Princeton, NJ: Princeton University Press, 1997), xi.

11. Ibid.

12. Polloczek, *Literature and Legal Discourse*, 13.

13. Willem J. Witteveen, "Law and Literature: Expanding, Contracting, Emerging," *Cardozo Studies in Law and Literature* 10, no. 2 (1998): 158, 156.

14. Jane B. Baron, "Law, Literature, and the Problems of Interdisciplinarity," *Yale Law Review* 108, no. 5 (1999): 1062.

15. Ibid., 1063, 1065, and 1066.

16. See, for example, Michele G. Falkow, "Pride and Prejudice: Lessons Legal Writers Can Learn from Literature," *Touro Law Review* 21 (2005): 349–426; Debora L. Threedy, "The Madness of a Seduced Woman: Gender, Law, and Literature," *Texas Journal of Women and the Law* 6 (Spring 1996): 1–46; Martha C. Nussbaum, *Poetic Justice: The Literary Imagination and Public Life* (Boston: Beacon, 1995); Robin L. West, "The Literary Lawyer," *Pacific Law Journal* 27 (1996): 1187–1211; Teree E. Foster, "But Is It Law? Using Literature to Penetrate Societal Representations of Women," *Journal of Legal Education* 43 (1993): 133–48; and Sherman J. Clark, "Literate Lawyering: An Essay on Imagination and Persuasion," *Rutgers Law Journal* 30, no. 3 (1999): 575–94, among others, for a discussion of this viewpoint.

17. See Sanford Levinson and Steven Mailloux, eds., *Interpreting Law and Literature: A Hermeneutic Reader* (Evanston, IL: Northwestern University Press, 1988), particularly Levinson's own reprinted essay, "Law as Literature."

18. David R. Papke, ed., *Narrative and Legal Discourse: A Reader in Storytelling and the Law* (Liverpool: Deborah Clarke Publications, 1991). Papke reprints Delgado's essay, "Storytelling for Oppositionists and Others: A Plea for Narrative," which originally appeared in *Michigan Law Review* 87 (1989): 2411–41. Culp was professor of law at Duke until his death in 2004 and was the editor of, among other projects, *Crossroads, Directions, and a New Critical Race Theory* (Philadelphia: Temple University Press, 2002).

19. Baron, "Problems of Interdisciplinarity," 1068.

20. Ibid., 1070.

21. Richard Delgado and Jean Stefancic, "Norms and Narratives: Can Judges Avoid Serious Moral Error?" *Texas Law Review* 68 (1991): 1929–60.

22. Falkow, "Pride and Prejudice."

23. Michael Asimow and Shannon Mader, eds., *Law and Popular Culture: A Course Book* (New York: Peter Lang, 2004). See West, "The Literary Lawyer," for a discussion of the problems attached to relying on the literary canon to explore law and literature.

24. Ronald Dworkin, "How Law Is Like Literature," in *Law and Literature: Text and Theory*, ed. Lenora Ledwon (New York: Garland, 1996), 32.

25. Ibid., 33.

26. Ziolkowski, *Mirror of Justice*, xii.

27. Barry R. Schaller, *A Vision of American Law: Judging Law, Literature, and the Stories We Tell* (Westport, CT: Praeger, 1997), xi.

28. Gaurav Desai, Felipe Smith, and Supriya Nair, "Introduction: Law, Literature, and Ethnic Subjects," *MELUS* 28, no.1 (2003): 6.

29. Ibid., 12.

30. Richard Weisberg, *Poethics and Other Strategies of Law and Literature* (New York: Columbia University Press, 1992), xii.

31. Ibid., 119.

32. Desai, Smith, and Nair, "Introduction," 5.

33. Whether this edition is still in the library, I have no way of checking, but I can attest to its presence in the summer of 2002. I discovered this feminist graffiti when I was on a Canadian High Commission funded trip to Toronto and Kingston. I am grateful to the Canadian High Commission for its support.

34. Weisberg, *Poethics*, 119.

35. Weisberg, "Literature's Twenty-Year," 49.

36. Ibid., 57.

37. St. Joan, "Sex, Sense, and Sensibility," 288.

38. Richard Posner, *Law and Literature*, rev. ed. (Cambridge, MA: Harvard University Press, 1998), viii.

39. Ibid., 5.

40. Ibid., 7.

41. Ibid., 14.

42. Ibid., 15.

43. Ibid., 12.

44. See her original research, "Law and Literature: An Unnecessarily Suspect Class in the Liberal Arts Component of Law School Curriculum," *Valparaiso Law Review* 23 (1989): 273–84, as well as the updated essay "'Law and Literature': Joining the Class Action," *Valparaiso Law Review* 29, no. 2 (1995): 665–859.

45. Stanley Fish, "Working on the Chain Gang: Interpretation in Law and Literature," in *Law and Literature: Text and Theory*, ed. Lenora Ledwon (New York: Garland, 1996), 50.

46. Weisberg, "Literature's Twenty-Year," 47; Judith Resnik, "Singular and Aggregate Voices: Audiences and Authority in Law & Literature and in Law & Feminism," in *Law and Literature*, Current Legal Studies, vol. 2, ed. Michael Freeman and Andrew D. Lewis (Oxford: Oxford University Press, 1999), 690.

47. Michael Thomson, "From Bette Davis to Mrs. Whitehouse: Law and Literature—Theory and Practice," in *Law and Literature*, Current Legal Studies, vol. 2, ed. Michael Freeman and Andrew D. Lewis (Oxford: Oxford University Press, 1999), 219.

48. Carol Sanger, "Feminism and Disciplinarity: The Curl of the Petals," *Loyola of Los Angeles Law Review* 27 (1993): 234.

49. Robin West, "Economic Man and Literary Woman: One Contrast," in *Law and Literature: Text and Theory*, ed. Lenora Ledwon (New York: Garland, 1996), 134n2.

50. Catherine A. MacKinnon, "Reflection on Sex Equality Under Law," *Yale Law Journal* 100 (1991): 1287. In her recent book, *Are Women Human?* MacKinnon actually suggests that on current evidence, the answer is no.

51. Martha Albertson Fineman, "Feminist Theory in Law: The Difference It Makes," in *Beyond Portia: Women, Law, and Literature in the United States*, ed. Jacqueline St. Joan and Annette Bennington McElhiney (Boston:

Northeastern University Press, 1997), 55.

52. Ibid., 59.

53. Ellen Adelberg and Claudia Currie, eds., *In Conflict with the Law: Women and the Canadian Justice System* (Vancouver: Press Gang, 1993), 15.

54. Frances Olsen, "Do (Only) Women Have Bodies?" in *Thinking Through the Body of the Law*, ed. Pheng Cheah, David Fraser, and Ruth Grbich (New York: New York University Press, 1996), 216.

55. Carol Smart, "The Woman of Legal Discourse," in *Criminology at the Crossroads: Feminist Readings in Crime and Justice*, ed. Kathleen Daly and Lisa Maher (New York: Oxford University Press, 1998), 25, 26, and 31.

56. Ibid., 26.

57. Helen Birch, ed., *Moving Targets: Women, Murder and Representation* (London: Virago, 1993), 4.

58. Allison Morris and Ania Wilczynski, "Rocking the Cradle: Mothers Who Kill Their Children," in *Moving Targets: Women, Murder and Representation*, ed. Helen Birch (London: Virago, 1993), 204.

59. Anne Worrall, *Offending Women: Female Lawbreakers and the Criminal Justice System* (London: Routledge, 1990), 31.

60. Morris and Wilczynski, "Rocking the Cradle," 199.

61. Ibid.

62. See the House of Commons Select Committee on Home Affairs report on http://www.publications.parliament.uk/pa/cm200405/cmselect/cmhaff/193/19315.htm, accessed July 2005.

63. See the U.S. Bureau of Justice figures at http://www.ojp.usdoj.gov/bjs/crimoff.htm#women, and a special report, revised in 2000, which offers a much fuller picture of women offenders at http://www.ojp.usdoj.gov-bjs-pub-pdf-wo.pdf.url, accessed July 2005.

64. Sarah Wight and Alice Myers, introduction to *No Angels: Women Who Commit Violence*, ed. Sarah Wight and Alice Myers (London: Pandora, 1996), xii-xiii.

65. Carolyn Heilbrun and Judith Resnik, "Convergences: Law, Literature, and Feminism," in *Beyond Portia: Women, Law, and Literature in the United States*, ed. Jacqueline St. Joan and Annette Bennington McElhiney (Boston: Northeastern University Press, 1997), 33.

66. Ibid., 34.

67. Robin West, *Narrative, Authority, and Law* (Ann Arbor: University of Michigan Press, 1993), 193.

68. Ibid., 192, 193.

69. Ibid., 179.

70. Ibid., 180.

71. Judith Resnik, "Changing the Topic," *Cardozo Studies in Law and Literature* 8, no. 2 (1996): 339.

72. Patricia J. Williams, *The Alchemy of Race and Rights: Diary of a Law*

Professor (Cambridge, MA: Harvard University Press, 1991), 83.

73. Ibid., 93.

74. Anne M. Coughlin, "Regulating the Self: Autobiographical Performances in Outsiders Scholarship," *Virginia Law Review* 81, no. 5 (1995): 1229–340. Coughlin is, in particular, focused on Patricia Williams, Jerome Culp, Richard Delgado, and Robin West.

75. Ibid., 1253–54.

76. Thérèse Murphy, "Bursting Primary Bubbles: Law, Literature and the Sexed Body," in *Tall Stories? Reading Law and Literature*, ed. John Morison and Christine Bell (Aldershot: Dartmouth, 1996), 57–82.

77. Annette Kolodny, "Dancing through the Minefield," in *The New Feminist Criticism*, ed. Elaine Showalter (London: Virago, 1986), 161.

78. Ibid., 160.

79. Resnik, "Singular and Aggregate," 695.

80. Kim Lane Scheppele, "Foreword: Telling Stories," *Michigan Law Review* 87, no. 8 (1989): 2083–84.

81. Ibid., 2079.

82. Maria Aristodemou, *Law and Literature: Journeys From Her to Eternity* (Oxford: Oxford University Press, 2000), 11.

83. Morley Callaghan, "A Wedding-Dress," in *Morley Callaghan's Stories* (London: MacGibbon and Kee, 1962), 1:53–58. Subsequent page references are cited parenthetically.

84. Gary Boire, "The Language of the Law: The Cases of Morley Callaghan," in *Dominant Impressions: Essays on the Canadian Short Story*, ed. Gerald Lynch and Angela Arnold Robbeson (Ottawa: University of Ottawa Press, 1999), 83.

85. Ibid., 83.

86. Ibid., 84.

87. Ibid.

88. Ibid., 79–80.

89. Toni Morrison, *Beloved* (London: Picador, 1988), 23.

90. Resnik, "Changing the Topic," 349.

91. See Wood's article "Refined Law: The Symbolic Violence of Victim's Rights Reforms" in *Un-Disciplining Literature: Literature, Law, and Culture*, ed. Kostas Myrsiades and Linda Myrsiades (New York: Peter Lang, 1999), 72–93.

92. Adelberg and Currie, *In Conflict*, 13.

93. Heilbrun and Resnik, foreword, xii.

94. Resnik, "Singular and Aggregate," 688.

Chapter 1

1. Jeremy Bentham, *Panopticon, or The Inspection House* (1787), http://www.cartome.org/panopticon2.htm, 2, accessed August 3, 2003.

2. Michel Foucault, "Panopticism," in *Discipline and Punish: The Birth of the Prison*, trans. Alan Sheridan (1977; London: Penguin, 1991), 200.

3. Laura Mulvey, "Visual Pleasure and Narrative Cinema," *Screen* 16, no. 3 (1975): 6–18.

4. Sandra Lee Bartky, "Foucault, Femininity, and the Modernization of Patriarchal Power," in *Feminism and Foucault: Reflections on Resistance*, ed. Irene Diamond and Lee Quinby (Boston: Northeastern University Press, 1988), 67.

5. Ibid., 72.

6. Joanne M. Gass, "Panopticism in *Nights at the Circus*," *Review of Contemporary Fiction* 14, no. 3 (1994): 71.

7. Angela Carter, *Nights at the Circus* (1984; London: Vintage, 1994), 210. Subsequent page references are cited parenthetically.

8. Foucault, "Panopticism," 200.

9. Bartky, "Foucault, Femininity," 67.

10. Merilyn Simonds, *The Convict Lover: A True Story* (Toronto: Macfarlane Walter and Ross, 1996).

11. Ibid., 29.

12. Foucault, "Panopticism," 200.

13. C. J. Taylor, "The Kingston, Ontario Penitentiary and Moral Architecture," in *Lawful Authority: Readings on the History of Criminal Justice in Canada*, ed. R. C. Macleod (Toronto: Copp Clark Pitman, 1988), 224.

14. Ibid., 229.

15. Bentham, *Panopticon*, 4.

16. Foucault, "Panopticism," 200.

17. Ibid., 201.

18. Taylor, "Kingston, Ontario Penitentiary," 242.

19. Ibid., 241.

20. Ibid., 237.

21. Foucault, "Panopticism," 219.

22. In a contemporary parallel, perhaps, consider the public outrage occasioned when photographs of Karla Homolka in prison party dress appeared in the *Montreal Gazette*; there were immediate calls for her to be transferred to a harsher prison environment. In contrast to her supposedly "cushy" incarceration, her ex-husband, Paul Bernardo—whom she helped convict in her testimony as part of a plea bargain arrangement for the manslaughter of Ontario teenagers Kristen French and Leslie Mahaffy—is held in Kingston Penitentiary, a maximum-security prison. Some would argue that this is proof that gender is already—and unfairly—a consideration in sentencing and treatment; others would argue that Homolka, like Marks, was also a victim of abuse and thus not entirely responsible for her crimes. In both cases, media interventions play a clear role in how these women are or were represented.

23. Anita Biressi, *Crime, Fear and the Law in True Crime Stories* (Houndmills: Palgrave, 2001), 167.

24. Margaret Atwood, *Alias Grace* (London: Bloomsbury, 1996), 26. Subsequent page references are cited parenthetically.

25. Queen's University Archives 599, MF POS 599.

26. Queen's University Archives MF 2342, Book 11, May 2, 1871–May 3, 1873.

27. Norman N. Holland and Leona F. Sherman, "Gothic Possibilities," in *Gender and Reading: Essays on Readers, Texts, and Contexts*, ed. Elizabeth A. Flynn and Patrocinio Schweickart (Baltimore: Johns Hopkins University Press, 1988), 215.

28. Susanne Becker, *Gothic Forms of Feminine Fictions* (Manchester: Manchester University Press, 1999), 68.

29. Peter J. Hutchings, *The Criminal Spectre in Law, Literature and Aesthetics: Incriminating Subjects* (London: Routledge, 2001), 55.

30. Ibid., 66.

31. Judith Knelman, "Can We Believe What the Newspapers Tell Us? Missing Links in *Alias Grace*," *UTQ: A Canadian Journal of the Humanities* 68, no. 2 (1999): 683.

32. Jane B. Baron, "Storytelling and Legal Intimacy," in *Un-Disciplining Literature: Literature, Law, and Culture*, ed. Kostas Myrsiades and Linda Myrsiades (New York: Peter Lang, 1999), 20.

33. Cristie March, "Crimson Silks and New Potatoes: The Heteroglossic Power of the Object in Atwood's *Alias Grace*," *Studies in Canadian Literature* 22, no. 2 (1997): 66.

34. In another context, Mary Lydon discusses the double meaning of the word "secreted": "its capacity to produce and conceal at the same time." See Mary Lydon, "Foucault and Feminism: A Romance of Many Dimensions," in *Feminism and Foucault: Reflections on Resistance*, ed. Irene Diamond and Lee Quinby (Boston: Northeastern University Press, 1988): 139. Both meanings of the word are implied here.

35. Hutchings, *Criminal Spectre*, 1; my italics.

36. Ibid., 2; italics in original.

37. Luce Irigaray, "Any Theory of the 'Subject' Has Always Been Appropriated by the 'Masculine,'" in *The Feminism and Visual Culture Reader*, ed. Amelia Jones (London: Routledge, 2003), 120.

38. Sarah Waters, *Affinity* (1999; London: Virago, 2000), 235. Subsequent page references are cited parenthetically.

39. Paulina Palmer, *Lesbian Gothic* (London: Cassell, 1999), 10.

40. Ibid., 3.

41. Ibid., 59.

42. Foucault, "Panopticism," 201.

43. Ibid.

44. Palmer, *Lesbian Gothic*, 8.
45. Ibid., 4.
46. Ibid., 60.
47. Foucault, "Panopticism," 200.
48. Marie Fox, "Crime and Punishment: Representations of Female Killers in Law and Literature," in *Tall Stories? Reading Law and Literature*, ed. John Morison and Christine Bell (Aldershot: Dartmouth, 1996), 148.
49. Foucault, "Panopticism," 200.
50. Bartky, "Foucault, Femininity," 82.

Chapter 2

1. See Caroline Rody, "Toni Morrison's *Beloved*: History, 'Rememory' and 'Clamor for a Kiss,'" *American Literary History* 7, no.1 (1995): 96, and Judith Misrahi-Barak, ed., *Revisiting Slave Narratives*, Coll. Les Carnets du Cerpac no. 2 (Montpellier: Université Montpellier III, 2005), passim, among others.

2. Ashraf H. A. Rushdy, *Neo-Slave Narratives: Studies in the Social Logic of a Literary Form* (New York: Oxford University Press, 1999), 3. Not all neoslave narratives take an African American perspective. Margaret Atwood's novel *The Handmaid's Tale* focuses on a European American woman's sexual slavery in a dystopian future modeled on contemporary society. Her novel has been well received, though not uniformly so: Maria Lauret, for example, argues that Atwood's use of the slave narrative is a sign of "political misdirectedness, or disingenuousness," and she lambasts white academics for ignoring Atwood's indebtedness to the African American genre. See Maria Lauret, *Liberating Literatures: Feminist Fiction in America* (London: Routledge, 1994), 182.

3. Deborah E. McDowell, "Negotiating between Tenses: Witnessing Slavery after Freedom—*Dessa Rose*," in *Slavery and the Literary Imagination*, ed. Deborah McDowell and Arnold Rampersad (Baltimore: Johns Hopkins University Press, 1989), 146.

4. Richard Schur, "The Subject of Law: Toni Morrison, Critical Race Theory, and the Narration of Cultural Criticism," *49th Parallel: An Interdisciplinary Journal of North American Studies* 6 (2000), 7, http://www.49thparallel.bham.ac.uk/back/issue6/schur.htm.

5. Angela P. Harris, "Race and Essentialism in Feminist Legal Theory," in *Representing Women: Law, Literature, and Feminism*, ed. Susan Sage Heinzelman and Zipporah Batshaw Wiseman (Durham, NC: Duke University Press, 1994), 112, 110.

6. Patricia J. Williams, *The Alchemy of Race and Rights: Diary of a Law Professor* (Cambridge, MA: Harvard University Press, 1991), 216.

7. Ibid., 217.

8. Yet, as we have seen in the introduction, not all critics see such personal revelations as necessarily positive. For example, Anne M. Coughlin argues that "[b]y recounting painful, personal experiences to an audience willing to pay for them, the authors use themselves and their suffering as a market commodity" (Coughlin, "Regulating the Self," 1232).

9. Christine Stansell, "White Feminists and Black Realities: The Politics of Authenticity," in *Race-ing Justice, En-Gendering Power*, ed. Toni Morrison (London: Chatto and Windus, 1993), 253–54; Imani Perry, "Occupying the Universal, Embodying the Subject: African American Literary Jurisprudence," *Law and Literature* 17, no. 1 (2005): 97–129.

10. Harris, "Race and Essentialism," 122.

11. bell hooks, "Critical Interrogation," in *Yearning: Race, Gender, and Cultural Politics* (Boston: South End Press, 1990), 54.

12. Maria Aristodemou, *Law and Literature: Journeys from Her to Eternity* (Oxford: Oxford University Press, 2000), 208.

13. Ibid., 208.

14. William Styron, *Confessions of Nat Turner* (New York: Random, 1967).

15. Sherley Anne Williams, *Dessa Rose* (1986; London: Virago, 1998).

16. Suzan Harrison, "Mastering Narratives/Subverting Masters: Rhetorics of Race in *The Confessions of Nat Turner, Dessa Rose,* and *Celia, a Slave,*" *Southern Quarterly: A Journal of the Arts in the South* 35, no.3 (1997): 16.

17. Valerie Martin, *Property* (London: Abacus, 2003).

18. Deborah E. McDowell and Arnold Rampersad, eds., *Slavery and the Literary Imagination* (Baltimore: Johns Hopkins University Press, 1989), viii.

19. Stephen M. Best, *The Fugitive's Properties: Law and the Poetics of Possession* (Chicago: University of Chicago Press, 2004), 270.

20. Hazel V. Carby, "Ideologies of Black Folk: The Historical Novel of Slavery," in *Slavery and the Literary Imagination*, ed. Deborah McDowell and Arnold Rampersad (Baltimore: Johns Hopkins University Press, 1989), 125–26.

21. Robin West, *Narrative, Authority, and Law* (Ann Arbor: University of Michigan Press, 1993), 14.

22. Orlando Patterson, *Slavery and Social Death: A Comparative Study* (Cambridge, MA: Harvard University Press, 1982); John W. Blassingame, ed., introduction to *Slave Testimony: Two Centuries of Letters, Speeches, Interviews, and Autobiographies* (Baton Rouge: Louisiana State University Press, 1977); Houston A. Baker Jr., *The Journey Back: Issues in Black Literature and Criticism* (Chicago: University of Chicago Press, 1980); and Robert B. Stepto, *From Behind the Veil: A Study of Afro-American Narrative* (Urbana: University of Illinois Press, 1979).

23. Gregg D. Crane, *Race, Citizenship, and Law in American Literature* (Cambridge: Cambridge University Press, 2002).

24. Karla F. C. Holloway, *Codes of Conduct: Race, Ethics, and the Color of Our Character* (New Brunswick, NJ: Rutgers University Press, 1995).

25. Paule Marshall, *Daughters* (London: Serpent's Tale, 1992). Marshall based her story of Congo Jane on the historical Nanny of Nanny Town and gave her a partner in Will Cudjoe.

26. Henry Louis Gates, Jr., *Loose Canons: Notes on the Culture Wars* (New York: Oxford University Press, 1992), 53.

27. Holloway, *Codes of Conduct*, 26–27.

28. Toni Morrison, ed., *Race-ing Justice, En-Gendering Power* (London: Chatto and Windus, 1993), ix.

29. Holloway, *Codes of Conduct*, 7.

30. Sarah E. Chinn, *Technology and the Logic of American Racism: A Cultural History of the Body as Evidence* (London: Continuum, 2000), 2.

31. Holloway, *Codes of Conduct*, 106.

32. Patterson, *Slavery and Social Death*, 7.

33. Margaret Walker, *Jubilee* (Boston: Houghton Mifflin, 1966); Gayl Jones, *Corregidora* (1975; London: Camden, 1988); and Octavia Butler, *Kindred* (1979; London: Women's Press, 1988).

34. Jones, *Corregidora*, 22; italics in original.

35. Ashraf H. A. Rushdy, "'Relate Sexual to Historical' Race, Resistance, and Desire in Gayl Jones's *Corregidora*," *African American Review* 34, no. 2 (2000): 291.

36. Each of these texts could merit a subsection of its own in this chapter, not least Walker's as a prototypical neoslave narrative. My decision to focus on other texts rests on the following points. Each of these texts was written in the 1960s or 1970s, so they significantly predate the novels under analysis here. Moreover, Jones's novel deals with non-U.S. slavery and focuses more on a descendant of slavery than on those who experienced slavery themselves; it is set in the twentieth century and thus is outside the scope of the chapter. Similarly, parts of *Kindred* are set in 1976, and the science fiction framework makes it hard to situate the novel within this chapter without adding a significant explanatory section.

37. Melton McLaurin, *Celia: A Slave* (Athens: University of Georgia Press, 1991). See also *State of Missouri v. Celia, a Slave*.

38. Nicole R. King, "Meditations and Mediations: Issues of History and Fiction in *Dessa Rose*," *Soundings* 76, nos. 2–3 (1993): 357.

39. Elizabeth Tobin, "Imagining the Mother's Text: Toni Morrison's *Beloved* and Contemporary Law," in *Beyond Portia: Women, Law, and Literature in the United States*, ed. Jacqueline St. Joan and Annette Bennington McElhiney (Boston: Northeastern University Press, 1997), 147.

40. Williams, *Alchemy of Race*, 188.

41. Jennifer Musial, "'Two Babies, Two Races, One Womb, Three Parents': New Reproductive Technologies and Cross Racial Births," *Politics and*

Culture 3 (2003), http://aspen.conncoll.edu/politicsandculture/page.cfm?key
=242.

42. Tobin, "Imagining the Mother's Text," 141, 142.

43. Lesley Higgins and Marie-Christine Leps, "'Passport Please': Legal, Literary, and Critical Fictions of Identity," in *Un-Disciplining Literature: Literature, Law, and Culture*, ed. Kostas Myrsiades and Linda Myrsiades (New York: Peter Lang, 1999), 119.

44. Misrahi-Barak, *Revisiting Slave Narratives*, 16–17.

45. Williams, *Dessa Rose*, 55.

46. J. California Cooper, *Family* (1991; New York: Anchor, 1992); Toni Morrison, *Beloved* (1987; London: Picador, 1988); Sherley Anne Williams, *Dessa Rose* (1986; London: Virago, 1998); and Valerie Martin, *Property* (London: Abacus, 2003). Subsequent page references to these sources are cited parenthetically.

47. Richard Weisberg, *Poethics and Other Strategies of Law and Literature* (New York: Columbia University Press, 1992), xii.

48. Ibid.

49. Ronald Dworkin, "How Law Is Like Literature," in *Law and Literature: Text and Theory*, ed. Lenora Ledwon (New York: Garland, 1996), 32.

50. Ibid., 35.

51. Fred D'Aguiar, "How Wilson Harris's Intuitive Approach to Writing Fiction Applies to Novels about Slavery," in *Revisiting Slave Narratives*, ed. Judith Misrahi-Barak, Coll. Les Carnets du Cerpac no. 2 (Montpellier: Université Montpellier III, 2005), 21.

52. Ibid., 22.

53. Harriet Jacobs, *Incidents in the Life of a Slave Girl*, ed. Nellie Y. McKay and Frances Smith Foster (New York: W. W. Norton, 2001), 117; originally published in 1861 under the pseudonym Linda Brent.

54. Hortense J. Spillers, "Mama's Baby, Papa's Maybe: An American Grammar Book," *Diacritics* 17, no. 2 (1987): 76.

55. In *Beloved*, Sethe sees her mother's brand and is told that this is the way to identify her should something bad happen; uncomprehending, the child asks to be branded herself, to prove their allegiance. At this suggestion, her mother slaps Sethe's face (Morrison, *Beloved*, 61).

56. Spillers, "Mama's Baby," 74; italics in original.

57. Carole Boyce Davies, "Mother Right/Write Revisited: *Beloved* and *Dessa Rose* and the Construction of Motherhood in Black Women's Fiction," in *Narrating Mothers: Theorizing Maternal Subjectivities*, ed. Brenda O. Daly and Maureen T. Reddy (Knoxville: University of Tennessee Press, 1991), 56.

58. Spillers, "Mama's Baby," 75.

59. See Marie Ashe, "The 'Bad Mother' in Law and Literature: A Problem of Representation," *Hastings Law Review* 43, no 4 (1992): 1017–37, and

Tonya Plank, "How Would the Criminal Law Treat Sethe? Reflections on Patriarchy, Child Abuse, and the Uses of Narrative to Re-imagine Motherhood," *Wisconsin Women's Law Journal* 12, no. 1 (1997): 83–111.

60. See Appendix B of Richard Delgado and Jean Stefancic's article, "Norms and Narratives: Can Judges Avoid Serious Moral Error?" *Texas Law Review* 68 (1991): 1929–60. They also suggest that *Dessa Rose* should fall into that category.

61. Kristin Boudreau, "Pain and the Unmaking of Self in Toni Morrison's *Beloved*," *Contemporary Literature* 36, no. 3 (1995): 453.

62. Kimberly Chabot Davis, "'Postmodern Blackness': Toni Morrison's *Beloved* and the End of History," *Twentieth Century Literature* 44, no. 2 (1998): 252, 255.

63. Ashraf H. A. Rushdy, "Daughters Signifyin(g) History: The Example of Toni Morrison's *Beloved*," *American Literature* 64, no. 3 (1992): 569.

64. Helena Woodard, "Troubling the Archives: Reconstituting the Slave Subject," in *Revisiting Slave Narratives*, ed. Judith Misrahi-Barak, Coll. Les Carnets du Cerpac no. 2 (Montpellier: Université Montpellier III, 2005), 85.

65. See chapter 3 for a fuller discussion of contemporary motherhood and its representations in the media and fiction.

66. For a detailed and informed analysis of Paul D's experiences of rape, see Pamela E. Barnett's essay, "Figurations of Rape and the Supernatural in *Beloved*," *PMLA* 112, no. 3 (1997): 418–27.

67. Aristodemou, *Law and Literature*, 211.

68. Davis, "Postmodern Blackness," 248.

69. Aristodemou, *Law and Literature*, 213.

70. Spillers, "Mama's Baby," 80; italics in original.

71. Rody, "Toni Morrison's *Beloved*," 93; italics in original.

72. Barnett, "Figurations of Rape," 419.

73. Rody, "Toni Morrison's *Beloved*," 107.

74. Ibid., 116n16.

75. Lorraine Liscio, "*Beloved*'s Narrative: Writing Mother's Milk," *Tulsa Studies in Women's Literature* 11, no. 1 (1992): 40.

76. Bernard W. Bell, "*Beloved*: A Womanist Neo-slave Narrative; or Multivocal Remembrances of Things Past," *African American Review* 26, no. 1 (1992): 7.

77. The Fugitive Slave Act of 1850, section 7.

78. Schur, "The Subject of Law," 1.

79. Tobin, "Imagining the Mother's Text," 145.

80. Alan Rice, *Radical Narratives of the Black Atlantic* (London: Continuum, 2003), 143.

81. Jean Wyatt, "Giving Body to the Word: The Maternal Symbolic in Toni Morrison's *Beloved*," *PMLA* 108 (1993): 476.

82. Mary Jane Suero Elliott, "Postcolonial Experience in a Domestic

Context: Commodified Subjectivity in Toni Morrison's *Beloved*," *MELUS* 25, nos. 3–4 (2000): 197, 189.

83. Elizabeth Fox-Genovese, *Within the Plantation Household* (Chapel Hill: University of North Carolina Press, 1988), 324.

84. Ibid.

85. Aristodemou, *Law and Literature*, 222; italics in original.

86. Fox-Genovese, *Within the Plantation Household*, 329.

87. Aristodemou, *Law and Literature*, 220.

88. Liscio, "*Beloved*'s Narrative," 39.

89. Ashraf H. A. Rushdy, "The Politics of the Neo-slave Narratives," in *Revisiting Slave Narratives*, ed. Judith Misrahi-Barak, Coll. Les Carnets du Cerpac no. 2 (Montpellier: Université Montpellier III, 2005), 98–99.

90. Marta E. Sánchez, "The Estrangement Effect in Sherley Anne Williams' *Dessa Rose*," *Genders* 15 (1992): 23.

91. Deborah E. McDowell, "Negotiating between Tenses: Witnessing Slavery after Freedom—*Dessa Rose*," in *Slavery and the Literary Imagination*, ed. Deborah McDowell and Arnold Rampersad (Baltimore: Johns Hopkins University Press, 1989), 156; italics in original.

92. Ibid., 128.

93. Andrée-Anne Kekeh, "Sherley Anne Williams's *Dessa Rose*: History and the Disruptive Power of Memory," in *History and Memory in African-American Culture*, ed. Geneviève Fabre and Robert O'Meally (New York: Oxford University Press, 1994), 220.

94. Kekeh, "History and the Disruptive Power of Memory," 225.

95. Nicole R. King, "Meditations and Mediations: Issues of History and Fiction in *Dessa Rose*," *Soundings* 76, nos. 2–3 (1993): 358; italics in original.

96. hooks, "Critical Interrogation," 55.

97. Ann E. Trapasso, "Returning to the Site of Violence: The Restructuring of Slavery's Legacy in Sherley Anne Williams's *Dessa Rose*," in *Violence, Silence, and Anger: Women's Writing as Transgression*, ed. Deirdre Lashgari (Charlottesville: University Press of Virginia, 1995), 224.

98. For further discussion of the role of scars in relation to slavery, see, among others, Carol E. Henderson, *Scarring the Black Body* (Columbia: University of Missouri Press, 2002), and Anne E. Goldman, "'I Made the Ink': (Literary) Production and Reproduction in *Dessa Rose*," *Feminist Studies* 16, no. 2 (1990): 313–30.

99. Harrison, "Mastering Narratives/Subverting Masters," 19.

100. *Scarring the Black Body*, 71, 75–76; italics in original.

101. Mae G. Henderson, "The Stories of O(Dessa): Stories of Complicity and Resistance," in *Female Subjects in Black and White: Race, Psychoanalysis, Feminism*, ed. Elizabeth Abel, Barbara Christian, and Helene Moglen (Berkeley: University of California Press; 1997), 285–304.

102. Brendan Bourne, "Porn Film Past Returns to Haunt Hempel," *Sun-*

day Times (London), June 5, 2005.

103. Angela P. Harris, "Race and Essentialism in Feminist Legal Theory," in *Representing Women: Law, Literature, and Feminism,* ed. Susan Sage Heinzelman and Zipporah Batshaw Wiseman (Durham, NC: Duke University Press, 1994), 120.

104. McDowell, "Negotiating between Tenses," 158.

105. Ibid. Williams's text, by fabulating a slave-slaveholder relationship where there isn't one, recalls the famous escape by William and Ellen Craft, whereby Ellen dressed as a slaveholder and William played the role of her faithful valet. See William Craft, *Running a Thousand Miles to Freedom* (1860; Baton Rouge: Louisiana State University Press, 1999). The story of the Crafts' daring escape is also refigured in Valerie Martin's novel *Property,* discussed below.

106. Ashraf H. A. Rushdy, "Reading Mammy: The Subject of Relation in Sherley Anne Williams' *Dessa Rose,*" *African American Review* 27, no. 3 (1993): 384.

107. McDowell, "Negotiating between Tenses," 159.

108. Sarah E. Chinn, *Technology and the Logic of American Racism,* 7.

109. Holloway, *Codes of Conduct,* 21.

110. Kari J. Winter, *Subjects of Slavery, Agents of Change: Women and Power in Gothic Novels and Slave Narratives, 1790–1865* (Athens: University of Georgia Press, 1992), 10.

111. Jane B. Baron, "Property and 'No Property,'" *Houston Law Review* 42, no. 5 (2006): 1443; see also Michele Goodwin, "Nigger and the Construction of Citizenship," *Temple Law Review* 76 (2003): 129–207.

112. Spillers, "Mama's Baby," 76.

113. In one instance, talking to Sarah, she is irritated by Sarah's competence: "It is one of the annoying things about her; on those occasions when she bothers to speak, she makes sense." Martin, *Property,* 7.

114. Baron, "Property and 'No Property,'" 1436.

115. Rushdy, "The Politics of the Neo-slave Narratives," 98.

116. Aristodemou, *Law and Literature,* 228.

117. Spillers, "Mama's Baby," 78.

Chapter 3

1. Robin West, *Narrative, Authority, and Law* (Ann Arbor: University of Michigan Press, 1993), 244.

2. Nan Goodman, *Shifting the Blame: Literature, Law, and the Theory of Accidents in Nineteenth-Century America* (Princeton, NJ: Princeton University Press, 1998), 10.

3. For an exploration of feminist responses to child abuse, for example, see Tonya Plank, "How Would the Criminal Law Treat Sethe? Reflections on

Patriarchy, Child Abuse, and the Uses of Narrative to Re-imagine Motherhood," *Wisconsin Women's Law Journal* 12, no. 1 (1997): 83–111; Abbe Smith, "Defending the Innocent," *Connecticut Law Review* 32 (2000): 485–522; and Marie Ashe and Naomi R. Cahn, "Child Abuse: A Problem for Feminist Theory," *Texas Journal of Women and the Law* 2 (1993): 75–112, among others.

4. Jackie Kay, *The Adoption Papers* (Newcastle: Bloodaxe Books, 2000).

5. The policy of transracial adoption has become a political hot potato in the United Kingdom, where the poetry is set. Currently, it is actively discouraged. Some argue that this policy has had the unintended result of ensuring that children who would once have been adopted remain in the care of social services, with all of the problems that attend to such unsatisfactory arrangements.

6. Martha Albertson Fineman, "Feminist Theory in Law: The Difference It Makes," in *Beyond Portia: Women, Law, and Literature in the United States*, ed. Jacqueline St. Joan and Annette Bennington McElhiney (Boston: Northeastern University Press, 1997), 59.

7. Ibid., 55

8. Anne Worrall, *Offending Women: Female Lawbreakers and the Criminal Justice System* (London: Routledge, 1990), 16.

9. Dorothy E. Roberts, "Motherhood and Crime," *Iowa Law Review* 79 (1993): 107.

10. Jane Hamilton, *A Map of the World* (1994; London: Black Swan, 1996); Sue Miller, *The Good Mother* (1986; New York: HarperCollins, 2002); Chris Bohjalian, *Midwives* (1997; New York: Vintage, 1998). Page references to these works are cited parenthetically.

11. Clearly, laws can compel people to act in particular ways when it is for the greater good: requiring citizens to separate their trash into waste and recyclables is one such fairly uncontroversial example.

12. Michelle S. Jacobs, "Requiring Battered Women Die: Murder Liability for Mothers Under Failure to Protect Statutes," *Journal of Criminal Law and Criminology* 88, no. 2 (1998): 584.

13. Ibid., 587n41.

14. Ibid., 585.

15. Associated Press, "Moms Are Held Accountable," *Columbia Daily Tribune*, October 9, 2004.

16. Jacobs, "Requiring Battered Women Die," 582–83.

17. Katherine A. Taylor, "Compelling Pregnancy at Death's Door," *Columbia Journal of Gender and Law* 7 (1997): 164, 87.

18. Ibid., 157, 87.

19. See, for example, Elizabeth Tobin's excellent article on Mary Beth Whitehead and Anna Johnson (surrogate mothers, only one of whom was connected genetically to "her" child), Jennifer Johnson (accused of drug trafficking through the umbilical cord), and Elizabeth Morgan (the doctor

who went to jail rather than disclose the whereabouts of her child to her husband). Elizabeth Tobin, "Imagining the Mother's Text: Toni Morrison's *Beloved* and Contemporary Law," in *Beyond Portia: Women, Law, and Literature in the United States*, ed. Jacqueline St. Joan and Annette Bennington McElhiney (Boston: Northeastern University Press, 1997), 140–74.

20. Ibid., 172n90.

21. HFEA (20/10/04) 190 Annex D, Section 13.5, http://www.hfea.gov.uk, accessed March 24, 2005. This annex is currently up for review.

22. Kim Dayton, "Family Fictions/Legal Failures: A Feminist View of Family Law and Literature," in *Beyond Portia: Women, Law, and Literature in the United States*, ed. Jacqueline St. Joan and Annette Bennington McElhiney (Boston: Northeastern University Press, 1997), 130.

23. Janet Ford, "Susan Smith and Other Homicidal Mothers: In Search of the Punishment That Fits the Crime," *Cardozo Women's Law Journal* 3 (1996): 521–59. See especially 524–27.

24. The way in which women are silenced by their lawyers is discussed briefly in the introduction and is further explored in chapter 4.

25. Shannon Farley, "When the Bough Breaks and the Cradle Falls," *Buffalo Law Review* 52 (2004): 602.

26. Michelle Oberman, "Mothers Who Kill: Coming to Terms with Modern American Infanticide," *American Criminal Law Review* 34 (1996): 89.

27. Michael L. Perlin, "'She Breaks Just Like a Little Girl': Neonaticide, the Insanity Defense, and the Irrelevance of 'Common Sense,'" *William and Mary Journal of Women and the Law* 10 (2003): 2.

28. Allison Morris and Ania Wilczynski, "Rocking the Cradle: Mothers Who Kill Their Children," in *Moving Targets: Women, Murder and Representation*, ed. Helen Birch (London: Virago, 1993), 201.

29. Ford, "Susan Smith," 523.

30. Roberts, "Motherhood and Crime," 137.

31. Marie Ashe, "The 'Bad Mother' in Law and Literature: A Problem of Representation," *Hastings Law Review* 43, no. 4 (1992): 1017–37.

32. Morris and Wilczynski, "Rocking the Cradle," 199.

33. Ford, "Susan Smith," 547.

34. Articles referenced on Westlaw up to March 2005.

35. Perlin, "'She Breaks,'" 23.

36. Frankie Y. Bailey and Steven Chermak, eds., *Famous American Crimes and Trials*, vol. 5 (Westport, CT: Praeger, 2004). Other sources are more reliable than the Praeger text, but I note it here simply by way of revealing the extent of publicity on the case.

37. Ford, "Susan Smith," 542.

38. Perlin, "'She Breaks,'" 21.

39. *Smith v. South Carolina*, 1995 WL 789245.

40. Pamela D. Bridgewater, "Connectedness and Closeted Questions: The Use of History in Developing Feminist Legal Theory," *Wisconsin Women's Law Journal* 11 (1997): 355.

41. Oberman, "Mothers Who Kill," 48.

42. Ibid., 66, 68.

43. Ford, "Susan Smith," 549.

44. Oberman, "Mothers Who Kill," 52.

45. See, generally, *Texas v. Yates*, 880, 205 and 853, 590 (Dist. Ct. 202).

46. Susan Sage Heinzelman, "Hard Cases, Easy Cases and Weird Cases: Canon Formation in Law and Literature," *Mosaic* 21, no. 2–3 (1988): 60.

47. Ibid., 59.

48. Yates has been linked with the itinerate preacher Michael Woroniecki (also known as Michael Warnecki) and his particular perspective of isolationism and withdrawal from organized religion, as well as his misogynistic view of women.

49. Lisa Teachey, "Yates' Fate Hinges on Which Psychiatrist Can Sway Jury," *Houston Chronicle*, March 4, 2002, http://www.chron.com/content/chronicle/special/01/drownings/index.html, accessed July 14, 2002.

50. Carol Christian, "Best Friend Says Lack of Care for Andrea Yates Was Alarming," *Houston Chronicle*, March 5, 2002, http://www.chron.com/cs/CDA/ssistory.mpl/special/drownings/1276115, accessed March 30, 2005.

51. He was also important in relation to her appeal. See chapter 5 for a discussion of the appeal.

52. Teachey, "Yates' Fate."

53. Charlotte Perkins Gilman, "The Yellow Wallpaper" (1892) in *The Charlotte Perkins Gilman Reader*, ed. Ann J. Lane (London: The Women's Press, 1981).

54. Pam Easton, "Husband Testifies during Texas Mother's Murder Trial," *Houston Chronicle*, February 27, 2002, http://www.chron.com/content/chronicle/special/01/drownings /index.html, accessed July 14, 2002.

55. Susan Ayres, "[N]ot a Story to Pass On: Constructing Mothers Who Kill," *Hastings Women's Law Journal* 15 (2004): 106, 102.

56. Oberman, "Mothers Who Kill," 34.

57. Ayres, "'Not a Story to Pass On,'" 107.

58. Morris and Wilczynski, "Rocking the Cradle," 216.

59. Sue Lees, *Ruling Passions: Sexual Violence, Reputation and the Law* (Buckingham: Open University Press, 1997), 147.

60. See, for example, Dale Spender, *Man-Made Language* (London: Routledge and Kegan Paul, 1980); Deborah Tannen, *You Just Don't Understand Me* (New York: William Morrow, 1990); and John Gray, *Men Are from Mars, Women Are from Venus* (New York: HarperCollins, 1993).

61. West, *Narrative, Authority, and Law*, 245.

62. Unpublished text cited in Fineman, "Feminist Theory in Law," 55.

63. http://www.apa.org/pubinfo/mem.html, accessed March 14, 2005.

64. American Psychiatric Association, *Therapies Focused on Memories of Childhood Physical and Sexual Abuse*, factsheet, June 2000, 1.

65. Elaine Showalter, *Hystories: Hysterical Epidemics and Modern Culture* (London: Picador, 1997), 5, 19.

66. Ibid., 205.

67. See, for example, *Phinney v. Morgan*. Although this case does not rest on recovered memories, it does rest on the "intentional infliction of emotional distress" and "failure to protect." This case, which tested the "discovery rule" and the statute of limitations, has become fodder for a variety of law review reports. In highlighting it here, I am not entering into a debate about what "really happened" or whether the action was fair; I am merely noting it as an example of a case in which a "nonperpetrator," as Jeanette Morgan was called, is the subject of a court case.

68. Helena Kennedy, *Eve Was Framed: Women and British Justice* (1992; London: Vintage, 1993), 98.

69. Unusually, *Sybil* contends that the mother in the story is responsible for the sexual abuse at the center of the text. Flora Rheta Schreiber, *Sybil* (Chicago: Contemporary Books, 1973).

70. Jane Smiley, *A Thousand Acres* (New York: Alfred Knopf, 1991).

71. Marina Leslie, "Incest, Incorporation, and *King Lear* in Jane Smiley's *A Thousand Acres*," *College English* 60, no. 1 (1998): 34.

72. Ibid., 35.

73. Amy Adler, "The Perverse Law of Child Pornography," *Columbia Law Review* 101 (2001): 226.

74. Patricia D. Cornwell, *The Body Farm* (1994; London: Warner Books, 1995). Scarpetta is introduced in Cornwell's first novel, *Postmortem* (1990; London: Warner Books, 1995). An unconventional woman, Scarpetta conducts love affairs (some of them illicit), offers a mother-figure to her niece, and is married to her work. She is a consummate cook, her one concession to the traditional image of a domestic woman (though a later example of her "cooking" human remains to reveal skeletal clues somewhat undercuts this image). Indeed, representations of her culinary skills diminish as the series continues. In the first book, however, Scarpetta's cooking is almost as lovingly detailed as the forensic evidence that ends up convicting the killer, and she compares herself favorably to her inadequate sister. Indeed, in condemning the "bad mother," it appears that Cornwell comes perilously close to reinforcing stereotypes of appropriate feminine behavior: "It was sad and a violation of tradition that Lucy knew nothing of these [culinary delights]. I assumed when she came home from school most days she walked into a quiet, indifferent house where dinner was a drudgery to be put off until the last minute. My sister should never have been a mother." However, this image is rescued by humor; the sentence that follows reads, "My sister should never

have been Italian" (Cornwell, *Postmortem*, 152). Here, the emphasis on domesticity has less to do with gender than with ethnic heritage.

75. Sir Roy Meadow was subsequently "struck off" by the General Medical Council in July 2005 for serious professional misconduct after giving misleading evidence about "cot deaths" (or Sudden Infant Death Syndrome) in the case of Sally Clark. He was reinstated after an appeal.

76. Indeed, much of the criticism of Showalter's book proceeds from the mistaken assumption that she is dismissive of sufferers of these unexplained syndromes. Critics are particularly angry that she treats claims of alien abduction on par with medical syndromes; others feel that she is insufficiently attendant to women's lived realities, or that she is acting as an apologist for those who commit crimes against women and children. These criticisms are based on limited readings or misreadings of her words.

77. Showalter, *Hystories*, 17.

78. Pierre Bourdieu, "The Force of Law: Toward a Sociology of the Juridical Field," trans. Richard Terdiman, *Hastings Law Journal* 38 (1987): 848.

79. Ilene Durst, "Valuing Women Storytellers: What They Talk about When They Talk about Law," *Yale Journal of Law and Feminism* 11 (1999): 258.

80. Thus I disagree with Durst's assertion of Alice's eventual triumph over the law; though she is acquitted, she remains sullied by the experience.

81. Carolyn Heilbrun and Judith Resnik, "Convergences: Law, Literature, and Feminism," in *Beyond Portia: Women, Law, and Literature in the United States*, ed. Jacqueline St. Joan and Annette Bennington McElhiney (Boston: Northeastern University Press, 1997), 30.

82. Kim Lane Scheppele, "Foreword: Telling Stories," *Michigan Law Review* 87 (1989): 2083.

83. As Josephine Ross argues, "Instead of evidence about Alice's integrity, the jury is given the superficial emblems that substitute for character evidence in courtrooms across America." See Josephine Ross, "'He Looks Guilty': Reforming Good Character Evidence to Undercut the Presumption of Guilt," *University of Pittsburgh Law Review* 65, no. 2 (2004): 231.

84. An exception to this might be the child molestation trial of Michael Jackson, which (predominantly female) fans attended as if a pageant had been put on for them alone.

85. Dayton, "Family Fictions/Legal Failures," 136.

86. Roberts, "Motherhood and Crime," 108.

87. Carol Sanger, "Seasoned to the Use," *Michigan Law Review* 87 (1989): 1343. To reference articles that cite the novel, see, for example, Laura Sack, "Women and Children First: A Feminist Analysis of the Primary Caretaker Standard in Child Custody Cases," *Yale Journal of Law and Feminism* 4, no. 2 (1992): 291–328, which begins by summarizing the novel; Carol Sanger, "Separating from Children," *Columbia Law Review* 96, no. 2 (1996): 375–517; or

Mary Becker, "Maternal Feelings: Myth, Taboo, and Child Custody," *Southern California Review of Law and Women's Studies* 1, no. 1 (1992): 133–224.

88. Carol Weisbrod, *Butterfly, the Bride: Essays on Law, Narrative, and the Family* (Ann Arbor: University of Michigan Press, 1999), 30.

89. Ibid., 31.

90. Roberta White argues that "[s]uch mingling of maternal love and sexual love would not seem taboo or alien in an ordinary family, and obviously Miller does not mean to suggest that it is so only because Leo and Anna are not married by law." Roberta White, "Anna's Quotidian Love: Sue Miller's *The Good Mother*," in *Mother Puzzles: Daughters and Mothers in Contemporary American Literature*, ed. Mickey Pearlman (Westport, CT: Greenwood, 1989), 16. It is hard to see how White comes to this conclusion.

91. Dawn Ann Drzal, "Casualties of the Feminine Mystique," *Antioch Review* 46, no. 4 (1988): 458.

92. White, "Anna's Quotidian Love," 15.

93. Ibid., 12–13.

94. Leo's confusion over the sexual mores of Anna's household have an uncomfortable similarity with the United Kingdom's law on rape; if a man holds a "reasonable" belief that a woman consents to sexual intercourse, even when her consent is not given, he cannot be culpable for that rape (Sexual Offenses Act 2003). Feminists have unsuccessfully campaigned to have this struck from the law, arguing rightly that what matters is consent, not whether a man believes consent has been given. The "honest belief" defense has been available to men in the U.K. since 1975, the case of *Morgan v. the director of public prosecution*. The Sexual Offenses Act 2003 changes the "honest belief" to "reasonable belief."

95. Bourdieu, "The Force of Law," 828.

96. Drzal, "Casualties of the Feminine Mystique," 458.

97. White, "Anna's Quotidian Love," 17.

98. Indeed, Sanger argues that the focus on Anna's sexual transgression "may skew readers' sense of other significant factors, such as comparative economic status, professional predictions about a child's well-being, and judicial biases that are more frequently at work when courts are choosing parents." Sanger, "Seasoned to Use," 1356.

99. Miller, *The Good Mother*, 301. For further discussion of how women's experiences are gendered in relation to the law, see Robin West, *Narrative, Authority, and Law* (Ann Arbor: University of Michigan Press, 1993), particularly chapter 4.

100. Lynda Haas, "'Eighty-Six the Mother': Murder, Matricide, and Good Mothers," in *From Mouse to Mermaid: The Politics of Film, Gender, and Culture*, ed. Elizabeth Bell, Lynda Haas, and Laura Sells (Bloomington: Indiana University Press, 1996), 204.

101. Pamela E. Klassen, "Sacred Maternities and Postbiomedical Bodies:

Religion and Nature in Contemporary Home Birth," *Signs* 26, no. 3 (2001): 778.

102. Ibid., 776.

103. Bourdieu, "The Force of Law," 834, italics in original.

104. Ibid., 828.

105. Ibid., 837.

106. Carol Smart, "The Woman of Legal Discourse" in *Criminology at the Crossroads: Feminist Readings In Crime and Justice,* ed. Kathleen Daly and Lisa Maher (New York: Oxford University Press, 1998), 25.

107. Plank, "How Would Criminal Law Treat Sethe?" 107, passim.

108. Oberman, "Mothers Who Kill," 51.

109. Shelley A. M. Gavigan, "Women's Crime: New Perspectives and Old Theories," in *In Conflict with the Law: Women and the Canadian Justice System,* ed. Ellen Adelberg and Claudia Currie (Vancouver: Press Gang, 1993), 219.

110. Regina Graycar, "Telling Tales: Legal Stories about Violence against Women," *Cardozo Studies in Law and Literature* 8, no. 2 (1996): 298.

111. Naomi Cahn, "The Power of Caretaking," *Yale Journal of Law and Feminism* 12 (2000): 178.

112. Dayton, "Family Fictions/Legal Failures," 130.

113. Tobin, "Imagining the Mother's Text," 166.

Chapter 4

1. Pierre Bourdieu, "The Force of Law: Toward a Sociology of the Juridical Field," trans. Richard Terdiman, *Hastings Law Journal* 38 (1987): 817; italics in original.

2. Steven Connor, "Transcripts: Law, Literature and the Trials of the Voice," *New Formations: A Journal of Culture/Theory/Politics* 32 (1997): 64.

3. Kim Lane Scheppele, "Foreword: Telling Stories," *Michigan Law Review* 87, no. 8 (1989): 2079.

4. Peter J. Hutchings, *The Criminal Spectre in Law, Literature and Aesthetics: Incriminating Subjects* (London: Routledge, 2001), 37.

5. Judith Butler, *Gender Trouble: Feminism and the Subversion of Identity* (1990; New York: Routledge, 1999), 177; italics in original.

6. Judith Resnik, "Changing the Topic," *Cardozo Studies in Law and Literature* 8, no. 2 (1996): 349.

7. See Jennifer L. Wood, "Refined Law: The Symbolic Violence of Victim's Rights Reforms," in *Un-Disciplining Literature: Literature, Law, and Culture,* ed. Kostas Myrsiades and Linda Myrsiades (New York: Peter Lang, 1999), 72–93.

8. See chapter 3 for more on the separation of good and bad women.

9. Maria Aristodemou, *Law and Literature: Journeys from Her to Eternity*

(Oxford: Oxford University Press, 2000), 22.

10. Carol Smart, "The Woman of Legal Discourse," in *Criminology at the Crossroads: Feminist Readings in Crime and Justice*, ed. Kathleen Daly and Lisa Maher (New York: Oxford University Press, 1998), 26.

11. Scottish law also has the verdict "Not proven," a sort of halfway house that suggests guilt but cannot enforce punishment.

12. Connor, "Transcripts," 62.

13. Ibid., 63.

14. James Boyd White, "The Judicial Opinion and the Poem: Ways of Reading, Ways of Life," in *Law and Literature: Text and Theory*, ed. Lenora Ledwon (New York: Garland, 1996), 15.

15. Jennifer Jones, "In Defense of the Woman: Sophie Treadwell's *Machinal*," *Modern Drama* 37, no. 3 (1994): 486.

16. Robin West, "Economic Man and Literary Woman: One Contrast," in *Law and Literature: Text and Theory*, ed. Lenora Ledwon (New York: Garland, 1996), 134n2.

17. For an excellent exploration of the history behind the play, see Patricia L. Bryan, "Stories in Fiction and in Fact: Susan Glaspell's 'A Jury of Her Peers' and the 1901 Murder Trial of Margaret Hossack," *Stanford Law Review* 49 (1997): 1293–363.

18. Renee Heberle, "Disciplining Gender; Or, Are Women Getting Away with Murder?" *Signs* 24, no. 4 (1999): 1105–6.

19. Susan Glaspell, *Trifles*, in *Plays by American Women 1900–1930*, ed. Judith E. Barlow (New York: Applause Theatre, 1985), 79. Subsequent page references are cited parenthetically in the text.

20. Robin West, "Invisible Victims: A Comparison of Susan Glaspell's 'Jury of Her Peers' and Herman Melville's 'Bartleby the Scrivener,'" *Cardozo Studies in Law and Literature* 8, no. 2 (1996), 234.

21. West, "Invisible Victims," 234; for a discussion of the text in relation to domestic violence, see Elizabeth Villiers Gemmette, "Filling in the Silence: Domestic Violence, Literature and Law," *Loyola University Chicago Law Journal* 32 (2000): 91–111, and Lillian Schanfield, "The Case of the Battered Wife: Susan Glaspell's 'Trifles' and 'A Jury of Her Peers,'" *Buffalo Women's Journal of Law and Social Policy* 5 (1997): 69–83.

22. Ironically, Heberle contends that "[f]eminists and legal advocates argue that the difference in severity between punishments for the murder of strangers and the murder of family members sends a message about the lesser value of women's lives, as women are the most common victims of domestic violence." See Heberle, "Disciplining Gender," 1105.

23. See Marina Angel, "Criminal Law and Women: Giving the Abused Woman Who Kills a Jury of Her Peers who Appreciate Trifles," *American Criminal Law Review* 33 (1996): 229–348; Marina Angel, "Teaching Susan Glaspell's 'A Jury of her Peers' and 'Trifles,'" *Journal of Legal Education* 53

(2003): 548–63; and Marina Angel, "Susan Glaspell's *Trifles* and *A Jury of Her Peers*: Woman Abuse in a Literary and Legal Context," *Buffalo Law Review* 45, no. 3 (1997): 779–844. See also Carrie Menkel-Meadow, "Portia Redux: Another Look at Gender, Feminism, and Legal Ethics," *Virginia Journal of Social Policy and the Law* 2 (1994): 75–114.

24. Sherri Hallgren, "'The Law Is the Law—and a Bad Stove Is a Bad Stove': Subversive Justice and Layers of Collusion in 'A Jury of Her Peers,'" in *Violence, Silence and Anger: Women's Writing as Transgression*, ed. Deirdre Lashgari (Charlottesville: University of Virginia Press, 1995), 204.

25. Richard Posner, *Law and Literature* (Cambridge, MA: Harvard University Press, 1998), 123.

26. Ibid., 125–26.

27. Ibid., viii.

28. Stanley Fish, "Working on the Chain Gang: Interpretation in Law and Literature," in *Law and Literature: Text and Theory*, ed. Lenora Ledwon (New York: Garland, 1996), 50.

29. Jacqueline St. Joan, "Sex, Sense, and Sensibility: Trespassing into the Culture of Domestic Abuse," *Harvard Women's Law Journal* 20 (1997): 288.

30. Ginger Strand, "Treadwell's Neologism: Machinal," *Theatre Journal* 44, no. 2 (1992): 167.

31. Sophie Treadwell, *Machinal*, in *Plays by American Women 1900–1930*, ed. Judith E. Barlow (New York: Applause Theatre, 1985), 173. Subsequent page references are cited parenthetically.

32. Marie Fox, "Crime and Punishment: Representations of Female Killers in Law and Literature," in *Tall Stories? Reading Law and Literature*, ed. John Morison and Christine Bell (Aldershot: Dartmouth, 1996), 145, 147, 148.

33. Sharon Pollock, *Blood Relations*, in *Plays by Women*, vol. 3, ed. Michelene Wandor (London: Methuen, 1984), 92; italics in original. Subsequent page references are cited parenthetically.

34. Scheppele, "Foreword," 2082–83.

35. Jean S. Filetti, "From Lizzie Borden to Lorena Bobbitt: Violent Women and Gendered Justice," *Journal of American Studies* 35, no. 3 (2001): 473.

36. Quoted in Filetti, "Lizzie Borden to Lorena Bobbitt," 473.

37. Cara W. Robertson, "Representing 'Miss Lizzie': Cultural Convictions in the Trial of Lizzie Borden," *Yale Journal of Law and the Humanities* 8, no. 2 (1996): 399.

38. Hutchings, *Criminal Spectre*, 66, 55.

39. Karlene Faith, "Media, Myths and Masculinization: Images of Women in Prison," in *In Conflict with the Law: Women and the Canadian Justice System*, ed. Ellen Adelberg and Claudia Currie (Vancouver: Press Gang, 1993), 188.

40. Elaine Adelberg and Claudia Currie, eds., *Too Few to Count: Canadian Women in Conflict with the Law* (Vancouver: Press Gang, 1987).

41. Karlene Faith, *Unruly Women: The Politics of Confinement and Resistance* (Vancouver: Press Gang, 1993), 1.

42. Elaine Aston, "Daniels in the Lion's Den: Sarah Daniels and the British Backlash," *Theatre Journal* 47, no. 3 (1995): 399.

43. Tracy C. Davis, "*Extremities* and *Masterpieces*: A Feminist Paradigm of Art and Politics," *Modern Drama* 32, no. 1 (1989): 102.

44. Sarah Daniels, *Masterpieces*, in *Plays: One* (London: Methuen, 1994), 169. Subsequent page references are cited parenthetically.

45. Davis, "*Extremities* and *Masterpieces*," 101.

46. Ibid.

47. Robin West, *Narrative, Authority, and Law* (Ann Arbor: University of Michigan Press, 1993), 180.

48. For a discussion of the patriarchy of the court, see Carol Sanger, "Seasoned to the Use," *Michigan Law Review* 87 (1989): 1363–64.

49. Sue Lees, *Ruling Passions: Sexual Violence, Reputation and the Law* (Buckingham: Open University Press, 1997), 1–2.

50. Ibid., 170.

51. Gabriele Griffin, "Violence, Abuse, and Gender Relations in the Plays of Sarah Daniels," in *The Cambridge Companion to Modern British Women Playwrights*, ed. Elaine Aston and Janelle Reinelt (Cambridge: Cambridge University Press, 2000), 204; italics in original.

52. Jones, "In Defense of the Woman," 486, 487.

53. Gary Boire, "Theatres of Law: Canadian Legal Drama," *Canadian Literature* 152/153 (1997): 127.

54. Angela P. Harris, "Race and Essentialism in Feminist Legal Theory," in *Beyond Portia: Women, Law and Literature in the United States*, ed. Jacqueline St. Joan and Annette Bennington McEhliney (Boston: Northeastern University Press, 1997), 116.

Chapter 5

1. David. A. Langford and Peter Robson, "The Representation of the Professions in the Cinema: The Case of Construction Engineers and Lawyers," *Construction Management and Education* 221 (2003): 802. The idea of creating a specific law-film canon is problematic, not least because of the way in which it may marginalize women, ethnic minorities, and lesbians and gay men. The problem of the canon, always an issue in the law-literature field, is even more acute for law films. While someone may happen across an out-of-print book, it is almost impossible to explore films that are not out on video or DVD.

2. Steve Greenfield, Guy Osborn, and Peter Robson, *Film and the Law*

(London: Cavendish, 2001), 21, 24.

3. John Denvir, ed., *Legal Reelism: Movies as Legal Texts* (Urbana: University of Illinois Press, 1996), xii.

4. Greenfield, Osborn and Robson, *Film and the Law*, 18–19.

5. I am aware that this "neat" example replicates the invisibility of lesbian spectatorship or indeed of the wider representation of homosexual desire. See Greenfield, Osborn, and Robson, 25, for a fuller discussion of the difficulties of incorporating representations of lesbian and gay men in a medium that insistently marginalizes them.

6. Richard K. Sherwin, "Framed," in *Reelism: Movies as Legal Texts*, ed. John Denvir (Urbana: University of Illinois Press, 1996), 71.

7. Rennard Strickland, "The Cinematic Lawyer: The Magic Mirror and the Silver Screen," *Oklahoma City University Law Review* 22, no. 1 (1997): 20.

8. In one random example, ITV's schedule for January 11, 2006, almost half of the twenty-one hours of programing were devoted to crime and law serials. These included three hours of *Quincy*, two hours of *L.A. Law*, and one hour of each of the following programs: *Kojak*, *The Bill*, *The Practice*, *Poirot*, and *The Adventures of Sherlock Holmes*. ITV3 also regularly airs repeats of *Kavanagh QC* and *Rumpole of the Bailey*, as well as contained miniseries such as *Frances Tuesday*.

9. *Andrea Pia Yates v. The State of Texas* (NOS 01–02–00462-CR/01–02–00463-CR).

10. The titles are: *The Amy Fisher Story*; *Amy Fisher: My Story*; and *Casualties of Love: The Long Island Lolita*.

11. Stephanie Savage, "Women Who Kill and the Made-For-TV Movie: The Betty Broderick Story," in *No Angels: Women Who Commit Violence*, ed. Alice Myers and Sarah Wight (London: Pandora, 1996), 124.

12. Helen Birch, ed., *Moving Targets: Women, Murder and Representation* (London: Virago, 1993), 1–2.

13. Savage, "Women Who Kill," 126, 120.

14. Ibid., 128–29.

15. Miriam Basilio, "Corporeal Evidence: Representations of Aileen Wuornos," *Art Journal* 55, no. 4 (1996): 58.

16. Ibid., 56.

17. Lynda Hart, *Fatal Women: Lesbian Sexuality and the Mark of Aggression* (Princeton, NJ: Princeton University Press, 1994), 30.

18. Karlene Faith, "Media, Myths and Masculinization: Images of Women in Prison," in *In Conflict with the Law: Women and the Canadian Justice System*, ed. Ellen Adelberg and Claudia Currie (Vancouver: Press Gang, 1993), 185.

19. Candice Skrapec, "The Female Serial Killer: An Evolving Criminality," in *Moving Targets: Women, Murder and Representation*, ed. Helen Birch (London: Virago, 1993), 244.

20. See particularly Broomfield's second film, a disturbing account of Wuornos's journey towards execution.

21. Christine Holmlund, "A Decade of Deadly Dolls: Hollywood and the Woman Killer," in *Moving Targets: Women, Murder and Representation*, ed. Helen Birch (London: Virago, 1993), 128.

22. The Motion Picture Production Code of 1930, Principle 3. All of the following references to the Hays Code focus on Principle 3.

23. Matthias Kuzina, "The Social Issue Courtroom Drama as an Expression of American Popular Culture," in *Law and Film*, ed. Stefan Machura and Peter Robson (Oxford: Blackwell, 2001), 85. In contrast to the USA, British film censorship has historically been directed toward limiting what *children*, not adults, can or cannot see, with the obvious exception of Mary Whitehouse's long campaigns against obscenity, and with the acknowledgement that censors also cut material in British films.

24. The Motion Picture Production Code, II.

25. Mary Ann Doane, *Femmes Fatales: Feminism, Film Theory, Psychoanalysis* (New York: Routledge, 1991), 2, italics in original.

26. Dennis Bingham, "'I Do Want to Live': Female Voices, Male Discourse, and Hollywood Biopics," *Cinema Journal* 38, no. 3 (1999): 11.

27. Ibid., 14.

28. Ibid., 7.

29. The Motion Picture Production Code Bingham, III.E.b.

30. Bingham, "'I Do Want to Live,'" 6.

31. This is an unusual character switch; see Nicole Rafter, "American Criminal Trial Films: An Overview of Their Development, 1930–2000," in *Law and Film*, ed. Stefan Machura and Peter Robson (Oxford: Blackwell, 2001), 17n13.

32. See *Miranda v. Arizona*, 1966, which overturned the conviction of Ernesto Miranda on the basis of the fact that he had not been informed of his rights to remain silent or to have an attorney present when being questioned; the official reading of rights upon arrest is now colloquially known as being "Mirandized." *I Want to Live!* portrays the bullying techniques used in the Miranda case: after Graham is arrested, she is surrounded by detectives questioning her. She asks for a lawyer but is not provided with one, and asks the charge but is not told. It is clear she has been kept for hours.

33. Alison Jaggar, "Love and Knowledge: Emotion in Feminist Epistemology," *Women, Knowledge, and Reality: Explorations in Feminist Philosophy*, ed. Ann Garry and Marilyn Pearsall (New York: Routledge, 1996), 180.

34. Sheila O'Hare, "The Barbara Graham Murder Case: The Murderess 'Walked to Her Death as if Dressed for a Shopping Trip,'" in *Famous American Crimes and Trials*, Vol. 3: 1913–1959, ed. Frankie Y. Bailey and Steven Chermak (Westport, CT: Praeger, 2004), 230.

35. Bingham, "'I Do Want to Live,'" 5–6.

36. Ibid., 22.

37. See, for example, Mark Tushnet, "Class Action: One View of Gender and Law in Popular Culture," in *Reelism: Movies as Legal Texts*, ed. John Denvir (Urbana: University of Illinois Press, 1996), 244–60; Paul Bergman and Michael Asimow, *Reel Justice: The Courtroom Goes to the Movies* (Kansas City: Andrews and McMeel, 1996); Carolyn Lisa Miller, "'What a Waste. Beautiful, Sexy Gal. Hell of a Lawyer.': Film and the Female Attorney," *Columbia Journal of Gender and Law* 4, no. 2 (1994): 203–32.

38. Bergman and Asimow, *Reel Justice*, 90.

39. Miller, "'What a Waste,'" 205.

40. Greenfield, Osborn, and Robson, *Film and the Law*, 125, 128, 131.

41. See Anita La Cruz, "Is 'Who Wears the Pants' An Empty Question? Comedy and Marriage in *Adam's Rib*," *BELLS: Barcelona English Language and Literature Studies* 9 (1998): 133–42.

42. David R. Shumway, "Screwball Comedies: Constructing Romance, Mystifying Marriage," *Cinema Journal* 30.4 (1991): 13.

43. In *It's A Small World*, *Adam's Rib*, *Father of the Bride*, *The People Against O'Hara*, *Inherit the Wind*, and *Judgment at Nuremberg*. See Rennard Strickland, "The Cinematic Lawyer: The Magic Mirror and the Silver Screen," *Oklahoma City University Law Review* 22, no. 1 (1997): 17.

44. Shumway, "Screwball Comedies," 17.

45. Anita La Cruz, "Is 'Who Wears the Pants' an Empty Question?", 137, 135.

46. Doane, *Femmes Fatales*, 25.

47. Shumway, "Screwball Comedies," 18.

48. For competing reviews of the movie, see the online journal *Picturing Justice*, http://www.usfca.edu/pj/index.html.

49. Referenced under "Mission" at http://www.elle.com, accessed February 9, 2005. The Web site claims that *Elle Magazine* "focuses on fashion, beauty, and style—with a brain."

50. Another way in which popularity and the law are strategically contrasted occurs later in the film; two of Elle's Delta Nu sorority sisters enter the courtroom where Elle is trying a case and shout, "Vote for Elle!"

51. Maria Aristodemou, *Law and Literature: Journeys from Her to Eternity* (Oxford: Oxford University Press, 2000), 2.

52. William H. Simon, "Moral Pluck: Ethics in Popular Culture," *Columbia Law Review* 101, no. 2 (2001): 422.

53. Heidi Slettedahl Macpherson, *Women's Movement: Escape as Transgression in North American Feminist Fiction* (Amsterdam: Rodopi, 2000), 186–87; italics in original.

54. Miller, "'What a Waste,'" 205.

55. The fact that it was a successful film almost inevitably led to a sequel, unimaginatively called *Legally Blonde II*, which took Emmett and Elle's

marriage plans as one of the main plot lines. Though not a success, the film still featured Reese Witherspoon as a feisty, feminine lawyer challenging the mores of power and upholding social causes.

56. Rachel Moseley and Jacinda Read, "Having It Ally: Popular Television (Post-) Feminism," *Feminist Media Studies* 2, no. 2 (2002): 245.

57. Ibid.

58. See, for example, Jonathan Cohen, and Rivka Ribak, "Sex Differences in Pleasure from Television Texts: The Case of *Ally McBeal*," *Women's Studies in Communication* 26, no. 1 (2003): 118–34, which focuses on the viewing patterns of Israeli students, and Tracey Owens Patton, "'Ally McBeal' and Her Homies: The Reification of White Stereotypes of the Other," *Journal of Black Studies* 32, no. 2. (2001): 229–60, which focuses on the "intentions" behind the portrayals of character (243) and argues that the nonwhite characters represent wholly negative qualities.

59. Patton, "'Ally McBeal' and Her Homies," 258.

60. Moseley and Read, "Having It Ally," 241, 239.

61. Kathleen Kelly Baum, "Courting Desire and the (Al)lure of David E. Kelley's *Ally McBeal*," *CLCWeb: Comparative Literature and Culture: a WWWeb Journal* 4, no. 1 (2002), http://clcwebjournal.lib.purdue.edu/clcweb 02–1/baum02.html, accessed June 30, 2004.

62. Of course, Jackson is best known for playing one of the original *Charlie's Angels*, and it appears that in casting her here, *Ally McBeal* is referencing this earlier series, given its focus on beauty.

63. Baum, "Courting Desire."

64. Robin West, *Narrative, Authority, and Law* (Ann Arbor: University of Michigan Press, 1993), 180.

65. Kathleen Newman, "The Problem That Has a Name: *Ally McBeal* and the Future of Feminism," *Colby Quarterly* 36, no. 4 (2000): 322.

66. Martha P. Nochimson, "*Ally McBeal*: Brightness Falls from the Air," *Film Quarterly* 53, no. 3 (2000): 29.

67. Ibid., 27.

68. Naomi Wolf, *The Beauty Myth: How Images of Female Beauty Are Used Against Women* (New York: William Morrow, 1991).

69. Season 1, episode 19, "Inmates," which revolved around a woman who believed herself to be the reincarnation of Lizzie Borden.

70. Baum, "Courting Desire."

71. Greenfield, Osborn, and Robson, *Film and the Law*, 4; italics in original.

72. Lenora Ledwon, ed., *Law and Literature: Text and Theory* (New York: Garland, 1996), 219.

73. Anthony Chase, *Movies on Trial: The Legal System and the Silver Screen* (New York: New Press, 2002), 13.

74. Greenfield, Osborn, and Robson, *Film and the Law*, 31–32.

75. Carol Gilligan, *In a Different Voice* (Cambridge, MA: Harvard University Press, 1982).

76. This is not to argue for a firm gender differentiation: John Cage is often depicted in feminine terms, for example. He is petite and full of insecurities, and he offers a caring ear to Ally when she needs it.

77. Carolyn G. Heilbrun and Judith Resnik, foreword to *Beyond Portia: Women, Law, and Literature in the United States*, ed. Jacqueline St. Joan and Annette Bennington McElhiney (Boston: Northeastern University Press, 1997), xii.

Conclusion

1. Robin West, "Jurisprudence and Gender," in *Feminist Jurisprudence*, ed. Patricia Smith (New York: Oxford University Press, 1993), 524–25.

2. Karlene Faith, *Unruly Women: The Politics of Confinement and Resistance* (Vancouver: Press Gang, 1993), 1.

3. Ibid., 58.

4. Ibid., 65.

5. Holly Johnson and Karen Rodgers, "A Statistical Overview of Women and Crime in Canada," in *In Conflict with the Law: Women and the Canadian Justice System*, ed. Ellen Adelberg and Claudia Currie (Vancouver: Press Gang, 1993), 107.

6. Johnson and Rodgers, "A Statistical Overview," 98; Karlene Faith, "Media, Myths and Masculinization: Images of Women in Prison," in *In Conflict with the Law: Women and the Canadian Justice System*, ed. Ellen Adelberg and Claudia Currie (Vancouver: Press Gang, 1993), 185.

7. Johnson and Rodgers, "A Statistical Overview," 107. See also the statistics on crime in the introduction.

8. Susan Sage Heinzelman, "Women's Petty Treason: Feminism, Narrative, and the Law," *Journal of Narrative Technique* 20, no. 2 (1990): 89.

9. Peter Brooks, *Troubling Confessions: Speaking Guilt in Law and Literature* (Chicago: University of Chicago Press, 2000), 63.

10. Lenora Ledwon, ed., *Law and Literature: Text and Theory* (New York: Garland, 1996), ix.

11. Kenji Yoshino, "The City and the Poet," *Yale Law Journal* 114, no. 8 (2005): 1839.

12. Ilene Durst, "Valuing Women Storytellers: What They Talk about When They Talk about Law," *Yale Journal of Law and Feminism* 11 (1999): 264–65.

13. Robin West, *Narrative, Authority, and Law* (Ann Arbor: University of Michigan Press, 1993), 245.

14. Joan Barfoot, *Critical Injuries* (2001; London: Women's Press, 2002), 176–77. Subsequent page references will be cited parenthetically.

15. Kent Roach, "Changing Punishment at the Turn of the Century: Restorative Justice on the Rise," *Canadian Journal of Criminology* 42, no. 3 (2000): 256.

16. Ibid., 272.

17. Faith, *Unruly Women*, 125.

18. Carolyn G. Heilbrun and Judith Resnik, foreword to *Beyond Portia: Women, Law, and Literature in the United States*, ed. Jacqueline St. Joan and Annette Bennington McElhiney (Boston: Northeastern University Press, 1997), xii.

19. Hilary Allen, "Rendering Them Harmless: The Professional Portrayal of Women Charged with Serious Violent Crimes," in *Criminology at the Crossroads: Feminist Readings in Crime and Justice*, ed. Kathleen Daly and Lisa Maher (New York: Oxford University Press, 1998), 66; italics in original.

20. West, "Jurisprudence and Gender," 522.

21. Peter Brooks, "Narrativity of the Law," *Law and Literature* 14, no.1 (2002): 9.

22. Martha Albertson Fineman, "Feminist Theory in Law: The Difference It Makes," in *Beyond Portia: Women, Law, and Literature in the United States*, ed. Jacqueline St. Joan and Annette Bennington McElhiney (Boston: Northeastern University Press, 1997), 55.

23. Maria Aristodemou, *Law and Literature: Journeys from Her to Eternity* (Oxford: Oxford University Press, 2000), 23.

24. Richard Posner, *Law and Literature*, rev. ed. (Cambridge, MA: Harvard University Press, 1998), 311.

25. Fineman, "Feminist Theory in Law," 54.

Bibliography

Adam's Rib, DVD, directed by George Cukor (1949; Warner Home Video, 2003).

Adelberg, Ellen, and Claudia Currie, eds. *In Conflict with the Law: Women and the Canadian Justice System*. Vancouver: Press Gang, 1993.

———. *Too Few to Count: Canadian Women in Conflict with the Law*. Vancouver: Press Gang, 1987.

Adler, Amy. "The Perverse Law of Child Pornography." *Columbia Law Review* 101 (2001): 209–73.

Allen, Hilary. "Rendering Them Harmless: The Professional Portrayal of Women Charged with Serious Violent Crimes." In *Criminology at the Crossroads: Feminist Readings in Crime and Justice*, edited by Kathleen Daly and Lisa Maher, 54–68. New York: Oxford University Press, 1998.

Ally McBeal, DVD, written by David E. Kelley (Twentieth Century Fox Television, Season One, 1997–98).

American Psychiatric Association. *Therapies Focused on Memories of Childhood Physical and Sexual Abuse*. Factsheet, June 2000.

American Psychological Association website, http://www.apa.org/pubinfo/mem.html.

Andrea Pia Yates v. State of Texas (NOS 01–02–00462-CR/01–02–00463-CR).

Angel, Marina. "Criminal Law and Women: Giving the Abused Woman Who Kills a Jury of Her Peers Who Appreciate Trifles." *American Criminal Law Review* 33 (1996): 229–348.

———. "Susan Glaspell's *Trifles* and *A Jury of Her Peers*: Woman Abuse in a Literary and Legal Context." *Buffalo Law Review* 45, no. 3 (1997): 779–844.

———. "Teaching Susan Glaspell's 'A Jury of Her Peers' and 'Trifles.'" *Journal of Legal Education* 53 (2003): 548–63.

Aristodemou, Maria. *Law and Literature: Journeys from Her to Eternity*. Oxford: Oxford University Press, 2000.

Ashe, Marie. "The 'Bad Mother' in Law and Literature: A Problem of Representation." *Hastings Law Review* 43, no. 4 (1992): 1017–37.

Ashe, Marie, and Naomi R. Cahn. "Child Abuse: A Problem for Feminist Theory." *Texas Journal of Women and the Law* 2 (1993): 75–112.

Asimow, Michael, and Shannon Mader, eds. *Law and Popular Culture: A Course Book*. New York: Peter Lang, 2004.

Aston, Elaine. "Daniels in the Lion's Den: Sarah Daniels and the British Backlash." *Theatre Journal* 47, no. 3 (1995): 393–403.

Atwood, Margaret. *Alias Grace*. London: Bloomsbury, 1996.

Ayres, Susan. "[N]ot a Story to Pass On: Constructing Mothers Who Kill." *Hastings Women's Law Journal* 15 (2004): 39–110.

Bailey, Frankie Y., and Steven Chermak, eds. *Famous American Crimes and Trials*. Vol. 5. Westport, CT: Praeger, 2004.

Baker, Houston A., Jr. *The Journey Back: Issues in Black Literature and Criticism*. Chicago: University of Chicago Press, 1980.

Barfoot, Joan. *Critical Injuries*. London: Women's Press, 2002. First published by Key Porter Books, 2001.

Barnett, Pamela E. "Figurations of Rape and the Supernatural in *Beloved*." *PMLA* 112, no. 3 (1997): 418–27.

Baron, Jane B. "Law, Literature, and the Problems of Interdisciplinarity." *Yale Law Review* 108, no. 5 (1999): 1059–85.

———. "Property and 'No Property.'" *Houston Law Review* 42, no. 5 (2006): 1425–49.

———. "Storytelling and Legal Intimacy." In *Un-Disciplining Literature: Literature, Law, and Culture*, edited by Kostas Myrsiades and Linda Myrsiades, 13–27. New York: Peter Lang, 1999.

Bartky, Sandra Lee. "Foucault, Femininity, and the Modernization of Patriarchal Power." In *Feminism and Foucault: Reflections on Resistance*, edited by Irene Diamond and Lee Quinby, 61–86. Boston: Northeastern University Press, 1988.

Basilio, Miriam. "Corporeal Evidence: Representations of Aileen Wuornos." *Art Journal* 55, no. 4 (1996): 56–61.

Baum, Kathleen Kelly. "Courting Desire and the (Al)lure of David E. Kelley's *Ally McBeal*." *CLCWeb: Comparative Literature and Culture: a WWWeb Journal* 4.1 (2002), http://clcwebjournal.lib.purdue.edu/clcweb 02–1/baum02.html.

Becker, Mary. "Maternal Feelings: Myth, Taboo, and Child Custody." *Southern California Review of Law and Women's Studies* 1, no. 1 (1992): 133–224.

Becker, Susanne. *Gothic Forms of Feminine Fictions*. Manchester: Manchester University Press, 1999.

Bell, Bernard W. "*Beloved*: A Womanist Neo-slave Narrative; or Multivocal Remembrances of Things Past." *African American Review* 26, no. 1 (1992): 7–15.

Bellow, Gary, and Martha Minow, eds. *Law Stories*. Ann Arbor: University of Michigan Press, 1996.

Bentham, Jeremy. *Panopticon, or The Inspection House* (1787), http://www.cartome.org/panopticon2.htm.

Bergman, Paul, and Michael Asimow. *Reel Justice: The Courtroom Goes to the Movies*. Kansas City: Andrews and McMeel, 1996.

Best, Stephen M. *The Fugitive's Properties: Law and the Poetics of Possession*. Chicago: University of Chicago Press, 2004.

Bingham, Dennis. "'I Do Want to Live': Female Voices, Male Discourse, and Hollywood Biopics." *Cinema Journal* 38, no. 3 (1999): 3–26.

Birch, Helen, ed. *Moving Targets: Women, Murder and Representation*. London: Virago, 1993.

Biressi, Anita. *Crime, Fear and the Law in True Crime Stories*. Houndmills: Palgrave, 2001.

Black, David A. *Law in Film: Resonance and Representation*. Urbana: University of Illinois Press, 1999.

Blassingame, John W., ed. Introduction to *Slave Testimony: Two Centuries of Letters, Speeches, Interviews, and Autobiographies*. Baton Rouge: Louisiana State University Press, 1977.

Bohjalian, Chris. *Midwives*. New York: Vintage, 1998. First published 1997 by Harmony Books.

Boire, Gary. "The Language of the Law: The Cases of Morley Callaghan." In *Dominant Impressions: Essays on the Canadian Short Story*, edited by Gerald Lynch and Angela Arnold Robbeson, 75–86. Ottawa: University of Ottawa Press, 1999.

———. "Theatres of Law: Canadian Legal Drama." *Canadian Literature* 152/153 (1997): 124–44.

Boudreau, Kristin. "Pain and the Unmaking of Self in Toni Morrison's *Beloved*." *Contemporary Literature* 36, no. 3 (1995): 447–65.

Bourdieu, Pierre. "The Force of Law: Toward a Sociology of the Juridical Field," translated by Richard Terdiman. *Hastings Law Journal* 38 (1987): 805–53.

Bridgewater, Pamela D. "Connectedness and Closeted Questions: The Use of History in Developing Feminist Legal Theory." *Wisconsin Women's Law Journal* 11 (1997): 351–66.

Brooks, Peter. "Narrativity of the Law." *Law and Literature* 14, no.1 (2002): 1–10.

———. *Troubling Confessions: Speaking Guilt in Law and Literature*. Chicago: University of Chicago Press, 2000.

Bryan, Patricia L. "Stories in Fiction and in Fact: Susan Glaspell's 'A Jury of Her Peers' and the 1901 Murder Trial of Margaret Hossack." *Stanford Law Review* 49 (1997): 1293–363.

Butler, Judith. *Gender Trouble: Feminism and the Subversion of Identity*. New York: Routledge, 1999. First published 1990 by Routledge.

Butler, Octavia. *Kindred*. London: Women's Press, 1988. First published 1979 by Doubleday.

Cahn, Naomi. "The Power of Caretaking." *Yale Journal of Law and Feminism* 12 (2000): 177–223.

Cain, Patricia A. "The Future of Feminist Legal Theory." *Wisconsin Women's Law Journal* 11, no. 3 (1997): 367–83.

Callaghan, Morley. "The Wedding-Dress." In *Morley Callaghan's Stories*, 1:53–58. London: MacGibbon and Kee, 1962.

Carby, Hazel V. "Ideologies of Black Folk: The Historical Novel of Slavery." In *Slavery and the Literary Imagination*, edited by Deborah McDowell and Arnold Rampersad, 125–43. Baltimore: Johns Hopkins University Press, 1989.

Carter, Angela. *Nights at the Circus*. London: Vintage, 1994. First published 1984 by Chatto and Windus.

Chase, Anthony. *Movies on Trial: The Legal System and the Silver Screen*. New York: New Press, 2002.

Chinn, Sarah E. *Technology and the Logic of American Racism: A Cultural History of the Body as Evidence*. London: Continuum, 2000.

Clark, Sherman J. "Literate Lawyering: An Essay on Imagination and Persuasion." *Rutgers Law Journal* 30, no. 3 (1999): 575–94.

Cohen, Jonathan, and Rivka Ribak. "Sex Differences in Pleasure from Television Texts: The Case of *Ally McBeal*." *Women's Studies in Communication* 26, no. 1 (2003): 118–34.

Connor, Steven. "Transcripts: Law, Literature and the Trials of the Voice." *New Formations: A Journal of Culture/Theory/Politics* 32 (1997): 60–76.

Cooper, J. California. *Family*. New York: Anchor, 1992. First published 1991 by Doubleday.

Cornwell, Patricia D. *The Body Farm*. London: Warner Books, 1995. First published 1994 by Charles Scribner's Sons.

———. *Postmortem*. London: Warner Books, 1995. First published 1990 by Macdonald and Co.

Coughlin, Anne M. "Regulating the Self: Autobiographical Performances in Outsiders Scholarship." *Virginia Law Review* 81, no. 5 (1995): 1229–340.

Craft, William. *Running a Thousand Miles to Freedom*. Baton Rouge: Louisiana State University Press, 1999. First published 1860.

Crane, Gregg D. *Race, Citizenship, and Law in American Literature*. Cambridge: Cambridge University Press, 2002.

Culp, Jerome. *Crossroads, Directions, and a New Critical Race Theory*. Philadelphia: Temple University Press, 2002.

D'Aguiar, Fred. "How Wilson Harris's Intuitive Approach to Writing Fiction Applies to Novels about Slavery." In *Revisiting Slave Narratives*, edited by Judith Misrahi-Barak, 21–35. Coll. Les Carnets du Cerpac no. 2. Montpellier: Université Montpellier III, 2005.

Daniels, Sarah. *Masterpieces*. In *Plays: One*. London: Methuen, 1994.

Davies, Carole Boyce. "Mother Right/Write Revisited: *Beloved* and *Dessa Rose* and the Construction of Motherhood in Black Women's Fiction." In *Narrating Mothers: Theorizing Maternal Subjectivities*, edited by Brenda O. Daly and Maureen T. Reddy, 44–57. Knoxville: University of Tennessee Press, 1991.

Davis, Kimberly Chabot. "'Postmodern Blackness': Toni Morrison's *Beloved* and the End of History." *Twentieth Century Literature* 44, no. 2 (1998): 242–60.

Davis, Tracy C. "*Extremities* and *Masterpieces*: A Feminist Paradigm of Art and Politics." *Modern Drama* 32, no. 1 (1989): 89–103.

Dayton, Kim. "Family Fictions/Legal Failures: A Feminist View of Family Law and Literature." In *Beyond Portia: Women, Law, and Literature in the United States*, edited by Jacqueline St. Joan and Annette Bennington McElhiney, 129–39. Boston: Northeastern University Press, 1997.

Delgado, Richard, ed. *Crossroads, Directions, and a New Critical Race Theory*. Philadelphia: Temple University Press, 2002.

Delgado, Richard. "Storytelling for Oppositionists and Others: A Plea for Narrative." *Michigan Law Review* 87 (1989): 2411–41.

Delgado, Richard and Jean Stefancic. "Norms and Narratives: Can Judges Avoid Serious Moral Error?" *Texas Law Review* 68 (1991): 1929–1960.

Denvir, John, ed. *Legal Reelism: Movies as Legal Texts*. Urbana: University of Illinois Press, 1996.

Desai, Gaurav, Felipe Smith, and Supriya Nair. "Introduction: Law, Literature, and Ethnic Subjects." *MELUS* 28, no.1 (2003): 3–16.

Doane, Mary Ann. *Femmes Fatales: Feminism, Film Theory, Psychoanalysis*. New York: Routledge, 1991.

Drzal, Dawn Ann. "Casualties of the Feminine Mystique." *Antioch Review* 46, no. 4 (1988): 450–61.

Durst, Ilene. "Valuing Women Storytellers: What They Talk about When They Talk about Law." *Yale Journal of Law and Feminism* 11 (1999): 245–67.

Dworkin, Ronald. "How Law Is Like Literature." In *Law and Literature: Text and Theory*, edited by Lenora Ledwon, 29–46. New York: Garland, 1996.

Elliott, Mary Jane Suero. "Postcolonial Experience in a Domestic Context: Commodified Subjectivity in Toni Morrison's *Beloved*." *MELUS* 25, nos. 3–4 (2000): 181–202.

Faith, Karlene. "Media, Myths and Masculinization: Images of Women in Prison." In *In Conflict with the Law: Women and the Canadian Justice System*, edited by Ellen Adelberg and Claudia Currie, 181–202. Vancouver: Press Gang, 1993.

———. *Unruly Women: The Politics of Confinement and Resistance*. Vancouver: Press Gang, 1993.

Falkow, Michele G. "Pride and Prejudice: Lessons Legal Writers Can Learn from Literature." *Touro Law Review* 21 (2005): 349–426.

Farley, Shannon. "When the Bough Breaks and the Cradle Falls." *Buffalo Law Review* 52 (2004): 597–627.

Ferguson, Robert A. *Law and Letters in American Culture.* Cambridge, MA: Harvard University Press, 1984.

Filetti, Jean S. "From Lizzie Borden to Lorena Bobbitt: Violent Women and Gendered Justice." *Journal of American Studies* 35, no. 3 (2001): 471–84.

Fineman, Martha Albertson. "Feminist Theory in Law: The Difference It Makes." In *Beyond Portia: Women, Law, and Literature in the United States,* edited by Jacqueline St. Joan and Annette Bennington McElhiney, 53–72. Boston: Northeastern University Press, 1997.

Fish, Stanley. *Doing What Comes Naturally: Change, Rhetoric, and the Practice of Theory in Literary and Legal Studies.* Durham, NC: Duke University Press, 1989.

———. "Working on the Chain Gang: Interpretation in Law and Literature." In *Law and Literature: Text and Theory,* edited by Lenora Ledwon, 47–60. New York: Garland, 1996.

Fludernik, Monica and Greta Olson. *In the Grip of the Law: Trials, Prisons and the Space Between.* Frankfurt am Main: Peter Lang, 2004.

Ford, Janet. "Susan Smith and Other Homicidal Mothers: In Search of the Punishment That Fits the Crime." *Cardozo Women's Law Journal* 3 (1996): 521–59.

Foster, Teree E. "But Is It Law? Using Literature to Penetrate Societal Representations of Women." *Journal of Legal Education* 43 (1993): 133–48.

Foucault, Michel. *Discipline and Punish: The Birth of the Prison.* Translated by Alan Sheridan. London: Penguin, 1991. First published 1977 by Allen Lane.

Fox, Marie. "Crime and Punishment: Representations of Female Killers in Law and Literature." In *Tall Stories? Reading Law and Literature,* edited by John Morison and Christine Bell, 145–78. Aldershot: Dartmouth, 1996.

Fox-Genovese, Elizabeth. *Within the Plantation Household.* Chapel Hill: University of North Carolina Press, 1988.

Freeman, Michael, and Andrew Lewis, eds. *Law and Literature.* Oxford: Oxford University Press, 1999.

Gass, Joanne M. "Panopticism in *Nights at the Circus.*" *Review of Contemporary Fiction* 14, no. 3 (1994): 71–76.

Gates, Henry Louis, Jr. *Loose Canons: Notes on the Culture Wars.* New York: Oxford University Press, 1992.

Gavigan, Shelley A. M. "Women's Crime: New Perspectives and Old Theories." In *In Conflict with the Law: Women and the Canadian Justice Sys-*

tem, edited by Ellen Adelberg and Claudia Currie, 215–34. Vancouver: Press Gang, 1993.

Gemmette, Elizabeth Villiers. "Filling in the Silence: Domestic Violence, Literature and Law." *Loyola University Chicago Law Journal* 32 (2000): 91–111.

———. "Law and Literature: An Unnecessarily Suspect Class in the Liberal Arts Component of Law School Curriculum." *Valparaiso Law Review* 23 (1989): 273–84.

———. "'Law and Literature': Joining the Class Action." *Valparaiso Law Review* 29, no. 2 (1995): 665–859.

Gilligan, Carol. *In a Different Voice*. Cambridge, MA: Harvard University Press, 1982.

Gilman, Charlotte Perkins. "The Yellow Wallpaper" (1892). In *The Charlotte Perkins Gilman Reader*, edited by Ann J. Lane, 3–19. London: Women's Press, 1981.

Glaspell, Susan. *Trifles*. In *Plays by American Women 1900–1930*, edited by Judith E. Barlow, 70–86. New York: Applause Theatre, 1985.

Goldman, Anne E. "'I Made the Ink': (Literary) Production and Reproduction in *Dessa Rose*." *Feminist Studies* 16, no. 2 (1990): 313–30.

Goodman, Nan. *Shifting the Blame: Literature, Law, and the Theory of Accidents in Nineteenth-Century America*. Princeton, NJ: Princeton University Press, 1998.

Goodwin, Michele. "Nigger and the Construction of Citizenship." *Temple Law Review* 76 (2003): 129–207.

Graycar, Regina. "Telling Tales: Legal Stories about Violence against Women." *Cardozo Studies in Law and Literature* 8, no. 2 (1996): 297–315.

Greenfield, Steve, Guy Osborn, and Peter Robson. *Film and the Law*. London: Cavendish, 2001.

Griffin, Gabriele. "Violence, Abuse, and Gender Relations in the Plays of Sarah Daniels." In *The Cambridge Companion to Modern British Women Playwrights*, edited by Elaine Aston and Janelle Reinelt, 194–211. Cambridge: Cambridge University Press, 2000.

Haas, Lynda. "'Eighty-Six the Mother': Murder, Matricide, and Good Mothers." In *From Mouse to Mermaid: The Politics of Film, Gender, and Culture*, edited by Elizabeth Bell, Lynda Haas, and Laura Sells, 193–211. Bloomington: Indiana University Press, 1996.

Hallgren, Sherri. "'The Law Is the Law—and a Bad Stove Is a Bad Stove': Subversive Justice and Layers of Collusion in 'A Jury of Her Peers.'" In *Violence, Silence and Anger: Women's Writing as Transgression*, edited by Deirdre Lashgari, 203–18. Charlottesville: University of Virginia Press, 1995.

Hamilton, Jane. *A Map of the World*. London: Black Swan, 1996. First published 1994 by Doubleday.

Harris, Angela P. "Race and Essentialism in Feminist Legal Theory." In *Representing Women: Law, Literature, and Feminism*, edited by Susan Sage Heinzelman and Zipporah Batshaw Wiseman, 106–46. Durham, NC: Duke University Press, 1994.

Harrison, Suzan. "Mastering Narratives/Subverting Masters: Rhetorics of Race in *The Confessions of Nat Turner, Dessa Rose*, and *Celia, a Slave*." *Southern Quarterly: A Journal of the Arts in the South* 35, no.3 (1997): 13–28.

Hart, Lynda. *Fatal Women: Lesbian Sexuality and the Mark of Aggression*. Princeton, NJ: Princeton University Press, 1994.

Heilbrun, Carolyn G., and Judith Resnik. Foreword to *Beyond Portia: Women, Law, and Literature in the United States*, edited by Jacqueline St. Joan and Annette Bennington McElhiney, xi–xii. Boston: Northeastern University Press, 1997.

———. "Convergences: Law, Literature, and Feminism." In *Beyond Portia: Women, Law, and Literature in the United States*, edited by Jacqueline St. Joan and Annette Bennington McElhiney, 11–52. Boston: Northeastern University Press, 1997.

Heinzelman, Susan Sage. "Hard Cases, Easy Cases and Weird Cases: Canon Formation in Law and Literature." *Mosaic* 21, no. 2–3 (1988): 60–72.

———. "Women's Petty Treason: Feminism, Narrative, and the Law." *Journal of Narrative Technique* 20, no. 2 (1990): 89–106.

Heinzelman, Susan Sage, and Zipporah Batshaw Wiseman. *Representing Literature: Law, Literature and Feminism*. Durham, NC: Duke University Press, 1994.

Henderson, Carol E. *Scarring the Black Body: Race and Representation in African American Literature*. Columbia: University of Missouri Press, 2002.

Henderson, Mae G. "The Stories of O(Dessa): Stories of Complicity and Resistance." In *Female Subjects in Black and White: Race, Psychoanalysis, Feminism*, edited by Elizabeth Abel, Barbara Christian, and Helene Moglen, 284–304. Berkeley: University of California Press, 1997.

Heberle, Renee. "Disciplining Gender; Or, Are Women Getting Away with Murder?" *Signs* 24, no. 4 (1999): 1103–12.

HFEA (20/10/04) 190 Annex D, Section 13.5, http://www.hfea.gov.uk.

Higgins, Lesley, and Marie-Christine Leps. "'Passport Please': Legal, Literary, and Critical Fictions of Identity." In *Un-Disciplining Literature: Literature, Law, and Culture*, edited by Kostas Myrsiades and Linda Myrsiades, 117–68. New York: Peter Lang, 1999.

Holland, Norman N., and Leona F. Sherman. "Gothic Possibilities." In *Gender and Reading: Essays on Readers, Texts, and Contexts*, edited by Elizabeth A. Flynn and Patrocinio Schweickart, 215–33. Baltimore: Johns Hopkins University Press, 1988.

Holloway, Karla F. C. *Codes of Conduct: Race, Ethics, and the Color of Our Character*. New Brunswick, NJ: Rutgers University Press, 1995.

Holmlund, Christine. "A Decade of Deadly Dolls: Hollywood and the Woman Killer." In *Moving Targets: Women, Murder and Representation*, edited by Helen Birch, 127–51. London: Virago, 1993.

hooks, bell. "Critical Interrogation." In *Yearning: Race, Gender, and Cultural Politics*. 51–5. Boston: South End Press, 1990.

House of Commons Select Committee on Home Affairs report, http://www.publications.parliament.uk/pa/cm200405/cmselect/cmhaff/193/19315.htm.

Hutchings, Peter J. *The Criminal Spectre in Law, Literature and Aesthetics: Incriminating Subjects*. London: Routledge, 2001.

Irigaray, Luce. "Any Theory of the 'Subject' Has Always Been Appropriated by the 'Masculine.'" In *The Feminism and Visual Culture Reader*, edited by Amelia Jones, 119–28. London: Routledge, 2003.

I Want to Live! DVD, directed by Robert Wise (1958; MGM Home Entertainment, 2004).

Jacobs, Harriet. *Incidents in the Life of a Slave Girl*, edited by Nellie Y. McKay and Frances Smith Foster. New York: W. W. Norton, 2001. First published 1861.

Jacobs, Michelle S. "Requiring Battered Women Die: Murder Liability for Mothers under Failure to Protect Statutes." *Journal of Criminal Law and Criminology* 88, no. 2 (1998): 579–660.

Jaggar, Alison. "Love and Knowledge: Emotion in Feminist Epistemology." In *Women, Knowledge, and Reality: Explorations in Feminist Philosophy*, edited by Ann Garry and Marilyn Pearsall, 166–90. New York: Routledge, 1996.

Johnson, Holly, and Karen Rodgers. "A Statistical Overview of Women and Crime in Canada." In *In Conflict with the Law: Women and the Canadian Justice System*, edited by Ellen Adelberg and Claudia Currie, 95–116. Vancouver: Press Gang, 1993.

Jones, Gayl. *Corregidora*. London: Camden, 1988. First published 1975 by Random House.

Jones, Jennifer. "In Defense of the Woman: Sophie Treadwell's *Machinal*." *Modern Drama* 37, no. 3 (1994): 485–96.

Kay, Jackie. *The Adoption Papers*. Newcastle: Bloodaxe Books, 2000.

Kekeh, Andrée-Anne. "Sherley Anne Williams's *Dessa Rose*: History and the Disruptive Power of Memory." In *History and Memory in African-American Culture*, edited by Geneviève Fabre and Robert O'Meally, 219–27. New York: Oxford University Press, 1994.

Kennedy, Helena. *Eve Was Framed: Women and British Justice*. London: Vintage, 1993. First published 1992 by Chatto and Windus.

King, Nicole R. "Meditations and Mediations: Issues of History and Fiction

in *Dessa Rose.*" *Soundings* 76, nos. 2–3 (1993): 351–68.

Klassen, Pamela E. "Sacred Maternities and Postbiomedical Bodies: Religion and Nature in Contemporary Home Birth." *Signs* 26, no. 3 (2001): 775–809.

Knelman, Judith. "Can We Believe What the Newspapers Tell Us? Missing Links in *Alias Grace.*" *UTQ: A Canadian Journal of the Humanities* 68, no. 2 (1999): 677–86.

Kolodny, Annette. "Dancing through the Minefield." In *The New Feminist Criticism*, edited by Elaine Showalter, 144–67. London: Virago, 1986.

Kuzina, Matthias. "The Social Issue Courtroom Drama as an Expression of American Popular Culture." In *Law and Film*, edited by Stefan Machura and Peter Robson, 79–96. Oxford: Blackwell, 2001.

La Cruz, Anita. "Is 'Who Wears the Pants' An Empty Question? Comedy and Marriage in *Adam's Rib.*" *BELLS: Barcelona English Language and Literature Studies* 9 (1998): 133–42.

Langford, David. A., and Peter Robson. "The Representation of the Professions in the Cinema: the Case of Construction Engineers and Lawyers." *Construction Management and Education* 221 (2003): 799–807.

Lauret, Maria. *Liberating Literatures: Feminist Fiction in America.* London: Routledge, 1994.

Ledger, Sally, and Stella Swain, eds. "Legal Fictions Special Issue" of *New Formations* 32 (1997).

Ledwon, Lenora, ed. *Law and Literature: Text and Theory.* New York: Garland, 1996.

Lees, Sue. *Ruling Passions: Sexual Violence, Reputation and the Law.* Buckingham: Open University Press, 1997.

Legally Blonde, DVD, directed by Robert Luketic (2001; MGM Home Entertainment, 2004).

Leslie, Marina. "Incest, Incorporation, and *King Lear* in Jane Smiley's *A Thousand Acres.*" *College English* 60, no. 1 (1998): 31–50.

Levinson, Sanford, and Steven Mailloux, eds. *Interpreting Law and Literature: A Hermeneutic Reader.* Evanston, IL: Northwestern University Press, 1988.

Liscio, Lorraine. "*Beloved's* Narrative: Writing Mother's Milk." *Tulsa Studies in Women's Literature* 11, no. 1 (1992): 31–46.

Lydon, Mary. "Foucault and Feminism: A Romance of Many Dimensions." In *Feminism and Foucault: Reflections on Resistance*, edited by Irene Diamond and Lee Quinby, 135–47. Boston: Northeastern University Press, 1988.

Machura, Stefan, and Peter Robson, eds. *Law and Film.* Oxford: Blackwell, 2001.

MacKinnon, Catherine A. *Are Women Human? and Other International Dialogues.* Cambridge, MA: Harvard University Press, 2006.

———. "Reflection on Sex Equality Under Law." *Yale Law Journal* 100 (1991): 1281–328.

Macleod, R. C., ed. *Lawful Authority: Readings on the History of Criminal Justice in Canada.* Toronto: Copp Clark Pitman, 1988.

Macpherson, Heidi Slettedahl. *Women's Movement: Escape as Transgression in North American Feminist Fiction.* Amsterdam: Rodopi, 2000.

March, Cristie. "Crimson Silks and New Potatoes: The Heteroglossic Power of the Object in Atwood's *Alias Grace*." *Studies in Canadian Literature* 22, no. 2 (1997): 66–82.

Marshall, Paule. *Daughters.* London: Serpent's Tale, 1992.

Martin, Valerie. *Property.* London: Abacus, 2003.

McDowell, Deborah E. "Negotiating between Tenses: Witnessing Slavery after Freedom—*Dessa Rose*." In *Slavery and the Literary Imagination*, edited by Deborah McDowell and Arnold Rampersad, 144–63. Baltimore: Johns Hopkins University Press, 1989.

McDowell, Deborah E., and Arnold Rampersad, eds. *Slavery and the Literary Imagination.* Baltimore: Johns Hopkins University Press, 1989.

McLaurin, Melton. *Celia, A Slave.* Athens: University of Georgia Press, 1991.

Menkel-Meadow, Carrie. "Portia Redux: Another Look at Gender, Feminism, and Legal Ethics." *Virginia Journal of Social Policy and the Law* 2 (1994): 75–114.

Miller, Carolyn Lisa. "'What a Waste. Beautiful, Sexy Gal. Hell of a Lawyer.': Film and the Female Attorney." *Columbia Journal of Gender and Law* 4, no. 2 (1994): 203–32.

Miller, Sue. *The Good Mother.* New York: HarperCollins, 2002. First published 1986 by HarperCollins.

Misrahi-Barak, Judith, ed. *Revisiting Slave Narratives.* Coll. Les Carnets du Cerpac No. 2. Montpellier: Université Montpellier III, 2005.

Morison, John, and Christine Bell, eds. *Tall Stories? Reading Law and Literature.* Aldershot: Dartmouth, 1996.

Morris, Allison, and Ania Wilczynski. "Rocking the Cradle: Mothers Who Kill Their Children." In *Moving Targets: Women, Murder and Representation*, edited by Helen Birch, 198–217. London: Virago, 1993.

Morrison, Toni. *Beloved.* London: Picador, 1988. First published 1987 by Chatto and Windus.

———, ed. *Race-ing Justice, En-Gendering Power.* London: Chatto and Windus, 1993.

Moseley, Rachel, and Jacinda Read. "Having it Ally: Popular Television (Post-) Feminism." *Feminist Media Studies* 2, no. 2 (2002): 231–49.

The Motion Picture Production Code, http://www.artsreformation.com/a001/hays-code.html.

Mulvey, Laura. "Visual Pleasure and Narrative Cinema." *Screen* 16, no. 3 (1975): 6–18.

Murphy, Thérèse. "Bursting Binary Bubbles: Law, Literature and the Sexed Body." In *Tall Stories? Reading Law and Literature*, edited by John Morison and Christine Bell, 57–82. Aldershot: Dartmouth, 1996

Musial, Jennifer. "'Two Babies, Two Races, One Womb, Three Parents': New Reproductive Technologies and Cross Racial Births." *Politics and Culture* 3 (2003), http://aspen.conncoll.edu/politicsandculture/page.cfm ?key=242.

Newman, Kathleen. "The Problem That Has a Name: *Ally McBeal* and the Future of Feminism." *Colby Quarterly* 36, no. 4 (2000): 319–24.

Nochimson, Martha P. "*Ally McBeal*: Brightness Falls from the Air." *Film Quarterly* 53, no. 3 (2000): 25–32.

Nussbaum, Martha C. *Poetic Justice: The Literary Imagination and Public Life*. Boston: Beacon, 1995.

Oberman, Michelle. "Mothers Who Kill: Coming to Terms with Modern American Infanticide." *American Criminal Law Review* 34 (1996): 1–90.

O'Hare, Sheila. "The Barbara Graham Murder Case: The Murderess 'Walked to Her Death as if Dressed for a Shopping Trip.'" In *Famous American Crimes and Trials*, vol. 3: 1913–1959, edited by Frankie Y. Bailey, and Steven Chermak, 224–41. Westport, CT: Praeger, 2004.

Olsen, Frances. "Do (Only) Women Have Bodies?" In *Thinking Through the Body of the Law*, edited by Pheng Cheah et al., 209–26. New York: New York University Press, 1996.

Palmer, Paulina. *Lesbian Gothic*. London: Cassell, 1999.

Papke, David R., ed. *Narrative and Legal Discourse: A Reader in Storytelling and the Law*. Liverpool: Deborah Charles Publications, 1991.

Patterson, Orlando. *Slavery and Social Death: A Comparative Study*. Cambridge, MA: Harvard University Press, 1982.

Patton, Tracey Owens. "'Ally McBeal' and Her Homies: The Reification of White Stereotypes of the Other." *Journal of Black Studies* 32, no. 2. (2001): 229–60.

Perlin, Michael L. "'She Breaks Just Like a Little Girl': Neonaticide, the Insanity Defense, and the Irrelevance of 'Common Sense.'" *William and Mary Journal of Women and the Law* 10 (2003): 1–31.

Perry, Imani. "Occupying the Universal, Embodying the Subject: African American Literary Jurisprudence." *Law and Literature* 17, no. 1 (2005): 97–129.

Plank, Tonya. "How Would the Criminal Law Treat Sethe? Reflections on Patriarchy, Child Abuse, and the Uses of Narrative to Re-imagine Motherhood." *Wisconsin Women's Law Journal* 12, no. 1 (1997): 83–111.

Pollock, Sharon. *Blood Relations*. In *Plays by Women*, vol. 3, edited by Michelene Wandor, 91–122. London: Methuen, 1984.

Polloczek, Dieter Paul. *Literature and Legal Discourse: Equity and Ethics from Sterne to Conrad*. Cambridge: Cambridge University Press, 1999.

Posner, Richard. *Law and Literature*. Rev. ed. Cambridge, MA: Harvard University Press, 1998.

———. "Law and Literature: A Relation Reargued." In *Law and Literature: Text and Theory*, edited by Lenora Ledwon, 61–89. New York: Garland, 1996.

Punter, David. *Gothic Pathologies: the Text, the Body and the Law*. Basingstoke: Macmillan, 1998.

Queen's University Archives 599, MF POS 599; and MF 2342, Book 11, May 2, 1871–May 3, 1873.

Rafter, Nicole. "American Criminal Trial Films: An Overview of Their Development, 1930–2000." In *Law and Film*, edited by Stefan Machura and Peter Robson, 9–24. Oxford: Blackwell, 2001.

Resnik, Judith. "Changing the Topic." *Cardozo Studies in Law and Literature* 8, no. 2 (1996): 339–62.

———. "Singular and Aggregate Voices: Audiences and Authority in Law & Literature and in Law & Feminism." In *Law and Literature*, Current Legal Studies, vol. 2, edited by Michael Freeman and Andrew D. Lewis, 687–727. Oxford: Oxford University Press, 1999.

Rice, Alan. *Radical Narratives of the Black Atlantic*. London: Continuum, 2003.

Roach, Kent. "Changing Punishment at the Turn of the Century: Restorative Justice on the Rise." *Canadian Journal of Criminology* 42, no. 3 (2000): 249–80.

Roberts, Dorothy E. "Motherhood and Crime." *Iowa Law Review* 79 (1993): 95–141.

Robertson, Cara W. "Representing 'Miss Lizzie': Cultural Convictions in the Trial of Lizzie Borden." *Yale Journal of Law and the Humanities* 8, no. 2 (1996): 351–416.

Rockwood, Bruce L., ed. *Law and Literature Perspectives*. New York: Peter Lang, 1996.

Rody, Caroline. "Toni Morrison's *Beloved*: History, 'Rememory' and 'Clamor for a Kiss.'" *American Literary History* 7, no.1 (1995): 92–119.

Ross, Josephine. "'He Looks Guilty': Reforming Good Character Evidence to Undercut the Presumption of Guilt." *University of Pittsburgh Law Review* 65, no. 2 (2004): 227–79.

Rushdy, Ashraf H. A. "Daughters Signifyin(g) History: The Example of Toni Morrison's *Beloved*." *American Literature* 64, no. 3 (1992): 567–97.

———. *Neo-Slave Narratives: Studies in the Social Logic of a Literary Form*. New York: Oxford University Press, 1999.

———. "The Politics of the Neo-slave Narratives." In *Revisiting Slave Narratives*, edited by Judith Misrahi-Barak, 91–102. Coll. Les Carnets du Cerpac no. 2. Montpellier: Université Montpellier III, 2005.

———. "Reading Mammy: The Subject of Relation in Sherley Anne Wil-

liams' *Dessa Rose*." *African American Review* 27, no. 3 (1993): 365–89.

———. "'Relate Sexual to Historical': Race, Resistance, and Desire in Gayl Jones's *Corregidora*." *African American Review* 34, no. 2 (2000): 273–97.

Sack, Laura. "Women and Children First: A Feminist Analysis of the Primary Caretaker Standard in Child Custody Cases." *Yale Journal of Law and Feminism* 4, no. 2 (1992): 291–328.

Sánchez, Marta E. "The Estrangement Effect in Sherley Anne Williams' *Dessa Rose*." *Genders* 15 (1992): 21–36.

Sanger, Carol. "Feminism and Disciplinarity: The Curl of the Petals." *Loyola of Los Angeles Law Review* 27 (1993): 225–68.

———. "Seasoned to the Use." *Michigan Law Review* 87 (1989): 1338–65.

———. "Separating from Children." *Columbia Law Review* 96, no. 2 (1996): 375–517.

Savage, Stephanie. "Women Who Kill and the Made-For-TV Movie: The Betty Broderick Story." In *No Angels: Women Who Commit Violence*, edited by Alice Myers and Sarah Wight, 113–29. London: Pandora, 1996.

Schaller, Barry R. *A Vision of American Law: Judging Law, Literature, and the Stories We Tell*. Westport, CT: Praeger, 1997.

Schanfield, Lillian. "The Case of the Battered Wife: Susan Glaspell's 'Trifles' and 'A Jury of Her Peers.'" *Buffalo Women's Journal of Law and Social Policy* 5 (1997): 69–83.

Scheppele, Kim Lane. "Foreword: Telling Stories." *Michigan Law Review* 87, no. 8 (1989): 2073–98.

Schreiber, Flora Rheta. *Sybil*. Chicago: Contemporary Books, 1973.

Schur, Richard. "The Subject of Law: Toni Morrison, Critical Race Theory, and the Narration of Cultural Criticism." *49th Parallel: An Interdisciplinary Journal of North American Studies* 6 (2000), http://www.49thparallel.bham.ac.uk/back/issue6/schur.htm.

Sharpe, Tony. "(Per)Versions of Law in Literature." In *Law and Literature*. Current Legal Studies, vol. 2, edited by Michael Freeman and Andrew D. Lewis, 91–115. Oxford: Oxford University Press, 1999.

Sherwin, Richard K. "Framed." In *Reelism: Movies as Legal Texts*, edited by John Denvir, 70–94. Urbana: University of Illinois Press, 1996.

Showalter, Elaine. *Hystories: Hysterical Epidemics and Modern Culture*. London: Picador, 1997.

Shumway, David R. "Screwball Comedies: Constructing Romance, Mystifying Marriage." *Cinema Journal* 30.4 (1991): 7–23.

Simon, William H. "Moral Pluck: Ethics in Popular Culture." *Columbia Law Review* 101, no. 2 (2001): 421–48.

Simonds, Merilyn. *The Convict Lover: A True Story*. Toronto: Macfarlane Walter and Ross, 1996.

Skrapec, Candice. "The Female Serial Killer: An Evolving Criminality." In *Moving Targets: Women, Murder and Representation*, edited by Helen

Birch, 241–68. London: Virago, 1993.

Smart, Carol. "The Woman of Legal Discourse." In *Criminology at the Crossroads: Feminist Readings in Crime and Justice,* edited by Kathleen Daly and Lisa Maher, 21–36. New York: Oxford University Press, 1998.

Smiley, Jane. *A Thousand Acres.* New York: Alfred Knopf, 1991.

Smith, Abbe. "Defending the Innocent." *Connecticut Law Review* 32 (2000): 485–522.

Smith v South Carolina, 1995 WL 789245.

Spillers, Hortense J. "Mama's Baby, Papa's Maybe: An American Grammar Book." *Diacritics* 17, no. 2 (1987): 64–81.

St. Joan, Jacqueline. "Sex, Sense, and Sensibility: Trespassing into the Culture of Domestic Abuse." *Harvard Women's Law Journal* 20 (1997): 263–308.

St. Joan, Jacqueline, and Annette Bennington. *Beyond Portia: Women, Law, and Literature in the United States.* Boston: Northeastern University Press, 1997.

Stansell, Christine. "White Feminists and Black Realities: The Politics of Authenticity." In *Race-ing Justice, En-Gendering Power,* edited by Toni Morrison, 251–67. London: Chatto and Windus, 1993.

Stepto, Robert B. *From Behind the Veil: A Study of Afro-American Narrative.* Urbana: University of Illinois Press, 1979.

Strand, Ginger. "Treadwell's Neologism: Machinal." *Theatre Journal* 44, no. 2 (1992): 163–75.

Strickland, Rennard. "The Cinematic Lawyer: The Magic Mirror and the Silver Screen." *Oklahoma City University Law Review* 22, no. 1 (1997): 13–23.

Styron, William. *Confessions of Nat Turner.* New York: Random House, 1967.

Tannen, Deborah. *You Just Don't Understand Me.* New York: William Morrow, 1990.

Taylor, C. J. "The Kingston, Ontario Penitentiary and Moral Architecture." In *Lawful Authority: Readings on the History of Criminal Justice in Canada,* edited by R. C. Macleod, 223–45. Toronto: Copp Clark Pitman, 1988.

Taylor, Katherine A. "Compelling Pregnancy at Death's Door." *Columbia Journal of Gender and Law* 7 (1997): 85–165.

Texas v Yates, 880, 205 and 853, 590 (Dist. Ct. 202).

Thomson, Michael. "From Bette Davis to Mrs. Whitehouse: Law and Literature—Theory and Practice." in *Law and Literature.* Current Legal Studies, vol. 2, edited by Michael Freeman and Andrew D. Lewis, 219–38. Oxford: Oxford University Press, 1999.

Threedy, Debora L. "The Madness of a Seduced Woman: Gender, Law, and Literature." *Texas Journal of Women and the Law* 6 (Spring 1996): 1–46.

Tobin, Elizabeth. "Imagining the Mother's Text: Toni Morrison's *Beloved* and Contemporary Law." In *Beyond Portia: Women, Law, and Literature in the United States*, edited by Jacqueline St. Joan and Annette Bennington McElhiney, 140–74. Boston: Northeastern University Press, 1997.

Trapasso, Ann E. "Returning to the Site of Violence: The Restructuring of Slavery's Legacy in Sherley Anne Williams's *Dessa Rose*." In *Violence, Silence, and Anger: Women's Writing as Transgression*, edited by Deirdre Lashgari, 219–30. Charlottesville: University Press of Virginia, 1995.

Treadwell, Sophie. *Machinal*. In *Plays by American Women 1900–1930*, edited by Judith E. Barlow, 171–255. New York: Applause Theatre, 1985.

Turner, J. Neville, and Pamela Williams, eds. *The Happy Couple: Law and Literature*. Annandale, NSW: Federation Press, 1994.

Tushnet, Mark. "Class Action: One View of Gender and Law in Popular Culture." In *Reelism: Movies as Legal Texts*, edited by John Denvir, 244–60. Urbana: University of Illinois Press, 1996.

U.S. Bureau of Justice special report (rev. 2000), http://www.ojp.usdoj.gov-bjs-pub-pdf-wo.pdf.url.

Walker, Margaret. *Jubilee*. Boston: Houghton Mifflin, 1966.

Ward, Ian. *Law and Literature: Possibilities and Perspectives*. Cambridge: Cambridge University Press, 1995.

Waters, Sarah. *Affinity*. London: Virago, 2000. First published 1999 by Virago.

Weisberg, Richard H. "Literature's Twenty-Year Crossing into the Domain of Law: Continuing Trespass or Right by Adverse Possession?" In *Law and Literature*. Current Legal Studies, vol. 2, edited by Michael Freeman and Andrew D. Lewis, 47–61. Oxford: Oxford University Press, 1999.

———. *Poethics and Other Strategies of Law and Literature*. New York: Columbia University Press, 1992.

Weisbrod, Carol. *Butterfly, the Bride: Essays on Law, Narrative, and the Family*. Ann Arbor: University of Michigan Press, 1999.

West, Robin. "Economic Man and Literary Woman: One Contrast." In *Law and Literature: Text and Theory*, edited by Lenora Ledwon, 127–36. New York: Garland, 1996.

———. "Invisible Victims: A Comparison of Susan Glaspell's 'Jury of Her Peers' and Herman Melville's 'Bartleby the Scrivener.'" *Cardozo Studies in Law and Literature* 8, no. 2 (1996): 203–49.

———. "Jurisprudence and Gender." In *Feminist Jurisprudence*, edited by Patricia Smith, 493–530. New York: Oxford University Press, 1993.

———. "The Literary Lawyer." *Pacific Law Journal* 27 (1996): 1187–1211.

———. *Narrative, Authority, and Law*. Ann Arbor: University of Michigan Press, 1993.

White, James Boyd. "The Judicial Opinion and the Poem: Ways of Reading,

Ways of Life." In *Law and Literature: Text and Theory*, edited by Lenora Ledwon, 5–28. New York: Garland, 1996.

White, Roberta. "Anna's Quotidian Love: Sue Miller's *The Good Mother.*" In *Mother Puzzles: Daughters and Mothers in Contemporary American Literature*, edited by Mickey Pearlman, 11–22. Westport, CT: Greenwood, 1989.

Wight, Sarah, and Alice Myers, eds. *No Angels: Women Who Commit Violence*. London: Pandora, 1996.

Williams, Patricia J. *The Alchemy of Race and Rights: Diary of a Law Professor*. Cambridge, MA: Harvard University Press, 1991.

Williams, Sherley Anne. *Dessa Rose*. London: Virago, 1998. First published 1988 by William Morrow and Co.

Winter, Kari J. *Subjects of Slavery, Agents of Change: Women and Power in Gothic Novels and Slave Narratives, 1790–1865*. Athens: University of Georgia Press, 1992.

Witteveen, Willem J. "Law and Literature: Expanding, Contracting, Emerging." *Cardozo Studies in Law and Literature* 10, no. 2 (1998): 155–60.

Wolf, Naomi. *The Beauty Myth: How Images of Female Beauty are Used Against Women*. New York: William Morrow, 1991.

Wood, Jennifer L. "Refined Law: The Symbolic Violence of Victim's Rights Reforms," in *Un-Disciplining Literature: Literature, Law, and Culture*, edited by Kostas Myrsiades and Linda Myrsiades, 72–93. New York: Peter Lang, 1999.

Woodard, Helena. "Troubling the Archives: Reconstituting the Slave Subject." In *Revisiting Slave Narratives*, edited by Judith Misrahi-Barak, 77–90. Coll. Les Carnets du Cerpac no. 2. Montpellier: Université Montpellier III, 2005.

Worrall, Anne. *Offending Women: Female Lawbreakers and the Criminal Justice System*. London: Routledge, 1990.

Wyatt, Jean. "Giving Body to the Word: The Maternal Symbolic in Toni Morrison's *Beloved.*" *PMLA* 108 (1993): 474–88.

Yoshino, Kenji. "The City and the Poet." *Yale Law Journal* 114, no. 8 (2005): 1835–96.

Ziolkowski, Theodore. *The Mirror of Justice: Literary Reflections of Legal Crises*. Princeton, NJ: Princeton University Press, 1997.

Index